Photoshop Elements 8 one-on-one

Advance Praise for Photoshop Elements 8 One-on-One

"As you work through this book, it quickly becomes apparent why Deke is often referred to as one of the world's best Photoshop instructors. He uses language and examples that make the seemingly complex incredibly simple, accessible, and understandable. And here's the best part, learning from Deke and his team is a ton of fun. If you're looking for an accessible and enjoyable book to help you learn more about Photoshop Elements this book will exceed your expectations."

> —Chris Orwig Brooks Institute of Photography Faculty, Professional Photographer, and Author, Visual Poetry www.chrisorwig.com

"It's obvious to see why Deke is one of the most popular teachers of Photoshop Elements. Stepping through the exercises in this book, you feel like he's right there with you. It's really one-on-one!" —Julieanne Kost Photoshop Evangelist, Adobe Systems *www.ikost.com*

Also from Deke Press

Adobe Photoshop CS4 One-on-One Adobe InDesign CS4 One-on-One Photoshop CS4 Channels & Masks One-on-One

Photoshop Elements 8 one-on-one

DEKE McCLELLAND AND COLLEEN WHEELER

BEIJING · CAMBRIDGE · FARNHAM · KÖLN · SEBASTOPOL · TAIPEI · TOKYO

Photoshop Elements 8 One-on-One

by Deke McClelland and Colleen Wheeler

Copyright © 2010 Type & Graphics, Inc. All rights reserved. *deke.com* Printed in the United States of America.

This title is published by Deke Press in association with O'Reilly Media, Inc., 1005 Gravenstein Highway North, Sebastopol, CA 95472.

O'Reilly Media books may be purchased for educational, business, or sales promotional use. Online editions are also available for most titles (*safari.oreilly.com*). For more information, contact O'Reilly's corporate/institutional sales department: 800-998-9938 or *corporate@oreilly.com*.

Development Editor:	Linda Laflamme	Design Mastermind:	David Futato
Copyeditor:	Genevieve d'Entremont	Video Producer:	Max Smith
Indexer:	Julie Hawks	Live-Action Video:	Tracy Clarke, Jacob
Technical Editor:	Doug Nelson		Cunningham, Loren Hillebrand
Managing Editor:	Marlowe Shaeffer	Video Editors:	Lucas Deming, Loren Hillebrand, Jeff Perkins
Manufacturing Manager:	Sue Willing	Quality Assurance:	Ryan Hannington
Publicist:	Theresa Pulido	Software Development	Ryan Hannington
Editor Emeritus:	Steve Weiss	Manager:	Charles Greer
Proofreader:	Nancy Kotary	O'Reilly Online Wranglers	Keith Falgren, Kirk Walter,
Back Cover Photos:	Jacob Cunningham,	, J	Gavin Carothers
	Derrick Story	Mental Health Inspector:	Toby Malina

Print History:

November 2009: First edition.

Special thanks to Michael Ninness, Lynda Weinman, Bruce Heavin, Jehf Jones, David Rogelberg, Sherry Rogelberg, Stacey Barone, John Nack, Addy Roff, Jeff Tranberry, Mark Brokering, Sally Smith Clemens, Betsy Weber, Joe Wikert, Adam Witwer, Betsy Waliszewski, Sara Peyton, Karen Montgomery, Laura Baldwin, and Tim O'Reilly, as well as Patrick Lor, Garth Johnson, Val Gelineau, Bob Geger, Sachin Jain, Nandan Jha, Luc Albert and the rest of the gangs at Fotolia. com, iStockphoto.com, PhotoSpin, and Adobe Systems. Extra special thanks to our relentlessly supportive families, without whom this series and this book would not be possible.(And Éirinn go Brách!)

Deke Press, the Deke Press logo, the One-on-One logo, the *One-on-One* series designations, *Photoshop Elements 8 One-on-One*, and related trade dress are trademarks of Type & Graphics, Inc. The O'Reilly logo is a registered trademark of O'Reilly Media, Inc.

Adobe, Photoshop, Elements, Acrobat, and Illustrator are either registered trademarks or trademarks of Adobe Systems Incorporated in the United States and other countries.

Many of the designations used by manufacturers and sellers to distinguish their products are claimed as trademarks. Where those designations appear in this book, and Deke Press was aware of a trademark claim, the designations have been printed in caps or initial caps.

While every precaution has been taken in the preparation of this book, the publisher and author assume no responsibility for errors or omissions, or for damages resulting from the use of the information contained herein.

This book was typeset using Adobe InDesign CS4 and the Adobe Futura, Adobe Rotis, and Linotype Birka typefaces.

[C]

RepKover, This book uses RepKover, a durable and flexible lay-flat binding.

11211112112111

IIII

III

TI

35

in

CONTENTS

PREFACE.	How One-on-One Works	xi
LESSON 1.	Getting Started with Photoshop Elements What Is Photoshop Elements? Getting Your Photos into Elements	5 7
	Examining Your Photos Comparing Similar Photos	14 20
LESSON 2.	Organizing Your Photos	31
	What Is Metadata?	33
	Creating and Using Keyword Tags	33
	Making Albums	45
	Finding Photos by Date	48
LESSON 3.	Auto Fixes and Quick Edits	61
	The Trade-Off of the Quick Fix	63
	Automatic Image Correction	64
	Saving Your Changes	73
	Lighting, Color, and Focus	76
	Saving in a Version Set	83
LESSON 4.	Crop Straighton and Siza	00
LE330N 4.	Crop, Straighten, and Size	89
	Whole-Image Transformations	89
	Using the Straighten and Crop Tools	95 100
	Recomposing the Image Contents	100
	Resizing an Image	103

LESSON 5.	Paint, Edit, and Heal The Essential Seven, Plus Two The Three Editing Styles	111 111 113
	Coloring Scanned Line Art	114
	Dodge, Burn, and Sponge	120
	Red Eyes and Yellow Teeth	124
	Healing a Damaged Image	128
LESSON 6.	Making Selections	139
	Isolating an Image Element	141
	Selecting Colored Areas with the Magic Wand	142
	Using the Marquee Tools	149
	Lassoing an Irregular Image	157
	Painting a Free-Form Selection	164
	Quick Selection and Refine Edge	170
LESSON 7.	Filters and Distortions	179
	The Subterfuge of Sharpness	181
	Sharpening an Image	183
	Creating Sharpness with the Emboss Filter	187
	Playing with the Filter Gallery	191
	Applying Free-Form Distortions	197
LESSON 8.	Building Layered Compositions	207
LLJJJON 0.	The Benefits and Penalties of Layers	207
	How to Manage Layers	210
	Arranging and Modifying Layers	211
	Importing and Transforming Layers	217
	Erasing a Background	227
LESSON 9.	Text and Shapes	235
LLSSON 5.	The Vector-Based Duo	237
	Creating and Formatting Text	238
	Applying a Special Text Effect	244
	Drawing and Editing Shapes	251
	Bending and Warping Type	259
	Applying and Modifying Layer Styles	265

LESSON 10.	Correcting Color and Tone	271
	Hue, Saturation, and Brightness	273
	Balancing the Colors	274
	Tint and Color	278
	Adjusting Brightness Levels	282
	Compensating for Flash and Backlighting	289
	Correcting with Camera Raw	292
LESSON 11.	Slideshows and Other Creations	301
	How Creations Work	303
	Laying Out Photo Book Pages	303
	Creating a Greeting Card	315
	Stitching a Panoramic Picture	322
LESSON 12.	Sharing Your Photos	331
	21st-Century Sharing	333
	Printing to an Inkjet Printer	334
	Creating a Picture Package	343
	Sharing Pictures Online	352
INDEX.		361

Contents ix

PREFACE

HOW ONE-ON-ONE WORKS

Welcome to *Photoshop Elements 8 One-on-One*, the latest in a series of (what we hope we conservatively term) lavishly visual, fullcolor titles that combine step-by-step lessons with over four hours of video instruction. As the name *One-on-One* implies, we'll walk you through Photoshop Elements 8 just as if we were teaching you in a classroom environment. Except that instead of getting lost in a crowd of students, you receive individualized attention. It's just you and me. Well, you and me and my trusty online sidekick and coauthor Colleen. Think of it as "one *and* one on one." Bottom line, you can't beat a 2:1 instructor-to-student ratio.

We created *One-on-One* with three audiences in mind. If you're a digital photographer or graphic artist—professional or amateur—you'll appreciate the hands-on approach and the ability to set your own pace. If you're a student working in a classroom or vocational setting, you'll enjoy the personalized attention, structured exercises, and end-of-lesson quizzes. If you're an instructor in a college or vocational setting, you'll find the topic-driven lessons helpful in building curricula and creating homework assignments. *Photoshop Elements 8 One-on-One* is designed to suit the needs of beginners and intermediate users. But we've seen to it that each lesson contains a few techniques that even experienced users don't know.

Read, Watch, Do

Photoshop Elements 8 One-on-One is your chance to learn and have fun with Photoshop Elements under the direction of a professional trainer with over 20 years of computer design and imaging experience and his long-time editor who learned her craft working on these very books. Read the book, watch the videos, do the exercises. Proceed at your own pace and experiment as you see fit. It's the best way to learn.

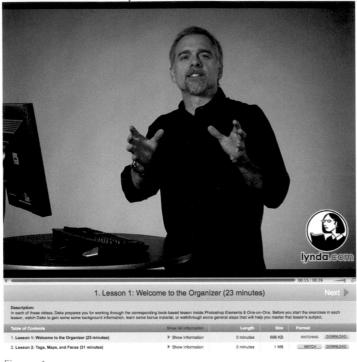

Figure 1.

Photoshop Elements 8 One-on-One contains twelve lessons, each made up of three to five step-by-step exercises. Every book-based lesson includes a corresponding video lesson (see Figure 1), in which we'll introduce the key concepts you'll need to know to complete the exercises. Best of all, every exercise is project-based, culminating in an actual finished document worthy of your labors (see Figure 2). The exercises include insights and context throughout, so you'll know not only what to do, but—just as important—why you're doing it. Our sincere hope is that you'll find the experience entertaining, informative, and empowering.

All the videos and sample files required to perform the exercises are available for download at *oreilly.com/go/deke-PSE8*. If you already have an O'Reilly login, you can click straight through to a page where you can play the videos, download the videos to your computer, and download the sample files. Together, the book, sample files, and videos form a single, comprehensive training experience.

Start with a file ...

follow the steps...

and end with an effect you're proud of.

Previous installments in the One-on-One series provided the video and practice files on a DVD bound in the back of the book. For the first time, we've made the decision to deliver video and practice files online instead. It's a more flexible, greener approach that cuts down on waste but still gives you the same great One-on-One instructional experience.

One-on-One Requirements

The main prerequisite to using *Photoshop Elements 8 One-on-One* is having Photoshop Elements 8 installed on your Microsoft Windows–based PC. You may have purchased Photoshop Elements as a standalone package (see Figure 3) or as part of a bundle that includes Photoshop Premiere Elements. Photoshop Elements 8 also ships for free with some brands of scanners and digital cameras.

For the first time in a while, Adobe has also made Photoshop Elements 8 for Mac available within the same timeframe as the Windows release. This book is based *exclusively on the Windows version*. Although much of Lessons 3–10 will work with either the Mac or the PC, there are vast differences in the tools that the Mac version supplies for organizing and sharing your files.

Any computer that meets the minimum requirements for Photoshop Elements 8 also meets the requirements for using *Photoshop Elements 8 One-on-One*. Specifically, this means:

- 1.6GHz or faster processor
- Microsoft[®] Windows[®] XP with Service Pack 2 or 3, Windows Vista[®], or Windows 7
- 1GB of RAM
- 2GB of available hard-disk space (for Elements, plus another 200 MB or so for the One-on-One practice files.)
- Color monitor with 16-bit color video card
- 1024 × 576 monitor resolution at 96 dpi or less
- Microsoft DirectX 9-compatible display driver
- DVD-ROM drive
- Web features require Microsoft Internet Explorer 6 through 8 or Mozilla Firefox 1.5 through 3.x

Finally, you'll need Internet connectivity for downloading the video and practice files. (You can stream the video if you wish or download it for later, as explained in the next section.)

Figure 3.

If you download the videos rather than streaming them from *www.oreilly. com/go/deke-PSE8*, then we recommend Apple's QuickTime Player software. (QuickTime offers superior playback functions, which is why we choose it over the Windows Media Player.) Many computers come equipped with QuickTime; if yours does not, you will need to install the free QuickTime Player by downloading it from *www.apple.com/quicktime*.

One-on-One Installation and Setup

Photoshop Elements 8 One-on-One is designed to function as an integrated training environment. Therefore, before embarking on the lessons and exercises, you must first install a handful of files onto your computer's hard drive. These are:

- All sample files used in the exercises
- Nearly 100 custom layer styles, which you'll be using throughout the exercises in this book
- Metadata files that you'll need to install so that the previously mentioned layer styles appear in your Elements Editor workspace
- The 12 lesson videos (if you wish to view them offline; playing them online doesn't require any downloading)
- QuickTime Player software (if it is not already installed and you want to watch downloaded versions of the videos offline)

These files are all available by going to *www.oreilly.com/go/deke-PSE8* and following the instructions there, with the exception of QuickTime Player, which you can download from *www.apple.com/quicktime*.

- 1. *Go to www.oreilly.com/go/deke-PSE8*. At this site, click the link that reads, "Watch and Download Video, Download Practice Files." If you already have an O'Reilly.com account, and you're logged in, you'll be taken to the download page straight away. If you need to create an account (it's free) or log in, then you'll be taken through that process and returned to the download page when you're done.
- 2. Download and set up a folder for the practice files. When you download the practice files, each lesson's worth of files will be archived in a separate *.zip* file for easier downloading. Once it's on your hard drive, you can right-click on the folder and choose **Extract All** to create an unzipped folder for each particular lesson.

Stash the files somewhere convenient and memorable, so that when we direct you to open one during an exercise, it won't be hard to find. We're going to suggest you make a *Lesson Files-PSE8 10n1* folder on your hard drive with separate folders for each lesson. If you follow this suggestion, then the instructions we've supplied at the beginning of each exercise will lead you right where you need to go.

3. (Optional) Download the videos if you prefer to watch them offline. At the outset of each book-based lesson, we'll ask you to play the companion video lesson. These video lessons introduce key concepts that make more sense when first seen in action. You can watch these videos online or download them to play on your own computer. Either way, start at www.oreilly.com/go/deke-PSE8 and follow the specific instructions from there.

Alternatively, you can watch the videos in a spiffy online player (see Figure 4), which doesn't require downloading either the movies themselves or a separate piece of software for playing them. We think it's a fairly lovely experience, actually. But if you have an unreliable Internet connection or you'd just rather have the freedom of keeping the videos where you can always get to them, then you can download them to your hard drive from the same site (and remember you'll need QuickTime to watch them if you choose that route).

The video lessons were crafted by the talented folk at online training trailblazers lynda.com. These high-quality videos are not excerpts from other training materials, but were crafted expressly to compliment the lessons in this book. As you can see, the shortcuts that Deke mentions during the video lesson will be shown on screen to help you learn.

Take note that the video lessons do not include follow-along project files. It works like this: you work along with us inside the book; during the videos you sit back and relax, letting Deke do all the work.

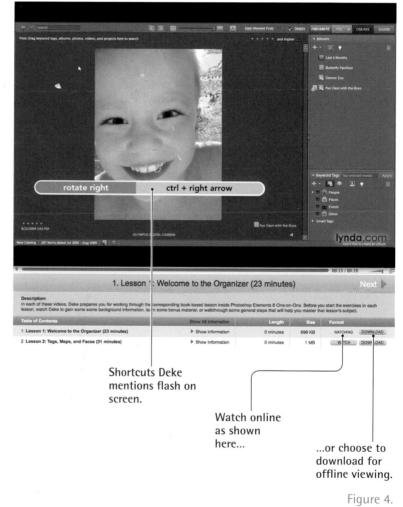

Folder		
	views	
10000	You can apply the view (such as Details or Icons) t	
:::	you are using for this folder to all folders of this type	
Lioped	Apply to Folders <u>R</u> eset Folders	
File	ed settings: s and Folders Always show icons, never thumbnails Always show icons, never thumbnails Display file icon on thumbnails Display file icon on thumbnails Display simple folder view in Navigation pane Display the full path in the title bar (Classic folders only) Hidden files and folders © Do not show hidden files and folders § Show hidden files and folders	4 IB
	Hide extensions for known file types Hide protected operating system files (Recommended)	1

- 4. *Download the layer styles files.* You'll start learning about layer styles in Lesson 5, so no need to worry about what the heck we're talking about now. What you do need to understand is that layer styles can't be created in Photoshop Elements, but they can be edited and applied in Elements. You need full-fledged Photoshop to create them, so we went ahead and did that for you. Download the *Layer styles.zip* from the web page as well.
- 5. *Quit the Organizer and Editor workspaces to install the layer styles.* The layer styles we provide need to be installed when Photoshop Elements isn't running. If Elements is running on your computer, you must exit the program before you install the layer styles files. Choose the **Exit** command from the **File** menu or press Ctrl+Q in both workspaces if necessary.
- 6. *Place the layer styles files in the appropriate folder on your computer.* Unzip the layer styles file and move the contents to one of the following directories, depending on your version of the Windows operating system:
 - Windows XP: C:\Documents and Settings\All Users\Application Data\Adobe\Photoshop Elements\8.0\Photo Creations\layer styles
 - Windows Vista: C:\ProgramData\Adobe\Photoshop Elements\8.0\Photo Creations\layer styles
 - Windows 7: C:\ProgramData\Adobe\Photoshop Elements\8.0\Photo Creations\layer styles

ProgramData is one of those tricky folders that Windows might be hiding from you. To see your hidden files, choose **Organize** \rightarrow **Folder and Search Options**. Then click the View tab and scroll down to the Files and Folders section, where you'll see an entry for Hidden Files and Folders. Choose **Show Hidden Files and Folders** (see **Figure 5**) and then Click OK. *ProgramData* should now be visible in your C: window view.

7. *Delete your current database file.* In order to reset your layer styles and make the gift we just gave you accessible from inside Elements, you have to delete the file called *ThumbDatabase.db3* that lives in one of the following locations, again depending on your version of Windows:

- Windows XP: C:\Documents and Settings\All Users\Application Data\Adobe\Photoshop Elements\8.0
- Windows Vista: C:\ProgramData\Adobe\Photoshop Elements\8.0\
- Windows 7: C:\ProgramData\Adobe\Photoshop Elements\8.0\

Elements will rebuild this file the next time it launches, so don't be worried if it takes a minute to get Elements fully loaded the next time you open the Editor workspace.

- 8. *Launch the Editor workspace*. We'll introduce you to the two different workspaces more carefully in Lesson 1, but for now launch Photoshop Elements and from the **Welcome Screen** click the large **Edit** button on the left.
- Turn on color management. Photoshop Elements ships with a killer color management engine that helps ensure that your colors remain consistent from one computer to another, as well as from your monitor to your printer. But it needs a bit of tweaking. Choose Edit→Color Settings.

Inside the **Color Settings** dialog box, select the **Allow Me to Choose** option, as in Figure 6. This lets you adjust the color management settings for a single image at a time. To accept your changes, click the **OK** button. Now the colors of your images will match (or at least more closely match) those shown in the pages of this book.

Congratulations! We are now in sync, and you're ready to begin following along with the exercises in this book.

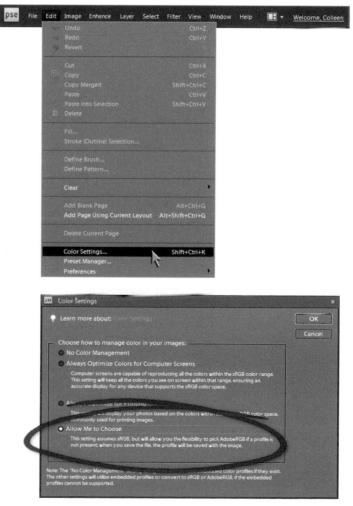

Structure and Organization

Each of the dozen lessons conforms to a consistent structure designed to impart skills and understanding through a regimen of practice and dialog. As you build your projects,we'll explain why you're performing the steps and why Photoshop Elements works the way it does.

Each lesson begins with a broad topic overview. At the beginning of each lesson you'll find a section called "About This Lesson," which lists the skills you'll learn and directs you to the video-based introduction. Be sure to follow the reminders for where to go to download the lesson files and watch the video lessons.

Next come the step-by-step exercises, in which we'll walk you through some of Elements' most powerful and essential image-editing features. A web icon, like the one

PEARL OF

WISDOM

Along the way, you'll encounter the occasional "Pearl of Wisdom," which provides insights into how Photoshop Elements and the larger world of digital imaging work. Although this information is not essential to performing a given step or completing an exercise, it may help you understand how a function works or provide you with valuable context.

More detailed background discussions appear in independent sidebars. These sidebars shed light on the inner workings of the Quick Fix mode's Auto buttons, the mysteries of the visible-color spectrum, the mechanics of print resolution, and other high-level topics that are key to understanding Photoshop Elements.

A colored paragraph of text with a rule above and below it calls attention to a special tip or technique that will help you make Photoshop Elements work faster and more smoothly. EXTRA CRED

Occasionally, a project is a bit ambitious. Our enthusiasm for a topic may even take us beyond the stated goal. In such cases, we cordon off the final portion of the exercise and label it "Extra Credit." If you're feeling oversaturated with information, go ahead and skip to the next exercise. If you're just warming up, by all means carry on; you will be rewarded with a completed project and a wealth of additional tips and insights.

Each lesson ends with a "What Did You Learn?" section, which features a multiple-choice quiz. Your job is to choose the best description for each of 12 key concepts outlined in the lesson. Answers are printed upside-down at the bottom of the page.

FURTHER INVESTIGATION

When we know of interesting information elsewhere that takes you beyond the scope of this book, we'll let you know about it with an invitation for "Further Investigation." In these notes, we'll provide links to URLs or other resources that will help you expand your knowledge of Photoshop Elements' power or peculiarities.

The Scope of This Book

No one book can teach you everything there is to know about Photoshop Elements, and this one is no exception. If you're looking for information on a specific aspect of Elements, here's a quick list of the topics and features discussed in this book:

- Lesson 1: Finding your way around the Photoshop Elements workspaces, importing your photos, organizing your image, and comparing photos with one another
- Lesson 2. Viewing the metadata that describes your images, attaching meaningful keyword tags, gathering your images into albums, adjusting the time stamp on images, and finding your photos by date with Elements' calendar tools
- Lesson 3: Using Elements' automatic adjustments for color and lighting, the tools of the Quick Fix panel, as well as ways to save your edited images as independent files or in sets
- Lesson 4: Ways to crop and transform an image, including the crop and straighten tools, as well as the Divide Scanned Photos, Image Size, and Canvas Size commands

- Lesson 5: Painting and retouching, including the paintbrush, dodge, burn, and red-eye removal tools, as well as the healing brushes and the various brush settings in the options bar
- Lesson 6: Selection tools, including the lasso, magic wand, and marquee tools, as well as the selection brush, magic selection functions, and the commands in the Select menu
- Lesson 7: The Editor's extensive collection of filters, including the Adjust Sharpening, High Pass, the many effects in the Filter Gallery, and the powerful Liquify function
- Lesson 8: Layer functions, including the Layers panel, stacking order, blend modes, transformations, and the eraser tools
- Lesson 9: Text and shape layers, including the type and shape tools, formatting attributes, scalable vector objects, the Warp Text dialog box, and applying layer styles
- Lesson 10: Color and brightness adjustments, including Hue/ Saturation and Levels, the Shadows/Highlights command, and the Camera Raw dialog box
- Lesson 11: The wide world of multimedia Creations, including photo albums, greeting cards, wall calendars, web galleries, and panoramas that comprise several photos stitched together
- Lesson 12: Ways to share your digital images, including printing single images and multiple photos, as well as emailing image files and posting them online

To find out where we discuss a specific feature, please consult the Index, which begins on page 361.

While we touch on almost every aspect of Photoshop Elements in some degree of detail, a few specialized topics fall outside the scope of this book. In the Organizer, we don't go into deep detail about how to use File \rightarrow Backup to make duplicates of your photos for safekeeping, nor do we explain how to use File \rightarrow Burn to copy images to a CD or DVD. And although we provide a general and, to our minds, very educational lesson on filters (Lesson 7, "Filters and Distortions"), we don't cover all of the Editor's filter commands. It's a pretty small list of missing functions, but you should know up front.

So now, we invite you to turn your attention to Lesson 1, "Getting and Organizing Photos." We hope you'll agree that *Photoshop Elements 8 One-on-One*'s combination of step-by-step lessons and video introductions provides the best learning experience of any Photoshop Elements training resource on the market.

GETTING STARTED WITH PHOTOSHOP ELEMENTS

PHOTOSHOP ELEMENTS 8 may be the most phenomenal bargain in the history of digital imaging. "Elements," as we like to call it, has image-editing power modeled after the professional-grade, industry-standard Adobe Photoshop CS4. Then it tosses in some powerful photo-organizing tools and project-creation features to provide all the sorting, managing, beautifying, sharing and presenting opportunities your photos will ever need. Bottom line, Photoshop Elements delivers far and away more

capabilities than any other image-editing program in its price range.

From the tadpole that was Photoshop LE (short for Light Edition)—a freebie version of Photoshop in which many of the program's most powerful functions were merely turned off-Photoshop Elements has matured into a unique piece of software that incorporates many of Photoshop's best features and tosses in a few dozen tricks of its own. It's an easy matter to chart the top capabilities of the two Photoshops and make Elements come out the winner Admittedly, such a table is unfair, which is why it appears barely rescued from the dustbin in Figure 1-1. Elements provides only rudimentary support for some features, and most of Photoshop proper's strengths are so rich and deep that they put the program in a class by itself. Still, the table makes a point. In fact, Elements has some tools that turn what would be complicated processes in fullfledged Photoshop into easy-often one-step-maneuvers.

Still, for a fraction of the price of the full-blown Photoshop CS4, Photoshop Elements 8 provides more features than most digital photographers will ever use. Photoshop Elements is a consumer-level program for folks with professional-quality aspirations.

Adobe Ph	otoshop	Photoshop Elements	1
and the second second		X	
and the second s		X	NOT THE PARTY OF
Ne browser Graphical image tags		X	
		X	1 - 1 - 1
Stack related photographs		X	
Quick Fix		X	and the second
Smart Fix mane correction	X	x	
Histogram palette Correct flash and backlighting	X	X	and and a
Correct Hash and backageters	X	X	
Auto-crop scanned images		X	1
Cookie-cutter copping Healing wush	X	X	E. San
Red-eye Curection	X	X	1 Lands
Multiple undos	X	X	
idenial effectshilters	X	X	
iree-form disprives	X	X	and the second second
Perspective cloning	X	×	
Independent Lawre	X	and a survey of the second	A MARTINE
Smart objects	X	X	1
Imane extractionaria	×		and the second second
Alpha channels	××	X	
Transpatency contra	×	X	
Layeistyles	x	×	A La Cartana
High-resolution text	Ŷ	X	and the set of the set
Text Warp	x	X	and the second
Vector-based shapes		X	
Output to email	X		
Color-managed printing	X	-	
Convento CMYK	1	· ·	
Print multiple images		XXXXX	1/ 000
Online picture sharing			
Create albums and cards	×	×	The second second
Print wall calendars	×	the sum of a	- Elin -
Web photo gallery Stitch photos into pano	rama X		
Stitch photos into parto			F !
			Figure 1-1.

ABOUT THIS LESSON

Project Files

Before beginning the exercises, make sure you've downloaded the lesson files from *www.oreilly.com/go/deke-PSE8*, as directed in Step 2 on page xiv of the Preface. This means you should have a folder called *Lesson Files-PSE8 10n1* on your desktop (or whatever location you chose). We'll be working with the files inside the *Lesson 01* subfolder. The first step is to get your bearings in the Photoshop Elements environment and import some photographs to explore with. In the following exercises, you'll learn how to:

- Distinguish between the two Elements workspaces . . page 5
- Import photos into Photoshop Elements page 7
- Organize your photos in the Organizer workspace . page 14
- Compare similar photos page 20

Video Lesson 1: Welcome to the Organizer

When you first run Photoshop Elements 8, the program greets you with an interactive Welcome Screen, and lets you choose between the two primary workspaces in Elements, the Organizer and the Editor. Click the Organize button to launch the Organizer, which lets you create catalogs of images and view the images as thumbnails.

The Organizer is so useful that we've made it the subject of the first video lesson, which you can either view online or download to view at your leisure from *www.oreilly.com/go/deke-PSE8*. During the video, you'll learn about the keyboard equivalents and shortcuts listed below.

Operation

Open the Catalog Manager Get images from a digital camera or card reader Zoom in to or out of thumbnails Rotate an image clockwise or counterclockwise Hide or show details below thumbnails Keyboard equivalent or shortcut Ctrl+Shift+C Ctrl+G (or insert memory card into reader) Ctrl+ (plus) or ((minus) Ctrl+→ or Ctrl+← Ctrl+D

What Is Photoshop Elements?

Photoshop Elements 8 is really two programs running in tandem. Adobe calls these programs *workspaces*. But when you first launch Elements from the icon on your desktop, you actually encounter a third environment, the Welcome Screen shown in Figure 1-2, which invites you to the software, allows you to sign into Adobe's online community, Photoshop.com (see the sidebar "What Is Photoshop.com?" on page 6), and gives you quick access to either of the two workspaces.

ORGANIZE	Welcome to Elements! We'd like to show you around. Choose	the option that best describes you.	
EDIT	l'm new to Photoshop Elements.	Show me what I need to know	
	I have an earlier version of Photoshop Elements.	Show me what's new and cool	

Figure 1-2.

The most important feature of the Welcome Screen, at least as far as this lesson is concerned, are the two big buttons on the left, Organize and Edit. If you click the Organize button, you launch the Organizer workspace, appropriately enough. The Organizer is a *media browser*, and it lets you import images from a digital camera, file folder, or scanner; preview many images at a glance; name, label, and attach other information to those images; and decide which (if any) you want to edit and print. If you click the Edit button on the Welcome Screen, you launch the aptly named Editor workspace. The Editor is an *image editor*; it lets you open a photograph and change it. You can adjust the brightness and contrast, alter the colors, move things around, sharpen the focus, retouch a few details, and even combine two photographs.

But it doesn't end there. You can also use Photoshop Elements to enhance artwork that you've scanned from a hand drawing or created with another graphics program. If you're artistically inclined, you can start with a blank document and create a piece of artwork from scratch. If that's not enough, Elements offers a wide variety

What Is Photoshop.com?

Photoshop.com is a web destination created by Adobe for sharing, storing, and even discussing your photographic projects. Anyone can get a free account by simply creating an account at *www.photoshop.com*, but users of Photoshop Elements have another path from within the application itself. Well, several paths, really. You can create an Adobe ID from the bottom of the Welcome Screen or by clicking on the Create New Adobe ID link at the top of the Organizer workspace. You'll be greeted with this handy screen to the right that explains the difference between the free account and the plus options.

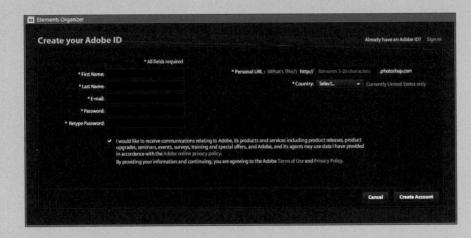

Unfortunately for our international readers, Photoshop.com accounts are available only in the U.S. right now.

The most obvious benefit of the plus account is the difference in storage, starting with the \$49.99 upgrade that kicks you up to 20 GB. Sure, you get access to some other bonus artwork, but let's face it, if you intend on sharing your work via Photoshop.com, the 2 GB that comes with the free account isn't going to get you very far. (As Deke points out, that's less than some memory cards these days.)

Note that you can also just buy more storage for your plus account, starting at \$19.99 for 20GB, but you'll be giving up the automatic delivery of bonus artwork, tutorials, and templates. For now, go ahead and create the free account, which will be plenty to complete the exercise in Lesson 12 of this book. As you can see above, it's a fairly simple set of instructions if you just follow Adobe's lead.

Elements will also let you create a "vanity" URL, something along the lines of *yourname.photoshop.com*. So it might be good to get in there and lay claim to your name or favorite sobriquet. Our guess is that over time, Adobe will add cool features to Photoshop.com, so getting on the bandwagon now, especially as it's free, seems like a good idea. of illustration tools, special effects, and text-formatting options. And when you're done creating, you can print the result, attach it to an email, or post it online. In this lesson, you'll get your initial introduction to the Organizer workspace. Specifically, you'll find your way around the interface, import images into Photoshop Elements, and give your photos a preliminary review and evaluation.

Getting Your Photos into Elements

After you've successfully opened the Organizer workspace (as explained in Video Lesson 1, "Welcome to the Organizer"), the next step is to tell the Organizer where your photos are. Happily, the Organizer gives you a number of easy ways to do this. You can direct the program to scour your hard drive for any image files it can find. From that point on, you can rely on Elements to transfer new photos from your camera to your hard drive automatically. Just insert your camera's memory card into a card reader or connect the camera directly to your computer via a USB or FireWire connection, and Elements automatically sets about importing the photos.

Elements keeps track of imported images in a *catalog*, which remembers the links to the images on your hard drive and stores any information that you might want to associate with the images. By default, Elements creates a catalog for you, giving it the apt but generic name *My Catalog*. A single catalog can manage hundreds or even thousands of photos, even if the images are scattered in multiple folders on different hard drives or even on backup CDs.

To see the Organizer import images from a digital camera media card, watch Video Lesson 1, "Welcome to the Organizer," downloadable from *www.oreilly.com/go/deke-PSE8*. In this exercise, however, you won't be working with your photos. Instead, we want you to import a select group of images that we've provided. This will ensure that what happens on your screen exactly matches the steps and figures shown in this book. It's sort of a control group, as the scientists say. If you've been experimenting on your own and have already imported some photos into Elements, don't worry. We'll begin this exercise by creating a fresh new catalog file just for this lesson. If you've worked in the program before, the *My Catalog* file that you've been using will be saved exactly as you left it. And we'll tell you how to open it again at the end of the exercise, so that you can regain access to your personal photos (and have a convenient way to delete ours when you're done with the lesson).

Figure 1-3.

- Launch Elements. You'll start this exercise in the Organizer workspace. Start up Photoshop Elements 8, and in the Welcome Screen that appears, click the Organize button. If this is the first time you've launched the Organizer, it'll ask whether you want to import photos into your default My Catalog file. For now, click No. (You can always import photos later by choosing File→Get Photos→By Searching. Then click the Search button, and away you go.)
- 2. Create a new catalog. Choose the Catalog command from the File menu or press Ctrl+Shift+C. As pictured in Figure 1-3, the resulting Catalog Manager dialog box gives you a brief explanation of what a catalog does, explains that most people only have one, and gives you a choice of catalogs to choose from. Since you're going to create your own, you don't really need to worry about these designations at the moment. Instead, simply click the New button.
- 3. *Take note of the backup warning.* The first catalog you create will be the one that is linked to your Photoshop.com account (see the sidebar "What Is Photoshop.com?" on page 6). So Elements is warning you that you won't be able to share any photos from this new catalog until you change that. This won't be entirely relevant until you get to Lesson 12, "Sharing Your Photos," but it's good to make a note of the fact before clicking **OK**.
- 4. *Name the new catalog and confirm a few settings.* Elements will present you with a new window where you can enter the name of your new catalog. Enter "One-on-One" in the name field. Leave the checkbox at the bottom of this dialog box turned on in order to import Elements' free music files into your catalog, which you can use to accompany slide shows and the like. Click **OK**.

The Organizer workspace should appear as pictured in Figure 1-4 on the facing page. Note that the Organizer window is empty and the new catalog name, *One-on-One*, appears in the lower-lefthand corner of the window.

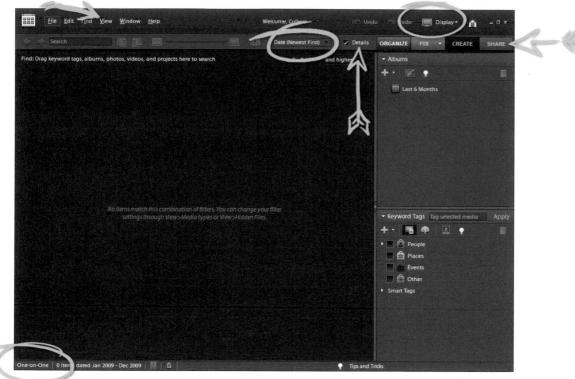

Just to make sure we're all in perfect agreement—and thus avoid the possibility of confusion later—check the settings of the following options (all shown in Figure 1-4):

- Click the down arrow to the right of the word **Display** at the upper right of the window, which will bring up a popup menu. Make sure you have **Thumbnail View** selected (or press Ctrl+Alt+1).
- Set the pop-up menu in the middle of the screen to **Date** (Newest First).
- Make sure the **Details** checkbox next to that pop-up menu is turned on.
- You should see the tabs for the four panels (Organize, Fix, Create, and Share) across the top of the panel bin on the right.
- If you see big blue icons for the 13 music files (most likely you won't, but just in case), choose View→Media Types, turn off the Audio checkbox, and click OK. (Leave the Photos, Video, Projects, and PDF checkboxes on.) Or press Ctrl+3.
- 5. *Add photos to your catalog.* Time to bring in some actual photos. From the File menu, choose Get Photos and Videos→From Files and Folders, or press Ctrl+Shift+G.

The Organizer Interface

Your journey with Photoshop Elements 8 begins with the Organizer, which is where you acquire and manage your digital photographs. To make sure that we are speaking the same language as we venture through the exercises in this lesson, let's take a moment to introduce you to this essential workspace. Labeled in the figure below, the key elements of the Organizer interface are as follows, in alphabetical order. (Colored labels indicate terms that are discussed in the context of other interface elements.)

- Catalog title: The Organizer uses catalogs to keep track of the images on your hard drive, CDs, and other media. You can create a catalog using File→Catalog, or just accept the one the Organizer creates for you by default.
- Cursor: The cursor (sometimes called the *pointer*) is your mouse's on-screen representative, moving to keep pace with your mouse. Use the cursor to select items, choose commands, and adjust settings.

Details: In the photo browser mode, the Organizer lists information about a photograph below its thumbnail. You should at least see the month and year when the image was captured. To see the filename as well, choose View→Show File Names.

To show or hide details, turn on or off the Details checkbox at the bottom of the workspace or press Ctrl+D.

Display options: Click the down arrow next to the word "Display" at the top right, and you'll see some different choices for displaying your images. The media browser shows a collection of thumbnails in the order defined by the sort order pop-up menu in the shortcut bar. Not shown in the figure, the date view organizes thumbnails into calendars, either by year, month, or day.

Zoom slider Shortcuts bar

Catalog title

- **Image thumbnail:** In the digital realm, the word *image* is a general term for any photograph or piece of scanned artwork. The Organizer previews images by displaying them as reduced *thumbnails*, varying in size from postage-stamp tiny to dollar-bill big. Clicking a thumbnail selects it and gives it a heavy blue outline. Press Shift while clicking to select a range of thumbnails; press Ctrl and click to select multiple nonadjacent thumbnails.
- Menu bar: Click a name in the menu bar to display a list of commands. Choose a command by clicking it. A command followed by three dots (such as Catalog...) displays a window of options called a *dialog box*. Otherwise, the command works right away.

The Properties panel is not on by default, and yet is one of the most useful for day-to-day work in Photoshop Elements. With it, you can examine the EXIF metadata captured by a digital camera. To hide or show the Properties panel, press Alt+Enter. It first appears as a freefloating panel, but if you click the double down arrow at the top, it will dock itself underneath the Keyword panel.

- **Rating filter:** By setting a number of stars and then choosing from the pop-up menu, you can tell Elements to reveal only those images that are higher than, lower than, or exactly a given star rating level.
- Shortcuts bar: Located below the menu bar, the shortcuts bar offers quick access to some of the Organizer's most common functions. Icons with tiny down-pointing triangles next to them (as in ▼) display menus of commands. Others produce immediate effects.

Perched atop the photo browser window (not shown), the *Timeline* charts the number of images that you captured on a month-by-month basis in the form of a standard-issue column graph. Each vertical bar is a month; a taller bar means more photos were shot in that month. Drag the blue month marker or click in the timeline to view a different month of thumbnails in the photo browser. The Timeline is no longer on by default; you can choose Window→Timeline or press Ctrl+L to turn it on.

- **Task Pane:** Aligned to the right edge of the workspace, the Panel Bin contains the tabs for the four main *panels*, which are windows of options that can remain visible on the screen even when you are performing other tasks. The default panel, Organize, has panes for Albums and Keyword Tags. You can resize these by clicking and holding on the borders in between, waiting for your cursor to become a double-headed arrow and sliding up/down or right/left.
- Window controls: The top-right corner of the Organizer window sports three controls that let you hide (minimize), resize (maximize), and close the workspace, respectively. Except when the Organizer is maximized (as when you click the licon), you can drag the size handle in the bottom-right corner of the workspace to make the window bigger or smaller.
- Zoom slider: Click or drag along the slider bar in the topright corner of the workspace to change the size of the scalable, always-smooth thumbnails. Or press Crtl and the \textcircled or \boxdot key to zoom incrementally. To zoom all the way in or out, click one of the icons on either side of the slider. You can also zoom all the way in so that you see just one big thumbnail at a time—by pressing the Enter key. The icon on the far right of the slider launches the *full-screen view*, a built-in slide show for viewing images free from the distractions of the Organizer interface.

6. *Navigate to the Lesson 01 folder*. In the **Get Photos and Videos from Files and Folders** dialog box that opens (Figure 1-5), navigate to the place you put the folder

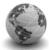

that contains your sample lesson files, which you installed as directed in the Preface (see Step 2 on page xiv). Double-click the *Lesson Files-PSE8 10n1* folder to open it. Inside you will see folders for each of the 12 lessons in this book. Click the *Lesson 01* folder to select it. (Do not double-click and open the folder; just click once to select it.)

Look in:	瀇 Lesson File	s - PSE8_1on1	•	OB P	•		Preview
C.	Name	Date modified	Туре	Size			
ecent Places	Lesson 01						
ETTERNI	📗 Lesson 02						
	🍶 Lesson 03						
Desktop	🗼 Lesson 04						
T	🗼 Lesson 05						
NJA-	🎍 Lesson 06						
lleen Wheeler	🗼 Lesson 07						
	🍌 Lesson 08						
Computer	🍌 Lesson 09						
100	🍌 Lesson 10						E Col Barton From California
-	🗼 Lesson 11						 Get Photos From Subfolders Automatically Fix Red Eyes
Network	🗼 Lesson 12						Automatically Suggest Photo Stacks
	File name:	[•	1	Open	Get Media
	-	Marta Chardela			-	Cancel	
	Files of type:	Media Files (pho	tos, vídeo, audio)	-	J	Cancer	· · ·
Copy Files	on Import						
Generate F	reviews						
√olume Name:	C:						

PEARL OF WISDOM

You may get a Import Attached Keyword Tags dialog box that says some of your images have keywords already attached to them. These are qualities that the Auto-Analyzer attached to your photos on import. It's fine to just click OK, and review later whether the Auto-Analyzer correctly made these assessments. You can read more about this feature in Lesson 2, "Organizing Your Photos.".

- 7. *Turn on the checkboxes.* Turn on both the **Get Photos from Subfolders** and the **Automatically Fix Red Eyes** checkboxes. The first option tells Elements to import all photos inside any and all folders that may reside in the *Lesson 01* folder. The second option enables a feature that promises to eliminate the dreaded flash-induced red eye before you ever get a chance to see it. In a moment, we'll see how well Elements performs this task.
 - 8. *Get the photos.* Click the Get Media button. Elements displays a fleeting window titled Getting Photos as it imports each of the 18 photographs contained inside the *Lesson 01* folder (see Figure 1-6). The browser window then fills with image thumbnails. A moment later, a progress bar appears as the program examines images that might contain red eye. In all, about 90 percent of the photos are under suspicion. Just sit back and let the program do its thing.

PEARL OF

WISDOM

After it checks for red eye, both the corrected and original versions of each of the two photos Elements found with red eye have been preserved in special groups called *version sets*—you'll learn more about these later.

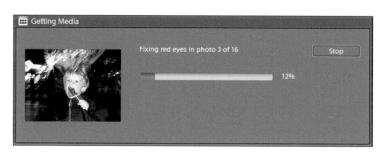

- 9. *Dismiss the message*. Next you must contend with the message pictured in Figure 1-7. Turns out, this one is irrelevant. Here's the gist: The program wants you to know that if your new catalog already contained some photos, the older images will now be hidden. But the catalog was empty, so no worries. Turn on the **Don't Show Again** checkbox, and then click **OK**.
- 10. *Click the Show All button at the top of the Photo Browser.* Or press the Backspace key. The newly imported photos are the only images in the catalog, so clicking **Show All** doesn't really change things. But you might as well get in the habit for when it does, right?
- 11. Make the thumbnails their absolute smallest. Click the little 📰 button at the left side of the Image Size slider (the one that appears circled in red in Figure 1-8) to shrink the thumbnails to their smallest possible size. You should now be able to take in all 20 thumbnails at once—even though, it must be said, the thumbnails are very tiny. Incidentally, you might be tempted to play with the slider to the right of this icon. But we'd be much obliged if you would save at least some playing for the next exercise, during which we'll introduce you to the wonders of this seemingly innocuous slider.

WISDOM

If at any point you'd prefer to work with your own photos, choose File \rightarrow Catalog, click the Open button, select *My Catalog*, and click yet another Open button. Your catalog is reinstated just as you left it. Use this same technique to switch back to the *One-on-One* catalog when you're ready to move on to the next exercise.

PEARL OF

Examining Your Photos

The Organizer is obviously great at showing you a "big picture" overview of the photos in your catalog. But when you want to examine one of those photos in closer detail, the Organizer can also show you—quite literally—the *big picture*. This flexibility makes the workspace ideal for sorting through a large catalog that contains a few thousand images. You can zoom in to inspect the most minute details of a particular photo and then zoom back out to view the thumbnail in the context of its mates.

However, the Organizer is much more than a means to view your photos. It also lets you make important changes to images, including correcting rotation problems and changing filenames—precisely what we'll be doing in this exercise. But first you'll learn how to use the Organizer's flexible controls to examine image thumbnails which is, after all, one of the workspace's most fun functions.

 Open the catalog. If the One-on-One catalog remains open from the preceding exercise, skip to Step 2. Otherwise, choose File→Catalog or press Ctrl+Shift+C. Then

click the **Open** button and double-click the *PSE8 10n1* file to open it. The contents of the catalog appear inside the Organizer.

If necessary, click the is icon to zoom all the way out, as you did at the end of the preceding exercise (see Figure 1-8). Notice that the month and year in which an image was taken appears below its thumbnail. If this information does not appear on your screen, turn on the Details checkbox at the top of the Organizer workspace.

- 2. *Enlarge the photos.* Slowly slide the thumbnail size slider at the top of the photo browser all the way to the right. Don't release the mouse button until you've reached the end of the slider. If you've a keen eye, you'll notice several things as you move the slider:
 - The thumbnails grow bigger, and therefore you see fewer of them on screen at a time.

- At a certain point, Elements adds to the details displayed below each thumbnail, starting with the day of the month each photo was taken, then eventually the time of day and star rating of each photo.
- After you've moved the slider as far as it will go to the right (see Figure 1-9), you've entered what the Organizer calls the *single-photo view*. Elements also displays any caption information that you may have entered for the image. In our case, the Olympus-brand camera used to take these photos has automatically captioned each image *Olympus Digital Camera*. This information doesn't exactly help differentiate one photo from the next, but you can always triple-click the caption below the large thumbnail to select it, and enter a new caption.

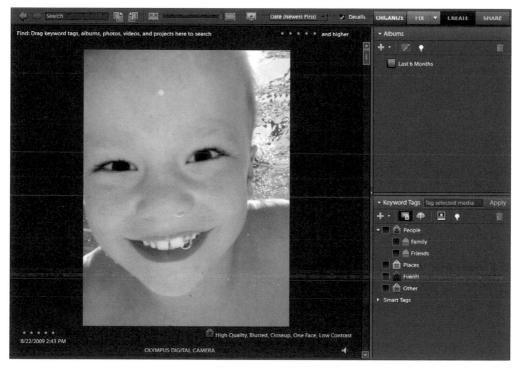

3. *Display filenames.* Turns out, we've already given these files something every bit as good as captions—distinctive filenames. So let's show the names. From the View menu, choose Show File Names. With any luck, the Organizer will display the filename *Underwater Sam.jpg* beneath the date and time.

WISDOM

As long as we're on the topic of preferences, we have another bit of info for those of you who may be curious. Because the Media Browser Arrangement menu is set to Date (Newest First), the images at the top of the browser are the most recent. But strangely, within a given day's grouping, the photos are displayed from oldest to newest. For instance, the photos taken on 10/18/2004 appear before the one snapped on 9/19/04, but the image shot at 7:16 PM appears before the one taken three minutes later. After you've finished this book, if you would rather the photos appear in *absolute* reverse chronological order, choose Edit \rightarrow Preferences \rightarrow General and select the option called Show Newest First within Each Day.

OF

- 4. Return to the small thumbnail size. Previous to this, you've clicked the iii icon to switch to the small thumbnail view. This time, we want you to try something different: click the blue Back arrow imes in the upper-left corner of the Organizer workspace or press the Backspace key (or Alt+←). This option works like the Back button in a web browser, taking you back to the most recent view.
- 5. *Switch to the largest thumbnail size*. Take your pick and do any one of the following:
 - Click the right-pointing arrow icon (the one that looks like ⇔).
 - Press the equivalent keyboard shortcut, $Alt+\rightarrow$.
 - Click the little picture-frame icon (I) to the immediate right of the thumbnail-size slider bar.

Whichever method you choose, you will once again maximize the *Underwater Sam.jpg* image in the photo browser. And in case you're wondering why we're going back and forth between views, we're just trying to give you a sense for the many ways you can scale thumbnails in the Organizer.

Here's another: you can also make the thumbnail size shrink and grow by pressing Ctrl + the \Box and \doteq keys, respectively. (Those are the minus and plus keys, in case you can't quite identify them without reading glasses. And we say that as people who quite unfortunately identify with your lack of identification.) 6. View the first several photos. To cycle through the images in single-photo view, press the → and ← keys. Press → to advance through the photos. Eight presses of → takes you to the image named *Trust me Sammy_edited-1.jpg*, which you might notice has a small version set icon in its upper-right corner.

This is one of the two photos that Elements chose as having a red-eye problem. As you can see, it was only 50 percent successful, and each of Deke's sons still has a slightly red-tinged eye. For more on fixing red-cyc using a tool with much more control, check out "Red Eyes and Yellow Teeth" in Lesson 5.

Stop pressing \rightarrow when you get to the *Sweatshirt Sam.jpg*, shown in Figure 1-10. As you can see, this photo is in need of some rotation.

- 7. Rotate the photo. You can use the icons above the preview screen to rotate images 90 degrees counterclockwise or clockwise. Sammy needs a clockwise rotation, so click the ☐ icon (circled in red in Figure 1-11) or press Ctrl+→. Figure 1-11 shows the result: Sammy has been properly uprighted.
- 8. Shrink the thumbnail view size. Some other images need rotation, so we might as well correct them all at once. Drag the thumbnail slider triangle to the left or press the 🖃 key until you can see all 20 thumbnails clearly.
- 9. Select the other thumbnails that need rotating. Select the thumbnail for the next photo that needs rotating (dated 7/23/2005). Then press the Ctrl key and click the two other photos (the statues) that appear on their sides, as in Figure 1-12 on the next page.

Figure 1-10.

Figure 1-11.

- Rotate the selected thumbnails. All the photos rest on their left sides. (Most built-in flashes perform best when the camera is tilted clockwise.) Press Ctrl+→ or click the ⁽¹⁾ icon. A moment later, the Organizer rotates the selected thumbnails upright.
- 11. View the last photo in single-photo view. Just one more problem to correct: all the images in the photo browser except one have descriptive filenames. So let's give it one. Double-click the sixth thumbnail, the one with the meaningless name *B0000583.jpg*. The selected image fills the photo browser window.
- 12. View the Properties panel. From the Window menu choose Properties, or press the keyboard shortcut Alt+Enter to display the Properties panel. To get the Properties panel out of your way, click the double down-pointing arrow at the top-right of the panel, as indicated in Figure 1-13. This takes what is otherwise a *free-floating panel* and anchors it to the Organize pane. Although it looks limited at the moment, the Properties panel is capable of displaying an abundance of information about the selected image. You can even use the panel to edit the image information.

Figure 1-13.

- 13. *Rename the selected photo.* Let's change both the caption and the filename assigned to this photo:
 - Click the thumbnail of the photo in the preview window, which will have the effect of waking up the **General** icon in the top-left corner of the **Properties** panel. This displays the Caption and Name fields, as well as a place to put notes and ratings.
 - Click the **Caption** field in the Properties panel. Press Ctrl+A to select the existing Olympus advertisement and replace it with "Boys in a Bubble", or words to that effect.
 - Press the Tab key to advance to the **Name** option and replace it with "Fountain Sam & Max.jpg". Then press the Enter key to accept the change.

Figure 1-14 shows the new caption and filename as they appear both in the Properties panel and under the magnified image preview.

PEARL OF

When you rotate thumbnails, add captions, or change filenames in the Organizer, Elements updates the original image files on your hard drive. And this brings up an important point: the images you see in your catalog are linked to the original images on your hard drive. This means you should take care when deleting photographs from a catalog. The saving grace: a catalog file shows low-resolution proxies of images, not the full-resolution originals. So when you remove a proxy from a catalog by pressing the Delete key, you are presented with an alert message containing a checkbox that gives you the option of deleting the original image as well. Do not turn this checkbox on unless 1) you hate the photo and you want to delete it forever and always, or 2) you have backed up the photos to a DVD or another hard drive.

WISDOM

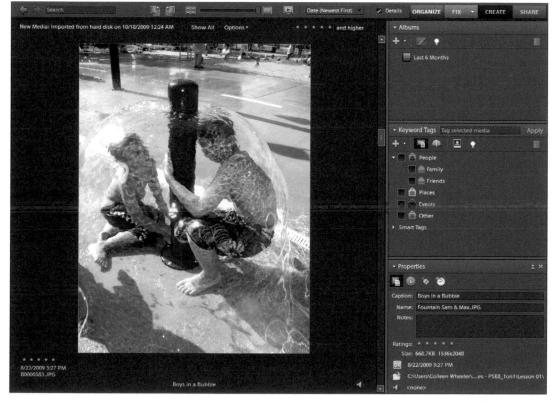

Figure 1-14.

Comparing Similar Photos

Digital photography encourages you to take a lot of pictures. After you finish paying for the camera, the memory card, and other equipment, snapping a digital photo is as close to free as anything the material world has to offer. But as you attempt to capture the perfect photo, you're liable to end up with piles of similar shots. It's possible to have so many similar shots, in fact, that you might want to see only the best one in the photo browser. But how do you choose which photograph is the best?

In this exercise, we'll look at two methods Elements offers for studying and comparing photos. You'll then learn how to create a *stack*, so that one shining image can serve as the representative for other similar photos in the photo browser.

1. Choose a specific day to view. To isolate the images we're going to use for this exercise, let's take advantage of Photoshop Elements' handy option that allows you to view your images within the context of a calendar. Open the **Display** pop-up menu and choose Date View. You'll see a calendar display, set to the cur-

												•	20	04	•									rt Batc r Local No.w				Ctri+Alt+ Ctri+Alt+ Ctri+Alt+	-3 Octo	ber 18, 200	14
			JAN							FEB						1	MAR						Sections	0000000	Irgania	ze in F	ull Screen	FIL		14.1	Ξ.
5	M	T	W	T	F	S	S	M	T	W	T	F	5	5		T	W	Ť	F	5	5	99	Comp	iare Pt	iotos !	Side by	y Side	F12			
				1	2	3	1	2	3	4	5	6	7	_	1	2	3	4	5	6		-			1	2	3	1.329		1	
	5	6	7	8	9	10	8	9	10	11	12	13	14	7	8	9	10	11	12	13	4	5	6	7	8	9	10	No.	1	K	
1	12	13	14	15	16	17	15	16	17	18	19	20	21	14	15	16	17	19	19	20	11	12	13	14	15	16	17	R.	a far a	-	
	19	20	21	22	23	24	22	23	24	25	26	27	28	21	22	23	24	25	26	27	18	19	20	21	22	23	24	1 K	in inte	449	
	26	27	28	29	30	31	29							28	29	30	31				25	26	27	28	29	30			•	••	
-																															
			MAY			hannad				JUN			housed				JUL			k	Lauren			AUG				19 Mil			
							c	14	т	w	т	c	c	c	N.C.	Ŧ		7	c	c	s	м	т	w	т	c					
						1			1	2	3	4	5	1				1	2	3	1	2	3	4	5	6	7				
	3	4	5	б	7	8	6	7	8	9	10	11	12	4	5	6	7	8	9	10	8	9	10	11	12	13	14				
	10	11	12	13	14	15	13	14	15	16	17	18	19	11	12	13	14	15	16	17	15	16	17	18	19	20	21				
	17	18	19	20	21	22	20	21	22	23	24	25	26	18	19	20	21	22	23	24	22	23	24	25	26	27	28				
	24	25	26	27	28	29	27	28	29	30				25	26	27	28	29	30	31	29	30	31	1							
	31							-						-							-	1	1	1							
							L	I	1				L			i				L		-	1	1	1	I					
	M		SEP							OCT							NOV							DEC							
1	. 24		1	2	3	4						1	2	È	1	2	3	4	5	6	- T	T	T	1	2	3	4				
1	6	7	8	9	10	11	3	4	5	6	7	8	9	7	8	9	10	11	12	13	5	6	7	8	9	10	11				
	13	14	15	16	17	18	10	11	12	13	14	15	16	14	15	16	17	18	19	20	12	13	14	15	16	17	18				
	20	21	22	23	24	25	17	18	19	20	21	22	23	21	22	23	24	25	26	27	19	20	21	22	23	24	25				
	27	28	29	30			24	25	26	27	28	29	30	28	29	30					26	27	28	29	30	31					
1		-	1	-		1	31							-	-						-	1	1	1	1						

Figure 1-15.

rent year, with blue cells indicating dates that have representative photos.

Start by clicking the Year button at the bottom of the workspace, and then use the blue **O** button to the left of the year at the top of your screen to navigate to that bygone year, 2004. Your screen should look like the one in Figure 1-15. In the top-right corner of the window, you can see a preview of the first of the six images of Deke and his boys that were shot on this day.

2. Enter the full-screen view mode. Double-click the cell for October 18 in the calendar, to switch to the Day view. Notice the icon below the large preview (which we've circled in Figure 1-16). This icon launches the Organizer's instant, full-screen slide show function. This photo review function falls somewhere in between, making it a great way to create an impromptu slide show without a lick of preparation. Click the icon, or press the F11 key. Your monitor switches to the full-screen view in the background, overlaid with some spectral transparent control panels that appear and disappear based on where your mouse is.

Figure 1-16.

- 3. *Change the settings.* The ghostly toolbar we need for this step appears under the caption, and wiggling your mouse should be enough to make it appear, if it's missing. Click the icon that looks like a wrench (see Figure 1-17) to open the **Full Screen View Options** dialog box. Here are our suggestions for these settings:
 - You're about to hear one of those hidden audio files that we imported into the catalog at the beginning of this lesson. Although the default choice is upbeat and cheerful to

be sure, it doesn't hold up well to repeated listenings. In other words, it will drive you nuts before this exercise is over. Set the **Background Music** option to something that wears better, namely, *Light_Jazz.mp3*.

- Turn off the **Include Captions** checkbox. Unless you have specifically taken the time to add your own captions in the Properties panel, this option will likely display a statement from the camera vendor that does nothing but obscure your view of the photographs.
- Turn on the **Show Filmstrip** checkbox. This adds a column of thumbnails known as the *filmstrip*, along the right side of the screen, which is great for navigation. Click a thumbnail to instantly see that image displayed large on the screen.
- Turn on the **Start Playing Automatically** checkbox. This option makes the slide show begin the moment you click OK.
- 4. Enjoy the slide show. When your Full Screen View Options dialog box looks like the one in Figure 1-17, click the OK button. Immediately, the mellow piano music plays as the six images fade gracefully from one to the next. After Elements displays the final image, the slide show stops.

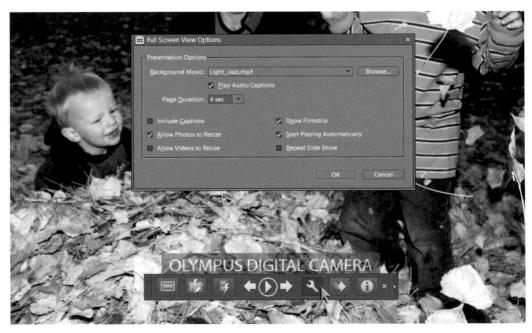

Figure 1-17.

5. Expand the toolbar. In Figure 1-18 we've captured a lovely leaffrolicking moment in the slide show. At any time, you can click the ▶ on the right end of that ghostly toolbar at the bottom to expand it to its full range of options. A few words about those options, as labeled in Figure 1-18:

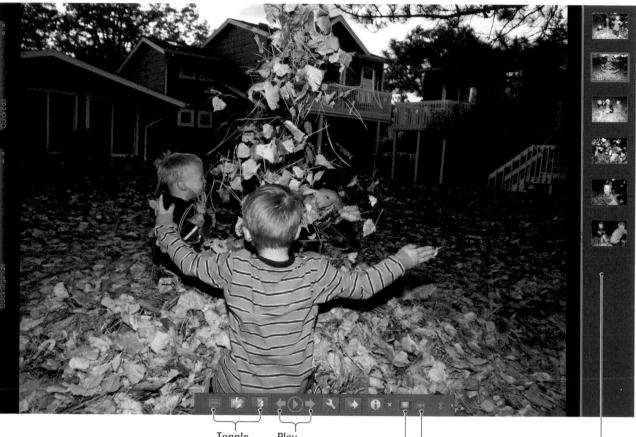

Toggle Play controls

- controls
- The toggle controls allow you to turn on and off the filmstrip, Quick Edit panel, and Quick Organize panel. (The latter two house features we'll learn about in subsequent lessons, so feel free to toggle them off for now.)
- Use the play controls to stop, restart, advance, or go back one slide. Or better yet, press the space bar to play and pause; once you've paused, you can use the \leftarrow and \rightarrow keys to advance from one slide to the next.

Side by side view Full screen view

Filmstrip

Figure 1-18.

Figure 1-19.

- The two other icons labeled in Figure 1-18 let you switch between the full-screen slide show and the related-yetaltogether-different photo comparison mode, which we'll explain in Step 6.
 - 6. *Enter the photo comparison mode.* In addition to the full-screen slide show, Photoshop Elements provides a mode for comparing photos, which splits the screen so that you can view two photos side by side (good for vertical portrait-style shots) or top and bottom (better for horizontal photos like these). To enter the photo comparison mode, do like so:
 - Click the first photo at the top of the filmstrip. Once again, you should see Deke with his boys and his mouth wide open in an expression of manic joy.
 - Back in the toolbar, click the Compare photos icon (as labeled back in Figure 1-18). Then choose the Above and Below command from the menu immediately to the right.

Elements divides the screen into two horizontal sections, with the first image at the top and the second at the bottom, as in Figure 1-19. Notice that Elements has numbered the corresponding thumbnails in the filmstrip 1 and 2.

As you might guess, the photo comparison mode is great for comparing photos. So let's compare the images of Deke and his kids, choose the best one, and stack the other five under our favorite in the photo browser.

7. Swap the second image for the third. The top half of the screen is currently selected; you can tell because it's outlined in blue. We like this photo, so let's leave it on the screen. The second photo has a nice pillar of leaves, but we're missing the faces. To select it, click in the bottom half of the screen so the blue outline surrounds the photo.

Now click the third thumbnail in the filmstrip or press the \downarrow key. The image loads into the bottom half of the screen and receives the number 2.

- 8. *Examine the two images.* To examine the two images and choose the best, we need to increase their magnification.
 - Press Ctrl+: Elements zooms in on the lower image because it's selected.
 - Now click the ***** button on the far right side of the toolbar. This links the upper image to the lower one, so that the two zoom and pan together.
 - Continue pressing Ctrl+ 🗈 until you reach the 200 percent zoom level (as identified by the number that flashes in a partially opaque window in the middle of the screen).
 - Drag inside either image with the hand-shaped cursor until Deke's is visible in both images, as in Figure 1-20.

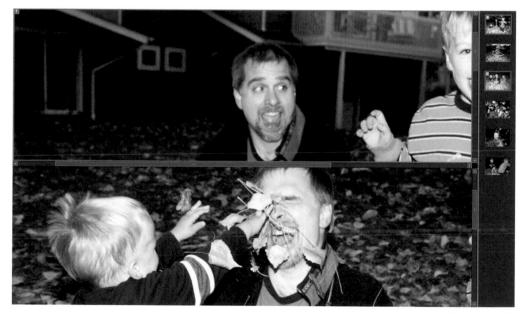

At this magnification level, Deke's face is in sharper focus in the bottom image. Furthermore, the bottom image features the endearing sight of little Sammy shoving a handful of leaves and twigs into Deke's eye. How can you top that? Clearly, the bottom image is superior. Let's mark it as such in the next step.

Figure 1-21.

- 9. *Rate the bottom photo.* With the blue box still surrounding the bottom photo, press the toolbar icon that looks like a lowercase letter *i* inside a circle. You'll recall this is the same icon as you saw in the Properties panel back in Step 13 of the previous exercise. (Ironically, it does not actually take you to the tab represented by the *i* icon, but no matter. The *i* in this case stands for Information.) In the **Properties General** window that opens, as shown in Figure 1-21, click the second star in the **Ratings** field to give this image a 2-star rating, indicating its superiority above the other, unrated photos.
- 10. *View the first six thumbnails in the photo browser.* Now that we know which photo is the best (okay, we didn't look at all six photos, but we saw enough), it's time to return to the photo browser.
 - Click the ⊗ button in the toolbar or press the Esc key to exit the photo comparison mode.
 - With the top thumbnail selected in the date view, click the micron (the one that looks like a pair of binoculars) to the right of the full-screen view button under the large preview. The Organizer cancels the date view and jumps to the selected image of Deke with the gaping maw amidst all the other images in the photo browser.

Figure 1-22.

11. Stack the six leaves photos. Adjust the zoom setting in the photo browser so you can see all six leaves images. Then select all six by clicking the first photo and Shift-clicking the last, as in Figure 1-22. Next, choose Edit→Stack→Stack Selected Photos or press Ctrl+Alt+S. All but the newest of the six photographs disappear. As shown in the magnified Figure 1-23 on the facing page, the remaining photo appears to be stacked in front of some other photos and bears a special stacks icon, circled in red in the figure. This icon indicates the existence of—you guessed it—a stack.

12. View all six photos in the stack. Although the stacked photos are currently invisible, they're still part of the catalog. Let's view them: Choose Edit→Stack to display a submenu of commands. Notice that you can choose Unstack Photos to undo the stacking, or Flatten Stack to delete all stacked images from the catalog except the one that's visible. Instead, choose Expand Photos in Stack or press the keyboard shortcut Ctrl+Alt+R.

As shown in Figure 1-24, the Organizer displays the six photos inside the selected stack with a background "bubble" that indicates they all belong together. (The other stacks with the telltale background are those created by our altering photos in one way or another—in our case, either by having Elements auto-fix the red eye or rotating the images back in the first exercise.)

Figure 1-24.

- 13. *Place the fourth thumbnail at the top of the stack.* Right-click the leaves-in-the-eye thumbnail—the one marked with the two yellow ☆ that we assigned in Step 9—and choose **Stack→Set as Top Photo**. The five-star image becomes the first thumbnail in the browser window.
- 14. *View all photos.* Click the ◀I button to the right of the final leaves image to re-collapse the stack. As you can see in Figure 1-25, the new thumbnail assumes its place of honor as the representative photo in the stack.

Now you have a basic sense of what the Organizer can do and what you can do with it. But star ratings and captions are only the first step. In the next lesson, we'll take a look at some of the powerful tools for further creating order from the chaos of your photo collection.

Figure 1-25.

WHAT DID YOU LEARN?

Match the key concept in the numbered list below with the letter of the phrase that best describes it. Answers appear upside-down at the bottom of the page.

Key Concepts

- 1. Welcome Screen
- 2. The Editor
- 3. The Organizer
- 4. Thumbnail
- 5. Catalog
- 6. Media browser
- 7. Timeline
- 8. Filmstrip
- 9. Properties
- 10. Date View
- 11. Stack
- 12. Full Screen View

Descriptions

- A. A feature of the photo browser, this charts the number of images that you captured on a month-by-month basis in the form of a column graph.
- B. The Organizer houses image thumbnails inside this kind of file, which remembers the links to the images on your hard drive and stores any information that you might want to associate with those images.
- C. A small preview image that represents your photograph in the Elements Organizer.
- D. When you assemble thumbnails into one of these, a single thumbnail serves as the representative for the other photos in the group.
- E. A vertical collection of thumbnails that allows you to see a group of images for a slideshow.
- F. This Organizer view shows a collection of thumbnails in the order defined by the sort order pop-up menu.
- G. This Organizer view sorts thumbnails into calendars, either by year, month, or day.
- H. This introductory message comes up when you launch Photoshop Elements and provides direct links to two workspaces.
- I. A method for studying images in slide show format, with accompanying music (to drive you insane).
- J. This exceptional workspace serves as a media browser and lets you import images from a digital camera as well as a hard drive or DVD.
- K. Photoshop Elements' main workspace, this program lets you open and make changes to photos, such as adjusting brightness and contrast and retouching details.
- L. This set of metadata information about your photo reveals things such as captions, camera type, date taken, ect..

Answers

1H' 5K' 3Ì' +C' 2B' 9E' 1V' 8E' 6F' 10C' 11D' 15I

ORGANIZING YOUR PHOTOS

Coach Bob with the 2. Colle

COMPUTERS and digital cameras have transformed the way we capture photographs. But although the trappings are different, the methods are often familiar. Consider storage and organization, for example. Where once we had shoeboxes, now we have hard drives. More often than not, our pictures in those digital shoeboxes are organized just as pell-mell as they were in their physical counterparts.

Physical organizational tools like labels and albums have their counterparts in the digital world as well. Photoshop Elements provides the means to add labels that can keep track of dates, places, people, events, and even moods, just like Colleen's mom used to do by hand with her fountain pen in the borders around family snapshots like the ones in Figure 2-1. (The stars and stripes on Colleen's Speedo also indicate these were taken at swim practice, Carmichael Park pool, sometime around the summer of 1976.)

Part of the wonder of electronic labeling is that you can cross-reference and search for photos in ways that even the most organized oldschool snapshot sorter never could. And those overstuffed albums in the back of your closet have been replaced by a digital version liv ing on your computer, ideal for sharing, regrouping, and allowing your photographs to live in more than one collection at the same time. Try that with an old print.

etherea

No, the traditional shoebox never had a friend like the Photoshop Elements Organizer. Assuming that you're willing to invest the time—a big *if*, to be sure—you can document photos in minute detail, which lets you search through them later in a matter of seconds. This feature is so fantastic that for years Photoshop-proper users also owned Elements simply to use the Organizer's unique image management capabilities.

Figure 2-1.

ABOUT THIS LESSON

Project Files

Before beginning this exercise, make sure you've completed Lesson 1 or you've downloaded and imported the Lesson 01 files from *www.oreilly.com/go/deke-PSE8*, as directed in Step 2 on page xiv of the Preface. This lesson reuses the image collection that you already imported during Lesson 1. Photoshop Elements has some remarkable organizational tools that are quick and easy to use, and will help you get a handle on your images in the way no shoebox ever could. In this lesson, you'll learn how to:

•	View all the information Photoshop Elements	
	knows about your image	page 33
•	Create and use tags to identify your photos	page 33
•	Make virtual albums	page 45
•	Adjust a timestamp and find photos by dates	page 48

Video Lesson 2: Tags, Maps, and Faces

The Photoshop Elements Organizer workspace has several tools for sorting, organizing, tagging, referencing, and generally getting a handle on your images. In this video, Deke shows you how to create and apply tags, pin your image to a map for reference, and use Elements' fun but unpredictable auto-analysis feature.

You can either view this video online or download to view at your leisure from *www.oreilly. com/go/deke-PSE8*. During the video, you'll learn about the keyboard equivalents and shortcuts listed below.

Keyboard equivalent or shortcut Ctrl+A Ctrl+N Ctrl+Shift+Q Ctrl+J Ctrl+L Ctrl+L Ctrl+Alt+D

bh

Operation	
Deselect all images	
Create a new tag	
Find untagged photos	
Adjust the date and time of a selected photogra	p
Show the Timeline	
Switch to the Date View	

What Is Metadata?

The features of the Organizer that we'll be concerned with in this lesson use information known as metadata. *Metadata* generally refers to "information about information," and in the case of your photographs, it refers to any bit of data about a photo's origin, content, creator, file format, quality, technical attributes, etc. Metadata can refer to something as straightforward as the photograph's filename or as subjective as the star-rating you assign to it based on your personal assessment. Regardless, it's all there, waiting for a program like Photoshop Elements to read and then use to sort and search.

The Properties panel that you first saw in the previous lesson gives you a glimpse into the copious amount of information that Elements knows about your image. Figure 2-2 shows just the Metadata tab of this panel for one image. (Elements is using a general term for a specific set of information here; arguably, the ratings, keywords, and history are also all part of the metadata, but you get the idea.)

The Organizer workspace has several useful tools and sorting mechanisms that can use this information to help you find a suitable image for a specific project, create a collection of similar images automatically, or understand the history and origin of a particular photograph.

In the video that opens this lesson, Deke took you through some of the ways Elements helps you automatically sort through a copious collection of images. In the next few exercises, we'll show you specifically how to create and exploit your own user-created metadata with the help of the Organizer workspace.

Figure 2-2.

Creating and Using Keyword Tags

Photoshop Elements lets you assign labels to images using tags. Strictly speaking, a *tag* is a descriptive word or phrase that you can associate with a photo. In Elements, a tag also includes a tiny graphic, giving it some visual presence and making it easier to identify. You can apply a tag to many photos at once, and a single photo may have multiple tags attached.

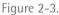

For instance, if you and your brother take a vacation to Guatemala, you might create a Guatemala tag and apply it to all those vacation photos. You might also want to create a tag for your brother, which you would naturally apply to all the photos you shot of him, including those taken in Guatemala (as symbolically illustrated in Figure 2-3). You can create tags for virtually anything—people, pets, places, events, you name it—and share them between images as much as you like.

All this tagging pays off when you're searching through thousands of digital photos for a specific shot. Double-click the Guatemala tag, for example, and the Organizer displays only the photos with that tag attached. Add the tag for your brother to the mix, and the Organizer displays only those photos that show your brother in Guatemala. Or you could exclude your brother's tag from the Guatemala shots, displaying only brotherless vacation photos. The virtual nature of tags makes it possible to group, sort, and arrange photos in multiple ways. If you've ever been frustrated trying to organize a large number of physical objectsshould your Tommy CD be filed under Opera or The Who?-you'll love the infinite flexibility of tags.

In this exercise, we're going to create and apply tags to some of the 20 imported photos in the *One-on-One* catalog that you imported in the previous lesson. Just imagine the payoff when you apply tags to not just 20 practice photos but also your own vast and ever-growing library of photographs.

You create and manage tags in the Keyword Tags panel, which has a permanent home in the Organize pane. (If you don't see the contents of the panel, click the ▼ next to the words Keyword Tags to expand the panel.) Every catalog starts out with a few starter tags as well as some categories and subcategories to keep the tags organized. (Turns out that you can also assign categories directly to thumbnails, too.) As you tag your own images, you'll likely want to create a hierarchical system of tag categories and subcategories. Just remember that the tags you create are saved in a particular catalog file, not with the associated images (unless you choose Write Keyword Tag and Properties Info into Photo from the Edit menu, but let's assume you haven't). If you start a fresh catalog, the Organizer makes only its default tags available to you.

- 1. Open the lesson catalog. This exercise starts assuming you've completed those in the previous lesson. Open the One-on-One catalog (if it's not already open) by using the File→Catalog command. Then scroll to the thumbnail for Floating Sam.jpg, and double-click it so that you see it in the single-photo view.
- Create a new tag. Open the pop-up menu next to the green

 [⊕] under Keyword Tags and choose Create New Tag, or press Ctrl+N, to display the Create Tag dialog box. Enter the infor- mation shown in Figure 2-4, like so:
 - This tag will be applied to pictures of Deke's buoyant son Sammy, so type "Sam" in the **Name** field.
 - As is often the case, our new tag handily fits in an existing category. Go to the **Category** pop-up menu and select **Family**, which is a subcategory of People.
 - Click the **OK** button to create the new tag. The ▼s next to the People and Family categories automatically twirl open to reveal the Sam tag.

From the same pop-up menu next to the green \oplus under Keyword Tags, you can choose Collapse All Keyword Tags to twirl all the categories closed or Expand All Keyword Tags to twirl them all open.

Graphical creatures that they are, tags display little thumbnails to tie a visual reference to the tag. The Sam tag sports a question mark because we haven't yet applied it to an image. We'll remedy that in the next step.

Incidentally, don't double-click the tag. We mention this because it's such a natural operation—seemed logical to us, anyway—but it runs a search, one that comes up empty. If we didn't catch you in time and you have accidentally double-clicked, just click the m icon in front of the Sam tag to turn off the search results you inadvertently asked for. Then click on the *Floating Sam.jpg* thumbnail again.

3. *Apply the Sam tag.* Instead of double-clicking, drag and drop the Sam tag from the panel onto the picture of Sam and his flotation device. You'll notice that several things happen:

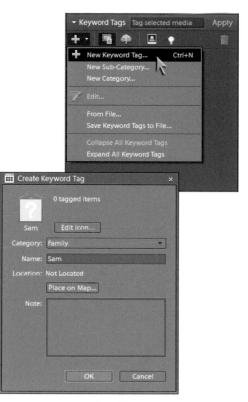

Figure 2-4.

- The tag appears momentarily in the lower-left corner of the thumbnail, and then disappears.
- The details area below the thumbnail shows the Sam tag and the People category icon, circled in Figure 2-5.

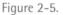

• Also circled in the figure, Elements replaces the question mark on the tag with an itty-bitty Sammy.

As it so happens, this particular photo of Sam doesn't make a good tag graphic because we can't see all of his face and he's lost in the tiny 22-by-22-pixel icon. We'll correct that in Step 7). In the meantime, let's add an event tag that tells us that this is a Summertime photo.

- 4. *Create a Seasons tag category.* We could place the Summertime tag in the predefined Events category, but we reckon seasonal moods are sufficiently special to deserve their own category. Imagine that we one day wanted to use this charming photo to represent the fun-filled days of Summer in a calendar project; we'd want to tag it in a way that we can find it again. That's the great thing about tags; you can organize them any way you like. Here's how (as documented in Figure 2-6 on the facing page):
 - Open the pop-up menu next to the green ⇔ button in the Keyword Tags panel, and choose **New Category** to display the **Create Category** dialog box.

- Click the Choose Color button to select a color to represent this category. In the Color Picker dialog box that opens, choose a color that you like. (To duplicate our deep green, enter the following values: H: 120, S: 90, B: 30, as shown.) Then click OK.
- Type "Seasons" in the Category Name field.
- Select a representative category icon. Our suggestion: scroll to and click the 16th option, the flower. Click **OK** and the Seasons category appears at the bottom of the Keyword Tags list.

PEARL OF

WISDOM

By default, you can move categories up or down in the Keyword Tags panel in any order you want, but tags are alphabetized within their categories. If you don't like this behavior, choose Edit→Preferences→Keyword Tags and Albums. Then click the options to switch categories, subcategories, and tags between Manual and Alphabetical modes.

- 5. Create a Summertime tag. Instead of going back to the same old pop-up menu, just right-click the Seasons category and choose Create new keyword tag in Seasons category. The Seasons category is already selected in the Create Keyword Tag dialog box. Type "Summertime" in the Name field and click OK. The new tag sports a question mark and the Seasons category's dark-green color.
- 6. *Apply the Summertime tag.* This time, drag and drop the image of Sammy from the preview window onto the **Summertime** tag in the **Keyword Tags** panel. As you can see, tagging images works both ways. The Season icon and Summertime tag appear alongside the People icon and Sam tag below the image preview.
- 7. *Edit the Summertime tag icon*. We now have a tiny version of Sammy and his kickboard valiantly trying to represent all of Summertime. To change the icon, do the following:

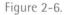

Figure 2-7.

- Right-click the **Summertime** tag and choose **Edit Summertime Keyword Tag** from the pop-up menu.
- In the Edit Keyword Tag dialog box, click the Edit Icon button to display the Edit Keyword Tag Icon dialog box. The animated square marquee on the big image thumbnail shows the cropping area for the tag icon.
- Resize and reposition the marquee so that it grabs only swirling chlorinated water and a bit of the lane ropes, as in Figure 2-7. Drag a square corner handle of the marquee to shrink it; drag inside the marquee to move it. Notice that the preview at the top of the dialog box updates to show you what the tag icon will look like. When you're happy with the preview, click **OK**.
- Click **OK** again in the Edit Tag Icon dialog box to change the Summertime tag in the Keyword Tags panel.
- 8. *Apply the Summertime tag.* There are more images that speak to the mood represented by the Summertime tag. To locate them, drag the Zoom slider at the top of the window until you can see all 15 thumbnails. (We don't have to worry about the stacked "Leaves" images from the last lesson; we know they are more Autumn than Summer.) Most likely, the tag details will disappear from below the Floating Sam thumbnail, replaced by a yellow tag icon, which tells you that at least one tag is applied.
 - Click the first image, *Underwater Sam.jpg*, then Shift-click on *Fountain Max.jpg* to select all of those images.
 - Ctrl-click the *Porch Max and Sam.jpg* image (the fifth from the end).
 - Drag the **Summertime** tag from the **Keyword Tags** panel to any of the selected images. You should see the flower icon representing "Seasons" appear under each of the thumbnails.

WISDOM

Later in this lesson, you'll see how Elements can help you find images by date. Arguably, we could use that future skill to grab everything that technically falls into the summer months, rather than go through and painstakingly tag them all "Summertime." But equally arguable is the fact that not every picture you snap during the summer months is going to have that carefree summertime vibe you may seek for a project. Nor is every shot of iconic summertime subjects—like lemonade stands, ice cream cones, and picnics going to fall within the technical dates of official summer. Tags allow you to indicate something more nuanced and subjective.

PEARL OF

Whether your images appear large or small, you can still inspect the tags applied to a thumbnail. Just select the thumbnail in the Organizer and click the Tags icon at the top of the Properties panel.

9. *Search for faces in the photos.* To help us finish applying the Sam tag to the appropriate photos, we'll use a hot new feature in Photoshop Elements 8 that automatically searches a collection of photographs for faces.

Here's how it works:

- Press **Ctrl+Shift+A** to deselect all the thumbnails so you can search the entire catalog at once.
- Now choose **Find**→**Find People for Tagging**, or press Ctrl+Shift+P.
- Elements asks if you're sure you want to analyze every single image in the currently displayed photos. This small catalog won't take much time, so click the **Yes** button to display the **People Recognition** window. Elements searches through the 20 images in the catalog and presents the first one for you, along with the helpful "Who is this?" query, as in Figure 2-8. (Note: your faces may vary.)

WISDOM

PEARL OF

All 20 photos in the catalog contain at least one person (if you count statues). In fact, Elements has probably been randomly asking you "Who is this?" throughout this lesson and the previous one. But although the program can find multiple faces in a single image, it can't see faces in profile, and it can't identify the backs of people's heads. In our tests, the ancient statues were apparently realistic enough to rate identification. And then, sometimes, the analyzer finds "secret" faces in foliage, water bubbles, and other places actual faces aren't. It's amusing, but it does mean that the People Recognition feature often serves up better entertainment than heavy organizational power.

- 10. *Identify Sam in the first image.* Click the black "Who is this?" box and you'll be met with a blank field. Type "Sam" into this and press **Return**. Then click the large right arrow in the dialog box to move to the next image.
- 11. *Add a missing face.* The next image features Sam in a flurry of bubbles with his eyes closed, and this distraction is enough to prevent People Recognition from recognizing it as a face. To give it a hand, click the **Add Missing Person** button in the lower left of the dialog box, and a bounding box will appear in the upper-left corner of the image preview, as shown in Figure 2-9. Drag the bounding box down and stretch it out to include all of Sammy's face. Then click the **Who is this?** question again, type "Sam" into the field that appears, and press **Return**.

As you work through People Recognition, Elements "learns" to identify the people who you tag frequently. To that end, you may not want to worry about these images that Elements doesn't recognize as people in the first place, because they are clearly not going to help Elements get to know Sam. It may be faster just to apply the Sam tag in the regular browser. Not nearly as amusing, though.

- 12. *Create a tag for Deke's older son*. Click the large right arrow in the People Recognition dialog box and you'll arrive at a picture of Max, Deke's older boy. Again you'll have to use the Add Missing Person button because Elements doesn't recognize faces with hands on their noses. Click the **Who is this?** field, type "Max", and press **Return**. If you happen to be able to see the Keyword Tags panel, you'll note that it's added a new Max tag to the People category. Click the right arrow in the dialog box to go to the next image.
- 13. Witness as Elements gets to know Sammy. At first blush, it seems somewhat miraculous that Elements already knows the next person is Sam, but then you realize it learned that from the previously applied Sam tag. Click to move to the next image. If you concentrate on just trying to identify Sam, you may be met with the startling question "Is this Sam?" accompanied by an invitation to accept or reject the suggestion.

Or you won't ever see it. Numerous experiments with the same exact images have yielded a variety of results for us.

Have as much fun as you feel you can stand with this feature (hang in there long enough to watch it find faces in the water fountain, or just watch Deke go through a similar task in the video that goes with this lesson), and then press **Done** to return to the media browser.

- 14. Modify the Sam tag icon. The Sam tag icon in the Keyword Tags panel still has that teeny image of Sam. To create a more discernible icon for Sam's tag:
 - Right-click the **Sam** tag in the Keyword Tags panel and choose **Edit Sam Keyword Tag** to display the **Edit Keyword Tag** dialog box, which lets you know you've assigned the tag to 15 images (presuming you made it all the way through the People Recognizer and you guessed correctly which ones were Deke's younger child).
 - Click the Edit Icon button to open the Edit Keyword Tag Icon dialog box. There you'll see Sam and his kickboard.
 - Notice that the Find button is flanked by two arrowheads, ◄ and ▶, which allow you to scroll through the tagged images. That's great, but it's even easier to click the **Find** button, which displays a scrolling list of all the tagged images.
 - See that first photo of Sammy underwater (selected in Figure 2-10)? It's a good full-on face shot, even if Sammy has a bubble or two escaping out of his nose. Select the image and click **OK**.
 - Back in the Edit Tag Icon dialog box, adjust the marquee until it focuses on Sam's face, as in Figure 2-11. Then click the **OK** button.
 - Click **OK** once more to escape the maze of dialog boxes and update the Sam tag. Your new and improved Sam icon should appear in the Keyword Tags panel.

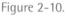

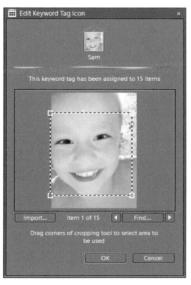

Figure 2-11.

- 15. *Adjust the Max tag.* During the People Recognition phase of this exercise, back in Step 12, we created a Max tag by simply answering the ubiquitous question, "Who is this?" Elements knew enough to know Max was a person (it is called "people recognition," after all) and filed the new tag in the People category. But let's be more specific and drag Max's tag into the **Family** subcategory. If you tagged Deke in Step 13, drag his tag to the Family category as well.
- 16. Create a subcategory. If you have a large family, you might want a category for each branch of the family tree. Luckily, the Organizer lets you create an unlimited number of subcategories. Right-click the Family item to display a shortcut menu, and choose Create new sub-category in Family sub-category. Then type "Kids" in the Sub-Category Name option and click OK.
- 17. *Place the tags inside the subcategory*. Drag and drop the **Sam** and **Max** tags onto the **Kids** icon to place them inside the new subcategory.

By now, you've done a lot of work. You've created tags and categories, you've assigned the tags to images, and you've edited tag icons. Plus, you've spent a fair amount of time meticulously selecting thumbnails, which is great practice for working in the Organizer. But truth be told, applying tags is only half the battle. The big payoff comes when you want to find pictures fast. If you want to take a break, now's a good time. Otherwise, stick with us as we exploit the true power of tags: searching.

18. Search for thumbnails with the Sam tag. Just to be thorough, start by clicking the Show All button at the top of media browser. Then expand the Leaves stack by clicking the D icon to the right of Leaves Max & Sam.jpg. In the Keyword Tags panel, notice the empty square to the left of each tag and category name. Click inside the square to the left of the Sam tag (circled in Figure 2-12 on the facing page) to display a tag icon and view only those thumbnails that are associated with the tag. The tag that governs (or filters) the search appears in the top-left corner of the Organizer window. It's currently reading Find: Sam. At the bottom of the window, Elements tells you it's found 14 items (with Sam—presuming you can tell Deke's adorable children apart) and there are 9 items not shown (no Sam tag).

Visible thumbnails match this tag

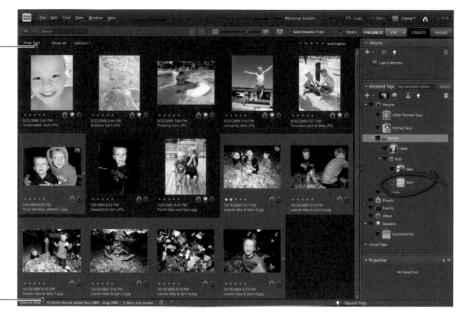

14 images match the Sam tag, 9 do not -

Figure 2-12.

19. Add the Summertime tag to the search filter. Scroll down the Keyword Tags list and click in the square to the left of the Summertime tag. This displays another 曲 icon and refines the search to only those images that contain both the Sam and Summertime tags (not one or the other, as you might expect). The number of items found is now reduced to six, and up at the top of the Organizer window, Elements tells you it's found Sam + Summertime.

You can also search by dragging tags from the Tags panel directly into the Find area above the thumbnails.

- 20. *View all the images*. Click the **Show All** button above the photo browser window. The Organizer cancels the search filter—both 确 icons disappear from the Keyword Tags panel—and the photo browser once again displays 15 thumbnails (the stacks have recollapsed).
- 21. Search for all images that have the Max tag. You can also search for images linked to a single tag by double-clicking the appropriate tag. For example, double-click the **Max** tag in the **Keyword Tags** panel, and the Organizer displays the six images with the Max tag.

22. *Filter out the Sam tag images.* Right-click the **Sam** tag in the Tags panel and choose **Exclude media with Sam tag from search results**. A red **●** icon appears next to the Sam tag, showing that any image featuring Sammy is excluded from the search (poor guy). In other words, the Organizer shows the three images that feature Max but not Sam, as pictured in Figure 2-13.

Incidentally, just in case you're wondering whether you can search for thumbnails that have *no* tags, the answer is oh gosh, yes. Just choose Find \rightarrow Untagged Items or press Ctrl+Shift+Q.

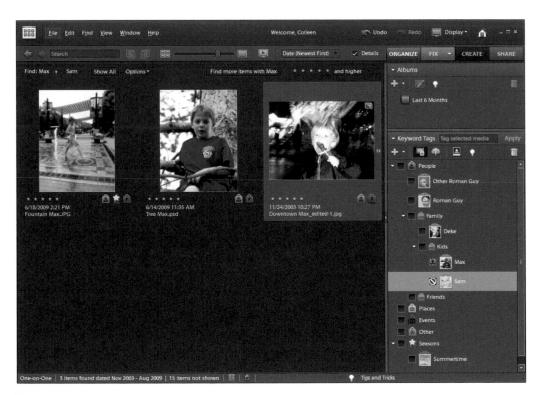

Now that you know how to create tags—and just how powerful they can be—a few quick words about getting rid of them: To remove a tag from a thumbnail, right-click the thumbnail and then select the tag that you want to remove from the ensuing submenu. If you want to delete a tag from the Keyword Tags panel, either select the tag and click the trash can icon at the top of the panel or rightclick the tag and choose the Delete command. You can delete any of the Organizer's default tags, except the Favorites and Hidden tags (the latter lets you hide thumbnails without removing them from a catalog). Deleting a tag removes it from any photos to which it has been applied; the photos themselves stay put.

EARL OF

WISDOM

New to Photoshop Elements 8 is the addition of Smart Tags, which automatically create tags based on the inspection made by the Auto-Analyzer. To the extent that you find these assessments useful, then the tags that correspond to them may be as well. To have Elements analyze your content, choose Edit→Run Auto-Analyzer. Elements will then apply those purple lightning-bolt tags representing High Quality, Long Shot, In Focus, and the like to your photos.

Making Albums

If tags can be compared to virtual Post-it[®] notes that you affix to your images, then albums would be the virtual paper clips that permit you to group your photos into meaningful collections. Simply put, they let you assemble minicatalogs of images, related by whatever topics you might dream up. Elements implements albums very much like it implements tags. You create and modify albums in a panel, and then drag and drop them from the Albums panel onto thumbnails in the photo browser window.

The one big advantage albums have over the search results produced by tags is that you can change the order of your photos in the browser window and save that sort order with the album. So if you need to arrange a sequence of images in a specific order inside a group, albums are the way to go.

You might also think of tags and collections this way: generally speaking, tags are designed to organize images that share a common subject; albums are for images that share a common destination or purpose. And in Lesson 11, you'll learn how to share these collections via your Photoshop.com account. In this brief exercise, we'll create an album of images with the intent of turning them into a slide show to send to Deke's Uncle Zeke. (The fact that he doesn't really have such an uncle, and if he did, he might or might not look like the guy in Figure 2-14, is of no consequence.) We'll add a few photos to the collection and then arrange them in a specific order. Having just completed the preceding exercise on tags, a lot of this exercise will seem familiar, but never fear; we'll point out many subtle but important distinctions as we go along.

1. *Open the Organizer*. If you have the Organizer open from the last exercise, skip to Step 2. In fact, we're assuming that you've completed the previous exercise. If

you haven't, you'll have better luck if you perform those steps in order first.

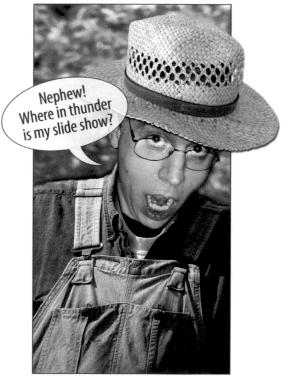

Figure 2-14.

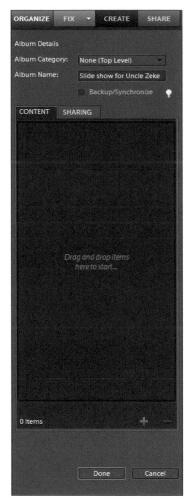

Figure 2-15.

- 2. *Display the Albums panel*. Click the **Show All** button at the top of the photo browser to see all 20 thumbnails. Then make sure the **Albums** panel is twirled open.
- 3. *Create a new album*. Click the triangle next to the green ⇔ under Albums to bring up a pop-up menu that lets you create a new album, smart album, or new album group.

PEARL OF

WISDOM

Like tag categories, album groups let you organize collections into, well, categories. If you're feeling fussy, you can even create (or nest) one album category inside another. But unlike tags, albums do not have to be organized. Whereas a tag must belong to a category, an album can roam free. So there's no need to create an album group unless you really want to. Smart albums, on the other hand, allow you to create albums with specific criteria, such as ratings, camera model, or filenames. Any time you then import new images that meet these criteria, they are automatically added to the smart album. Technically, the preloaded album that Elements comes with, Last 6 Months, is a smart album based on date.

That said, here's what to do:

- Choose New Album to open the Album details panel.
- Select the desired category from the **Album Category** popup menu. If you had already created one or more album categories, they would appear in this pop-up menu. As it is, your only choice is **None (Top Level)**.
- Type "Slide show for Uncle Zeke" in the **Name** option, as in Figure 2-15. (If you can't bring yourself to enter that, name the collection whatever you want.)
- Click **Done** to add the new album to the Albums panel, complete with a green photo album icon to indicate that it's a user-generated album.
- 4. Select a few photos. Now to add some photos to the album. Start by scrolling to the bottom of the media browser and expand the stack of Deke and his boys playing in the leaves. Select the two sculpted busts by clicking the first one and then Shiftclicking the second. Shot in the Victoria and Albert Museum in London, these heads hail from the famous Fakes and Forgeries gallery. Being an art forger by trade, Uncle Zeke should be interested. But since he's also a family guy, we need to add a picture or two of Deke's family. Ctrl-click the *Leaves Max & Sam-1.jpg* thumbnail—featuring both the boys and Deke in the leaves—to add it to the selection.

5. *Add the images to the album.* Grab one of the selected thumbnails and drag them up to the Album panel, then drop them on the Slide show for Uncle Deke. As illustrated in Figure 2 16, the two statues and all the "Leaves" photos sport a green album tag underneath their thumbnails. Apparently, adding one image from a stack to an album causes all of them to be included. In this case, Uncle Zeke will probably appreciate the extra shots of the grandnephews, but it's good to know if you are creating albums of your own.

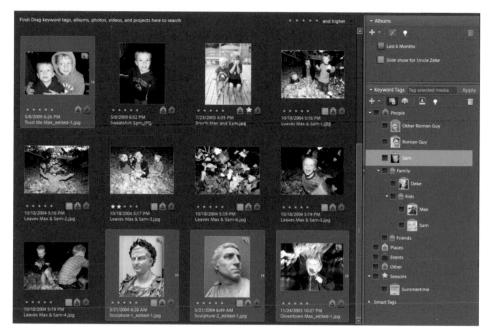

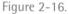

6. View the photos in the album. Click the Slide Show for Uncle Zeke collection in the Albums panel and the media browser displays the eight images in your collection. Well, it will as soon as you re-expand the stack. Although this might seem identical to filtering images with tags, there is a difference: You can't combine multiple collections to filter thumbnails as we did with the Sam and Summertime tags in the preceding exercise. One collection search cancels the other.

Notice that each thumbnail presents a number in its upper-left corner. Because you added the thumbnails at the same time, they remain in date order, as in the Organizer. If you had added thumbnails to an album one at a time, they would appear in the order in which they were added. But regardless of their initial order, you can re-sort the thumbnails any way you like. 7. Reorder the images. Let's save the starred image of Deke and the lads for the end of the slide show. Unfortunately, Elements won't let you reorder the stack in this case. So right-click on any of the Leaves images and choose Unstack Photos. Then drag the Leaves Max & Sam-3.jpg thumbnail to the end of the collection. As you drag, the only indication for where your photo will land is the fact that any surrounding thumbnails slide everso-subtly out of the way.

To preview this collection of images as a slide show, click the \blacksquare icon to the left of the zoom slider or press the F11 key. For this collection, turn off the Include Captions checkbox and set the Background Music option to None. Then click the OK button to enter the full-screen photo review mode. Click the play button (\bigcirc) in the top-left corner of the screen to set the slide show playing. When you've had enough, click the stop button (\bigcirc) or press the Esc key. For complete information on this photo-reviewing mode, read the last exercise in the previous lesson, "Comparing Similar Photos" on page 20.

If Uncle Zeke isn't looking there to watch on your home computer, you can post the album online using a variety of templates, which you'll learn how to do in "Sharing Pictures Online" in Lesson 12.

Finding Photos by Date

Often, a photo's most distinguishing feature isn't the who, the what, or the where—it's the *when*. And if you need to search for photos by when they were taken, the Organizer gives you the *how*. We're speaking of the *date view*, used briefly in the previous lesson, which fills your screen with a calendar and shows thumbnails of your images in the date cells. It's a great way to view your photos in the context of time, giving you an illustrated calendar of your very own special events.

The Organizer draws a photo's date from its *EXIF metadata*. Although this sounds technical, EXIF (pronounced *eks-if*) is actually a common standard that imparts such basic information as the time the photo was taken, the make and model of camera, the aperture setting, the focal length, and whether the flash fired. (Check out Figure 2-2 back at the beginning of this lesson to see a typical list of EXIF data for an image.) Most digital cameras save EXIF data when the shot is taken. If no EXIF info exists, as in the case of a scanned image, the Organizer uses the date the image was last modified. This system works extremely well—except when the Organizer assigns a date that's just plain wrong. And it's pretty easy for that to happen. For example, if you don't set your camera's clock, the EXIF metadata will be inaccurate. And if you scan in an ancient photo, you'll probably want the Organizer to manage the image according to when the photo was originally taken, not when you last edited the scan. Luckily, the Organizer gives you the power to override the recorded info and assign new dates and times.

In this exercise, we'll do just that, adjusting the time for a few photographs to account for shifting time zones. Then we'll move on to explore the timeline and see how it lets you limit searches to a specific period of time. Finally, we'll take a look at the date view's various calendar settings and see how to change the display of thumbnails and important events.

- 1. *View all imported thumbnails.* Again we're assuming you have the *One-on-One* catalog open inside the Organizer, and that you've uploaded the set of images we've been working with since the previous lesson. Also, if necessary, click the **Show All** button at the top of the workspace to make sure all 20 images are available in the photo browser.
- 2. Examine the recorded date and time for the first piece of sculpture. Check whether the Properties panel is open. (If it isn't, press Alt+Enter to bring it up.) Then scroll down and double-click the thumbnail for the *Sculpture-1.jpg_1* photo-the guy with the laurel wreath around his head-so that it fills the screen. Now view the General settings in the Properties panel. As shown in Figure 2-17, Elements seems to be under the impression that Deke shot the photo on May 21, 2004, at 6:28 а.м. Strange, that, because Deke is never up before 6:29 а.м. Unless of course he's been working so feverishly that he's awake from the night before. But then he wouldn't be out taking pictures, would he? Meanwhile, the V&A museum doesn't even open until 10 A.M.

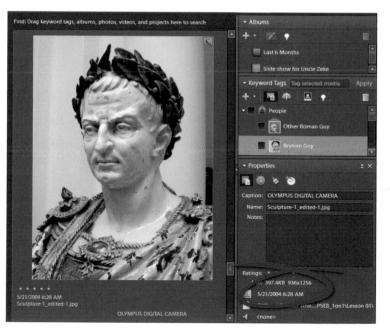

Figure 2-17.

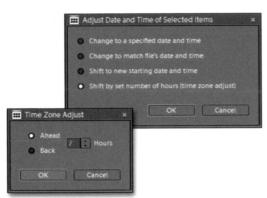

Figure 2-18.

To activate a handy feature that allows you to adjust a date by simply double-clicking the date below the thumbnail, press Ctrl+K to go to the General panel of Preferences and turn on the final checkbox, Adjust Date and Time by clicking on Thumbnail Dates. The problem is that Deke shot these photos in London. But the *time stamp* on his camera, an Olympus C-5060, was still on Colorado time, seven hours earlier. And so the camera being unable to gauge Deke's position on the planet's surface or the sun's altitude in the sky (it was 2004, after all, and cameras were not quite as geographically aware as they are now) embedded Colorado's time of day into the metadata of all the London photos.

- 3. Adjust the time of day for the V&A pics. Zoom out and expand the stacks for both sculpture images by clicking the ▶ to the right of each thumbnail. Then click the first thumbnail and Shift-click the last. Next, choose Edit→Adjust Date and Time of Selected Items or press Ctrl+J to display the winsome dialog box shown in Figure 2-18. This dialog box presents you with four options:
 - The first allows you to set all selected photos to a single date and time, according to your specifications.
 - The second option tells the Organizer to ignore the EXIF metadata and instead sets the date and time of each file to the last time it was modified.
 - The third option allows you to enter a new date and time for the earliest of the selected photos and then shifts the others relative to the first. If your camera's clock was set incorrectly, the relative increments from one wrong time to the next are accurate. In other words, correct the earliest photo in the sequence and the others will be updated in kind.
 - The fourth option lets you adjust the time of each photo by a set number of hours, just what we need to correct the time zone problem.

Select the final option, **Shift by set number of hours (time zone adjust)**, and then click **OK**. Elements displays another dialog box (also shown in Figure 2-18) that lets you move the time forward or backward a prescribed number of hours. Select the **Ahead** option and set **Hours** to 7. Then click the **OK** button. Once again, click the first thumbnail bust and note the new time: 1:27 P.M. in Figure 2-19 on the facing page. The Organizer now records the time just as if Deke had remembered to advance his camera's clock.

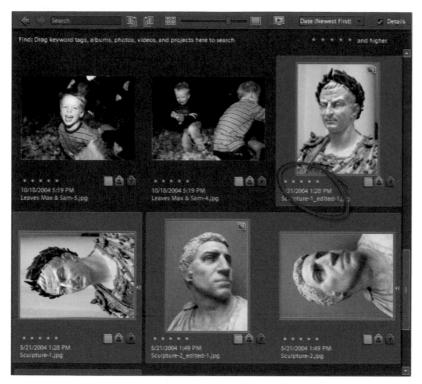

Figure 2-19.

PEARL OF

WISDOM

It's worth noting that the new times are recorded within the context of the catalog file only. Photoshop Elements avoids changing the EXIF metadata embedded in the files because Adobe's lawyers regard EXIF as legal data, potentially admissible in a court of law. Although Deke personally considers this notion ridiculous—it's an easy matter to fake EXIF information with no one the wiser—the cogs of the great legislative wheel turn slowly. For now, EXIF is (supposedly) off-limits. For Deke's secret sauce on actually changing EXIF data, check out this episode of dekePod: http://www.deke.com/content/mctadata-torensics-what-a-crock.

4. *Take a look at the timeline.* From the Window menu, select **Timeline**. The Organizer's *timeline* is that long strip between the shortcuts bar and the media. Pictured in Figure 2-20, the timeline contains a series of pale blue bars. As in a standard bar graph, each bar represents a month in which photos in the catalog were originally captured by a digital camera. The taller the blue bar, the more photos there are for that month.

Click a blue bar to display the gray marker (the one with the green bar inside it). You can drag this marker along the timeline to focus on a particular month, or just click a different bar to reposition the marker. To appreciate how helpful the timeline can be, adjust your media browser so that you can see the entire catalog in thumbnails.

5. *Focus on the one of the two tallest bars.* To switch to a different point in time, click the bar on the far right in the timeline, which represents the six photos from August 2009. As Figure 2-21 shows, the photo browser jumps to display the first thumbnail for that month, which shows Sam underwater. Just to make sure you don't miss the thumbnail, Elements temporarily outlines it in green and flashes the time marker. No need to wonder what photos you shot in a specific month; Elements couldn't make it any clearer.

Figure 2-21.

6. Narrow the timeline's date range to 2003. In addition to the vertical bars, the timeline features range markers—the down-and-up pointers on either side of the timeline—that you can use to narrow a specific period of time. Drag the left range marker to 2004 under the timeline, then drag the right marker to 2005. As witnessed in Figure 2-22, this limits the photo browser photos so we are seeing only the photos shot from 2004–2005.

Figure 2-22.

Dragging the range markers lets you limit the time range in one-month increments. If you need to set specific start and end dates for your range, choose Find \rightarrow Set Date Range or press Ctrl+Alt+F, and then specify the start and end dates for your search. To clear a date range, choose Find \rightarrow Clear Date Range or press Ctrl+Shift+F.

7. View images that have the Max tag. The timeline interacts with tag filters to help you find exactly the photos you're looking for. In the **Keyword Tags** panel, double-click the **Max** tag. Despite the fact that the catalog includes 13 images tagged to Max, only the 6 from 2003 appear on the screen. If you look closely, you may also notice that the timeline changes to reflect the influence of the tag.

8. *Switch to the date view.* Now let's check out the date view that we first saw in the previous lesson. Click to open the Display pop-up menu from the menu bar and choose **Date View**, or press Ctrl+Alt+D. If you haven't touched this view since the last exercise in Lesson 1, you should now see the single-day view for October 18, 2004. Click the **Month** button at the bottom of the screen.

Click the \bigcirc and \bigcirc buttons on either side of the month name at the top of the calendar to switch from one month to another. Or you can press the bracket keys, [] and [].

9. *Navigate back to October 2004.* As pictured in Figure 2-23, calendar displays the holidays of Thanksgiving (Canada) and Halloween in a pinkish hue. Even more significantly, an image thumbnail appears in the cell for October 18, which happens to be the very day that the photos of the boys and Deke playing in the leaves was taken. That's the beauty of the month view—

Figure 2-23.

the photos you take on a given day are automatically assigned to the corresponding cell in the calendar.

The right side of the workspace lets you view photos and modify information associated with the selected day, October 18:

- The preview window to the right of the calendar can play an instant (albeit tiny) slide show of all the images for the selected day. Click the blue I or I button to move through the images one at a time.
- The tiny desk calendar icon () below the right side of the inset slide-show window lets you add special events to the calendar. You'll learn more about this soon.
- On the left below the mini-slideshow is the Daily Note area, where you can click to enter any information that occurs to you about the selected day. We very much recommend using this. Just a few notes can spark a lot of memories later.

Because the timeline, tags, and albums aren't features of the date view, the various limits and filters of the photo browser have no effect here. All photos for a specific month are available from the date cells and inset slide-show window.

- 10. *Add a customized holiday.* We'd like to add a special event: imaginary Uncle Zeke's imaginary birthday. We could accomplish this by clicking the cell for his birthday (which seems to shift with editions of this book, as an imaginary birthday should), October 7, and then clicking the desk calendar icon on the far right side of the workspace. But for holidays and events, let's go to command central: the Calendar preferences.
- 11. Customize the Calendar preferences. Choose Edit→Preferences→Date View to display the dialog box shown in Figure 2-24. The first category of date view preferences is Options, of which there is only one: whether to use Monday as the first day of the week or keep it as Sunday. Leave this checkbox turned off.

Figure 2-24.

Take a scroll through the Holidays list, and you'll see that the folks at Adobe have perversely decided to deactivate just one holiday from their long list: April Fools' Day. Someone at Adobe probably figures it inspires too much inter-office ruckus. But heck, it's such fun ruckus. So turn on the **April Fools' Day** checkbox. (If you want to eliminate the bad ruckus, we think you should turn off **Valentine's Day**.)

Finally, here's the category of options we're looking for: Events. Do the following:

- Click the **New** button to display the **Create New Event** dialog box.
- Enter "Uncle Zeke's Birthday" in the Event Name field.
- Set the Month to October and the Day to 7.
- Keep the **Repeating Event** and **Every Year** checkboxes turned on because Uncle Zeke has a birthday practically every year. (Let's do the old guy a favor and leave the **Until** option turned off.)
- Click **OK**, and you'll see Uncle Zeke's Birthday (October 7) in the Events window.
- Click **OK** to close the Calendar preferences. The October 7 cell now lists Uncle Zeke's Birthday in green, as we've circled in Figure 2-25 on the facing page.

PEARL OF

WISDOM

Unlike most settings in the Organizer, custom events are *not* stored in the current catalog file. They are stored in a special file buried on your hard drive called *customevents.dat*. This allows Elements to include your custom events in all catalogs that you create, not just the current one. You may not want to be reminded of the imaginary Uncle Zeke's birthday from now to eternity, so when you've finished working through this lesson, you'll probably want to revisit Edit→Preferences→Calendar, select his birthday from the Events window, and click the handy Delete button. Or you could just send us a present every year, and we'll make sure it gets to him.

12. *Change the cell icon for October 18.* Now let's turn our attention to back October 18. By default, the cell for that date shows the first photo shot, but as you recall from the last lesson, we determined that the leaves-in-the-eyes shot was our favorite. Click the **October 18** cell to select it, and then click the **Day** button at the bottom of the screen. Or just double-click the October 18 cell.

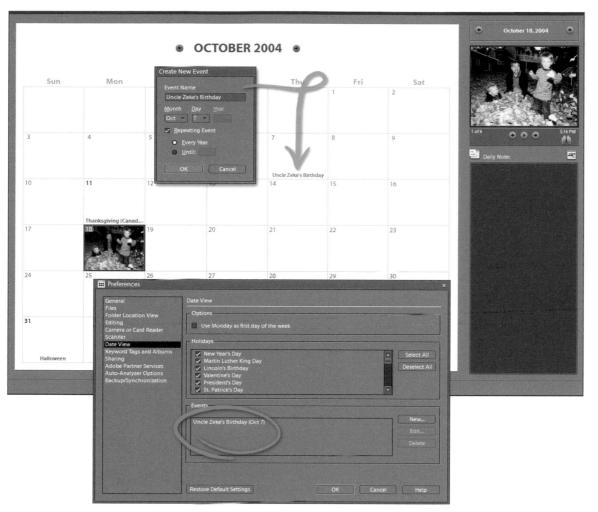

Figure 2-25.

This switches to the day view, which is essentially an expanded version of the right side of the month view. The Daily Note section appears larger and the slide show expands to fill the main window. You can also read the caption of the designated photo for the day. To change which photograph serves as the date icon in the month view, right-click the third of the six thumbnails (the one we decided was best back in Lesson 1) and choose the only option, **Set as Top of Day**. Now click the **Month** button at the bottom of the screen, and you'll see the new thumbnail in the calendar cell. 13. *Switch to the year view.* Finally, let's take a step back and look at the year in review. Click the **Year** button at the bottom of the screen to reveal the year view; we've advanced it to 2009 in Figure 2-26.

Although the year view lacks thumbnails, it has everything else. Holiday dates are lavender, and custom events are green. Dates containing photos are shaded blue. The active date gets a dark outline, and you have access to the slide show and the Daily Note field. From here you can click a date cell to select it, double-click a date cell to open it in the day view, or double-click the name of a month to open that month in the month view.

The Organizer makes time travel so easy that H. G. Wells would be jealous. We know because he came forward in time and told us himself. And our prediction for the future—well, the next several lessons anyway—is that with all this organization and the ability to find any photo you're looking for, you're going to want those photos to be worth locating. And you'll be able to make that happen with the tools in Photoshop Elements' other amazing workspace, the Editor.

WHAT DID YOU LEARN?

Match the key concept in the numbered list below with the letter of the phrase that best describes it. Answers appear upside-down at the bottom of the page.

Key Concepts

- 1. Metadata
- 2. Tags
- 3. Keywords
- 4. Album
- 5. People Recognizer
- 6. Filter
- 7. Smart tags
- 8. Auto-analyzer
- 9. EXIF metadata
- 10. Time stamp
- 11. Calendar preferences
- 12. Top of Day

Descriptions

- A. A common standard of metadata that contains basic information such as the time the photo was taken, the make and model of camera, the aperture setting, etc.
- B. Automatic tags applied by Photoshop Elements' Auto-Analyzer.
- C. Data about your photographs that includes hardware, rating, filename, keywords, and technical specifications.
- D. A mechanism in Photoshop Elements that automatically scans your images for qualities like high contrast, blurriness, or focus.
- E. The set of preferences that control which day is considered the start of the week and which holidays appear in the Date View.
- F. A set of parameters that sorts out your viewable images based on criteria you determine.
- G. A descriptive bit of information attached to a photo that might include a keyword or a particular quality such as "low contrast" or "blurry."
- H. A new tool in Photoshop Elements that uses face-recognition technology to help you find faces for tagging.
- I. A designation for the image that will represent a given day in the calendar view.
- J. A collection of photographs joined under a particular grouping.
- K. The time assigned to a photo by the camera setting.
- L. A descriptive word or phrase that captures the people, event, mood, or other quality of a photo.

Answers

IC' 5C' 3F' 4l' 2H' 6E' 2B' 8D' 6V' I0K' IIE' I5I

AUTO FIXES AND QUICK EDITS

THE ORGANIZER workspace is great for acquiring, managing, tagging, and comparing your photographs, but its ability to change an image file is limited. You can rotate a photo, you can crop a photo, and in the Organizer's Fix tab, you can apply a variety of completely automatic adjustments (which we'll examine in this lesson). But when it comes time to really roll up your sleeves and improve the appearance of an image—whether to correct its brightness, sharpen its focus, or enhance it with a few cool effects—you need the other great workspace included with Photoshop Elements 8, the Editor.

The Editor workspace comes in three flavors. The first, the Edit Full mode, is so capable and complex that we'll devote more than half of this book to it (see Lessons 4 through 10). The second, the Edit Quick mode, lets you apply a variety of corrections quickly and with little effort. Edit Ouick relies on a series of buttons and slider bars (as illustrated in Figure 3-1, with some help from our robot friend created by Fotolia.com photographer Leo Blanchette), along with original and corrected previews of the image. Happily, Edit Quick is simple enough to cover in a single lesson, and this lesson is it. By the way, the third mode of the Editor workspace, Edit Guided, walks you through some common tasks step by step, as if Adobe were paying homage to a certain stepby-step series of books, maybe? Anyway, Edit Guided won't need much in the way of explanation from us, because that's exactly what it's designed to do: explain it to you as you go. We'll save our pages and wisdom for the things that don't come with their own instructions.

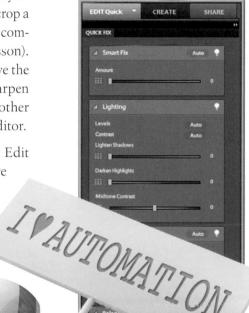

Driginal robot photo © 2008 Leo Blanchette from Fotolia.com

Figure 3-1.

ABOUT THIS LESSON

Project Files

Before beginning the exercises, make sure you've downloaded the lesson files from *www.oreilly.com/go/deke-PSE8*, as directed in Step 2 on page xiv of the Preface. This means you should have a folder called *Lesson Files-PSE8 10n1* on your desktop (or whatever location you chose). We'll be working with the files inside the *Lesson 03* subfolder. Elements has some preliminary editing tools that are quick and easy to use, and may provide all the image editing you need to get your images on their way. In this lesson, you'll learn how to:

٠	Correct your images with automatic tools	page 64
•	Save edits to your photographs	page 73
•	Adjust lighting, color, and focus	page 76
•	Save a version set	page 83

Video Lesson 3: The Fix Tab and Quick Edit Features

Photoshop Elements offers you two ways to quickly fix your images with a minimum of time and effort. In this video, Deke concentrates on the Fix panel in the Organizer, which gives you some simple buttons for making global changes to your images. You'll also get your first look at the Editor workspace, the home of another automated feature, the Edit Quick mode.

You can either watch the video lesson online or download to view at your leisure from *www.oreilly. com/go/deke-PSE8.* During the video, you'll learn about the keyboard equivalents and shortcuts listed below.

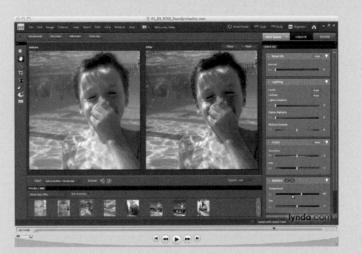

Operation Scroll with the hand tool Zoom in or out Fit the image on screen or view actual pixels Scroll up or down Scroll to the right or left Undo or redo an operation Keyboard equivalent or shortcut Space bar-drag inside image Ctrl+: (plus) or Ctrl+: (minus) Ctrl+: (zero) or Ctrl+: (one) Page Up or Page Down Ctrl+Page Up or Ctrl+Page Down Ctrl+Z or Ctrl+Y

The Trade-Off of the Quick Fix

The purpose of the automatic tools in the Organizer's Fix panel and the Edit Quick mode in the Editor is to address, as simply and efficiently as possible, the most common problems that an image might face. To its credit, Photoshop Elements 8 does an admirable job of matching quick solutions with common problems. But of course, it's not always effective and it's not always easy.

First, consider the Auto options, which you can access either in the Organizer (via the Fix panel) or in the Editor (via the Enhance menu or in Edit Quick mode). If you're in the Organizer and you click the Fix tab, you'll see that you have options for Auto Color, Levels, Contrast, Sharpen, Red-Eye Fix, and something called Auto Smart Fix, which rolls tone, color, and contrast adjustments all together in a handy, if sledgehammer-like, package. These commands are repeated in the Enhance menu of the Editor, where you can see most of them also have useful shortcut options built in. And finally, as you can see in Figure 3-2, when they appear in the Edit Quick panel (all but the Red-Eye Fix, that is, which is haphazardly useful anyway), they are accompanied by sliders that allow for some (but not great) subtlety of adjustment.

There's no penalty for trying these quick fixes out: you may get just what you need, and you can always press Ctrl+Z to undo auto adjustments if they fail to give you the desired results. For some images, especially low-contrast ones, these tools can work quite well, and others not so much. We're just saying that you should be prepared to pull other weapons out of your editing arsenal if your particular image needs more personal attention. In other words, don't place too much faith in the Auto buttons. Like all automated functions, these buttons trade control and predictability for ease of use. And be sure to undo the results of one auto adjustment before trying another. Of the five Auto buttons in the Quick Fix panel, only Sharpen should be combined with the others (labeled as such in Figure 3-2).

As we mentioned earlier, if you go the Edit Quick route for applying these auto fixes, you gain some control in the form of sliders that fine-tune adjustments to some degree, but we wouldn't go so far as to call the Edit Quick panel easy to use. The order in which options are presented is confusing and suggests relationships that don't exist. Among the Lighting controls, for example, the three slider bars have nothing to do with the Levels and Contrast options above them. Remember, the Edit Quick mode is no image magician either. Like most computer software, it's a collection of useful controls that respond well to the reasoned input of an educated user.

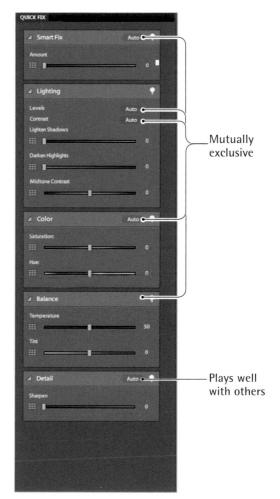

Figure 3-2.

Fortunately, that's all right with you, because an educated user is precisely what you'll be when you finish this lesson.

In the next several pages, we'll explain how the various settings work, what kind of image problems they're designed to fix, and when you can expect the best results. We'll also show you how to save your changes, and how to use version sets to track the changes you've made to an image. By the end of this lesson, you'll not only have a sense of how the Edit Quick panel works, but also be ready to take on the more capable color and tone adjustments that we'll cover in Lesson 10. In the exercises in this lesson, we'll apply these auto or semi-auto fixes to some sample images to see what can be accomplished.

Automatic Image Correction

The Auto commands couldn't be easier to use. Choose a command and watch it do its thing. You don't need our help to figure that out. The problem is, what "thing" is the Auto button doing? And is that thing going to benefit your image or make it worse? To answer these questions, we have to dig a bit deeper, which is the purpose of this first exercise.

All of these initial Auto commands are available via handy, well-labeled buttons in the Organizer workspace as well. If you want access to a helpful before/after view option, we'll apply these commands via the Editor's Edit Quick panel in this exercise. But if you want a really easy application of the Auto features you see here, simply choose your image in the Organizer and open the orange-tabbed Fix panel, where you'll see a list of one-click buttons for each Auto command. For speed and simplicity (and not waiting for the Editor workspace to load), it can't be beat.

The following steps examine the behavior of Auto Smart Fix, Levels, Contrast, Color Correction, and Sharpen. Except for Sharpen, each command is meant to be used independently of the others. Apply one. If you like the result, great. If not, undo and try another. Here's an example:

- 1. *Launch the Editor workspace*. To start things off, let's enter the Editor workspace without opening an image first. You can do this in one of two ways:
 - Click the **Edit** button on the lefthand side of the Welcome screen.

• If you happen to already be in the Organizer, choose Edit→Deselect to turn off any thumbnails you may have selected. Then click the orange tab to enter the Fix panel and press the Edit Photos button near the bottom of the panel.

Whichever route you choose, Photoshop Elements launches the Editor workspace and displays the Edit Full panel. Click the down arrow at the righthand side of the Edit panel's tab, as shown in Figure 3-3, and choose **Edit Quick** from the pop-up menu.

- Open an image. Choose File→Open or press the keyboard shortcut Ctrl+O. When the Open dialog appears, make your way to the *Lesson 03* folder inside the *Lesson Files*-*PE8 1on1* folder that you downloaded from the Web. Then select the file called *Low contrast skull.jpg* and click the Open button.
- 3. *Assign the Adobe RGB profile to the image*. If you followed my advice in the Preface and picked "Allow Me to Choose" from the Color Settings dialog box (see Step 9 on page xvii), you'll be greeted by the alert message pictured in Figure 3-4, which tells you that the image lacks a *color profile*.

Figure 3-3.

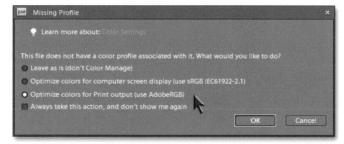

Figure 3-4.

Photoshop Elements can't tell where the image came from or how its colors should really look. Click the third option, **Optimize colors for Print output (use AdobeRGB)**, to bring *Low contrast skull. jpg* into the professional-standard Adobe RGB color space. Then click **OK**. The dull and lifeless photo of a saber-toothed tiger skull appears on screen.

PEARL OF

WISDON

If you encounter this alert message when opening your own images, I recommend that you follow the same instructions outlined in the previous step. While you're at it, you might as well bypass future alerts and open images in the Adobe RGB space automatically by turning on the Always take this action, and don't show me again checkbox. By bringing the image into the Adobe RGB color space, you've taken the first step toward your image displaying and printing correctly, even on a different computer.

The Editor Interface

The Editor workspace divides into three parts: Edit Quick, Edit Full, and Edit Guided. Labeled in the figures below, the key elements of the Editor interface are as follows, in alphabetical order. (The blue labels indicate items that we discuss in the context of other interface elements; for a discussion of the gray labeled items, see the previous lesson.)

- Editor modes: Click the down arrow on the orange Edit tab to choose from Edit Full, Edit Quick, and Edit Guided. Pictured below, Edit Quick mode lets you correct the colors in an image with relatively little effort. All other edits—from touch-up tools to filters, from layers to effects—are the domain of Edit Full mode, pictured on the facing page. The third choice, Edit Guided, walks you through a set list of common editing activities.
- **Image previews:** The Edit Quick mode presents you with one or two image previews. To determine how many previews appear, as well as their orientation, select an option from the View pop-up menu in the lower-left corner of the interface.
- Image window: In the Edit Full mode, each open image appears inside a separate window, thus permitting you to open multiple images at once. The figure on the facing page shows four images open in Edit Full mode, with tabs for each across the top of the image window. Click these tabs to switch between open image documents.
- **Options bar:** The settings here modify the behavior of the active tool. The options bar is *context-sensitive*, so you see a different set of options each time you switch to a different tool.

- **Panel:** A *panel* is a window of options that remains on screen regardless of what you're doing (unless you intentionally make it disappear). Most panels reside in the panel bin, which is permanently affixed to the right side of the interface. But in the Edit Full mode, panels can float independently in front of the image window. To move a floating panel, drag the gray title bar at the top of the panel. To add a floating panel to the panel bin or nest one panel with others, drag it to the desired location and let go when the desired area turns blue.
- Project bin: The project bin lets you browse through all images that are open in the Editor. In the figure below, there are a total of four images open. Click O or O to cycle from one image to the next. You can collapse or expand the project bin by hovering over its title bar and dragging the double arrow cursor down to collapse it, or double-clicking the title bar to expand it.

Edit Full

- Toolbox: The toolbox provides access to the Editor's drawing, editing, and selection tools. Click an icon to select a tool, and then use the tool in the image preview or window. A small wedge (as in ▲) shows that multiple tools share a single box, or *slot*. Click and hold a slot to display a flyout menu of alternate tools. Or press the Alt key and click a slot to cycle between tools. Each edit mode gives you access to different tools, with the whole array displayed in Edit Full and the bare minimum for your desired task in Edit Guided.
- Zoom control: Use the zoom control to change the magnification of the image previews. It lives under the image preview on the right when you're in Edit Quick mode, and on the left in Edit Full or Edit Guided. You can also press the keyboard shortcuts Ctrl+ are or Ctrl+ to zoom in or out, regardless of the mode.

Edit Guided

If you don't get the missing profile error message, and you want to get in sync with the rest of the book, click the Close button above the image window to close *Low contrast skull.jpg*. Next, choose **Edit→Color Settings**, select the **Allow Me to Choose** option, and click **OK**. Now reopen the skull image and change its color space, as directed in the previous paragraph.

Figure 3-5.

- Make sure you are in before-and-after view 4. with horizontal arrangement. Given that you're not sure how best to go about correcting this image, Elements knows you may find it helpful to compare the altered image to its original state. So it opens a before and after view that allows you to watch your changes occur while measuring where you started. Check the View menu in the lower-left corner of the window (circled in Figure 3-5) and make sure it is set to Before & After - Horizontal, where the photo is displayed in two side-by-side previews, as you can see in our example. The Before view shows the image as it looked when you first entered the Quick Fix mode: the After view will show the results of your edits. Because you haven't made any edits so far, the two are identical.
- 5. Set the Zoom level to avoid a jagged appearance. In order to see your image as smoothly and accurately as possible, you have to set the Zoom level to something compatible with Element's best rendering abilities—which basically means 25, 50, or 100 percent, depending on what fits on your screen. Skip the annoying pop-up slider next to the Zoom value, and simply press Ctrl+ the appropriate number of times to bump the zoom to the next increment (which will probably be 50 percent). You can also double-click the current value and type in a new one.
- 6. *Apply Auto Contrast.* The skull image suffers from both low contrast and a slight purple cast. Because the word "contrast" figures into the title of the image, let's try to fix that problem first. Go to the **Lighting** panel and click the **Auto** button to the right of the word **Contrast**. (This will give you the same results you would have seen by applying Auto Contrast from the button in the Organizer or choosing Enhance→Auto Contrast from the Editor.)

True to its name, the Quick Fix features in Edit Quick panel quickly fix the image. As shown in Figure 3-6, the contrast improves dramatically, but the purplish cast lives on. It's okay, but I have a sneaking suspicion that a different Auto button might serve us better.

- 7. *Undo the previous adjustment*. Before you can apply a new color adjustment, you need to "unapply" the preceding one in one of the following ways:
 - Click the blue 🗇 icon in the shortcuts bar.
 - Choose Edit→Undo Auto Contrast.
 - Press Ctrl+Z.
 - As we haven't done much, you could use the **Reset** button on the right above the After image. (But you may have to reset your Zoom value after doing so in order to get the images back to where you want them.) This puts the image back in its original state.

However you do your undo, Elements restores the righthand preview to the original version of the image.

PEARL OF

NISDOM

The effects of the Quick Fix functions are *cumulative*. So if you were to click another Auto button without first undoing Auto Contrast, the second Auto function would be applied on top of the first one. You would not only reduce the effect of the second Auto function but also risk degrading the quality of the image. So if you make an Auto adjustment and you don't like the results, be sure to undo it before trying a new adjustment.

8. *Apply Auto Levels.* Click the **Auto** button to the right of the word **Levels**. This time, Elements produces the effect shown in Figure 3-7. It is a better correction than the last one, almost entirely removing the purple cast. But the skull now looks a bit too brown, and other Auto color correction functions remain untested.

The only way to know whether the other Auto buttons can do better is to try them out, which means undoing Auto Levels. At the same time, I want to reserve the right to come back to this edit. The next step explains a hidden method for doing just that.

Figure 3-6.

Figure 3-7.

Figure 3-8.

Figure 3-9.

- 9. Switch to Edit Full, then back. Without undoing or resetting the image, click the down arrow on the right of the gold Edit tab and choose Edit Full from the pop-up menu. Elements displays the corrected skull in an independent image window. Go back to the down arrow in the Edit tab and choose Edit Quick to return to Quick Fix mode. Now both the Before and After views show the results of the Auto Levels adjustment.
- 10. Undo the last adjustment. Now here's the remarkable part: click the blue 𝔅 icon in the shortcuts bar or press Ctrl+Z (choosing the Reset button option does not work for this trick). Elements undoes the effects of the Auto Levels function and restores the original, low-contrast image to the After view. In two easy steps, we've managed to swap the Before and After views, as in Figure 3-8. This permits us to keep the Auto Levels adjustment while trying out new ones.
- 11. *Apply Auto Color.* Click the **Auto** button at the top of the **Color** panel. As you can see in Figure 3-9, the result comes close to accurately representing the original scene. But the real question is, do I like it the best? The greenish cast gives it a hospital flavor that I'm not too crazy about—and not just because this particular animal is beyond the help of modern medicine.
- 12. *Undo the correction*. Click the 🕅 icon at the top of the screen or press Ctrl+Z to undo the operation.

Normally, you also have the option of clicking the Reset button to restore the image as it first appeared when you entered the Quick Fix mode. But in our case, this would reset the After view so it matches the present Before view (the post—Auto Levels state), and we don't want that. To step backward a single operation, undo is the way to go. 13. Apply Auto Smart Fix. Click the very first Auto button, the one to the right of the words Smart Fix. Photoshop Elements applies the most complex of its automatic adjustments. Pictured in Figure 3-10, the result bears a strong resemblance to the Auto Levels adjustment that you applied in Step 7. But if you look closely, you'll notice two important differences: First, the contrast of the Smart Fix image is more subtle, with lighter, more detailed shadows. Second, the Smart Fix image hangs on to some residual purple, in contrast to the strong orange-brown cast of the Auto Levels correction.

CREDIT

The Smart Fix adjustment happens to be my favorite of the bunch, but it's still slightly more purple than I'd like. If it's good enough for you, feel free to skip to the next exercise, "Saving Your Changes" on page 73 Or stick with me here and, in a few brief steps, learn how you can adjust the performance of the Smart Fix function using a slider bar. It's subtle stuff, but worthy of a quick look.

EXTRA S

- 14. *Undo the Smart Fix adjustment*. To see the results of the Smart Fix slider bar, you first need to cancel the effects of the previous adjustment. So, as you've done so often in the past, click the blue \Re icon in the shortcuts bar or press Ctrl+Z.
- 15. Adjust the Smart Fix Amount slider. The Amount slider bar in the top panel permits you to vary the intensity of the Smart Fix operation. The middle setting is equivalent to clicking the Auto burton. Experiment with moving the slider tab back and forth. Moving the slider to the right trends the image toward yellow, and yellow is just what this photo needs. So drag the slider option all the way to the right, as in Figure 3-11.

Figure 3-10.

Figure 3-11.

By definition, an Auto button adjusts an image without troubling you with the details. But that doesn't mean it applies the same level of correction to one photograph as it does to another. Quite the contrary: each Auto button analyzes an image and corrects it accordingly. A dark image receives different correction than a light one, a yellowish image receives different correction than a bluish one, and so on.

Although every image gets individualized attention, the Auto buttons modify it according to consistent sets of rules. The following list explains how each function works:

- Auto Contrast locates the darkest color in an image and makes it as dark as it can be without changing its color. It then makes the lightest color as light as possible. For example, if the darkest color is blue and the lightest color is yellow, the blue becomes a darker blue and the yellow a lighter yellow. The color balance remains unchanged just what you want when an image is properly colored, but not at all what you want when it's not.
- Auto Levels makes no attempt to preserve colors. Instead, it makes the darkest color a neutral black and the lightest color a neutral white. The result is more often than not a shift in color balance. This can be a good thing if the color balance needs fixing. But Auto Levels may go too far, replacing one color cast with another. In the example below, the color cast shifts from pink to blue.

- Auto Color can be a bit slower because it tries to do more. Like Auto Levels, it deepens shadows and lightens highlights with the intention of creating neutral blacks and whites. But where Auto Levels may shift the intermediate shades from one color to another, Auto Color tries to pinpoint brightness ranges and keep them neutral as well. Among these are the middle colors in an image, known as the *midtones*. Auto Color finds the midtones that are closest to gray and then leeches away the color. By sheer coincidence, this happens to be the best method for automatically correcting the colors in the image below.
- Unique to Photoshop Elements, Auto Smart Fix is the most complex of the automatic color correction functions. Like Auto Contrast, it expands the contrast of an image without changing the lightest and darkest colors. It then brings out details by lightening the shadows and darkening the highlights. And finally, it evaluates the color cast and shifts the colors in the opposite direction. For the photo below, the result is a shift toward green.

Because it attempts to balance shadows, highlights, and colors, the Smart Fix function frequently outperforms the rest of the Auto pack. But it's by no means foolproof, as illustrated below. That's why I recommend that you test each of the Quick Edit mode's Auto functions and decide for yourself which one delivers the most desirable results for each of your images.

Original image

Auto Contrast

Auto Levels

Auto Color

Auto Smart Fix

- 16. *Commit the Smart Fix adjustment*. Elements doesn't apply the slider setting until you tell it to do so in one of the following ways:
 - Click the ✓ icon to the right of the words Smart Fix at the top of the panel.
 - Press the Enter key.
 - Apply a different color adjustment.

For now, just press the Enter key. For the sake of comparison, the final image appears to the right of the original in Figure 3-12. Keep this image open; we'll save it in the very next exercise.

Uncorrected skull

Smart Fix, cranked up to full volume

Figure 3-12.

Saving Your Changes

Permit us (well, Deke, technically) to relate a rather sad but illustrative story: "Back in March of 1994, I got my hands on my first digital camera, a QuickTake 100 from Apple. By modern standards, the images were tiny, measuring a scant 640 by 480 pixels. But at the time, the QuickTake was the height of cool technology. Knowing Photoshop quite well by then, I didn't hesitate to edit the photos and save the changes. In other words, I saved over the originals."

Figure 3-13.

To understand the significance of this rash act, consider the photo in Figure 3-13. After shooting this image, Deke increased the brightness and contrast, rotated it, exaggerated the sharpness, and cropped it to a heartbreaking 409 by 634 pixels (reproduced here at a mere 140 pixels per inch). These days the notorious digital imaging guru himself regards this image with a combination of horror and dismay. Garish and noisy, it leans slightly to the left and drunkenly into the pinks. If he had the original, he could reapply his edits with the subtlety and savvy born of more than another decade of experience, not to mention the accuracy afforded by a more sophisticated screen display. But alas, he was so liberal with confidence and conservative with disk space that the edited file is all that remains.

Fortunately, Photoshop Elements prevents you from making such mistakes. The first time you choose **File** \rightarrow **Save** when working with an original image, Elements asks you to save the image under a new name or in a different location so that the original file—the one captured by the digital camera or scanner—will remain intact. And it's a good thing, too. As your image-editing acumen grows, you will probably grow dissatisfied with your early efforts, just as Deke has. With the original images at hand, you can take a fresh crack at improving those old photos.

This exercise explains how to save your changes to an image with the future in mind.

 Start with the corrected skull. If you closed this photo, take heart; it's quick work to replay the last exercise. Open the file Low contrast skull.jpg in the Lesson 03

folder. Then, crank the **Smart Fix slider** all the way to the right and press the Enter key. Who knew we could summarize seven pages in a single paragraph?

2. Choose the Save command. Choose File→Save or press Ctrl+S to display the Save As dialog box. Most likely, Elements automatically takes you to the Lesson 03 folder, which contains the original skull photo. If not, make your way to the Lesson Files-PE8 10n1 folder and then open the Lesson 03 folder.

To see thumbnail previews of your saved images, click the iii icon in the upper-right corner of the Save As dialog box and choose the Extra Large Icons option, as illustrated in Figure 3-14. This works only for JPEGs, not PSDs.

- 3. Rename the edited image. The existing occupant of the File name option box hardly fits your newly edited image, does it? So change the name to "STT skull.jpg" or something similar. (STT stands for saber-toothed tiger, in case you're wondering.)
- 4. *Leave the other settings unchanged*. Pictured in Figure 3-14, these settings include the following:
 - The Format option determines how a file is saved and how it can be used in the future. The most common format for digital images is JPEG (pronounced *jay-peg*), which makes files small and portable. For higher-quality images, you can choose TIFF, the format used to print all the images in this book. Or you can select Elements' native PSD (Photoshop Document), which lets you save your images with all the program's advanced features intact, including selections, layers, and editable text. For this exercise, leave the **Format** option set to **JPEG** (*.**JPG**; *.**JPEG**; *.**JPEG**.
 - Turn on the Include in the Elements Organizer checkbox to automatically list the saved image inside the catalog that you last opened in the Organizer workspace. Assuming you haven't switched catalogs since you completed the last lesson (if you did, please take a moment now to switch it back), Photoshop Elements will add the corrected skull to the Elements 8 10n1 catalog.
 - Turn on the ICC Profile: Adobe RGB (1998) checkbox to embed a color profile into your image, which identifies how Elements last displayed the colors. If you later open the image on another computer using an application that recognizes color profiles (such as Photoshop Elements, Photoshop CS4, and most other Adobe applications), there's a good chance the image will look approximately the same as it does on your computer.

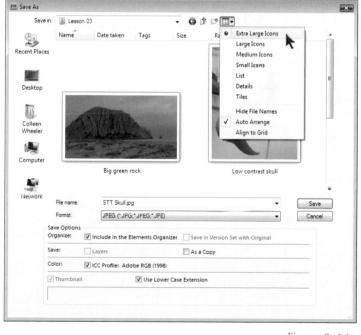

Figure 3-14.

• For compatibility with all varieties of computer systems— Windows, Macintosh, or otherwise—leave the Use Lower Case Extension checkbox turned on. This way, the filename will end in .*jpg* and not .*JPG*.

Matte: None	-	ОК
- Image Options		Reset
Quality: 10 Maximum	-	Preview
small file	large file	374.8K
- Format Options		
Baseline ("Standard")		
Baseline Optimized		
ousenne optimized		

Figure 3-15.

- 5. *Click the Save button.* Click **Save** to accept your filename and other settings and exit the Save As dialog box. Elements next displays the **JPEG Options** dialog box, which asks you to specify how you want the JPEG file to be saved.
- 6. *Confirm the JPEG settings.* The JPEG file format reduces the size of a file by compromising the quality of the image using what's known as *lossy compression*. Lower quality means a smaller file on disk; more quality means a larger file. For the best balance, we recommend that you adjust the settings in the JPEG Options dialog box (shown in Figure 3-15) as follows:
 - Use the Quality setting to define the amount of compression applied to an image. You can adjust this value from as high as 12 to as low as 0. To see the effect of the Quality setting on the image, leave the Preview checkbox turned on and watch the After image in the Edit Quick mode. Elements also estimates the resulting file size at the bottom of the dialog box. For instance, a Quality setting of 12 results in a file size of about 750K, but a Quality of 0 takes the file size down to a mere 50K. For a decent-looking image that's light on your hard drive, set the **Quality** option to 10.
 - The remaining options control how your JPEG image loads in a web page. To ensure compatibility with other software, select the first option, **Baseline** ("**Standard**").
- 7. Save the image. Click the OK button to save the image.

Congratulations—you've managed to save your corrected image and maintain the original digital photograph for posterity. Click the Close button above the After image or choose **File**→**Close** to close the skull image.

Lighting, Color, and Focus

There's more to quick fixing than a bunch of one-shot Auto buttons. You can achieve greater control—and make dramatic improvements to an image—using the slider bars of the Edit Quick panel. In this exercise, we'll explore the sliders in the Lighting, Color, and Sharpen panels. And rather than opening an image directly into the Editor, as we did at the beginning of this lesson, we'll try out a different scenario: importing an image into the Organizer and then handing it off to the Edit Quick mode. These steps will also set the foundation for the final exercise in this lesson, in which you'll learn about the Organizer's unique version sets. 1. *Open the Organizer*. Assuming you're still in the Edit Quick mode from the preceding exercise, click the **Organizer** button in the shortcuts bar, circled in Figure 3-16. A few moments later, Elements loads the Organizer workspace and displays the media browser.

File Edit Image Enhance Layer Select Filter View Window Help

2. View all the thumbnails. If necessary, open the One-on-One catalog using File→Catalog. Scroll to the bottom of the photo browser and you'll find the corrected version of the saber-toothed tiger photograph, which Elements loaded into the Organizer per your instructions in the Save As dialog box (shown in Step 4 on page 75). The photo was shot during a visit to the La Brea Tar Pits on February 22, 2003, making this the earliest image in the catalog. So it appears last in the sort order, as highlighted in Figure 3-17.

-

Sign In

Create New Adobe ID

C Reset Panels

Figure 3-16.

Figure 3-17.

3. Import an image into the catalog. Choose File→Get Photos and Videos→From Files and Folders or just press Ctrl+Shift+G. Use the "Look in" pop-up menu at the top of the dialog box to switch to the Lesson 03 folder inside Lesson Files-PE8 1on1. Select the file named Big rock and friend.jpg, and then click the Get Media button. After the Organizer displays the imported image in the photo browser window, click the Back to All Photos button or click the Backspace key to see the image in context with the other photos in the catalog. Colleen captured this one on June 25, 2009, so it lands as the first item in the collection.

Figure 3-18.

Figure 3-19.

- 4. Experiment with the Smart Fix option. As a lark, let's look at how you can apply the Auto commands while still in the Organizer. Scroll to the imported image at the top of the window. Click the thumbnail for Big rock and friend.jpg to select it. Next, click the orange tab to open the Fix panel, and then click the Auto Smart Fix button at the top of the list. As you can see in Figure 3-18, in a flash, Elements removes some of that green soupish quality and brings out some of the detail in the rock and sky, but the image is still flat and a tad purple. Nice try, Elements, but no cigar. Press Ctrl+Z to undo the operation.
- 5. Open the image in the Edit Quick workspace. Right-click the image thumbnail and choose Edit with Photoshop Elements from the contextual menu. Elements opens the image in the Editor with the Edit tab set by default to Edit Full, even though (if you're coming straight from the previous exercise) you left it in Edit Quick mode. Click the downward arrow at the right of the Edit tab and choose Edit Quick from the drop-down menu.

PEARL OF

WISDOM

If you want to see something interesting, press Alt+Tab and choose the Elements Organizer or go to your Windows task bar and switch back to the Organizer for a moment. The thumbnail for *Big rock and friend.jpg* now sports a red band and a lock icon (see Figure 3-19), signifying that it's open inside the Editor. The result: you can't tinker with it inside the Organizer. Who says the left hand doesn't know what the right hand is doing? Press Alt+Tab to switch back to the Editor and continue.

6. Arrange the view for a landscape. Unlike the skull image from the previous exercise, this landscape will make better use of workspace real estate if the before version is on top of, rather than to the left of, the after image. From the View pop-up menu, choose Before & After – Vertical. Press Ctrl+: to move the zoom level to the next desirable increment where you can see most of the image.

- 7. Adjust the Temperature and Tint settings. You don't have to work through the sliders in the Quick Fix panel in any particular order (except, as you'll see, we'll apply sharpening last). But as color balance seems to be a key issue in this image, we might as well start with trying to offset some of that pea-green color. (Although Morro Bay, where this image was shot, is famous for two things, its rock and its smokestack, in reality the latter does not put out this much green haze.) You could try the Hue option, which lets you spin colors around the rainbow, but in this case we just want to peel away some of the greens. The Quick Fix mode offers two ways to remove unwanted color cast in the **Balance** pane. The needs of this particular image require us to use them in opposite order of how they appear:
 - The Tint slider moves colors along a different axis, namely green to magenta. In our case, we want to do whatever it takes to move away from green. So drag the **Tint** slider toward magenta to a value of **40** to urge those greens into remission.
 - The job of the Temperature slider bar is to make colors cooler (that is, more blue) or warmer (more red). Removing the green made the sky look a tad bit warm (for such an

obviously overcast day), so drag the **Temperature** slider tab *very* slightly to the left, to a value of **47**.

As you can see in Figure 3-20, the result has already made a dramatic change from where we started.

PEARL OF

WISDOM

At this point, you could accept the changes you made in the Balance pane by clicking the \checkmark next to the word Balance or by pressing the Enter key. But no need. The moment you begin fooling around with the Lighting sliders in the next step, Elements will accept the Balance adjustments automatically. The program then stores those adjustments as a single operation and restores the sliders to their original positions, allowing you to apply new adjustments as you so desire. If you were to later decide that you didn't like your Color adjustments, you could click \frown or press Ctrl+Z to undo the operation and then reassign both sliders.

Figure 3-20.

8. *Lighten the shadows.* Next, let's lighten the shadows just a touch. Drag the **Lighten Shadows** slider ever so slightly to the right. The slider goes from 0 to 100, but we really only want to move one digit to 1, as in Figure 3-21. Even taking this minor step pulls a lot of detail from the rock; going a step further would loose the dark crevasse-y goodness of the rock's features.

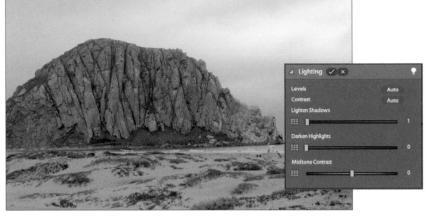

Figure 3-21.

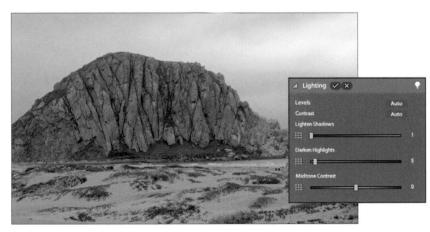

Figure 3-22.

 Darken the highlights. To restore some drama to the sky, drag the Darken Highlights to a value of 5. This helps restore some texture to the clouds and the surf instead of leaving them uniformly bright.

PEARL OF

WISDOM

You'll notice that as you start to move the Darken Highlights slider to the right, the transitions in the sky start to separate into distinct areas of color. This phenomenon is known as *banding* or *posterization*, and it's fairly common in large expanses of continuous tones where there just simply isn't enough data to create smooth transitions between subtle grades of color. In this case, it won't hurt the image irreparably, but it is a side effect of our using an automatic (easy) tool.

As you can see in Figure 3-22, we've made some definite improvements to the lighting, but the bulk of the image will respond most dramatically to the third slider of the Lighting pane.

10. *Adjust the contrast in the midtones*. Most of this image, notably that very prominent rock, lives in the midtones, and that's where we'll apply the next adjustment. Move the **Midtone Contrast** slider to the right all the way to 50. That's admittedly too much, but there's a convenient way to back it off to just the right place (rather than painstakingly getting that slider just where you want it). Because Elements knows you are working with the Midtone Contrast, you can move that slider one step at a time back to the left by pressing the right arrow key on your keyboard. (The arrow keys will operate whichever slider you touched last.) You can watch the number indicator to the

right of the slider go down with each press as you note the image's progression. A value of around 40 seems like just the right balance of drama and reality, as you can see in Figure 3-23.

11. *Boost the saturation*. To play up some of the colors in the image, drag the **Saturation** slider to the right to a value of 15, until the rust tones on the left of the rock really come out, as in Figure 3-24.

These steps provide a basic introduction to the relatively nothought color correction tools Photoshop Elements provides. Rest assured, we'll deal with shadows, highlights, contrast, and the others at greater length in Lesson 10, "Correcting Colors and Exposure." But before we leave the Edit Quick mode, there's one more aspect to this photograph that I want to improve: the sharpness.

- 12. Zoom the image to 100 percent. In order to correctly apply sharpening, you need a smooth, accurate view of the image, and that's best done at 100 percent zoom, thus avoiding any of the jagged edges that Elements preview creates at odd zoom levels. The best place to observe sharpening as you apply it is in areas with a lot of detail. So let's try focusing our attention on the right of the image.
 - Start by choosing Before & After Horizontal from the View pop-up menu.
 - Click the **Actual Pixels** button on the right above the image window, which will automatically take you to 100 percent zoom view.
 - Choose the hand tool (the one that looks like ��) from the toolbox on the left. Click on the righthand side of either image and drag to the left in order to focus attention on the details in the (lifeguard stand, open sky, and the little brother rock) of the image.

Note that both the before and the after preview move to the same location so that you can continue to compare identical features of your image.

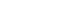

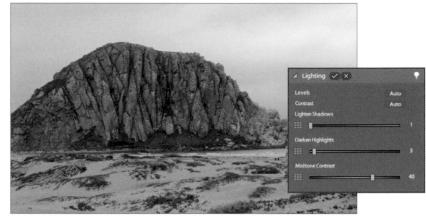

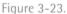

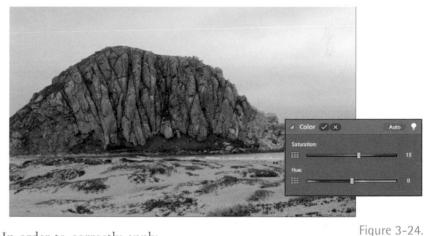

- 13. *Maximize your view of the image*. The 100 percent view is better for gauging the focus of an image, but you can't see as much of the image on-screen at any one time. If you want to see more of the photograph, expand the amount of room devoted to the image previews:
 - First, make sure the Editor workspace is taking up the entire screen. If it isn't, click the maximize button (□) in the upper-right corner of the interface.
 - Next, hide the **Project Bin** along the bottom of the window by double-clicking on its title bar.
 - Finally, abandon the side-by-side view by choosing After Only from the View pop-up menu. We've done so much to this image at this point, the comparison has ceased to be useful compared to seeing as much of the rock crevasses as possible during this next adjustment. Then, use the hand tool to move back to the right side of the image.
 - 14. *Try out Auto Sharpen*. If you need more room in the panels in order to get to the Detail panel at the bottom, you can twirl closed the Smart Fix, Lighting, Color, and Balance panels by clicking the ⊽to collapse them. Then, click the **Auto** button in the **Detail** panel in Figure 3-25. Elements applies what it considers to be an ideal

amount of image sharpening, but in my opinion, it's too much (no one wants a sharp sky). Assuming you agree with me, click the 🗇 icon in the shortcuts bar or press Ctrl+Z to remove the effects of the Auto button. Let's try the slider instead.

15. *Sharpen the image manually.* Click once on the Sharpen slider handle to call Element's attention to it, then use the left arrow key to move the value slowly up to about 15. As Figure 3-26 shows, this provides us with a more subtle sharpening effect that better outlines the important details in the image. Go ahead and click the ✓ or press the Enter key to accept this final adjustment.

Now that you've corrected the image (see the inset in Figure 3-26 to see how far you've come), keep it open and continue directly into the next brief exercise, in which I show you how to save the edited image along with the original in the Organizer.

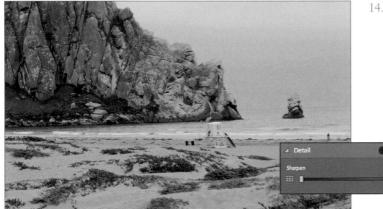

Figure 3-25.

Saving in a Version Set

You'll naturally want to save and manage your corrected image in the Organizer, just like the *STT skull.jpg* image. The difference this time is that the original version of *Big Rock and friend.jpg* is already in the Organizer. You could change the name of the edited version to keep it from overwriting the original, but then you'd end up with two versions of the same photo in the Organizer. And is that what you really want?

For example, suppose that you want access to all incarnations of an image, but you want to see just one thumbnail preview. And you want that one thumbnail to show the image at its best. As luck would have it, Elements provides the answer.

You can save both the edited and original versions of the image in a version set. When you ran the auto red-eye correction in the previous lesson, the two photos that Elements corrected were saved in version sets along with their corresponding originals. In general, a *version set* behaves like the stack of playing-in-the-leaves photographs that you created at the end of Lesson 1 (Step 11 on page 26). However, stacks are useful for manually consolidating similar photos in the Organizer, whereas version sets are created to con-

Figure 3-26.

solidate photos that are *identical* except for color adjustments and other modifications.

In the next steps, you'll save the edited version of *Big rock and friend*. *jpg* in a version set along with the original image. You'll then see how the version set looks in the Organizer's photo browser. And finally, I *promise*, we'll check out those two version sets that we created in Lesson 1 (Step 8 on page 12), and see how well Elements did at automatically finding and fixing red eye.

 Open the Save As dialog box. Make sure the edited version of Big Rock and Friend.jpg remains open inside the Quick Fix mode. (If the image is not open, follow the steps in the preceding exercise, "Lighting, Color, and Focus" on page 76.) Then choose File→Save or press Ctrl+S to display the Save As dialog box.

Figure 3-27.

- 2. *Turn on the Version Set option*. If it isn't on already, turn on the **Save in Version Set with Original** checkbox, highlighted with an orange arrow in Figure 3-27. The Editor automatically suggests a new name for the file, *Big rock and friend_edited-1.jpg*. This prevents the edited file from overwriting the original; plus, it initiates a numbering scheme, in the event you decide to save other edited versions of the image.
- 3. *Save the edited image*. Make sure the Save As dialog box is trained on the *Lesson 03* folder. Then, confirm that all available checkboxes except As a Copy are turned on (as you can see in Figure 3-27) and click the **Save** button.
- 4. *Dismiss the Version Set message*. Elements greets you with a long but helpful message that explains the nature and purpose of version sets. After you've read and thoroughly digested the information, turn on the **Don't show again** checkbox and then click the **OK** button.
- 5. *Confirm the JPEG settings*. Next comes the familiar **JPEG Options** dialog box. Set the **Quality** value to 10 if necessary, keep **Baseline ("Standard")** selected, and click **OK**.
- 6. *Close the image*. To best view the image in the Organizer, close it and free it from the Editor workspace. Choose File→Close or click the Close button just above the After image.

7. View the version set in the Orga*nizer*. After closing the photograph in the Editor, Elements should automatically switch you to the Organizer workspace. If not, press Alt+Tab or click the Organizer button in the shortcuts bar at the top of the screen. If necessary, scroll to the top of the image viewing window where you'll find Big rock and *friend_edited-1.jpg*, indicated with the yellow rectangle in Figure 3-28. The version set icon appears in the upper-right corner of the thumbnail, indicated with the red circle in the figure.

8. *View the two photos in the version set.* Right-click the version set thumbnail and choose **Version Set** to display a submenu that gives you the following options, as shown in Figure 3-29:

- **Expand Items in Version Set** displays just those images contained in the version set.
- **Collapse Items in Version Set** is available when you want to undo the expansion you just performed.
- The Flatten Version Set command disbands the version set and deletes all photos except the top thumbnail photo (by default, the edited version) from the catalog.
- The **Convert Version Set to Individual Items** command also disbands the version set, but keeps all the included

6/25/2009 4:38 PM Big rock and friend.jpg

5/25/2009 4:38 PM

rock and friend_edited-1.jpg

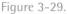

PEARL OF

WISDOM

Organizer assumes by default that you want the edited version of the image to be the one that appears in the photo browser, but this doesn't have to be the case. While viewing all photos in the version set (as I presume you are doing now), right-click the original image and choose Version Set \rightarrow Set as Top Item. The original photo will now represent the version stack in the photo browser, with the edited version stacked beneath it.

photos in the catalog, displaying them side by side in the browser.

• The fifth command, **Revert to Original**, disbands the version set and deletes all photos except the original.

Choose **Expand Items in Version Set** to see the edited and unedited versions laid out side by side. In case you don't recognize them, that's the edited version on the left and the original on the right in Figure 3-29.

9. Examine a red-eye set. Now let's check out the two version sets that we created in automatically in Lesson 1, when we let the Organizer automatically search and destroy red-eye problems (see "Getting Your Photos into Elements," Step 8 on page 12). Click on the arrow to the right of the thumbnail to expand the version set.

Figure 3-30 reveals that Elements did a commendable job of pinpointing Max's glowing red eyes in the original photo and fixing them in the edited version, on the left. (You may need to increase the thumbnail size with the slider at the top to really see it.) Now that's some useful automation for you.

Figure 3-30.

The moral of the story of this lesson is: sometimes the Photoshop Elements robot gets it right, and sometimes it doesn't. But at least now you know how to work your way through the automatic options to see whether they work for your particular image. Sometimes they won't, that's for sure, but in the next several lessons you'll be learning about the precision power of the Photoshop Elements Editor, so you have nothing to fear from ineffectual robots. You'll be able to roll up your sleeves and get things just the way you want them.

WHAT DID YOU LEARN?

Match the key concept in the numbered list below with the letter of the phrase that best describes it. Answers appear upside-down at the bottom of the page.

Key Concepts

- 1. Edit Quick
- 2. Edit Full
- 3. Color profile
- 4. Project Bin
- 5. Auto Contrast
- 6. Auto Levels
- 7. Auto Color
- 8. Auto Smart Fix
- 9. JPEG
- 10. Temperature
- 11. Banding
- 12. Version set

Descriptions

- A. This file format reduces the size of a file by compromising the quality of the image to the extent that you specify.
- B. Deepens shadows and lightens highlights in an image, while changing them to neutral grays. It also leeches away the color from the midtones that are closest to gray.
- C. This Editor mode lets you apply a variety of corrections to an image with only small investments of time and effort.
- D. The most powerful of the Auto functions, this button expands an image's contrast, lightens the shadows, darkens the highlights, and attempts to correct the color cast—all with varying degrees of success.
- E. An effect where what should be a gradual change of tone turns to abrupt blocks of color.
- F. Makes the darkest color in an image neutral black and the lightest color neutral white, usually creating a shift in color balance.
- G. This Editor mode offers the most capable and complex image-editing tools in Photoshop Elements.
- H. Makes the darkest color in an image as dark as possible and the lightest color as light as possible, without actually changing the colors.
- 1. Similar to a stack, this type of image group pairs all edited versions of a photo with the untouched original.
- J. This component of the Editor interface features clickable thumbnails that allow you to browse through all the images you have open.
- K. Makes colors cooler (more blue) or warmer (more red).
- L. Embedded in an image file, this information helps maintain the image's consistent appearance from one computer screen to another, or from the computer screen to a printer or another device.

Answers

IC' 5C' 3F' 4]' 2H' 6E' 2B' 8D' 6V' 10K' 11E' 151

LESSON

TiTT

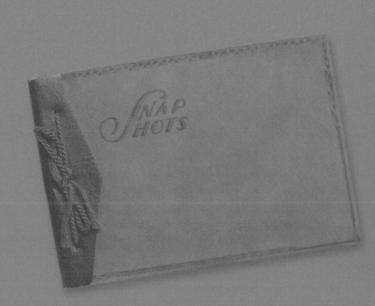

CROP, STRAIGHTEN, AND SIZE

I SUPPOSE IT'S possible that some people, on some remote planet, believe that the perfect photograph is one that needs no editing. On this far-flung world, programs such as Photoshop Elements are tools of last resort. The very act of opening a photograph in an image editor is a tacit declaration that the photo is a failure. Every command, tool, or option applied is regarded as a mark of flimflam or forgery.

But that's hardly the case here on Earth. Despite oft-voiced (and occasionally reasonable) concerns that modern image editing is distorting our perception of places and events, image manipulation has always been part and parcel of the photographic process. And there's no better example of this than cropping.

Long before computers were widely available and eons before Elements and its older sibling Photoshop hit the market, it has been common practice among professional photographers to frame a shot and then back up a step or two before snapping the picture. This way, they have more options when it comes time to crop. Of course, nothing says you have to crop the image the way you first framed it; as illustrated in Figure 4-1, you can crop it any way you want to. And that's precisely the point. Even back in the old days, photographers shot their pictures with editing in mind because doing so ensured a wider range of post-photography options.

Whole-Image Transformations

If image editing is the norm, the norm for image editing is wholeimage transformations. This includes classic operations such as scale and rotate applied to an entire image all at once, but also new tools that take out information in "the middle" and put the two sides back together. You'll find that whole-image transformations can produce dramatic and surprising effects.

Figure 4-1.

ABOUT THIS LESSON

Project Files

Before beginning the exercises, make sure you've downloaded the lesson files from *www.oreilly.com/go/deke-PSE8*, as directed in Step 2 on page xiv of the Preface. This means you should have a folder called *Lesson Files-PSE8 1on1* on your desktop (or whatever location you chose). We'll be working with the files inside the *Lesson 04* subfolder. In this lesson, we explore ways to crop, straighten, and resize digital photographs using a small but essential collection of tools and commands. You'll learn how to:

•	Automatically crop and straighten one or more images scanned to a single file page 89
•	Use the straighten and crop tools to straighten an image and crop to a specific aspect ratio page 95
•	Cut an image into a custom shape and set it against a new background
•	Adjust the resolution of an image and select the best interpolation setting

Video Lesson 4: Image and Canvas Size

This video lesson introduces you at last to the Full Editor in Photoshop Elements, and shows you how to make your way around the workspace. During the lesson, Deke covers changing and managing the number of pixels in an image. To fully understand this topic, you must come to terms with the concepts of *image size* and *canvas size*. The two describe the number of pixels in an image in different ways.

You can either watch the video lesson online or download to view at your leisure by going to *www. oreilly.com/go/deke-PSE8.* During the video, you'll learn about the keyboard equivalents and shortcuts listed below.

Command or operation Show or hide Info panel Image Size Scrub a numerical value Scrub in 10× increments Highlight Resolution value in Image Size dialog box Change unit of measurement from Info panel Advance to the next or previous option Keyboard equivalent or shortcut F8 Ctrl+Alt+I Drag back and forth on option name Shift-drag on option name Alt+R Click +, icon, next to X, Y coordinates Tab or Shift+Tab More important, whole-image transformation forces you to think about basic image composition and ponder some important questions:

- The photo in Figure 4-2 is clearly at an angle, but just what angle is it? Photoshop Elements gives you ways to discover that angle (47.7 degrees), but it also gives you a new tool that does the job automatically with no messy math required.
- After you rotate the image, you have to crop it. Never content to limit you to a single approach, Elements dedicates no fewer than three tools, five commands, and a score of options to the task (symbolically illustrated in Figure 4-3). Variety is the spice of life, but which method do you use when?
- After the crop is complete, there's the problem of scale. Should you reduce or increase the number of pixels? Or should you merely reduce the resolution to print the image larger, as in Figure 4-4?

I provide these questions merely to whet your appetite for the morsels of knowledge that follow. If they seem like a lot to ponder, never fear; the forthcoming lesson makes the answers perfectly clear.

Figure 4-2.

Figure 4-3.

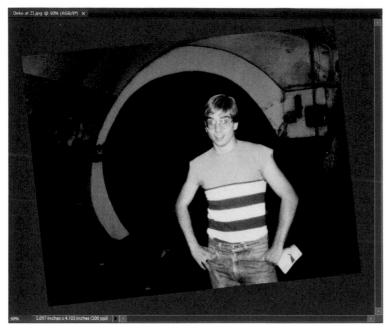

Figure 4-5.

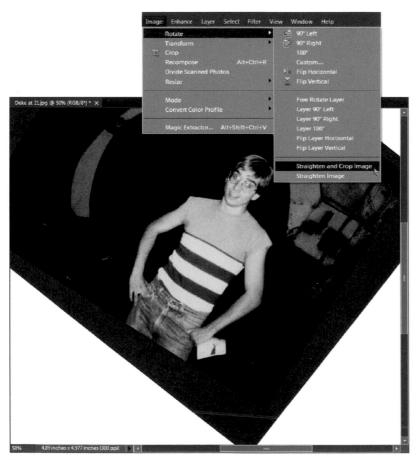

Figure 4-6

Auto Crop and Straighten

As you just learned about the Auto features in the previous lesson, it seems appropriate to start this lesson with the automatic straightening and cropping commands. Basically, these commands are designed to accommodate scanned images, particularly those captured by a flatbed scanner. Photoshop Elements can open a crooked image, rotate it upright, and crop away the area outside the image—all automatically, without so much as batting an eye. Better yet, the program can work this magic on multiple images at the same time. Prepare to be amazed.

1. *Open the scanned image.* From the Photoshop Elements Editor workspace, open *Deke*

at 21.jpg in the *Lesson 04* folder inside *Lesson Files-PE8 10n1*. It features a photo of Deke in a Paris subway back when he was a twig of a lad (see Figure 4-5).

2. Choose the Straighten and Crop Image command. One way to fix a crooked scan is to choose the Straighten and Crop Image command. But there's one tiny problem: it succeeds only occasionally. The command performs well when a photo is set against a squeaky clean white background. But any amount of dust, hair, or color variation throws it off.

To see the command in action, choose Image→Rotate→Straighten and Crop Image. As you can see in Figure 4-6, thanks to the deep blue color of the background and a smattering of dust, Elements incorrectly evaluates the image and rotates it nearly 45 degrees clockwise, or about six times as far as it should. Worse, the program chops off the corners of the photo, leaving us with less information than we started with.

- 3. Undo the last operation. Clearly, we can't leave the image the way it is. So choose Edit→Undo Straighten and Crop Image or press Ctrl+Z to restore the image file to its previous canvas size and orientation. At least where this image is concerned, Straighten and Crop Image is an unqualified failure. Fortunately, a much better solution is close at hand.
- 4. Choose the Divide Scanned Photos command. To straighten and crop a scanned photo set against even a dusty, colored background, choose Image→Divide Scanned Photos. As if on autopilot, Photoshop Elements duplicates the image and then runs a sequence of operations that culminate with the expertly corrected photograph shown in Figure 4-7. And because the revised photo appears in its own image window, the original scan remains unscathed, just in case you want to take another swing at it later.

PEARL OF

WISDO

Why in the world is a command that straightens and crops snapshots called Divide Scanned Photos? Divide them from what, exactly? Well, from each other, as it turns out. Although Divide Scanned Photos is just the ticket for straightening and cropping a single photo, its true strong suit is addressing multiple photos at a time, as the next steps explain.

5. *Open another scan*. Close the *Deke at* 21.jpg image without saving it. Then, open the file called *The gang.jpg*, also included in

the Lesson 04 folder. Therein you'll find a collection of seven images of various shapes and sizes—some photographs, some printed artwork, all witnessed in Figure 4-8. Deke created this file by taking the seven pictures and throwing them down on a flatbed scanner, a technique called gang scanning. Then, rather than using the scanner's software to assign each image to a separate file, he captured them all to one file.

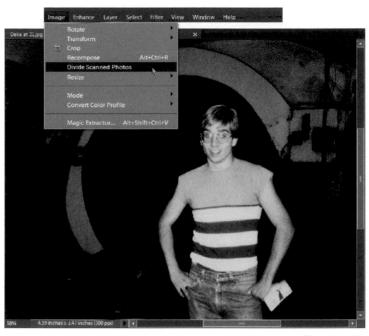

Figure 4-7.

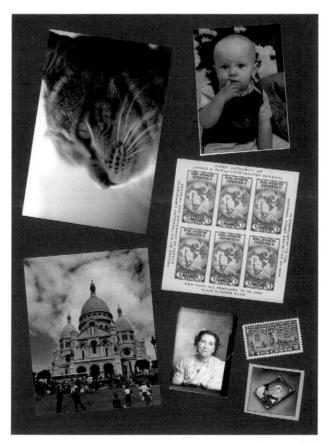

Figure 4-8.

Figure 4-9.

Figure 4-10.

- 6. Choose the Divide Scanned Photos command. Amazingly, that's all there is to it. The moment you choose Image→Divide Scanned Photos, the windows start flying as the program duplicates, rotates, and crops each image.
- 7. *Review the cropped images*. In all, the command generates seven separate images, each named *The gang copy* followed by a number and displayed in its own tab, and each with its own thumbnail in the project bin, in the order shown in Figure 4-9. Note that Elements analyzes the pictures from top to bottom. This is why the photo of Deke's son Sammy—which is slightly higher than that of his late, lamented tabby cat—comes up first.

The Divide Scanned Photos command does a swell job of straightening the images, even managing to accurately evaluate pictures with irregular edges, such as the perforated special delivery stamp. But it doesn't know when an image is on its side. That means the snapshot of the late, lamented tabby still needs our assistance.

- 8. Rotate the cat photo. Click the tab for the cat photo, which Elements has named The gang copy 3. (Oh, heartless program!) Then choose Image→Rotate→90° Right, which rotates both image and window one-quarter turn clockwise. This rotates the entire image, changing it from vertical to horizontal, as in Figure 4-10.
- 9. *Save the images.* Elements does not automatically save the images it generates; you have to do that manually. If you want to keep any of these images, you have to save them. (As far as this book is concerned, we're through with these files, so trash them at will. For the sake of background, we'll continue.)

When saving a photograph, the JPEG format with a high Quality setting is generally your best bet. But because JPEG modifies image details in its attempt to minimize the file size, it is not well suited to high-contrast artwork, such as the stamps. You may prefer to save these images as TIFF files. Then again, you may prefer not to save the images at all. It's up to you. If an image (such as the hard drive, a.k.a. *The gang copy 8.jpg*) requires further cropping or the *contents* of a photo are crooked (from, for example, having shot the image with a nonlevel camera), you can take advantage of the straighten and crop tools, as discussed in the next exercise.

Using the Straighten and Crop Tools

The Divide Scanned Photos command works wonders on crooked images captured with a scanner, but it isn't worth a hill of beans on crooked images shot with a digital camera, which is probably where the bulk of your digital images are coming from these days.

Consider the image in Figure 4-11. This photo of a granary near Perry, Oklahoma, was snapped by Laura Bigbee-Fott. The sun was setting, but Laura's son Burton was definitely *not* setting, so Laura had just a few seconds to snap the photo before heading home. It's a peaceful, lonesome shot, but Laura wasn't exactly holding the camera level when it was taken. Without an obvious rectangle to work with, neither of the commands we've seen so far does any good. Luckily, Photoshop Elements has a tool that makes straightening images a breeze.

Let's imagine our goals for this exercise are to both straighten the image and crop it to make a 4- by 6-inch print. Were you to scale the image to 6 inches wide in its current state, it would measure 4¹/₂ inches tall. This means we have to adjust the *aspect ratio*—the relationship between the height and width of the image—by trimming away half an inch of image. Deciding which half inch to trim is an aesthetic decision that might actually help us improve the appearance of the photo.

1. Open a crooked photograph. Open the file named Granary.jpg, located in the Lesson 04 folder inside Lesson Files-PE8 1on1. Of the two tasks we have to perform—straightening and cropping—straightening needs to come first. Straightening necessitates cropping, so you might as well do all the cropping in one pass.

Figure 4-11.

- 2. *Select the straighten tool in the toolbox.* Click the straighten tool, as illustrated in Figure 4-12. (Or press **P** for *plumb*, if by some stretch of the imagination that helps you remember.)
- 3. *Confirm the options bar settings*. The humble straighten tool offers just two settings in the options bar. Both should be set to their defaults:
 - The **Canvas Options** setting determines whether and how Elements resizes the canvas to accommodate the rotated image. Make sure it's set to **Grow or Shrink Canvas to Fit**, because we want to do any cropping ourselves in a later step.
 - Leave **Rotate All Layers** turned on. (Turn this option off only when you want to rotate one layer in a composition independently of others.)

Also press **D** or click the tiny **b** icon at the bottom of the toolbox to restore the default foreground and background colors—black and white, respectively.

Figure 4-12.

Figure 4-13.

4. Straighten the image. If you're looking for perpendicular lines in the image—lines that ought to be vertical or horizontal—you'll probably first notice the vertical sides of the granary. However, the straighten tool works only on horizontal lines. Use it on the side of the granary and the entire image will be turned on its ear. That pretty much leaves us with the horizon as our sole reference guide. There's a bit of a crest in the land to the left of the granary, so let's concentrate on the horizon on the right.

Drag along the horizon from the right side of the granary all the way to the right side of the image, as in Figure 4-13. Take a moment to check that the line accurately reflects the angle of the horizon before releasing the mouse button. A split second later, Elements rotates the image to make the horizon absolutely flat. Your image should now be upright. But in expanding the boundaries of the image to include the rotated photograph, the straighten tool exposed empty wedges around the corners, as in Figure 4-14. The wedges appear in the background color, which you set to white in Step 3. You need to crop away the wedges, but how? Using the crop tool, of course.

Figure 4-14.

Elements *can* automatically delete the wedges for you. Before using the straighten tool, set Canvas Options to Crop to Remove Background. Then drag with the tool. The program automatically removes any hint of wedges without cropping any more than it absolutely has to. The other setting, Crop to Original Size, maintains the image's original pixel dimensions, which results in slimmer wedges. We opted for Grow Canvas to Fit because it preserves the most information for our manual crop, coming up next.

5. *Select the crop tool in the toolbox.* Click the crop tool icon in the toolbox (see Figure 4-15) or press **C** for *crop*, not to mention *clip*, *cut*, and *curtail*.

Figure 4-15.

6. *Draw a crop boundary.* Drag inside the image window to draw a rectangle around the approximate portion of the image you want to keep, as demonstrated in Figure 4-16. As you do so, you enter the *crop mode.* From this point until you press Enter or Esc, most of Elements' commands and panels are unavailable. You have now made a commitment—albeit a short-term one—to cropping.

Figure 4-16.

As with the marquee tools, you can adjust the position of the crop boundary while drawing it by pressing and holding the spacebar. But don't get too hung up on getting things exactly right. You can move, resize, and even rotate the crop boundary after you draw it, as you'll see in Step 8.

- 7. *Change the Aspect Ratio attribute in the options bar.* We want this image to measure 4 by 6 inches—half again as wide as it is tall—and it's all but certain that the crop boundary you drew doesn't exactly conform to that aspect ratio. So go to the options bar and change the **Aspect Ratio** setting to **4** x 6 in. Your crop boundary snaps to the desired proportions.
- 8. *Move and scale the crop boundary.* Make the boundary as large as you can without including any of the background wedges. Drag the dotted outline or one of the eight square handles surrounding the boundary to scale it. Drag inside the crop boundary to move it.

- Press Alt while dragging to scale with respect to the center of the boundary. The corners move, but the center stays in place.
- To rotate the crop boundary, move your cursor outside the boundary and drag.

Try to make your crop boundary look like the one pictured in Figure 4-17.

 Apply your changes. Click the green checkmark (✓) that appears in the tab below the bottom-right corner of the crop boundary. Or just press the Enter key. Elements crops away everything outside the boundary. The result is the more compelling shot featured in Figure 4-18.

Figure 4-17.

The slightly panoramic 4-by-6 aspect ratio lends a widescreen feeling to the image, better capturing the desolation of the Oklahoma plains.

Figure 4-18.

Recomposing the Image Contents

In the previous exercise, you saw how cropping not only made up for gaps created by canvas manipulations but also focused the viewer's attention toward key elements in an image, in our case the lonely barn on the side of the tracks. In essence, when you crop you are, in fact, changing the framing that the photographer originally captured. But trimming away the edges isn't your only option for changing the relationship of the contents of your image. In Photoshop Elements 8, you can now recompose the image "from the inside out," using technology that originally appeared in the CS4 version of Photoshop.

The new recompose tool employs a technique called *content-aware scaling*, meaning that as you change the dimensions of an image, Elements makes intelligent decisions about which parts are important to keep and which can be sacrificed for the new composition. The upshot is that, in many cases, you can scale an image's background while leaving the foreground unharmed. And if Elements doesn't quite have the same criteria as you do with regard to what should and shouldn't be kept in a given image, this new tool also provides you with a way of communicating what you think should be rejected or preserved during the rescale. In this exercise, we'll use the recompose tool to remove a banana smoothie from the middle of a trio of fruity options. Why? Well, either because Colleen dislikes bananas rather vehemently, or because Deke drank all the banana-flavored smoothies and we need to take it off the menu.

Lesson Files-PE8 10n1 that you downloaded from the Web, and open the file *Smoothie Selection.jpg*, which was captured by Elena Elisseeva from Fotolia. com. You can see in Figure 4-19 that this image has clearly distinguishable foreground objects against a mediumto-low contrast background of a gently clouded sky, which provides perfect fodder for using the recompose tool.

2. *Choose the new recompose tool.* Appropriately enough, the recompose tool is paired up in the toolbox with the crop tool that you used in the last exercise.

Figure 4-19.

When a toolbox button has a small black triangle in its lowerright corner, that's your clue that there are multiple tools nested together. If you click and hold on any toolbox button with such a triangle, you'll eventually see a flyout menu with all the tools that live along with it. Whichever tool you used last is on top of the stack, so if you're coming straight from the last exercise, you should see the crop tool. Click and hold on the crop tool until the flyout menu appears, from which you can choose the recompose tool, as shown in Figure 4-20.

Alternatively, you can right-click on a toolbox button to see the alternatives for that item, or, in the case of the crop tool, pressing the C key toggles through all the options of that particular grouping of tools.

- 3. Dismiss the introduction to the new tool. Elements is justifiably proud of this fairly amazing technology, and as such, when you choose the recompose tool for the first time, it gives you a set of quick instructions for how to use it. We have you covered there, so feel free to turn on the Don't Show Again checkbox and dismiss this helpful hint by clicking OK.
- 4. Make the image narrower. Ideally, we'd like to see whether we can get rid of the banana smoothie in the middle without harming the strawberry or kiwi drinks on either side. This will necessarily result in a skinnier image, so grab the square handle on the right side of the image and drag inward to the right edge of the banana-filled glass, then release to see if Elements feels the same way about bananas that Colleen does.

The result, as you can see in Figure 4-21, is that Elements leaves the strawberry smoothie relatively unscathed, narrows the banana drink drastically but leaves the garnish intact, and reduces the kiwi by about a quarter width. Elements is on the right track as far as Colleen is concerned, but it's not quite what we had in mind, so click the Reject Change button at the lower righthand side of the image preview and let's try giving the tool a hand.

You'll notice that left to its own devices, the recompose tool pretty much leaves the garnishes alone. The hunks of actual fruit are high-contrast items that seem more important to the Recompose algorithm than the relatively undifferentiated liquids or sky.

- 5. *Choose the mark for removal tool.* In order to communicate our own particular recomposition desires, we'll have to mark the banana smoothie for death by hand. The tool we'll need is in the Options bar (shown in Figure 4-22):
 - There are four marking tools that let you paint protection (green) or rejection (red) highlights over key items in your image. The matching erasers allow you to remove that highlighting. Choose the mark for removal tool (the red-dipped paintbrush with the X circled in Figure 4-22).

Figure 4-22.

• Because the undesired object is fairly large and uniform, we can use a fairly large brush for efficiency, so set the Size to 200 px. Skip the hard-to-control pop-up slider, and simply select the current value and type **200** into the box.

Preset: No Restriction

• The Preset value allows you to tell Elements what you want the final dimensions to be, but as we don't know exactly what we want, leave it as No Restriction for now.

Figure 4-23.

- 6. *Mark the unwanted for deletion*. Paint over the banana smoothie with the brush, being particularly exact along the edge of the banana slice, as we've done in Figure 4-23.
- 7. *Recompose the image again.* Once again, grab the center handle on the right-hand side, drag the right boundary to the right edge of the yellow drink, and let go. This time, Elements has removed the undesired banana smoothie from the middle and seamed the remaining sky back together. To get it exactly where we have it in Figure 4-24 on the facing page, and avoid a squished strawberry or warped kiwi glass, set the **Width** in the Options bar to exactly **5.0 in**. (You have to enter the "in", or Elements will read it as a percentage.)
- 8. *Commit to your change*. Once you get the banana-removal just as you like, click the ✓ at the lower right of the image to accept your change. Elements will compute the seam for a minute and then reveal a properly banana-less composition.

PEARL OF

WISDON

The Recompose tool will obviously work better with some images and compositional aspirations than others. It's worth experimenting with the Protect and Remove brushes on different elements in your image to see what happens during the Recompose process. After you've resized, you can also adjust the Amount slider in the Options bar (which mitigates the distortion caused during resize) to see whether you can get just the desired effect. You also might have to heal the seam with the healing brush (see Lesson 5) for high-resolution images, as we've had to do here.

Resizing an Image

The single most essential command in all of Photoshop Elements may be Image→Image Size. Designed to resize an entire image all at once—canvas, pixels, the whole shebang— Image Size lets you scale your artwork in two very different ways.

Figure 4-24.

First, you can change the physical dimensions of an image by adding or deleting pixels, a process called *resampling*. Second, you can leave the quantity of pixels unchanged and instead focus on the *print resolution*, which is the number of pixels that print within an inch or a millimeter of page space.

Whether you resample an image or change its resolution depends on the setting of a checkbox called Resample Image. As you'll see, this one option has such a profound effect on Image Size that it essentially divides the command into two separate functions. In the following steps, we explore how and why you might resample an image. To learn about print resolution, read the sidebar "Changing the Print Size" on page 106.

1. Open the image you want to resize. Open the file named *Enormous chair.jpg*, included in the *Lesson 04* folder inside *Lesson Files-PE8*

10n1. Shown in Figure 4-25, this 21-foot-tall rocking chair is not only enormous in real life but also contains more pixels than almost any file we've seen so far in this book (not including layers).

Figure 4-25.

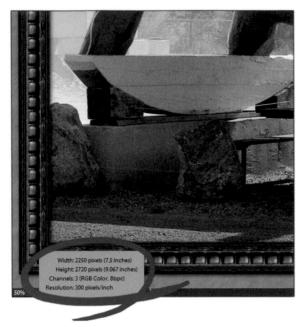

Figure 4-26.

Figure 4-27.

2. *Check the existing image size.* To see just how many pixels make up this image, click and hold the box in the bottom-left corner of the image window that reads **7.5 inches × 9.067 inches (300 ppi)**. (If you see something different here, click the **D** to the right of the box and choose **Document Dimensions**. That will put us in agreement, but it won't affect the outcome of this step.)

As Figure 4-26 shows, clicking on the box reveals a pop-up window that lists the size of the image in pixels, along with its resolution. This particular image measures 2250 pixels wide by 2720 pixels tall, for a total of $2250 \times 2720 = 6.12$ million pixels. When printed at 300 pixels per inch (or *ppi* for short), the image will measure 7.5 inches wide by a little more than 9 inches tall.

- 3. *Magnify the image to 100 percent.* Double-click the zoom tool icon in the toolbox. Then scroll around the photograph until you can see the sign tacked to the front of the chair. Pictured in Figure 4-27, the text on the sign is perfectly legible, a testament to the high resolution of the photograph. But there's also a lot of noise (the film-grain–like effect). So even though we have scads of pixels, they aren't necessarily in great shape.
- 4. *Decide whether you need all these pixels*. This may seem like a cerebral step, but it's an important one. Resampling amounts to rewriting every pixel in your image, so weigh your options before you plow ahead.

PEARL OF

WISDOM

In this case, the image contains $\overline{0.12}$ million pixels, just sufficient to convey crisp edges and fragile details, such as the text on the sign. But these pixels come at a price. Lots of pixels consume lots of space in memory and on your hard drive, plus they take longer to transmit, whether to a printer or through email or on the Web.

Let's say you want to email this image to a couple of friends. If your friends want to print the photo, they can print it smaller or at a lower resolution. But chances are they won't print it at all; they'll just view it on-screen. A typical high-resolution monitor can display at most 1600 by 1200 pixels, a mere 30 percent of the pixels in this photo. Conclusion: resampling is warranted. This is a job for the Image Size command.

- 5. Choose the Image Size command. Choose Image→Resize→ Image Size, or press Ctrl+Alt+I. Photoshop Elements displays the Image Size dialog box (see Figure 4-28), which is divided into two parts:
 - The options in the Pixel Dimensions area let you change the width and height of the image in pixels. Lowering the number of pixels is called *downsampling*; increasing the pixel count is called *upsampling*. We'll be downsampling, which is by far the more common practice.
 - The Document Size options control the size of the printed image. They have no effect on the size of the image on the screen or on the Web.
- 6. *Turn on the Resample Image checkbox*. Located at the bottom of the dialog box, this option permits you to change the number of pixels in an image.
- 7. *Select an interpolation setting.* Below the Resample Image checkbox is a pop-up menu of interpolation options, which determine how Photoshop Elements blends the existing pixels in your image to create new ones. When you're down-sampling an image, only three options matter:
 - When in doubt, select Bicubic, which calculates the color of every resampled pixel by averaging the original image in 16-pixel blocks. It is slower than either Nearest Neighbor or Bilinear (neither of which should be used when resampling photographs), but it does a far better job as well.
 - Bicubic Smoother compounds the effects of the interpolation to soften color transitions between neighboring pixels. This helps suppress film grain and noise.
 - Bicubic Sharper results in crisp edge transitions. Use it when the details in your image are impeccable and you want to preserve every nuance.

Because this particular image contains so much noise, **Bi-cubic Smoother** is the best choice.

8. *Turn on the Constrain Proportions checkbox*. Unless you want to stretch or squish your image, leave this option turned on. That way, the relationship between the width and height of the image—known as the *aspect ratio*—will remain constant.

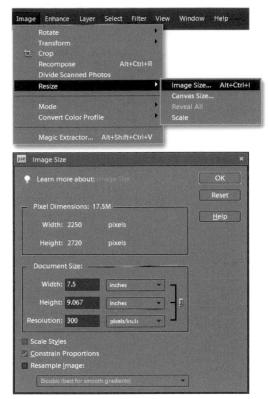

Figure 4-28.

As often as not, you'll have no desire to change the number of pixels in an image; you'll just want to change how it looks on the printed page. By focusing exclusively on the resolution, you can print an image larger or smaller without adding or subtracting so much as a single pixel. Doing so means you aren't throwing away any valuable data that you might want later.

For example, let's say you want to scale the original *Enormous chair.jpg* image so that it prints 10 inches wide by 12 inches tall. Would you upsample the image and thereby add pixels to it?

Absolutely not. The Image Size command can't add detail to an image; it just averages existing pixels. So upsampling adds complexity without improving the quality. Upsampling can be helpful—when matching the resolution of one image to another, for example—but these occurrences are few and far between.

The better solution is to modify the print resolution. Try this: Open the original *Enormous chair. jpg.* (This assumes that you have completed the "Resizing an Image" exercise and saved the results of that exercise under a different filename, as directed by Step 14 on page 108.) Then, choose Image→Resize→Image Size and turn off the Resample Image checkbox.

Contrary to what you might reasonably think, print resolution is measured in *linear* units, not square units. For example, if you print an image with a resolution of 300 ppi, 300 pixels fit in a row, side-by-side, an inch wide. In contrast, a square inch of this printed image would contain $300 \times 300 = 90,000$ pixels.

Note that the Pixel Dimensions options are now dimmed and a link icon (*) joins the three Document Size values, as in the screenshot below. This icon tells you that it doesn't matter which value you edit or in what order. Any change you make to one value affects the other two, so you can't help but edit all three values at once. For example, change the Width value to 10 inches. As you do, Elements automatically updates the Height and Resolution values to 12.089 inches and 225 ppi, respectively. So there's no need to calculate the resolution value that will get you a desired set of dimensions; just enter one of the dimensions and Elements does the math for you.

Click OK to accept your changes. The image looks exactly the same as it did before you entered the Image Size dialog box. This is because you changed the way the image prints, which has nothing to do with the way it looks on-screen. If you like, feel free to save over the original file. You haven't changed the structure of the image; you just added a bit of sizing data.

To learn more about printing—including how you can further modify the print resolution from the Print Preview dialog box—read the first exercise in Lesson 12, "Printing to an Inkjet Printer."

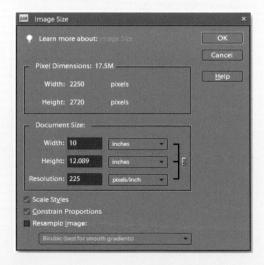

- 9. *Specify a Resolution value.* When Resample Image is turned on (Step 6), any change made to the Resolution value affects the Pixel Dimensions values as well. So if you intend to print the image, it's a good idea to get the Resolution setting out of the way first. Given that we are emailing the image and are not sure whether it will ever see a printer, a **Resolution** of **200 ppi** should work well enough.
- 10. *Adjust the Width value*. The Pixel Dimensions values have dropped to 1500 by 1813 pixels. But given that most screens top out at 1600 by 1200 pixels, that's still too big. Under **Pixel Dimensions**, reduce the **Width** value to 900 pixels, which changes the Height value to 1088 pixels. This also reduces the

Document Size to 4.5 by 5.44 inches (see Figure 4-29), plenty big for an email picture.

- 11. Take notice of the new file size. The Pixel Dimensions header should now read 2.80M (was 17.5M), where the M stands for megabytes. This value represents the size of the image in your computer's memory. The resampled image will measure 900 × 1088 = 979,200 pixels, a mere 16 percent of its previous size. Not coincidentally, 2.8M is precisely 16 percent of 17.5M. The complexity of a file is directly related to its image size, so this downsampled version will load, save, print, and email much more quickly.
- 12. *Click OK.* Photoshop Elements reduces the size of the image on-screen and in memory. As verified by Figure 4-30, the result continues to look great when printed, but that's partly because it's printed so small. The real test is how it looks on your screen.

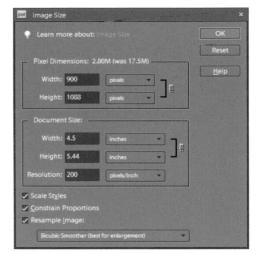

Figure 4-29.

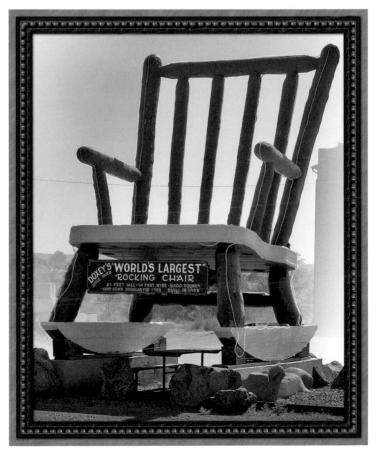

Figure 4-30.

13. Magnify the image to the 300 percent zoom ratio. Use the zoom tool to zoom in on the sign, as in Figure 4-31. The letters are rougher—no surprise given the lower number of pixels—but they remain legible. And the photo overall is less grainy. Downsampling with the Bicubic Smoother setting (see Step 7 on page 105) goes a long way toward smoothing away the noise.

Figure 4-31.

14. *Choose the Save As command*. Choose **File**→**Save As**, or press Ctrl+Shift+S. Then give the file a new name. Don't fret about the JPEG settings; just go ahead and accept the defaults. The reason we have you do this is to emphasize the following very important point.

PEARL OF

WISDOM

At all costs, you want to avoid saving your downsampled version of the image over the original. *Always* keep that original in a safe place. I don't care how much better you think the downsampled image looks; the fact remains that it contains fewer pixels and therefore less information. The high-resolution original may contain some bit of detail you'll want to retrieve later, and that makes it worth preserving.

WHAT DID YOU LEARN?

Match the key concept in the numbered list below with the letter of the phrase that best describes it. Answers appear upside-down at the bottom of the page.

Key Concepts

- 1. Cropping
- 2. Whole-image transformations
- 3. Interpolation
- 4. Divide Scanned Photos
- 5. Gang scanning
- 6. Aspect ratio
- 7. Reveal All
- 8. Content-aware scaling
- 9. Print resolution
- 10. Downsampling
- 11. Bicubic Smoother
- 12. Resample Image

Descriptions

- A. A means of cutting away the extraneous portions of an image to focus the viewer's attention on the subject of the photo.
- B. To change the physical dimensions of an image by reducing the number of pixels.
- C. A quick-and-dirty method of capturing several images with a flatbed scanner to a single image file, which you crop later.
- D. The number of pixels that will print within a linear inch or millimeter of page space.
- E. The relationship between the height and width of the image.
- F. The process of throwing away pixels and making up new ones by averaging the existing pixels in an image.
- G. Operations such as Image Size and the Rotate commands that affect an entire image, including any and all layers.
- H. Intelligent rescaling that takes into account which parts of an image are important to keep and which can be sacrificed for the new composition.
- 1. Turning off this checkbox keeps the Image Size command from interpolating the pixels in an image.
- J. Although designed to accommodate multiple images, this command is Elements' best method for cropping and straightening a single image.
- K. This command enlarges the size of a layered image to display any hidden pixels that lie outside the image boundaries.
- L. An interpolation setting that makes a special effort to suppress film grain, noise, and other artifacts.

Answers

1V' 5C 3E' tl' 2C' 6E' 2K' 8H' 6D' 10B' 11F' 151

PAINT, EDIT, AND HEAL

×

.

SO FAR, WE'VE seen a wealth of commands that correct the appearance of an image based on a few specifications and a bit of numerical input. On balance, nothing's wrong with these commands, and many are extraordinarily useful. But all the automation in the world can't eliminate the need for some occasional old-fashioned, hard-fought, wrist-breaking, sometimes-toilsomebut-always-rewarding artistic labor.

Such is the case with painting and retouching in Photoshop Elements. Whether you want to augment a piece of artwork or adjust the details in a photograph, it's time to give the commands a slip and turn your attention to the toolbox. Elements devotes nearly half its tools—including all those pictured in Figure 5-1 —to the tasks of applying and modifying colors in an image. The idea of learning so many tools and putting them to use may seem intimidating. And they require you to paint freehand in the image window, responding directly to your talents and dexterity—or your lack thereof. Fortunately, despite their numbers, the tools are a lot of fun. And even if your fine motor skills aren't everything you wish they were, there's no need to fret. We'll show you all kinds of ways to constrain and articulate your brush strokes in the following exercises.

The Essential Seven, Plus Two

Of the ten tools shown in the toolbox in Figure 5-1, seven include flyout menus of additional tools, giving you a total of twenty-two tools. Of those, sixteen are *brush-based*; select such a tool and drag in the image window to create a brush stroke of colored or modified pixels. The remaining six tools are modeled after the selection tools, which we'll discuss in more detail in the next chapter.

Figure 5-1.

ABOUT THIS LESSON

Project Files

Before beginning the exercises, make sure you've downloaded the lesson files from *www.oreilly.com/go/deke-PSE8*, as directed in Step 2 on page xiv of the Preface. This means you should have a folder called *Lesson Files-PSE8 1on1* on your desktop (or whatever location you chose). We'll be working with the files inside the *Lesson 05* subfolder. The exercises in this lesson explain how to use Photoshop Elements' paint, edit, and healing tools to brush color and effects into an image. You'll learn how to:

•	Color a piece of scanned line art page 114
•	Retouch a face using the dodge, burn,
	and sponge tools
•	Fix common red eyepage 124
	Restore a damaged photo and its timeworn

Video Lesson 5: Brush Options

Many of the paint, edit, and heal tools rely on a common group of options and settings that Adobe calls the *brush engine*. These options dictate the thickness, fuzziness, and scatter pattern of a brush stroke. You can adjust brush engine settings from the options bar and keyboard, as well as from the Tablet Options and More Options panels.

You can either watch the video lesson online or download to view at your leisure by going to *www. oreilly.com/go/deke-PSE8.* During the video, you'll learn about the keyboard equivalents and shortcuts listed below.

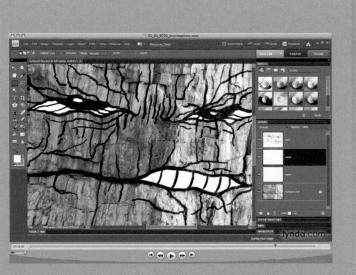

Tool or operation Brush tool (paintbrush) Incrementally enlarge or reduce brush diameter Make the brush harder or softer Change the Opacity setting of the active brush Change the Flow setting of the active brush Display brush panel Lift color with eyedropper

Keyboard equivalent or shortcut B () (right bracket) or () (left bracket) Shift+() or Shift+() 1, 2, 3, ..., 0 Shift+1, 2, 3, ..., 0 Right-click with paintbrush in image window Alt-click with paintbrush in image window Brush-based or otherwise, you don't need to learn every one of these tools. As with everything in Photoshop Elements, some tools are good, and some tools are bad. In this lesson, we'll focus on what we consider to be the essential brush-based tools: the paintbrush (which Adobe calls the brush tool); the dodge, burn, sponge, and clone stamp tools; and the spot and standard healing brushes. We'll also look at two selection-type tools: the paint bucket and the red-eye removal tool.

PEARL OF

WISDOM

The brush-based tools rely on a central *brush engine*. A single dollop of paint—the "brush" itself—is repeated over and over again with such rapidity that Elements appears to be painting a smooth line. The options bar lets you control various aspects of the brush, including its size, shape, and opacity. Deke will introduce you to these and other functions in Video Lesson 5, "Brush Options" (as explained on the opposite page).

This emphasis on brushes may lead you to think that tools such as the paintbrush and sponge are best suited to creating original artwork. Although you *can* create artwork from scratch in Elements, it's not what the program's designers had in mind. The purpose of these tools is to help you edit photographic images or scanned artwork, and that's how we'll use them in this lesson.

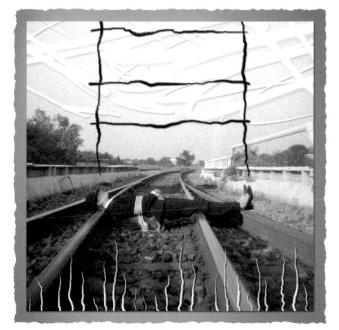

Figure 5-2.

The Three Editing Styles

Photoshop Elements lets you use tools—brush-based or otherwise—to apply and modify colors in three ways:

- The first group of tools, the *painting tools*, permit you to paint lines and fill shapes with the foreground color. Deke drew the lines in Figure 5-2 with the paintbrush while switching the foreground color between black and white.
- *Editing tools* is a catchall category for any tool that modifies rather than replaces the existing color or luminosity of a pixel. For instance, the burn tool darkens pixels, the dodge tool lightens them, and the sponge tool changes the saturation values, as demonstrated in Figure 5-3.

Figure 5-4.

• The *cloning and healing tools* permit you to clone elements from one portion of an image to another. Using a sophisticated color-matching algorithm, the healing tools are capable of merging the cloned details with their new backgrounds to create seamless transitions, as illustrated in Figure 5-4.

Coloring Scanned Line Art

Photoshop Elements is great at manipulating digital photographs. But it's also a capable program for coloring scanned line drawings and otherwise enhancing original artwork. This means you can exploit the best aspects of traditional and digital media:

- It's easier to draw on paper with a pencil and pen than it is to sketch on screen, if only because you can see the entire sheet of paper all at once without zooming or panning.
- Meanwhile, it's easier to add colors in Photoshop Elements than hassle with conventional paints.

Skeptical about that last point? Fair enough. In this exercise, you'll take a hand-drawn illustration and apply colors to it using just two tools: the paint bucket and paintbrush. Not only will you learn how to paint *precisely* inside the lines—and without exercising the least bit of care—but you'll also do so without harming so much as a single stroke in the original drawing.

1. *Open the scanned artwork.* Starting in the Editor workspace, go to the *Lesson 05* folder inside *Lesson Files-PE8 10n1* and

open *Butterfly.tif.* Pictured in Figure 5-5 on the facing page, this artwork is part traditional and part digital. It started as a sketch drawn with a common, run-of-the-mill Sharpie on a piece of cheap copier paper. But Deke's original sketch included just the left half of the butterfly. To create the entire insect, he copied the sketch, flipped it, and joined the two halves, all inside Photoshop Elements. Your job is to color the butterfly. In this case, that means painting inside the black lines and leaving the white background alone.

Figure 5-5.

2. Make a new layer. We're going to take advantage of a technique that involves painting on an independent layer. A layer is an image element that floats independently. Choose Layer→New→Layer or press Ctrl+Shift+N to add a layer to your image. In the New Layer dialog box, name the layer "Color". Then click the word Normal and choose Screen from the Mode pop-up menu, as in Figure 5-6. Click the OK button to add the new layer to the top of the Layers panel.

WISDOM

Named for the effect that occurs when you point two slide projectors at a single screen, the Screen blend mode ensures that the new layer lightens everything below it (and does so more uniformly than the Lighten mode). Because all colors are lighter than black and nothing is lighter than white, the Screen mode will show the paint inside the black lines but not in the white background.

3. Change the foreground color to red. Let's start by coloring the butterfly red. Choose Window→Color Swatches to display the Color Swatches panel, which contains a collection of predefined colors. Make sure the pop-up menu at the top of the panel is set to Default. Then click the very first color swatch, red, as in Figure 5-7, to designate it the active foreground color.

ransform Trop							
rop							
lecompose			t+Ctrl+R				
	ned Pho	tos					
lesize							
Node					Bitmap		
onvert Col	or Profil	e		•	Grayscale		
				Sen autor	an and the state of the second	Gr	
Aagic Extra	ctor	Alt+Shift	t+Ctri+V	~	RGB Color	<u> </u>	
					8 RityChan	1	
					o bica ciriam		
nop Elemen	ts Edito	r					
Changin	g mode:	s can affe	ect the a	ppeara	ince of laye	rs. Flatten i	imag
	esize fode anvert Cok lagic Extra- top Elemen Changin;	esize lode anvert Color Profile lagic Extractor op Elements Edito Changing mode:	tode anvert Calor Profile lagic Extractor Alt+Shif op Elements Editor	esize lode onvert Color Profile lagic Extractor Alt+Shift+Ctrl+V op Elements Editor Changing modes can affect the a	esize	esize Rode Rode Rode Rode Bitmap Grayscale Indexed Col Rog Color Rog Color Bits/Chan Color Table op Elements Editor Changing modes can affect the appearance of laye	esize

- 4. *Select the paint bucket tool.* Click the paint bucket icon in the toolbox, as in Figure 5-8. Or press the K key.
- 5. *Click inside the image window.* To fill the entire butterfly with the foreground color, click anywhere inside the image window. The Screen mode that you assigned in Step 2 ensures that only the black lines are affected. But hey, what gives? Instead of filling lines with red, the paint bucket colors them gray. The problem: this is a grayscale image. Ideally suited to black-and-white line art, a grayscale file is simple and small. This is because each pixel is permitted a luminosity value and nothing more; hue and saturation are out of the picture. One look at Figure 5-8 confirms that the foreground color swatch at the bottom of the toolbox is not the red we clicked but a grayscale version of it. To add color to the image, you must first convert it.
- 6. Convert the image to RGB. To open up the color spectrum, choose Image→Mode→RGB Color. A highly misleading alert message prompts you to flatten your artwork and get rid of the layer you created in Step 2. This inane suggestion is intended to avoid the color shifts that sometimes result when recalculating blend modes. The problem is, these shifts are *not even possible* when converting from grayscale to RGB. In other words, there's no reason on earth to flatten. Sadly, there is no Heck No! or Are You Crazy? button. So you'll have to satisfy yourself by clicking the Don't Flatten button, as in Figure 5-9.

To choose the RGB Color command from the keyboard, press and hold the Alt key and type I-M-R. Then press the D key to activate the Don't Flatten button.

7. *Fill the layer again.* Again click inside the image window with the paint bucket tool. Now that the image is set to accommodate color, the black lines of the butterfly turn red.

To color the butterfly from the keyboard, press Alt+Backspace. This handy shortcut fills the entire layer with the foreground color.

8. *Select the paintbrush tool.* Photoshop Elements supplies you with two painting tools: the paintbrush (a.k.a. the brush tool) and the pencil. The pencil paints jagged lines, making it most useful for changing individual pixels. The paintbrush is more versatile, permitting you to modify the sharpness of a line and tap into a wealth of controls that the pencil can't touch.

When you want to paint, get the paintbrush. Click the paintbrush icon in the toolbox (see Figure 5-10) or press the B key.

- 9. Change the foreground color to blue. Click the fifth swatch in the top row of the Color Swatches panel (the swatch displays the hint RGB Blue when you hover over it) to change the foreground color to blue.
- 10. Select the soft 300-pixel brush. Go to the options bar at the top of the screen and click the arrow to the right of the brush preview (just to the left of the word Size) to bring up a pop-up panel of predefined brush settings. Scroll down the list and click the first brush labeled 300. (When you hover over the brush setting, you should see the hint Soft Round 300 pixels. as in Figure 5-11.) This selects a circular brush with a diameter of 300 pixels and a hardness of 0. That is, the brush is big and fuzzy. To hide the pop-up panel and accept your changes, press the Enter key. Or just start painting in the image window. (The other way to hide the pop-up panel is to press the Esc key, but that also abandons your changes.)

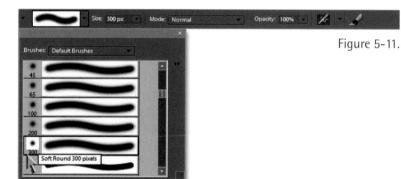

If your brush preview doesn't look like the one in Figure 5-11, click the double-arrow on the right of the pop-up panel to open yet another pop-up menu, and choose Stroke Thumbnail in order to get the preview of the stroke your chosen brush will paint.

To incrementally change the size of the brush, raise or lower the Size value in the options bar. You can also change the brush attributes from the keyboard using, of all things, the bracket keys. Press the 🗋 key to reduce the brush diameter; press 🗄 to raise it. Press Shift+🗄 to make the brush softer; press Shift+ to make it harder. These shortcuts may seem weird, but once you come to terms with them, they're a heck of a lot easier than hunting around for the corresponding options. Our mouse-muscles get tired, and we think keystrokes are easier once you learn them.

Figure 5-10.

Figure 5-12.

- 11. *Paint inside the butterfly.* Paint as much of the butterfly as you like, wherever you like. As you do, Photoshop Elements confines your brush strokes to the line art, as shown in Figure 5-12.
- 12. *Adjust the Scatter and Fade values.* If you're hungry for more brush options, click the \mathscr{A} icon at the right end of the options bar. This displays the pop-up panel pictured in Figure 5-13, which includes many of the options that we discuss in Video Lesson 5, "Brush Options." Then do the following:
 - Increase the fifth value, **Scatter**, to **25** percent. This separates the spots of color laid down by the paintbrush, as you can see previewed on the left side of the options bar (circled in Figure 5-13).
 - Increase the Fade value to 150. This tells Photoshop Elements to gradually fade the brush stroke to transparent over the course of 150 spots of color. This ensures that you don't obliterate one color as you lay on another.

Figure 5-13.

When you finish, press the **Enter** key to accept your changes and hide the panel. If the panel remains visible, press **Enter** again.

- 13. *Switch colors and paint*. Select a color that strikes your fancy and paint inside the butterfly. When the paint runs out (according to the Fade value), switch colors and paint some more. To achieve the result pictured in Figure 5-14, we painted one brush stroke in yellow, a second in green, and a third in a color called Pure Yellow Orange (which is swatch number 61 in the Color Swatches panel). The colors go a long way toward offsetting the rigid symmetry of the insect. Naturally, we're all for that. The only reason the butterfly is symmetrical in the first place is because Deke was too lazy to draw the other half.
- 14. Enter 0 for the Fade and Scatter values.Click the *d* icon on the far right side of the options bar. Then restore the Fade and Scatter values to their default settings of 0 and press Enter.
- 15. *Switch to black and choose the Overlay mode*. Press the **D** key to restore black as the foreground color. Then choose **Overlay** from the **Mode** pop-up menu in the options bar. The Overlay mode will paint with black while maintaining some of the most vivid colors that you added in previous steps.
- 16. Paint inside the bug's body. Paint the body and the two antennae. If the effect is too light, paint a second brush stroke. Each stroke results in a progressively darker effect.
- 17. *Paint the tips of the wings.* Press the right bracket key ([]) twice to increase the diameter of the brush to 500 pixels. Paint along the top and bottom edges to give the wings a bit of a toasting, as shown in Figure 5-15. Again, feel free to paint in multiple strokes.
- 18. Save your artwork. If you want to keep your artwork, choose File→Save As or press Ctrl+Shift+S. Inside the Save As dialog box, choose Photoshop (*.PSD; *.PDD) from the Format pop-up menu. Then click the Save button.

ly, ly is as

Figure 5-14.

Figure 5-15.

Dodge, Burn, and Sponge

We now move from painting to editing. And by *editing*, we mean using Photoshop Elements' tools to modify the saturation values, brightness levels, and color transitions in a photographic image. In this lesson, we'll use some tools that earn their name and effects from techniques used in traditional darkroom photography:

- The dodge tool lightens pixels as you paint over them.
- The burn tool darkens pixels as you paint over them. If you're having problems keeping the dodge and burn tools straight, just think of toast—the more you burn it, the darker it gets.
- The sponge tool adjusts the saturation of colors, making them either duller or more vivid.

Elements provides other edit tools, but these are the most useful. The following exercise explains how to use them to solve some common image problems.

Figure 5-16.

1. Open a photo that requires detail-level adjustments. Open the image titled Wheeler

at 13.psd in the Lesson 05 folder inside Lesson Files-PSE8 folder. This photo was shot by Colleen at one of those amazing moments where her son was at a magic place between the seriousness of teenagerdom and the nacho-cheese appreciation of childhood. You can see remnants of the latter on the right side of his mouth, in Figure 5-16. As wonderful as the expression and the pleasingly softfocused background of the baseball park are, the midday lighting is problematic, as harsh daylight sun left half of Wheeler's face in shadow and half exposed to the point of glow-in-the-dark ghastly.

If you don't want to use Wheeler's face for this exercise, Colleen will try not to hold it against you. Because in truth, you can just as easily use a picture of yourself, a loved one, or a dire enemy. The specific concerns may be different, but the general approach will be the same.

- 2. *Click the dodge tool in the toolbox.* At the end of the toolbox (see Figure 5-17), possibly nestled behind the sponge tool, the dodge tool is one of the *toning tools*. To get the dodge tool from the keyboard, press the **O** key. (That's the letter, not zero.) If another tool appears at the bottom of the toolbox, keep pressing O until you get the lollipop-looking dodge tool.
- 3. Work on the midtones. From the options bar, set the Range to Midtones. Some images benefit from shadow or highlight adjustment, but for this image, midtones are exactly what we want to adjust.
- Reduce the Exposure value to 30 percent. Located in the options bar, the Exposure value controls the intensity of edits applied by the dodge tool. In our experience, the default value of 50 percent is too extreme for most editing work. Just press the 3 key, or select the value and change it to 30 percent.
- 5. Drag over the image details you want to lighten. In Wheeler's case, most of the dodging work is needed on the left side of the image. With a fairly large brush (we're using one set to 200 pixels), make a few sweeping strokes across the dark side of Wheeler's hair, following the wisps around under his chin. The effects of the tool are cumulative, so try not to go over the same area twice. Click three times over each eye. Draw down the crease on the left side of his nose, then gently caress Wheeler's right cheek (channel Colleen, who still sees this as her "little boy," despite his sage expression) on the left side of the image to bring it out of the darkness. In Figure 5-18, the blue arrows give you an idea of where our strokes landed.

PEARL OF

WISDOM

The biggest mistake people make when working with the edit tools is to push things too far. For example, it's tempting for Colleen to remember the towhead child this once was and lighten Wheeler's hair beyond the light brown it actually is. Or click one too many times over the eyes to bring out her baby's baby blues. Of course, going too far on either of those would make her boy look like a gamine 1960s cover girl with streaked hair and white eye shadow. It's better to make small adjustments—one or two passes at most—so that you leave the shadows and reality intact.

Figure 5-17.

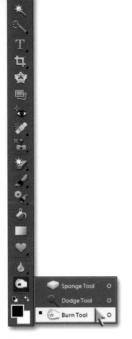

Figure 5-19.

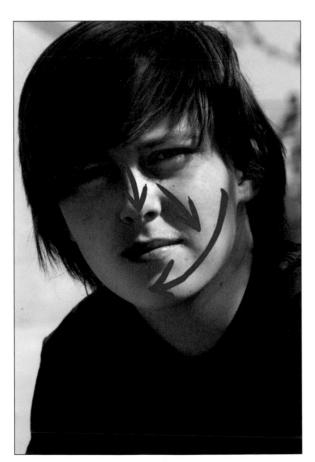

You don't have to worry about going over the same area twice with quite as much care as you did with the dodge tool, but don't turn Colleen's son into George Hamilton. Just make him look like a ballplayer who's actually made it out to practice once or twice. Leave him relatively fair (because he is); it's the beginning of the season.

6. Select the burn tool in the toolbox. Click and hold the dodge

just press the O key.

tool icon to display a flyout menu, and then choose the little

hand icon that represents the burn tool, as in Figure 5-19. Or

7. Reduce the Exposure value to 40 percent. Again, the default

8. Drag over the image details that you want to darken. The burn

tool adds shadows, and shadows give an image volume, depth,

and form. You may need to reset the Size value to 200 pixels,

because switching to the burn tool gives Elements a chance to

switch up your settings. Paint down the bridge of Wheeler's nose

to bring back those boyish freckles, and remove the pallor on the left side of his face (the right side of the image) by making

a few broad strokes over his face, as indicated in Figure 5-20.

4 key to permit yourself more subtlety and flexibility.

Exposure value is 50 percent, too much for burning. Press the

- Select the sponge tool in the toolbox. Now to modify the saturation levels. Press Alt and click the burn tool icon in the toolbox to advance to the next toning tool, the sponge. Or press the O key.
- 10. *Reduce the Flow value to 30 percent*. Although it's calculated differently, the Flow value in the options bar serves the same purpose as the dodge and burn tools' Exposure value: it modifies the intensity of your brush strokes. In our experience, the default value of 50 percent is too much. Press the **3** key to knock the **Flow** down to **30** percent.

Figure 5-20.

- 11. *Dab in the image to leech away aberrant colors.* Make sure the **Mode** option in the options bar is set to **Desaturate**. Start with a brush **Size** of **70** pixels and drag on the reddish spot next to Wheeler's nose. Then, reduce the brush size and click in the corner of his eye, as indicated in Figure 5-21. Doing so leeches out the redness that was intensified during the burn pass.
- 12. *Switch the Mode setting to Saturate.* You can also increase the saturation of colors using the sponge tool. After choosing **Saturate** from the **Mode** pop-up menu in the options bar, sweep across Wheeler's hair to increase the red-golden highlights, click twice in each iris to bring up those blues, click once on the lips while avoiding the nacho cheese remnants. The final image, shown in Figure 5-22, is a face that proves once in a while his mom gets him away from the video game console and out into the sunshine with his teammates.

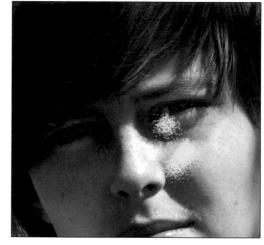

Figure 5-21.

13. *Save your image.* If anyone else other than Colleen would like to save this file, choose **File→Save As** or press Ctrl+Shift+S and rename the image "Wheeler Gorgeous at 13.jpg" or maybe something slightly less embarrassing to a 13-year-old. In the **JPEG Options** dialog box, leave the **Quality** set to 10 and click **OK**.

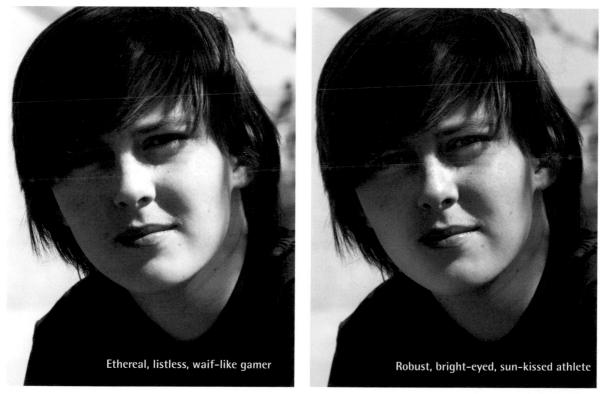

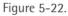

Red Eyes and Yellow Teeth

Red eye is a common by-product of consumer cameras. Because the strobe is mounted so close to the lens element on a point-andshoot camera, the flash has a tendency to pass through a moderately dilated iris and bounce off the back of the retina, as illustrated in Figure 5-23. And when you view the well-lit interior of an eye from a few feet away, it looks red.

Figure 5-23.

Although red eye can occur in real life—when you catch a pedestrian in the beams of your car headlights, for example—the effect is fleeting and rare. As a result, red eye in a photograph looks weird—so weird, in fact, that Photoshop Elements 8 provides two ways to eliminate it:

- As you learned way back in Lesson 1, the Organizer automatically checks for red eye when adding images to a catalog. This same function is available in the Editor by choosing Enhance→Auto Red Eye Fix. Only problem: it frequently doesn't work. Often it fixes one red eye in a photo and not the other.
- The second red-eye fix, the Editor's red-eye removal tool, can correct pupils with a single click. It's easy to use, it's well implemented, and it's the perfect tool for one particular job.

In this exercise, we'll use the red-cye removal tool to fix the pupils of Colleen's son and nephew. Finding red-eye in photographs of children is fairly common; children's eyes adapt quicker to lowlight situations, thus leaving their pupils nice and large and ripe for red-eye effect. We'll also revisit the sponge tool briefly to remove another common problem in portraits, slightly yellowed teeth.

1. *Open an image*. Navigate to the *Lesson 5* folder of *Lesson Files-PSE8*, and open *Alien Children.jpg*. In truth, these are not aliens, but Colleen's son (obviously younger and less serious than in the previous exercise) and nephew who were suffering from little more than jet lag and exposure to the flash of her compact digital camera. The unnatural looking red-eye you see in both children in Figure 5-24 definitely detracts from this moment of cousinly love.

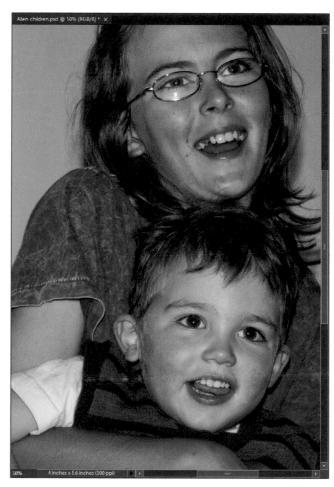

Figure 5-24.

2. *Select the red-eye removal tool in the toolbox.* To remove the red eye caused by the camera's flash, click the eyeball icon in the toolbox, as in Figure 5-25. Or press the **Y** key.

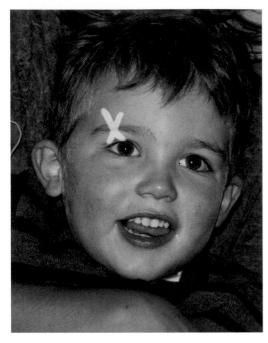

Figure 5-26.

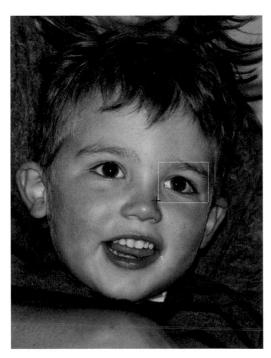

Figure 5-27.

3. *Click near one of the smaller child's pupils.* Just so we're on the same page, zoom in on Paco's right pupil (in the center-foreground). Then click up and to the left of the eye, at the approximate position indicated by the yellow X in Figure 5-26. As long as you click on or even *near* the pupil, Elements replaces the red eye with black.

PEARL OF

WISDOM

What makes the red-eye removal tool so smart that it can find a pupil in the vicinity of your click point? First, it finds the nearest area of red or pink in the image. Second, it confirms that an ellipse will fit inside that area and paints the ellipse black, making sure to preserve all the highlights. To get a sense of what the tool does when there's no pupil to be seen, click near the ketchup splotches on Wheeler's right check and watch it turn the biggest, roundest splotch into a very dark mole. Point made? Press Ctrl+Z to undo.

You may notice that the red-eye removal tool darkens a bit more than the pupil. In Paco's case, it removed some of the natural color variation from his iris, which is causing the adjustment to look rather unnatural. If you find that bothersome, you can modify the behavior of the tool using a few values in the options bar:

- Use the first option, Pupil Size, to expand or reduce the area affected by the tool. Virtually any value results in the pupil getting colored. But a lower value—such as 15 percent—prevents the surrounding areas from being affected.
- If the pupil ends up looking gray instead of black, undo the operation, raise the Darken Amount value, and try again. If you discover that you're losing highlights, lower the value.

Well, that's how the options are supposed to work, anyway. In our experience, even radical adjustments—a Pupil Size of 1 percent and a Darken Amount of 100 percent, for example produce such subtle changes that you can barely see the difference. (The final option, Auto, applies the hit-or-miss Auto Red Eye Fix command.)

4. *Drag around the other pupil.* Here's another way to use the tool: Still armed with the red-eye removal tool, draw a rectangular marquee around Paco's left eye. For the best results, your marquee should enclose the entire eye, as illustrated in Figure 5-27. Assuming everything goes according to plan, Elements blackens the pupil to match the other perfectly.

- 5. *Fix Wheeler's pupils.* The red eye on Wheeler (in the back) is not quite as pronounced as his three-year-old cousin's, but it's still noticeable. Click Wheeler's left pupil (at the top right of the image) using either of the methods mentioned in Step 3 or Step 4, and it cleans up nicely. But his right pupil, despite being visibly reddish to the observer, is not red enough to catch the red-eye tool's attention. Even clicking dead center does not seem to yield results. We'll have to convince the red-eye tool that this is, in fact, red eye.
- 6. Saturate Wheeler's left pupil with the sponge tool. To increase the red eye to Elements' recognition threshold, start by choosing the sponge tool from the toolbox, which we used to remove redness in the last exercise. Set the Size to 30 pixels and the Flow to 100 percent. If the sponge tool is still where you left it in the last exercise, the Mode should still be set to Saturate. If not, change it now. Line the brush cursor up with Wheeler's right pupil and click about five times. See, Elements? Look at Figure 5-28. We told you it was red!
- 7. *Remove the ironically enhanced red-eye*. Return to the redeye tool and click in the now definitely red pupil, and lo and behold, Elements now understands this to be red and properly removes it.
- 8. Use the sponge tool to whiten Wheeler's teeth. Speaking of the sponge tool, we can use it to touch up Wheeler's teeth so they're as pearly as those of his baby cousin. Press O to return to the sponge tool. Change the Mode to Desaturate in the options bar, make sure the brush size is small enough to avoid the gums. (Desaturated gums are lifeless gray and not a healthy pink, so we want to avoid creating a new dental situation for Wheeler.) Set the Flow to 40 percent and paint over Wheeler's teeth until the slight yellow cast has been removed. As you can see in Figure 5-29, desaturating the teeth brightens them up without making them look oddly glowing.
- Save your changes. At last, a picture fit for Grandma. If you like, you can now save these spiffed-up children by pressing Ctrl+Alt+S and giving the new file something appropriate, like Cool cousins.jpg.

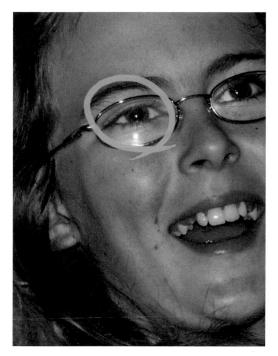

Figure 5-28.

Figure 5-29.

Figure 5-30.

Healing a Damaged Image

The edit tools are well suited to a variety of retouching scenarios. But they can't create detail where none exists. To fix dust and scratches or cover up scars and wrinkles, you need tools that can paint imagery on top of imagery, tools like the clone stamp tool and healing brushes:

- The clone stamp tool paints one section of an image onto another, a process called *cloning*. You identify the portion of the image that you want to clone, and then paint away.
- The healing brushes also clone. The big difference is that after you paint, Elements mixes the cloned pixels with the color and lighting that surrounds the brush stroke to create a seamless patch. The spot healing brush selects the area to clone automatically; the standard healing brush lets you decide.

This final exercise shows you how to use these powerful tools to fix a variety of photographic woes, ranging from rips and tears to blemishes and age spots:

 Open a broken image. Open the file Bluebeard.jpg located in the Lesson 05 folder inside Lesson Files-PSE8 10n1. Available

in perfect condition from PhotoSpin's Ed Simpson International People collection, this version of the photo appears so tragically scratched because, well, Deke scratched it. He printed the image to a continuous-tone Olympus P-400 image printer, folded the output once vertically and again horizontally, scored the crease with a pair of scissors, pressed it flat, and scanned it. The result appears in Figure 5-30. The image is representative of the worst sorts of photographic wounds, found in both the subject of the photo and the medium.

2. *Click the spot healing brush in the toolbox.* As witnessed in Figure 5-31 on the facing page, the spot healing brush looks like a bandage with a handful of dots to the left of it (*P*). Click the bandage or press the J key. (If you don't see the dots, press J again.)

- 3. *Confirm the default settings.* In the options bar, make sure that **Source** is set to **Proximity Match**. This setting uses the pixels around the perimeter of a brush stroke to determine how the painted area is healed. (The other option, Create Texture, averages the colors inside the brush stroke. Although this may sound okay, it usually results in an unacceptably blurry patch.) Also confirm that the brush preview on the left side of the options bar has a hard edge. If in doubt, press **Shift+[]** a few times to be sure.
- 4. *Click the lesser mole below the giant mole.* Increase the **Brush** diameter a couple of notches, to **30** pixels. Then, click the little mole below the great mole on the left cheek (his right), which appears circled in yellow in Figure 5-32. In one operation, Elements selects the area you clicked, looks for a close equivalent elsewhere in the image, clones from the equivalent area, and blends it with the surrounding image data. Upshot: the mole disappears, as witnessed in the right half of the figure.

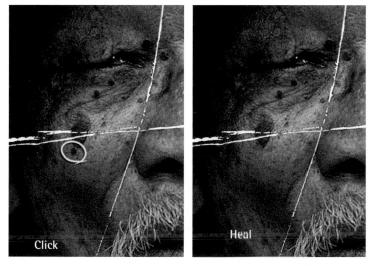

If Elements replaces the unsightly mole with some other unsightly defect, don't fret. Just press Ctrl+Z and try again.

5. *Heal the giant mole.* Now for something more challenging and less predictable. Drag over the giant mole on the left cheek. As you drag, Elements paints a translucent milky brush stroke. When you release, the program hunts down what it regards as a near match—usually something quite close by—and merges it with the area around the mole.

PEARL OF

NISDOM

The good news: no matter what, the mole goes away. The bad news: Elements may very well replace it with something just as bad or worse. To give you an idea of what we mean, Figure 5-33 shows the area of the mole followed by three different outcomes. (In each case, we undid the previous operation before trying again.) In the final case, it required painting over the area multiple times to get it just right. In other words, be prepared to undo a few operations, fuss with the tool, and sigh with exasperation before achieving a credible patch.

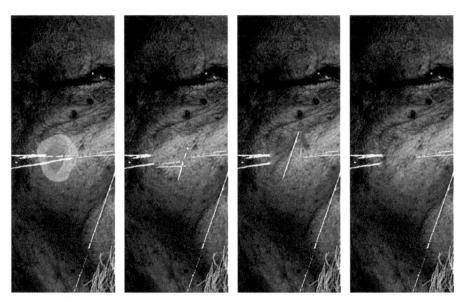

Figure 5-33.

At this point, you may be wondering: what good is an automated tool if it requires this much effort to make it function properly? Answer: not much. Our none-toohumble opinion? The spot healing brush is a failed solution to a problem that doesn't exist. It was designed to simplify the performance of the standard healing brush, which hails from the full version of Photoshop (version 7, to be exact). But between us, the standard healing brush doesn't require simplification. What Adobe regards as the more complex tool, we see as the more capable, more expedient, and ultimately easier to use tool. So use it we shall in the remaining steps.

6. *Select the standard healing brush.* Click and hold the bandage icon in the toolbox, and then choose the

second tool, which is the standard variety of the healing brush, as in Figure 5-34. Alternatively, you can Alt-click the bandage icon or press the J key.

7. *Confirm the default settings*. Again consult the options bar and confirm that the default settings are in play. Specifically, confirm that **Source** is set to **Sampled** and the **Aligned** checkbox is off. The Sampled setting tells Elements to clone pixels from a spot inside an image (as you'll specify in the next step); turning off Aligned lets you clone repeatedly from that one pristine spot.

If these options are not set properly, you can restore all default settings in one operation by clicking the down arrow icon on the far left side of the options bar and choosing the **Reset Tool** command.

- 8. Set the source point for the healing. The healing brush uses a source point to identify which portion of the image you want to clone. To set the source point, press the **Alt** key and click at the spot below the left cheek indicated by the crosshairs in Figure 5-35.
- 9. *Heal the left part of the scratch.* Check the options bar to make sure the brush diameter is set to 19 pixels. Then do the following:
 - Drag over the top-right fragment of the left scratch, indicated by the yellow brush stroke in the first example in Figure 5-36. (Note that the brush stroke colors in this figure are for illustration purposes only; your brush strokes will be normal.)
 - Press the key to reduce the brush diameter to 10 pixels. Then, drag along the bottom fragment, as indicated in cyan in the figure.
 - In a separate brush stroke, drag along the remaining portion of the left scratch, indicated in purple.
 - Finally, paint the area pictured in green.

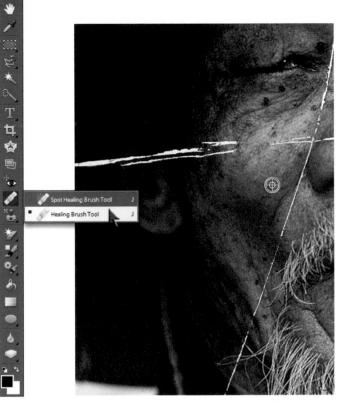

Figure 5-34.

Figure 5-35.

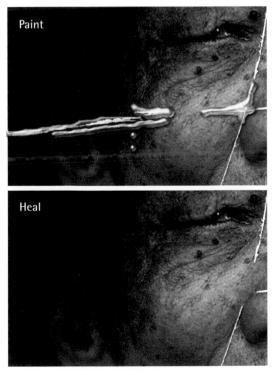

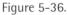

In each case, we're starting the brush stroke on the right and dragging to the left. If you're right-handed, this may seem backward. But it's important to follow Lefty's (that is, Deke's) lead in this case; if you drag from left to right, you will clone the vertical scratch and mar your image.

PEARL OF

WISDOM

If you look at the options bar, you'll see that you're using a hard brush, which is as it should be. A hard brush prevents the healing tool from incorporating distant and unrelated details into its mended pixels. In this case, the hard brush permits you to skirt between scratch lines without incorporating the white from one line into the healing for another. Just make sure that each brush stroke completely covers a scratch without crossing or touching another one.

Alas, as powerful as the healing brush is, it may produce less than perfect results. You can clearly see rows of inconsistent pixels running through the old man's cheek and ear (see the spotlighted example in Figure 5-37). Known as *scarring*, these bad seams tell the world that your image has been modified. Fortunately, you can re-heal an area by painting over it once, twice, or as many times as you like.

- Move the source and paint short strokes. Using the healing brush effectively is all about selecting a good source point. Thankfully, when one source fails, you can switch to another. Sources generally work best when set in an area that closely resembles the *destination* (the area you want to heal).
 - To heal inside the ear, for example, Alt-click in the top part of the ear and then drag over the scarred section.
 - To heal in the face, set the source point in the lower area of the cheek, where the flesh is relatively smooth.
 - To heal the shadows in the hat, Alt-click somewhere in those shadows. If you get some haloing along the edge of the ear—a function of Elements recruiting ear colors into its healing algorithm—Alt-click along the edge of the ear and paint again.

Keep your brush strokes short. When using larger brushes, individual clicks can be very effective. We finally arrived at the revised cheek and ear shown in the bottom image in Figure 5-37.

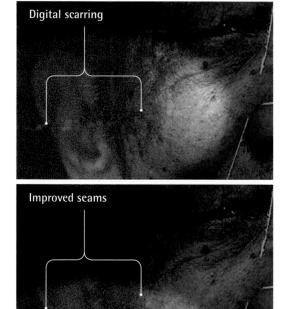

Figure 5-37.

- 11. *Set a new source.* Now to fix the nearly vertical scratch in the bottom half of the image. Scroll down, then press **Alt** and click just to the left of the scratch along the red hat strap, as shown on the left side of Figure 5-38.
- 12. *Click and Shift-click to draw straight lines.* Set the **brush diameter** to **20** pixels. Click at the point where the scratch intersects the red strap, indicated by the yellow target in the right half of Figure 5-38. Then press the **Shift** key and click midway up the scratch, at the point indicated by the cyan target in the figure. Photoshop Elements connects the two points with a straight line of healing, which we've colorized in orange. Finish off the scratch by Shift-clicking just to the left of the nose, indicated by the purple target.
- 13. *Heal the bottom of the scratch.* That still leaves an inch or so of scratch at the bottom of the image. Once again, click where the strap intersects the scratch (the yellow target in Figure 5-38) to reset the relationship between the source and destination points. Then press **Shift** and click down and to the left to heal away the scratch.
- 14. *Fix scars and repeated details*. If you look closely enough, you can make out repeated details around the nose and mouth. But the bigger problems occur near the collar and among the whiskers, as highlighted on the left side of Figure 5-39. To fix these, you'll need to source very similar areas—meaning collar-to-neck transitions and whiskers at similar angles—and paint them in using very small brushes, as small as 6 or 7 pixels in diameter.

To build up the two horizontal whiskers, we sourced what little remained of one, clicked to double its width, sourced that, clicked again, and so on. It takes a little patience, but in the end, you can build something out of almost nothing (shown in the right half of the figure).

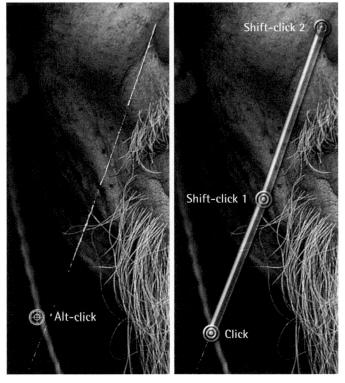

Figure 5-38.

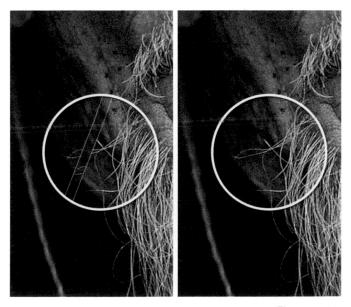

Figure 5-39.

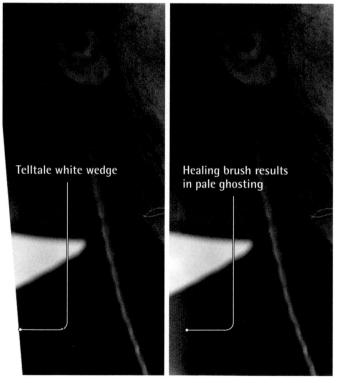

Figure 5-40.

- 15. *Clean up the remaining scratches.* From here on out, it's more of the same. You can fix the remaining scratches—those in the top and right portions of the image—by setting new source points and using the Shift-clicking technique laid out in Step 12. If you're looking for additional practice, use the healing brush for cleaning up blemishes. Go ahead and paint over most of the moles and age spots, but leave the wrinkles. Wrinkles add character, and this particular gentleman wears them well.
- 16. *Select the clone stamp tool.* This photo suffers one final flaw. The bottom-left corner exhibits a telltale wedge of white that lets you know the image has been straightened. You could of course crop the wedge away, as we did in "Using the Straighten and Crop Tools" in Lesson 4. But that would rob the image of a lot of really great detail, and no one wants to do that. The solution: rebuild the corner with cloning.

PEARL OF

WISDOM

Your inclination might be to start painting away with the healing brush. But as Figure 5-40 shows, the healing brush is the wrong tool for this particular job. Its specialized pixel-mending technology, which so often leads to flawless patches, fails here because the far edges of the corner are populated by white pixels. The healing brush thus merges with white, resulting in an unrealistic ghosting effect.

It's time to switch to the original cloning tool, the clone stamp tool. Select the **clone stamp tool** from the toolbox (see Figure 5-41 on the facing page) or press the **S** key. Much simpler than the healing brush, the clone stamp tool lifts details from the source and paints them into the destination, with no fancy blending in between. Even so, it's sometimes the best tool for the job.

- 17. *Remove the corner wedge*. You already know how to use the clone stamp tool because it handles just like the standard healing brush. Here's what we want you to do:
 - Press the 🗋 key a few times to raise the brush diameter to 50 pixels.
 - The brush preview in the options bar should show a soft brush. Because there is no special blending, the logic is simple—soft brushes ensure soft transitions. If in doubt, make the brush its absolute softest by pressing Shift+① four times.
 - Confirm that the Aligned checkbox is turned on (as by default). This ensures that you continually clone from a relatively common point, so that one brush stroke aligns with another.
 - Press the Alt key and click in the middle of the edge of the man's shoulder, as indicated by the crosshairs in the left example of Figure 5-42. Be sure that the center of the crosshairs lands directly on the border between shoulder and sky.
 - Start painting at the three-way intersection of shoulder, sky, and wedge, as indicated by the yellow target in the figure. If you want help getting the cursor exactly aligned, press the Caps Lock key to get the precise cursor.
 - Paint the edge of the shoulder out to the side of the image, and then paint downward to fill in the rest of the man's garment.
 - To fill in the hat and the triangle of sky, you'll need a new source point. Alt-click at the base of the hat, near the left edge, as indicated by the crosshairs in the right example of Figure 5-42.

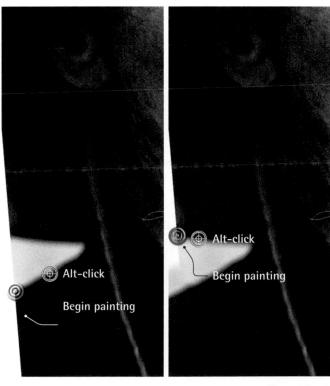

• Begin painting at the point indicated by the magenta target in the figure. Then paint down into the sky and up into the hat.

When you're finished, you may want to switch back to the healing brush to smooth over any awkward transitions in the sky. The clone stamp tool and the healing brush make a great team: use the clone stamp tool to make big changes in the image, and then use the healing brush to smooth over the problematic transitions.

Figure 5-43 compares the original version of the image—that is, the one Deke purposely damaged—to the photograph as it appears after we repaired it inside Photoshop Elements. If you search hard enough, you can find a few scars and flaws. But we suspect most folks would have no idea this image has been tampered with at all—not once but twice.

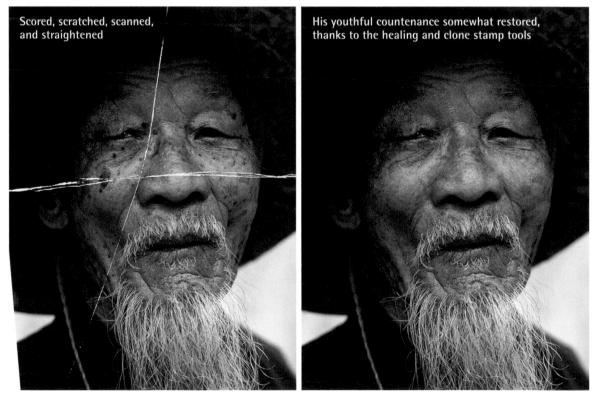

Figure 5-43.

WHAT DID YOU LEARN?

Match the key concept in the numbered list below with the letter of the phrase that best describes it. Answers appear upside-down at the bottom of the page.

Key Concepts

- 1. Painting tools
- 2. Editing tools
- 3. Healing tools
- 4. Screen
- 5. Bracket keys ([] and [])
- 6. Scatter
- 7. Dodge tool
- 8. Burn tool
- 9. Sponge tool
- 10. Exposure
- 11. Cloning
- 12. Aligned

Descriptions

- A. This tool darkens pixels as you paint over them.
- B. Available from the options bar, this value controls the intensity of the edits applied with the dodge and burn tools.
- C. This clone stamp tool and healing brush option preserves the physical relationship between the source and destination points (the point where you Alt-click and the point where you begin painting, respectively).
- D. These are the most convenient ways to change the diameter of a brush; adding Shift changes the hardness of the brush.
- E. This tool adjusts the saturation of colors, making them either duller or more vivid.
- F. Available from the More Options pop-up panel, this slider bar separates the spots of color laid down by the paintbrush.
- G. These tools modify (rather than replace) the existing color or luminosity of a pixel; examples include the burn and smudge tools.
- H. The process of painting one section of an image onto another.
- I. This tool lightens pixels as you paint over them.
- J. These tools permit you to create lines and to fill shapes with the foreground color; the brush and pencil tools belong to this category.
- K. If you paint on a layer that has this blend mode applied to it, your painting will lighten everything beneath it.
- L. These tools permit you to clone photographic details from one portion of an image to another.

Answers

11' 5C' 3F' 4K' 2D' 9E' 11' 8V' 6E' 10B' 11H' 15C

DUTT

DE

MAKING SELECTIONS

MANY COMPUTER PROGRAMS allow you to manipulate elements on a page as objects. That is to say, you click or double-click an object to select it, and then you modify the object in any of several ways permitted by the program. For example, if you go to the Windows desktop and double-click the Recycle Bin icon, your PC shows you a window full of files that you've thrown away. To make a word bold in Microsoft Word, you double-click the word and then click the Bold button. Every object is a unique,

The real world harbors a similar affinity for objects. Consider the three sunflowers pictured in Figure 6-1. In life, those flowers are objects. You can reach out and touch them. You can even cut them and put them in a vase.

selectable thing.

Although Photoshop Elements lets you modify snapshots taken from the world around you, it doesn't behave like that world. And it bears only a passing resemblance to other computer programs. You can't select a sunflower by clicking it, because Elements doesn't perceive the flower as an independent object. Instead, the program sees pixels. And as the magnified view in Figure 6-1 shows, every pixel looks a lot like its neighbor. In other words, where you and I see three sunflowers, Photoshop Elements sees a blur of subtle transitions, without form or substance.

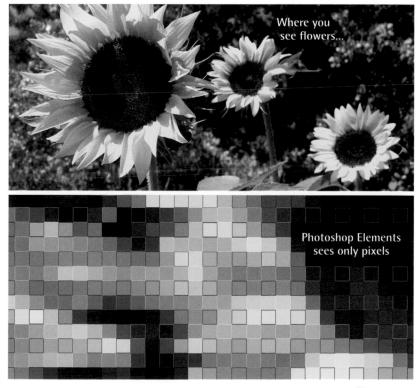

Figure 6-1.

ABOUT THIS LESSON

Project Files

Before beginning the exercises, make sure you've downloaded the lesson files from www.oreilly.com/go/deke-PSE8, as directed in Step 2 on page xiv of the Preface. This means you should have a folder called *Les*son Files-PSE8 1on1 on your desktop (or whatever location you chose). We'll be working with the files inside the *Lesson 06* subfolder. This lesson examines ways to select a region of an image and edit it independently of other regions using the various selection tools along with a few menu commands. You'll learn how to:

•	Select a region of continuous color page 142
•	Define and use geometric selection outlines page 149
•	Select free-form portions of an image with the lasso and polygonal lasso tools page 157
•	Paint an outline with the selection brush page 164

• Loosely sketch a selection with the magic selection brush page 170

Video Lesson 6: Selection Tools

Elements' selection tools rank among its most essential capabilities. Unless you want to apply an operation to an entire image or layer, you have to first define the area that you want to affect by dragging or clicking with a selection tool. Deke shares an overview of Elements' selection tools, as well as a few of the most common selection-editing commands.

You can either watch the video lesson online or download to view at your leisure by going to *www. oreilly.com/go/deke-PSE8.* During the video, you'll learn about the keyboard equivalents and shortcuts listed below.

Command or operation Fill selection with foreground color Deselect image Add to selection Subtract from a selection Hide selection outline Move marquee as you draw it Inverse (reverse selection)

Keyboard equivalent or shortcut Alt+Backspace Ctrl+D (or click outside selection) Shift-click or drag with selection tool Alt-click or drag with selection tool Ctrl+H Press and hold the space bar Ctrl+Shift+I So rather than approaching an image in terms of its sunflowers or other objects, you have to approach it in terms of pixels. This means specifying which pixels you want to affect and which you do not, using *selections*.

Isolating an Image Element

Let's say you want to change the color of the umbrella shown in Figure 6-2. But to colorize the umbrella and only the umbrella, you must first select it. Never mind that the umbrella is so obviously an independent object that even an infant could pick it out. For all its power, Photoshop Elements is no infant. If you want to select the umbrella, you must tell the program exactly which group of pixels you want to modify.

Fortunately, Elements provides a wealth of selection functions to help you do just that. Some functions select regions of colors automatically; others require you to painstakingly define the selection by hand. Still others, like the tools we used to describe the bluish regions in Figure 6-3, select geometric regions. All the tools can be used together to forge the perfect outline, one that exactly describes the perimeter of the element or area that you want to select.

As if to make up for its inability to immediately perceive image elements such as umbrellas and sunflowers, Photoshop Elements treats *selection outlines*—those dotted lines that mark the borders of a selection—as independent objects. You can move selection outlines independently of an image. You can combine them or subtract from them. You can undo and redo selection modifications. You can even save selection outlines for later use.

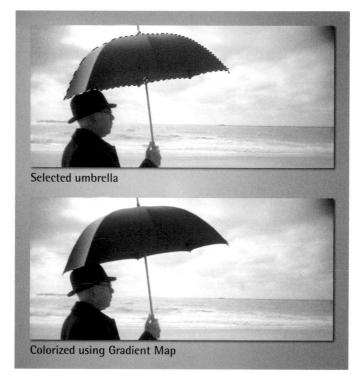

Figure 6-2.

Figure 6-3.

Figure 6-4.

Furthermore, a selection can be every bit as incremental and precise as the image that houses it. Not only can you select each and every pixel inside an image—as a group or independently—but you can also specify the degree to which you want to select a pixel—all the way, not at all, or in any of a couple of hundred levels of translucency in between.

This means you can match the subtle transitions between neighboring pixels by creating smooth, soft, or fuzzy selection outlines. In Figure 6-4, we selected the umbrella and the man holding it and transferred the two to a different backdrop. Not only were we able to maintain the subtle edges between the man and his environment, we were also able to make the darkest portions of his coat translucent so they blend with the backdrop. Selections take work, but they also deliver the goods.

Selecting Colored Areas with the Magic Wand

We'll start things off with one of the most automated tools in all of Photoshop Elements, the magic wand. A fixture of the program since way back when it was called Photoshop LE, the magic wand lets you select an area of color with a single click. It works especially well for removing skies and other relatively solid backgrounds, as the following exercise explains.

1. *Open two images.* Make sure the Editor workspace is running. Then, open the *Giraffe.jpg* and *Bolivian backdrop.jpg* files, located in the *Lesson 06* folder inside

Lesson Files-PSE8 1on1. (You can select two images at a time in the Open dialog box by clicking one and Ctrl-clicking the other.) You'll see thumbnails for both images open in the Project Bin. We've chosen to arrange these side by side with the giraffe on the left, and then dragged the bar in between until the *Giraffe*. *jpg* was almost entirely visible, as illustrated in Figure 6-5 on the facing page. You'll want to choose an arrangement that allows you access to *Giraffe.jpg* first, as that's where we'll start. Our goal during this exercise is to use the magic wand tool to select the giraffe and then bring it into the *Bolivian backdrop*. *jpg* image. The fact that the two images come from different continents doesn't bother Photoshop Elements one bit.

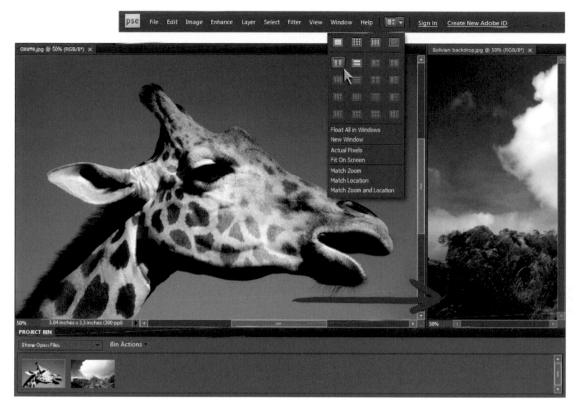

- 2. *Select the magic wand tool in the toolbox.* Click the magic wand tool in the toolbox along the left side of the Editor screen (see Figure 6-6) or press the W key.
- 3. *Confirm the options bar settings.* Pictured in Figure 6-7, the options bar displays a series of settings for the magic wand. Confirm that they are set as follows:
 - The **Tolerance** value defines the range of tones the wand selects at a time. We discuss this very important option in Step 5, but in the meantime, leave it set to its default, 32.
 - Turn on the Anti-alias checkbox to soften the selection outline just enough to make it look like an organic, photo-graphic boundary. We talk more about this option in Step 13 on page 147.
 - Turn on **Contiguous** to make sure that the magic wand selects only adjacent regions of color. You'll get a sense of how contiguous selections work in Step 6.

🔳 🖥 🗂 🗧 🛛 Tolerance: 32 🖉 Anti-alias 🏑 Contiguous 📄 Sample All Layers 🛛 Refine Edge.

Because this image does not include layers, the Sample All Layers checkbox has no effect.

Figure 6-5.

Figure 6-7.

4. *Click anywhere in the sky behind the giraffe*. For the record, we happened to click at the location illustrated by the cursor in Figure 6-8. But if our experimentations are any indication, you can click just about anywhere and you won't select the entire sky. That may seem like an odd thing. Here's this tool that selects regions of color, and it can't select what may be the most consistently colored, cloudless sky ever photographed. What good is it?

PEARL OF WISDOM

What looks to you like a field of homogeneous blue that lightens a bit as it travels from top to bottom is in fact a collection of roughly 500,000 independent colors. Given current settings, the wand can select at most half that number, so some pixels are bound to get left out.

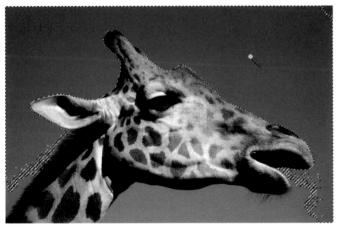

Figure 6-8.

5. *Raise the Tolerance value*. The Tolerance setting determines how many colors are selected at a time, as measured in luminosity values. By default, Photoshop Elements selects colors that are 32 luminosity values lighter and darker than the click point. After that, the selection drops off. Given that Elements did not select the entire sky, the Tolerance must be too low.

Raise the value to 50. The easiest way is to click the word **Tolerance** in the options bar to highlight the value, type **50**, and press the **Enter** key. Note that this has no immediate effect on the selection. Tolerance is a *static* setting, meaning that it affects the next operation you apply.

- 6. *Expand the selection using the Similar command.* The Select menu provides two commands that let you expand the range of a selection based on the Tolerance setting. They both affect any kind of selection, but they were created with the wand tool in mind:
 - Select→Grow reapplies the magic wand as if we had clicked all the pixels at once inside the selection with the magic wand tool. In other words, it uses the selection as a base for a larger selection. The Grow command selects only contiguous pixels—pixels adjacent to the selected pixels.

 Select→Similar is almost identical to Grow, except that it selects both adjacent and nonadjacent pixels. So where Grow would select blue sky pixels up to the point where it encounters nonblue pixels, such as the giraffe's mane, Similar selects all blue pixels within the Tolerance range, regardless of where they lie, including those deep inside the mane.

PEARL OF

WISDOM

Remember the Contiguous check box in the options bar (Step 3 on page 143)? Grow is like using the magic wand with Contiguous turned on; Similar is like using the tool with Contiguous turned off. For example, suppose that you clicked with the wand tool inside the righthand sunflower back in Figure 6-1. The Grow command would expand the selection outline inside that particular sunflower; Similar would expand the selection to include all three sunflowers.

For our purposes, we want to get all the blue pixels, wherever they may reside, so choose **Select→Similar**, as shown in Figure 6-9.

- 7. *Fill out the selection*. With a modicum of luck, you should have selected the entire sky. But if you miss a spot, press the **Shift** key and click that spot in the image window. Shift-clicking with the magic wand adds to a selection.
- 8. Reverse the selection. You may wonder if this approach makes sense. You want to select the giraffe, and yet you've gone and selected the sky. As it turns out, this is by design. It's easier to select a solidcolored sky than a spotty-colored giraffe, and you can always reverse the selection. Choose Select→Inverse or press Ctrl+Shift+I to select those pixels that are not selected and deselect those that are. In this case, now the giraffe is selected and the sky is not (see Figure 6-10).

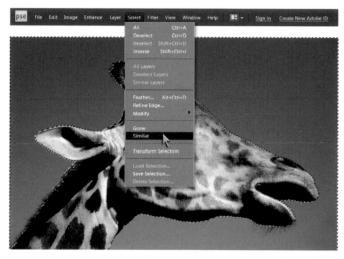

Figure 6-9.

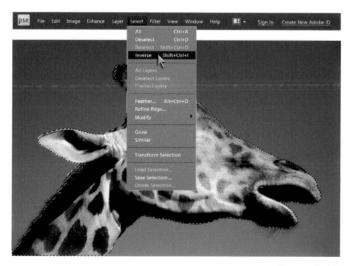

Figure 6-10.

PEARL OF

WISDOM

If you aren't able to pull the tabbed windows out of your current window arrangement, it might be because your Preferences aren't set the same way ours are. Choose Edit→Preferences, and in the General tab, make sure you have the Allow Floating Documents in Full Edit Mode checkbox turned on. You'll notice that this restores the Float in All Windows option in the Arrange menu as well.

- 9. *Select the move tool in the toolbox.* Click the move tool in the toolbox (see Figure 6-11) or press the V key (as in mooV). The move tool lets you move selected pixels within an image or from one image to another.
- 10. Drag the giraffe into the Bolivian backdrop. This operation is a little tricky, so for this first foray, let's change the arrangement to maximize your changes of seeing what you're doing. First, grab the tab for the Bolivian backdrop.jpg file, and drag it out of the arranged windows, down and to the right, so you can see the whole thing. Next, position your move tool cursor inside the giraffe so the cursor appears as a plain arrowhead. A bounding box will appear around the giraffe selection. Then drag the giraffe from the Giraffe.jpg image window into the Bolivian backdrop.jpg image window. Before you release the mouse button, press and hold the Shift key. Finally, release the mouse button and then release the Shift key.

By pressing Shift on the drop, you instructed Photoshop Elements to *register* the giraffe inside its new background, so that it lands in the same spot relative to the new background as it enjoyed in the old background, as shown in Figure 6-12. Had you not pressed Shift, the giraffe would have landed wherever you dropped it. (If you didn't get it quite right, press Ctrl+Z to undo the operation and try again.)

Figure 6-12.

KTRA CREDI

At this point, you have successfully used the magic wand tool to transfer the giraffe into a new habitat. The only problem is that it doesn't look particularly realistic. In fact, it looks like what it is—a digital montage. If that's good enough for you, skip ahead to the next exercise, "Using the Marquee Tools," which begins on page 149. But if you want to make this giraffe look like it's really at home, we have a few steps to go.

11. Select the Background layer in the Layers panel. The Layers panel most likely appears in the lower half of the Panel Bin on the right. If not, choose Window→Layers or press the F11 key to open it. You should see two layers, one for the giraffe—an imported selection always appears on a new layer—and another for the background. Click the Background layer to make it active, as shown in Figure 6-13.

Figure 6-13.

- 12. Apply the Gaussian Blur filter. To create a more realistic depthof-field effect, blur the background. The best command for this purpose is Filter→Blur→Gaussian Blur, a mathematically derived blur function that happens to do the trick. Choose this command, change the Radius value to 12 pixels, and click the OK button, as demonstrated in Figure 6-14.
- 13. Zoom in on a few details. Use the zoom tool at the top of the toolbox to zero in on the giraffe's horns and mane and gauge how well Elements selected the image. As you can see in Figure 6-15 on the next page, the selection has some slight problems:
 - The horns look a little jagged. More careful inspection reveals that the jagged edges are mitigated by a slight softening effect. Known in technical circles as *antialiasing*, this softening is a function of the Anti alias checkbox that you turned on back in Step 3. The checkbox instructed the magic wand to partially select a thin line of pixels around the perimeter of the selection, thus creating a slight fade between the giraffe and its new background. Had you turned Anti-alias off, the edges of the horns would appear even more jagged.

Figure 6-14.

Figure 6-15.

Figure 6-16.

• Pictured in the bottom half of Figure 6-15, the mane exhibits a problem called *haloing* (also called *fringing*), where a foreground image is outlined with a fringe of background color, in this case blue.

The jagged edges aren't perfect, but they look fine when we're zoomed out and are likely to print fine as well. The haloing is another matter. That you should fix. And although Elements has a command designed specifically for this purpose (Enhance \rightarrow Adjust Color \rightarrow Defringe Layer), it's something of a dog, in our humble opinion. We'll fix this problem with the help of a better tool: a predefined layer style.

- 14. *Select the giraffe layer in the Layers palette.* Click the **Layer 1** item to make it active.
- 15. *Bring up the Deke Edges styles*. Directly above the Layers panel, you should see a panel called **Effects**. If not, choose **Window→Effects** or press the F7 key to open it. Make the following choices:
 - From the row of icons under the word Effects, choose the button second from the left to bring up the layer styles, which houses a series of drop shadows, glows, and other methods for tracing the perimeter of a layer.
 - Click the second pop-up menu to unfurl it. You should see a collection of options that begin with the word *Deke*, as in Figure 6-16. (The Deke libraries appear only if you installed these presets, as directed in Step 6 on page xvi.) Choose **Deke Edges** to trace the inside edge of a layer with any of 10 colors.
- 16. *Apply the Orange Edge Tint style.* Of all the hues represented by the Deke Edges styles, orange is the one that best matches the yellowish brown of the animal's mane, spots, and horns. So click the thumbnail named **Orange Edge Tint** in the Effects palette. Then click **Apply** at the bottom of the panel. Elements traces a subtle corona of orange around the inside perimeter of the giraffe's head and neck.
- 17. Adjust the layer style settings. Currently, the inner glow effect is too thick, meaning that it doesn't merely tint the edges but seeps into the giraffe's face as well. Fortunately, you can change this. Notice the *fx* to the far right of Layer 1 in the Layers panel? This symbol indicates that a style has been applied to the layer.

Double-click the *fx* to display the **Style Settings** dialog box, as illustrated in Figure 6-17. Then, reduce the **Inner Glow Size** value to 40 pixels, so the glow just covers the mane, and click the OK button.

The Orange Edge Tint style ably corrects the blue haloing, as demonstrated in Figure 6-18. To learn more about layer styles and their many practical and creative uses, read Lesson 9, "Text and Shapes."

Using the Marquee Tools

After seeing the magic wand and its ability to select irregular regions of color, you may question the usefulness of a geometric selection tool such as the rectangular or elliptical marquee. After all, how many image elements are precisely rectangular or elliptical? The answer is: plenty. Every image begins life as a rectangle, and ellipses are as common as, well, our own Mother Earth.

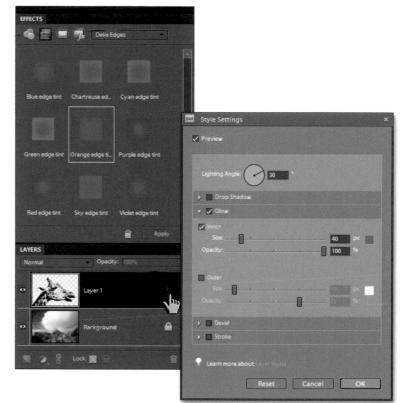

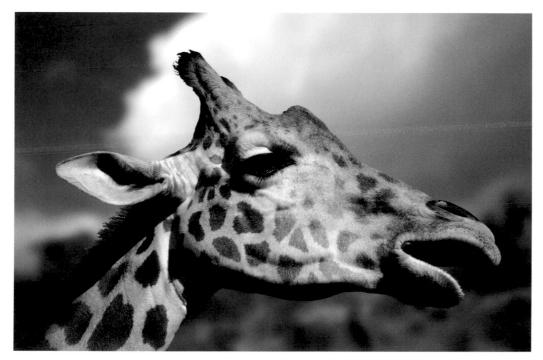

Figure 6-18.

But it goes beyond that. Both tools are great for selecting general regions to be used for a wide variety of purposes, such as creating composites, as the following exercise makes clear:

- Open three images. Open the Moon.jpg, Red sky.jpg, and Road.jpg files, all of which appear nicely arranged in Figure 6-19, courtesy of one of the Arrange menu's
 3-up options. These files are located in the Lesson 06 folder inside Lesson Files-PSE8 1on1. In the following steps, we'll combine these images in a complex composition using the undeniably simple rectangular and elliptical marquee tools. We'll also add a dynamic fill layer to make the colors of the road and moon conform to those of the vivid red sky.
- 2. Select the rectangular marquee tool in the toolbox. Click the **Arrange** button and choose **Consolidate All** to should bring the *Road.jpg* image to the front. Click the rectangular marquee tool in the toolbox (see Figure 6-20) or press the M key. (If you get the elliptical marquee tool instead, press the M key again.) The rectangular marquee tool lets you select rectangular portions of an image.

- 3. Confirm the options bar settings. In the options bar, make sure that the Feather value is set to 0 and the Mode is set to Normal. These default settings ensure that the marquee tool draws hard-edged rectangles of unconstrained height and width. In other words, they cause the tool to behave normally.
- 4. Increase the canvas size on the bottom and sides. You're going to have to trust us here for a moment. Later, in Step 6, we're going to apply an effect we want on only the top edge of the selection, so in this step we're going to "buffer" the other three edges with some whitespace. Choose Image→Resize→Canvas Size. In the dialog box that appears, add space to the bottom and sides of *Road.jpg* by increasing the Width to "5.147 inches" and the Height to "5.75 inches". Leave the Relative checkbox turned off. And in order to have Elements add the extra space to the bottom and sides, move the Anchor setting to the top by clicking the up arrow above the gray box, leaving the setting looking as it does in Figure 6-21. Click OK.
- 5. Select the bottom portion of the image. Drag with the rectangular marquee tool to select the bottom portion of the Road.jpg image shown in Figure 6-22. Make sure you select all the way to the edges, including the extra canvas you added in Step 4.

If you miss a bit of an edge, press the spacebar (while keeping the mouse button down) to temporarily stop drawing out the marquee selection and adjust its position instead. When the spacebar is down, the marquee moves; release the spacebar to continue drawing.

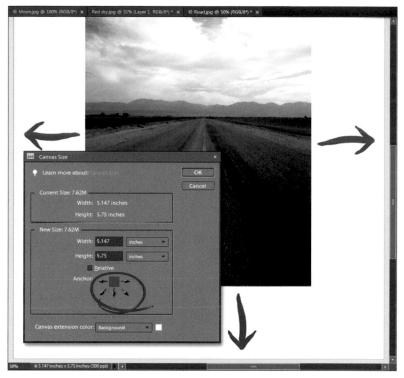

Figure 6-21.

Figure 6-22.

6. Choose the Feather command. Choose Select→Feather or press Ctrl+Alt+D to display the Feather Selection dialog box, which allows you to blur the boundaries of a selection outline, making for smoother transitions. Enter a relatively enormous Feather Radius value, such as 120 pixels, and click OK. This creates a gradual transition between selected and deselected pixels, as indicated by the sudden roundedness of the selection corners.

PEARL OF

If Feather is so deft at creating gradual transitions, why didn't we use it to fix the edges of the giraffe? The purpose of the Feather command is to blur the edges of a selection so that it has an indistinct boundary. A blurry boundary around a sharply focused giraffe would have looked all wrong. But a road that fades gradually into its background will look great.

WISDOM

7. *Drag the selected bit of road and drop it into the red sky image.* You could use the move tool at the top of the toolbox, as you did in the previous exercise, but let's try something trickier that leverages the new tabbed view in Elements 8. Press the **Ctrl** key (to temporarily get the move tool), grab the road selection, and drag it up to the tab for *Red sky.jpg* (don't let go yet). After a split second, the *Red sky.jpg* image appears in the window. Move your cursor down into the new image and let go.

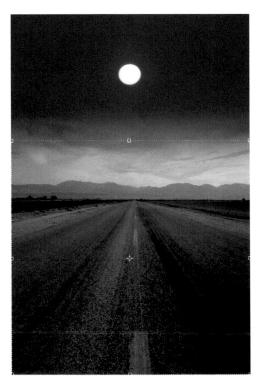

Figure 6-23.

Wherever your selection lands, use the move tool again to reposition it so that it looks like Figure 6-23.

The reason we can't use the trick of holding down the Shift key to register the two images together (as we did in the previous exercise) is because the two images are no longer the same dimensions. When we added the canvas area to the road image, we negated our chance for having these two images align automatically.

The nice transition between the red sky and clouded horizon of the road image is brought to you courtesy of the feathering you applied to the selection before bringing it in. If we hadn't added the canvas around the sides and bottom edges back in Step 4, those edges would have a soft red transition too, giving us red all the way around, which in this case is not what we want. By increasing the canvas, they're happening out where we can't see them.

- 8. *Bring the moon image to the front*. Click the tab for *Moon.jpg* to bring it to the front.
- 9. *Select the elliptical marquee tool.* Go to the toolbox and choose the elliptical marquee tool from the marquee tool flyout menu. Or press the M key (or Shift+M, depending on how you set your preferences).
- 10. *Select the moon (and then some)*. Drag with the elliptical marquee tool to select an area well outside the moon, as illustrated in Figure 6-24.

Here are three keyboard tricks that can help you define your selection while dragging with the elliptical marquee tool. Press the Alt key to draw from the center of the image out; this might help you align the selection outline evenly around the moon. Press the Shift key to constrain the ellipse to a circle. (The moon is not quite circular, but you still may find Shift helpful.) Press the spacebar to move the ellipse on the fly.

- 11. Feather the edges of the selection. Choose Select→Feather or press Ctrl+Alt+D. Enter a Feather Radius value of 12 pixels and click OK. Although you can't tell yet, this value blurs the outline around the moon. Granted, it's not as blurry as the super-gradual transition we assigned to the road, but it's blurry nonetheless.
- 12. *Drag the moon into the red sky image*. Press **Ctrl** and drag the moon into the *Red sky.jpg* image tab, and wait for the image to open. Drop it in front of the sun over the road, as pictured in Figure 6-25.

To move an image element after you drop it, press the Ctrl key and drag it to the desired location. You can also press the Ctrl key and nudge the image using the four arrow keys ($\uparrow, \downarrow, \leftarrow, \rightarrow$).

- 13. *Invert the colors in the moon*. Choose **Filter→Adjustments→ Invert** or press Ctrl+I to invert the light and dark colors in the moon. The moon turns a deep blue, as in Figure 6-26. The luminosity values are good, but we want the colors to match the rest of the image.
- 14. Add a layer of vermilion. We'll colorize the image in an unusual but highly effective way. Go to the Layers panel and click the O symbol at the bottom of the panel. This displays a popup menu of specialty layers. Choose Solid Color, which creates a layer filled with a single color. To find out what color you'd like, Elements displays the Color Picker dialog box.

Figure 6-24.

Figure 6-25.

The first three values—**H**, **S**, and **B**—stand for Hue, Saturation, and Brightness. Change them to **20**, **100**, and **100**, respectively, as in Figure 6-27. Then click **OK** to create a new layer, completely filled with vermilion. This probably seems like a weird step—after all, you just blotted out your entire image! But suspend your disbelief for a moment and trust us; it'll look great.

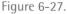

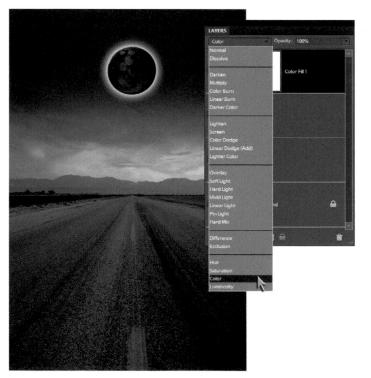

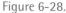

15. Change the blend mode to Color. Now to mix the vermilion with the layers below it. Click the word Normal at the top of the Layers panel and choose Color from the pop-up menu that appears. This retains the hue and saturation of the vermilion layer and mixes them with the luminosity values of the moon, road, and sky below it. See? All better. The colorized result appears in Figure 6-28.

CREDII

You can stop now. After all, you've used the rectangular and elliptical marquee tools to great effect, merging three images from different photographs into a seamless whole. But the marquee tools can also be used to paint color into an image. In the remaining steps, we'll explain how to add a jet of white descending from the moon to the road and how to lift color from an image using the eyedropper tool. If you don't feel like following along, skip to the next exercise, "Lassoing an Irregular Image" on page 157. Otherwise, we have just six more steps.

EXTRA '

- 16. *Create a new layer in front of the road*. Click the **Layer 1** item in the Layers panel. If you accurately followed the steps, Layer 1 contains the image of the road. Click the a icon at the bottom of the panel to create a new layer in front of the road.
- 17. *Draw a new marquee*. Get the rectangular marquee tool by pressing M, pressing Shift+M, or selecting it from the toolbox. Then draw a marquee that connects the moon to the road. It should be slightly narrower than the moon and descend slightly into the road, as shown in Figure 6-29.

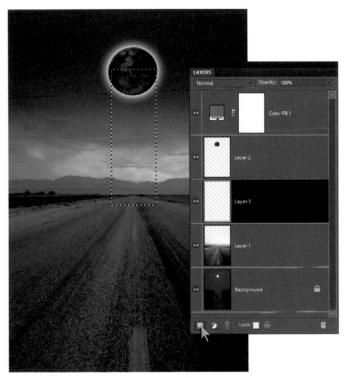

Figure 6-29.

- 18. Feather the selection. Choose Select→Feather, and note that the Feather Radius value is still set to 12 pixels, as you specified back in Step 11. This continues to be a wonderful setting. To accept it and move on, click OK. The corners of the rectangular marquee appear to round off slightly.
- Hide the selection outline. The selection outline is a bit intrusive for our taste, so let's hide it. Choose View→Selection or press Ctrl+H to hide the animated dotted outline—a.k.a. "marching ants"—around the marquee.

Note that the selection outline is still there; the animated outline is merely hidden so that you see the results of your changes better. To redisplay the marching ants, press Ctrl+H again.

- 20. Fill the selection with white. Press the D key to switch to the default foreground and background colors, black and white. Then press Ctrl+Backspace to fill the selection with the background color. Even though the selection is invisible, Elements goes ahead and colors it white.
- 21. *Reduce the Opacity setting.* The white rectangle is too opaque, so let's make it more translucent. Select the **Opacity** value in the Layers palette and change it to **40** percent. Or forget about selecting the value and just press the 4 key. (If pressing 4 doesn't work, press the Esc key to deactivate the Color blend mode from Step 15, and then press 4 again.) As long as the marquee tool is still active, the column of white turns translucent, as shown in Figure 6-30.

Figure 6-30.

EARL OF

The Opacity value acts as an ingredient mixer. If you think of the white rectangle as one ingredient and the road below it as another, Opacity determines how much of each image is used to create the final blend. A value of 100 percent favors the rectangle. So 40 percent makes the rectangle quite translucent, with 60 percent of the road showing through.

The most amazing aspect of this otherworldly composition is that we managed to pull it off using Elements' simplest selection tools, the rectangular and elliptical marquees. Of course, it didn't hurt to soften the transitions with the Feather command. We sincerely hope that this exercise leaves you with a sense of the many and varied applications for geometric selection outlines in Photoshop Elements.

Lassoing an Irregular Image

Although there may be a good deal of handy geometric shapes in the world around us, not every item you'll ever want to select is a rectangle or circle. Enter a couple of handy tools named after capturing wayward items, the lasso tools. True to their name, the *lasso tools* let you select irregular portions of an image. The primary lasso tool invites you to drag around an image to trace it freehand. But like freehand tools in all graphics programs, the lasso is haphazard and hard to control, at least when using a mouse.

That's why Photoshop Elements also includes a *polygonal lasso*, which allows you to select straight-edged areas inside an image. Admittedly, the polygonal lasso tool doesn't suit all images, particularly those that contain rounded or curved objects. But as you'll see, the tool is easy to control and precise to boot.

In the following exercise, you'll experiment with both the standard and polygonal lasso tools, and get a feel for why the latter is typically more useful. You'll also get the opportunity to play with a couple of special effects commands from Elements' Filter menu.

1. Open an image. Open the Denver Public Library. jpg file located in the Lesson 06 folder inside Lesson Files-PSE8 10n1. This image captures an amazing work of architecture with a terribly dull backdrop, as shown in Figure 6-31 on the next page. It seems to me that a structure like this should be paired with a dramatic sky. Fortunately, Photoshop Elements excels at dark and stormy nights.

Figure 6-31.

Figure 6-32.

- Click the lasso tool in the toolbox. It's the one that looks like a Wild West-style lariat. Alternatively, you can press the L key. (The tool icon should look like P. If it includes a magnet or it has spikes, press L until you see P.) The lasso tool can be difficult to control, but we want you to experience the tool for yourself so you can decide what you think of it firsthand.
- 3. *Try dragging around the library building.* The portion of the building we'd like you to select appears highlighted in Figure 6-32. Trace along the red line to select the area inside the building. (The green area represents the region outside the selection.) Feel free to occasionally drag outside the boundaries of the image window.

The lasso is flexible, scrolling the image window to keep up with your movements and permitting you to drag outside the image to select the extreme edges. But if you're anything like us, you'll have a heck of a time getting halfway decent results out of it.

- 4. Deselect the image. Assuming your selection looks like complete and utter garbage, choose Select→Deselect or press Ctrl+D to throw it away and start over. If, on the other hand, your selection outline looks great, give yourself a gold star and skip to Step 7.
- 5. Select the polygonal lasso tool in the toolbox. Click and hold the lasso icon to display a flyout menu of additional tools, and then choose the polygonal lasso (the spikylooking one; see Figure 6-33 on the facing page). Or just press L or Shift+L a couple of times. However you select it, the polygonal lasso lets you select straight-sided areas inside an image.

6. Click around the roof of the library. We added the yellow arrowheads in Figure 6-34 to point to the cight corners at which you need to click. Start by clicking at the corner labeled ①. (There's no special reason to start at this particular corner; it's just as good a point of reference as any of the others.) Then move the cursor down to corner ②. As you do so, a straight line connects the cursor to ①. Make sure this line follows the line of the roof, and then click to set the corner in place. Keep clicking the corners in the order indicated in the figure.

If you have problems, some words of advice. First, take your time. Click deliberately and take care not to double-click, because the latter completes the selection. Second, if you make a mistake, press the Backspace key to delete the last click point. Or press Ctrl+D to abandon the selection and try again. And third, hang in there; you'll get it.

After you click at corner **3**, you have two options for completing the selection:

- Click corner ① to come full circle and close the selection outline.
- Double-click at point ③ to end the selection and connect points ① and ③ with a straight segment. Or click at ③ and press Enter.
- 7. Select the elliptical marquee tool. The central tower of the building is a cylinder, and the top of a cylinder is elliptical. You could try to select the rounded edges using the lasso, or you could use a tool better suited to ellipses. Press M (or Shift+M) a couple of times or select the elliptical marquee from the toolbox flyout menu.
- 8. *Select the cylindrical top of the building.* This is another tricky step, so read the following paragraph before you begin.

Press and hold the **Shift** key. Then drag with the elliptical marquee tool to add the ellipse to the existing straight-sided selection. After you begin your drag, you can release the Shift key.

Figure 6-35.

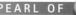

WISDOM

As you drag, remember that you can press the spacebar to move the ellipse on the fly. When you get the ellipse into position, release the spacebar and continue dragging. When the ellipse is properly sized (as in Figure 6-35), release the mouse button.

- 9. *Select the polygonal lasso*. Click the lasso icon in the toolbox and then select the polygonal lasso tool from the flyout menu. Or press the L key or Shift+L to return to the tool.
- 10. *Select the lower portion of the cylinder*. Press the **Shift** key and click the perimeter of the central building. It should take you just four clicks (see Figure 6-36). Remember to double-click or press Enter to close the selection.

PEARL OF

WISDOM

So far, everything we've drawn has been a crisp-edged selection. The only softening is due to antialiasing, which minimizes jagged transitions. But let's say that for purely aesthetic reasons, we think it'd be terrific if the area around the bottom of the photo that we have yet to select sported a blurry selection outline. We can apply the feathering you learned about in Step 6 of the last exercise, and do so on the fly by adjusting the polygonal lasso tool's Feather value as described below.

- 11. *Raise the Feather value in the options bar*. Click the **Feather** item in the options bar to highlight the value. Then type **6** and press Enter. Like most of the values in the options bar, this one has no influence over the existing selection; instead, it affects the next selection outline you create.
- 12. Increase the size of the image window. Size the window so that you can see a generous amount of light gray pasteboard around all sides of the image. (The dark gray background of the application window doesn't count.) The easiest way to see the pasteboard is to maximize the image window by clicking the □ icon in the top-right corner of the window. If necessary, you can also press Ctrl+ □ to zoom out.

Figure 6-36.

13. Select the main building with the polygonal lasso tool. Press the Shift key and click around the lowest elements of the building. To make sure you select everything, click outside the image in the light gray pasteboard, as illustrated in Figure 6-37.

Figure 6-37.

- 14. Send the selection to its own layer. Now let's set about transforming the background into the dark and stormy night that we promised at the outset of this exercise. With the entire building now selected, choose Layer→New→Layer via Copy or press Ctrl+J to send it to its own layer.
- 15. Select the Background layer in the Layers palette. Make sure the Layers panel is visible on the right side of the screen. (If it isn't, choose Window→Layers.) Then click the Background layer in the panel to make the lowest layer active.
- 16. *Lift some dark blue from the windows*. To make the dark and stormy night, we'll be using a filter that relies on the active foreground color. This means changing the foreground color to something dark and stormy, such as deep blue. Begin by selecting the eyedropper tool in the toolbox or pressing the I key. Then click a dark-blue pixel in one of the center windows in the cylindrical portion of the library. Elements updates the foreground color at the bottom of the toolbox; for now, nothing else changes.

- 17. Apply the Fibers filter. Choose Filter→Render→Fibers to open the Fibers dialog box. The Fibers filter draws rough vertical lines of color in the foreground and background colors. In our case, the dark blue and white create an effect similar to rain. The default values shown in Figure 6-38 are fine, so click **OK** to accept.
- 18. Apply the Difference Clouds filter. Press D to make sure the foreground and background colors are set to their default black and white, respectively. Choose Filter→Render→Difference Clouds to merge a cloud pattern into the Fibers rain and create a dark, nasty storm.
- 19. *Repeat Difference Clouds a few times*. Pressing **Ctrl+F** repeats the most recently applied filter. Each additional application of Difference Clouds inverts the background and applies more clouds. To achieve the effect pictured in Figure 6-39, press Ctrl+F five times in a row. Given the random nature of this filter, your results will look slightly different.

Rain rarely falls strictly in back of a building. But frankly, we like the look of the stormy sky when isolated to the background. We think it makes the library seem safer—more like a cozy, kooky, mad-scientist's hangout, the kind of place where you can curl up and read a scary book.

Figure 6-39.

The final lasso tool, the magnetic lasso, is one of the most amazing selection tools in Photoshop Elements' arsenal. No kidding—this tool can actually sense the edge of an object and trace it automatically, even when the contrast is low and the background colors vary. But as miraculous as this sounds, the magnetic lasso has never won the hearts and minds of Photoshop Elements users the way, say, the magic wand has. Why? Part of the reason is that it requires you to work too hard for your automation. Perhaps worse, the tool makes a lot of irritating mistakes, thereby requiring you to work *even harder* for your automation. Even so, the magnetic lasso can work wonders, especially when tracing highly complex edges set against evenly colored backgrounds.

To give it a whirl, select the magnetic lasso from the lasso tool flyout menu. As when using the polygonal lasso, click along the edge of the image element that you want to select to set a point. Next, move the cursor—no need to drag; the mouse button does not have to be pressed—around the image element. As you move, Elements automatically traces what it determines is the best edge and lays down square *anchor points*, which lock the line in place. In the figure below, we clicked the bottom-left corner of the library's trapezoidal roof and then moved the cursor up and around to the right.

Some other techniques:

- If the magnetic lasso traces an area incorrectly, trace back over the offending portion of the line to erase it. Again, just move your mouse; no need to press any buttons.
- Anchor points remain locked down even if you trace back over them. To remove the last anchor point—at any stage in the game—press the Backspace key.
- Elements continuously updates the magnetic lasso line until it lays down a point. To lock down the line manually, just click to create your own anchor point.
- Of the various options bar settings, the most useful is Width, which adjusts how close your cursor has to be to an edge to "see" it. Large values allow you to be sloppy; small values are great for working inside tight, highly detailed areas.

The best thing about the Width setting is that you can change it by pressing one of the bracket keys. While working with the magnetic lasso, press [] to make the Width value smaller; press [] to make it larger.

• Double-click or press Enter to complete the selection. You can also click the first point in the shape. Press the Esc key to cancel the selection.

Photoshop Elements' smartest lasso tool is clearly the most challenging to use. But it's usually worth the effort. And remember: you can always combine it with other tools.

Figure 6-40.

Source	ОК
Selection: Frog	Cance
Invert	Cance
Operation	
New Selection	

Figure 6-41.

Painting a Free-Form Selection

The next selection tool, the selection brush, offers two advantages over the ones we've looked at so far. First, for many of us, painting with a brush is easier than dragging with, say, a lasso. Painting gives you unique control over your selection outline, particularly if you're using a drawing tablet from Wacom or some other manufacturer.

The second advantage of the selection brush is that it simulates the more sophisticated *masking* functions of full-fledged Photoshop. Remember when we feathered the selection outline around the moon back in the "Using the Marquee Tools" exercise (see Step 11 on page 153)? As you may recall, the marching ants were incapable of accurately representing the soft-edged selection. Masking eschews marching ants for a translucent overlay; the overlay shows you varying degrees of selection by equating them to levels of transparency. If a pixel is completely selected, the overlay is transparent. Otherwise, the overlay becomes murkier and murkier as the selection fades away.

In this exercise, you'll use the selection brush both in the standard marching ants selection mode and in the mask mode to select a couple of objects in a layered image. You'll also see how Elements lets you save and load selection outlines—a tremendous time-saver should you ever need to select a complex object more than once.

1. Open a layered image. Open the file named My someday prince.psd, which is located in the Lesson 06 folder inside Lesson Files-PSE8 10n1.

Figure 6-40 shows a lovely blue poison arrow frog captured by Terry McGleish for iStockphoto. This document contains two layers. We'll begin with the image of the frog set against white on the top layer. You'll select this frog with the selection brush.

 Load a selection outline. We've already selected part of the frog to get you started. To load this selection, choose Select→Load Selection to display the dialog box in Figure 6-41. Make sure that Frog is active in the Selection pop-up menu. Also confirm that the Invert checkbox (which reverses the selection) is turned off, and then click OK. Elements draws marching ants around one front leg and one rear leg. Your task is to complete the job.

- 3. *Choose the selection brush.* Press the A key to choose the selection brush, which shares a flyout menu in the toolbox with the quick selection tool. You can also select the tool from the flyout menu (see Figure 6-42).
- 4. *Adjust the brush size*. You'll begin your frog selection by roughing in the frog's body. But you need a nice big brush. As Figure 6-43 shows, the selection brush offers its share of unique options in the options bar:
 - The Size option changes the diameter of the brush. Increase the **Size** to **40** pixels to get a nice big brush.
 - The Mode pop-up menu offers two options, Selection and Mask. Make sure it's set to **Selection**.
 - The Hardness value sets the sharpness of the brush. Make sure **Hardness** is set to **100** percent, which results in an antialiased brush. Like a roll of cheap toilet paper, it retains only the barest hint of softness.

You can resize the selection brush using the bracket keys. Press [] to shrink the brush or [] to make it bigger. Press Shift+[] to make the brush softer; press Shift+[] to make it harder. These shortcuts might seem odd, but as you saw in Lesson 5, "Paint, Edit, and Heal," they can be big time-savers.

Figure 6-43.

5. *Rough in the middle of the frog.* Press Ctrl+1 to zoom in to the 100 percent view size. Spacebar-drag to center the frog in the image window. Then paint a selection well inside the central portion of the frog's body, as in Figure 6-44. Right away, the selection brush behaves differently from the other selection tools. Even though you already have an active selection (the one you loaded in Step 2), there's no need to press the Shift key to add to it. The brush automatically operates in add mode.

If you accidentally paint outside the edges of the frog, you have two options for getting back inside the lines:

- Click the 🕅 button in the shortcuts bar or press Ctrl+Z to undo the last brush stroke.
- Press the Alt key and paint over the mistake. Alt puts the selection brush in subtract mode. So rather than painting over the area you want to select, Alt-drag to paint over the area you want to deselect.

WISDOM

For the best results, keep your brush strokes short and sweet. When you are engrossed in painting, it's tempting to paint away for several seconds at a time. Problem is, if you make a mistake at the end of such a long stroke, undoing takes you back to the very beginning and you lose all those seconds of work. Short strokes keep the loss to a minimum.

PEARL OF

Figure 6-45.

6. Paint around the edges of the amphibian's body. Now to home in and select those pesky edges. For that, you'll want to be closer. Press Ctrl+: to magnify the image to 200 percent. Then, press the : key twice to reduce the brush diameter to 20 pixels. Because the edges of the frog aren't razor-sharp, we need to soften the brush. Pressing Shift+: would lower the Hardness value in 25-percent increments, taking it down to 75 percent. That's too soft for these edges, so we recommend you click Hardness in the options bar and change the value to 90 percent.

Paint inside the perimeter of the frog. Don't leave any gaps between the already selected middle of the animal and its meandering edges. Leave the front leg deselected for now. And don't obsess about getting the outline super-smooth. He's a frog, after all; what do a few warts matter? When you finish, your selection should look something like the one pictured in Figure 6-45.

- 7. *Select the frog's leg.* Because the sides of the frog's foreleg—oh heck, let's call it a *forearm*—is reasonably straight, here's a trick for selecting it.
 - First, press the 🗋 key to reduce the diameter of the brush to 10 pixels.
 - Position your cursor as shown in the top window in Figure 6-46, making sure the edge of the cursor is along the upper edge of the frog's forearm. Click once to create a small circle of selection.
 - Move your cursor to the location indicated by the bottom window in the figure, and then Shift-click.

Photoshop Elements paints a straight stripe of selection. Shift-clicking always connects the last click point to the next one, so it's an easy way to create straightedged selections. Repeat this trick along the lower edge of the frog's forearm.

To paint the details of the frog's fingers, shrink the brush size to 6 pixels or so. Then continue painting until the entire outline of the frog is filled in. And don't forget to Shift-click like crazy. This guy's fingers are rife with straight segments.

- 8. Save the selection. After all the time you spent painting the frog selection, you owe it to yourself to save it. Choose Select→Save Selection. In the Save Selection dialog box, set the Selection option to Frog. Leave the Replace Selection option turned on and click OK. Elements replaces the partial selection that we drew for you with the full frog outline.
- 9. Delete the frog's background. The frog is selected. So to get rid of the background, we need to reverse the selection. Choose Select→Inverse or press Ctrl+Shift+I. If you're zoomed in on a detail of the frog, you'll swear nothing happened. But press Ctrl+i to zoom all the way out and you'll see those ants marching around the entire perimeter of the image. The frog outline now represents a hole in the selection.

Press the Backspace key to reveal the background beneath the Frog layer. Wishing and hoping below the blue critter is a dreamy-looking little girl photographed by Gisele Wright, once again available from iStockphoto.

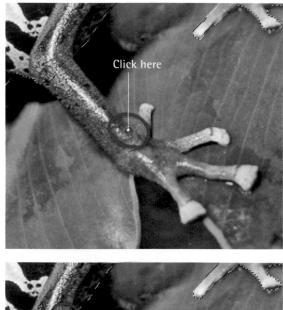

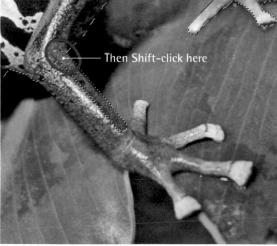

Figure 6-46.

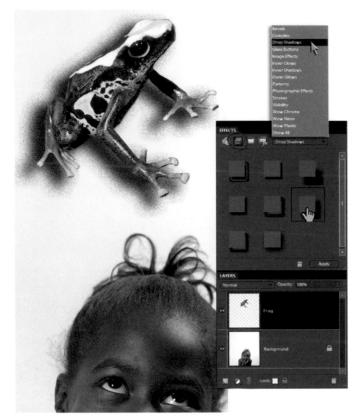

Figure 6-47.

PEARL OF

WISDON

In the Selection mode, you paint to select; in the Mask mode, you paint to deselect. So the red coating indicates an area that is not selected. The area outside the coating—where the rubylith is transparent—is selected. True to its name, a mask protects an image from harm and leaves the rest of the image vulnerable to edits.

- 10. *Give the frog a shadow*. Let's add a layer style to the frog to help it stand out from its brand-new off-white background. Choose **Select→Deselect** or press Ctrl+D to deselect the animal's empty background. Next, do the following:
 - Go to the **Effects** panel on the right side of the screen. (If the panel is missing, press the F7 key.)
 - Click the Layer Styles button (second button from the left under the Effects tab, circled in Figure 6-47).
 - Choose **Drop Shadows** from the pop-up menu.
 - Click the third thumbnail in the second row, **Noisy**, which will produce a diffused shadow appropriate for a magical frog.
 - Click **Apply** at the bottom of the Effects panel.

The result appears in Figure 6-47.

- 11. Switch to the Mask mode. Now let's shift to the Background layer and complete the design. Click the Background layer in the Layers panel or press Alt+[]. Next, change the Mode setting in the options bar to Mask. Although there's no immediate change to the image, the options bar gets two new options:
 - The Overlay Opacity setting determines the translucency of the masked areas. Unless you have some reason for changing it, leave this option set to 50 percent.
 - The Overlay Color option defines the color of the mask. The default red color harkens back to the precomputer days of publishing, when you masked photographs and other artwork by cutting red plastic sheets called *rubylith*. (To change the overlay color—say, if you were working with red items on a red background—click the color swatch and select another color.) For our purposes, red will do just fine.
- 12. *Paint inside the girl's outline*. Change the **Size** of the selection brush to 150 pixels. Then, paint inside the girl's face and body, taking care to stay well within the lines. As you do so, you lay down a translucent coating of red. Fair enough, but what the heck is going on?

As in the Selection mode, holding down the Alt key reverses the tool. Therefore, if you find yourself painting outside the boundary of the girl, you can Alt-drag with the brush to erase the mask.

- 13. *Paint around the perimeter of the girl.* Now to get in and brush those edges. We won't lie to you; this takes some skill and determination, and your mask may come out looking a little different than ours. But we can offer some pointers:
 - When filling in the girl's arms and shoulders, try shifting to a smaller, softer brush. Press the 🗋 key several times to reduce the diameter of the brush to 50 pixels or so. The focus on the girl is pretty soft, so press Shift+[] once to lower the **Hardness** value to 75 percent.
 - Before tracing her ears, decrease the **Size** value even further, to about 20 pixels.
 - We want a nice, soft outline around the girl's scalp. So for her hair, decrease the **Hardness** value another notch to 50 percent.

As you'll no doubt be happy to hear, you can skip the tendrils of hair sticking up from the top of her head because the next step eliminates any need to accurately select them. So when you finish your mask, it should look vaguely similar to the one in Figure 6-48.

14. Paint a thought balloon. The next step is to use the Mask mode's unique selection-display ability to paint a dreamy thought balloon behind the girl's head. In the options bar, take the Hardness value all the way down to 0 and increase the brush Size to 300 pixels. Scrub over the frog and the protruding strands of the girl's hair to mask those areas completely. Then paint a cloud-like balloon over and behind the girl's head, as in Figure 6-49. Yours doesn't have to look exactly like this one; let your artistic muse be your guide.

PEARL OF

WISDOM

Just to reiterate: although you can create a soft-edged selection with the marquee, lasso, or wand, the narrow-minded marching ants fail utterly at *showing* softness. Only the selection brush and its Mask mode let you see the soft edges as you create them.

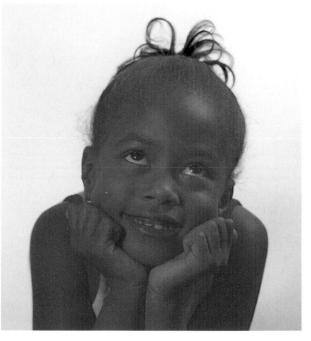

Figure 6-48.

Figure 6-49.

Figure 6-50.

- 15. *Hide the overlay.* Choose View→Selection or press Ctrl+H to hide the red overlay so you can better see the results of the next step.
- 16. *Fill the selection with blue*. Choose **Edit→Fill Selection** or press Shift+Backspace to display the **Fill Layer** dialog box. Then do the following:
 - Choose Color from the Use pop-up menu. Change the H, S, and B values to 220, 50, and 90, respectively. Then click OK.
 - Set the **Mode** option to **Multiply**, and then click **OK**. The blue merges with the back-ground inside the selected portions of the Background layer, as in Figure 6-50.
- 17. Save your newest selection. Now that you've spent all that time working on this wonderful mask, you might as well save it. Choose Select→Save Selection, which lets you save a selection, regardless of what form it's in. Leave the Selection option set to New, enter "Girl and balloon" in the Name field, and click OK. This image now has two saved selection outlines, which you can load and use again at any time simply by choosing Select→Load Selection.

Quick Selection and Refine Edge

Adobe is slow to add selection tools. Seventeen years after introducing the world to the magic wand, it ushered in two new features to full-fledged Photoshop, which in turn passed versions down to Photoshop Elements. The first of these is the speciously named quick selection tool. (Little about its performance suggests that you'll complete your selection chores faster.) In contrast to the magic wand, the *quick selection tool* is sensitive not to color ranges but to *edges*, which are sudden transitions from dark to light. Paint inside the element you want to select, and Photoshop Elements grows the selection outline to what it considers to be the outlying edges of that element.

The quick selection tool is just okay by us. It's easy enough to use that you don't need our help to figure it out, and there's not much advice we can offer for improving its less-than-ideal results. It's here in this exercise primarily as a preamble to another recent selection innovation—one that's very useful called *Refine Edge*. This more complicated but equally more powerful command allows you to edit any selection outline and see the results of your edits in a couple of ways as you apply them. Even the slightly scaled-down version of Refine Edge that comes with Elements is pretty handy.

- 1. *Open two images.* Open the files named *Sun-flowers.tif* and *Storm clouds.psd*, both of which are located in the *Lesson 06* folder inside *Lesson Files-PSE 10n1*. Figure 6-51 shows the photographs captured by Lee Pettet (flowers) and Kevin Russ (clouds), again care of iStockphoto.
- 2. *Choose the quick selection tool from the toolhox.* Thanks to the wispy clouds and sliver of ground, the selection brush tool is poorly suited to selecting the sunflowers. So choose the more powerful selection brush, the quick selection tool, from the flyout menu shown in Figure 6-52.
- 3. *Increase the brush size*. The default brush size is a bit small for our purposes. Press the 🗋 key three times to increase the cursor size to 30 pixels.
- Click in the image. Click once at the position in the larger sunflower illustrated in the left half of Figure 6-53. A selection outline appears, complete with marching

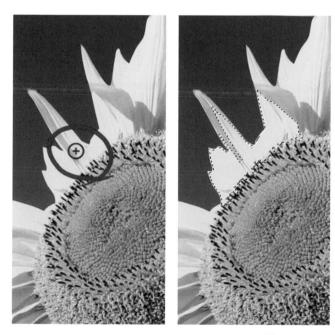

Figure 6-53.

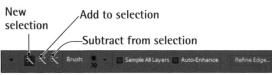

Figure 6-54.

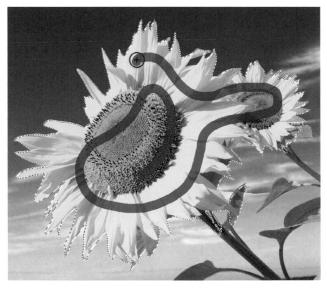

Figure 6-55.

ants, as in the right half of the figure. (If your selection looks different than ours, it's because you clicked in a slightly different location. In any case, don't worry about it. We'll all achieve the same results before the exercise is over.) The selection is very similar, if not identical, to what you would get had you clicked with the magic wand tool. Not bad for a start, but let's educate Elements a little further.

5. *Paint inside the sunflowers.* After you use the quick selection tool to make a selection, the tool automatically switches to the *add mode*, meaning that more brushing adds to the selection calculation. This is confirmed by a glance at the options bar, which shows that icon has switched to the ^[S] icon (labeled "Add to selection" in Figure 6-54).

Paint a swirly brush stroke inside the yellow parts of the two sunflowers, roughly following the red path in Figure 6-55, and then release the mouse button. As you move over the flowers, Elements expands the selection to roughly what you see in the figure. You should be able to grab most of the yellow areas (as well as a stray green one or two) this way.

6. *Paint in the stalks and leaves.* Now to select the green areas (and any stubborn yellow ones). Press the 🗋 key a few times to shrink the size of the brush so you can get to the slender areas. Some of the stems require a brush as small as 5 pixels. For delicate details like these, try single clicks and see how much of the stem areas Elements catches up in the selection.

However you get there, keep painting until all the yellow and green areas of the flowers appear inside the selection. Don't fret that you select some sky in the process; we'll address that in the next step.

To help pinpoint your strokes in small areas, press the Caps Lock key, which changes the cursor to a crosshair, known as the *precise cursor*. (Just be sure to turn off Caps Lock when you're finished, because it affects *all* cursors.) If you accidentally paint into the blue sky, press Ctrl+Z to undo the last stroke.

7. *Paint away the sky.* With any luck, the main region of the sky that surrounds the flowers and stalks remains deselected, and that's a good thing. But lots of little patches of blue are peeking out between the various leaves and stems, and those need to be de-

selected too. Thus far, the quick selection tool can't tell the difference between those blue sky patches and the green stalks, so you'll have to show it.

To paint away the background, click the 🕅 icon in the options bar (labeled "Subtract from selection" in Figure 6-54). The cursor now also sports a minus in the middle, as you can see in Figure 6-56. Next, click in the selected pockets of sky to deselect them.

There are more than a dozen little patches of sky,

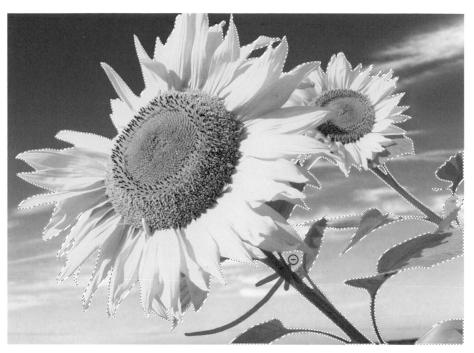

including a couple near the top of the image between the yellow petals, so take care to get them all. Zoom in if necessary to see detail. In the end, your selection outline should look like the one in Figure 6-56.

- 8. Click the Refine Edge button Okay, quick selection is either going to be quick-and-sloppy or not-so-very-quick and still somewhat flawed. In truth, it's fairly crude, but the Refine Edge command can help. When you have the quick selection or magic wand tool active, the Refine Edge button will be available in the options bar. (For other selections, it's available via Select→Refine Edge.) Click the button to display the dialog box shown in Figure 6-57.
- 9. *Preview the selection with a colored overlay.* First, turn your attention to the bottom half of the Refine Edge dialog box and the two "Möbius tube" (*D*) icons above the Description item. Clicking an icon changes your preview of the selection in the image window. Choose the second one, which puts a colored overlay over all the parts of the image that are outside your selection.

You can change the color and opacity of the overlay by double-clicking on the icon. From there, double-click the color swatch and set a new one from the Color Picker. Set the opacity by entering your desired percentage. The default of red at 50 percent works fine for this exercise.

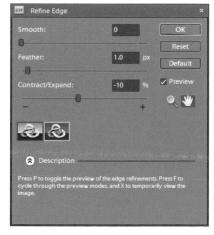

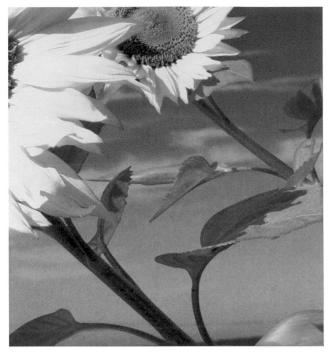

Figure 6-58.

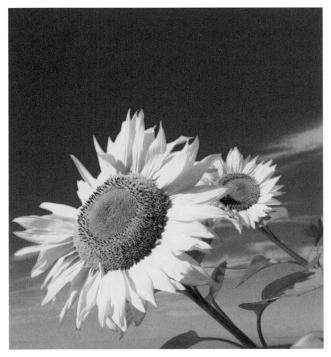

Figure 6-59.

- 10. *Turn off and on the preview*. Speaking of the **Preview** checkbox, turn it off or press the P key. You are now looking at the selection outline the way it really is, as created by the quick selection tool. Turn the **Preview** option back on. Notice that with the default settings the refined edge will contract the selection (as indicated by the increase in the orange—created by red overlaying green—encroaching into the leaves and stems, as you can see in Figure 6-58).
- 11. *Adjust the settings.* The goal here is to contract the selection so that there is no blue-sky outline around the flower, leaves, or stems when we move the flower to the storm cloud background. The following settings will help our cause:
 - The Smooth slider allows you to reduce the jagged edges of your selection. Because it rounds off corners and we want to keep the sharp edges of the petals and leaves, set **Smooth** to **0**.
 - The Feather setting creates the blurry no-man'sland in which the next setting can operate. We need some room, but again we don't want our edges to get too soft, so set the **Feather** to **1** pixel.
 - The Contract/Expand slider allows you to constrict or spread your selection. If you move this slider all the way to the left, you'll see that the red overlay invades the selection to the point of choking off the stems. If you move it all the way to the right, you can see a rim of blue sky appear all around the flower. We want to err on the side of removing as much sky as possible without enfeebling the flower, so set Contract/ Expand to –10.

The final preview is shown in Figure 6-59. It may seem a little bit of an encroachment of the mask into our flower, but the key is to remove any tell-tale blue sky from the background that will be distracting when we move to our new stormy setting. In this case, the flowers have variegated edges anyway, so it's an easier place to "cheat." Click **OK**.

12. *Drag the sunflowers to the storm clouds*. Make sure you can get to the *Storm clouds.psd* file, either

via its tab at the top of the consolidated image window or in a window of its own, depending on your view preference. Next, press the **Ctrl** key and drag the selected flowers into the *Storm clouds.psd* image window. No need to press the Shift key this time; just drop them any old place. Then Ctrl-drag the sunflowers so the bottom-right corner of the flowers snap into alignment with the bottom-right corner of the clouds, as in Figure 6-60.

- 13. *Paint the stalks with a gradient.* The lighting of the flowers is all wrong for their new background. But we can make it better—and eliminate any remaining blue edges around the stalks—by adding a gradient. Illustrated by the numbered items in Figure 6-61, hcrc's how the process works:
 - Go to the Layers panel and click the a icon to the right of the word Lock (labeled
 On the right side of Figure 6-61). This

Figure 6-60.

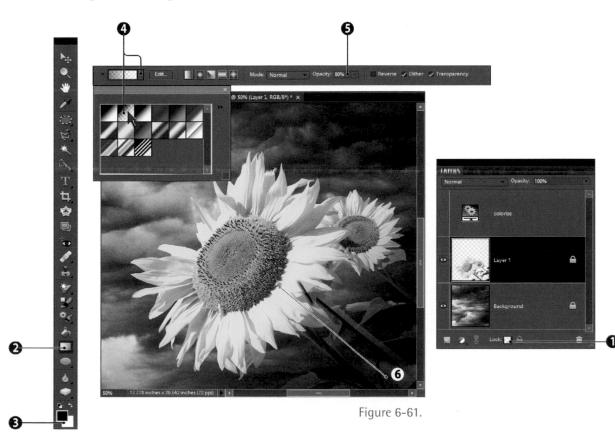

locks the transparency of the layer, which prevents you from painting outside the edges of the flowers. (You can also press the D key.)

- Select the gradient tool from the toolbox (2). The shortcut for the gradient tool is G.
- Press the D key or click the bicon (3) to restore the default foreground and background colors, black and white. (These are the global foreground and background colors, not the ones that govern the magic selection brush.)
- Go to the options bar and click the arrow to the left of the Edit button to display a pop-up panel of gradient styles. Select the second thumbnail, the one that flows from black to a checkerboard pattern (④). This loads the gradient tool with a foreground-to-transparent gradient. In this case, it's black-to-transparent.
- Press Enter to hide the panel. Press the 8 key to lower the Opacity setting for the gradient tool to 80 percent (6).
- Drag from the bottom-right corner of the *Storm clouds.jpg* image window up and to the left, until you reach the right-hand petals of the large flower (labeled **③** in the figure).

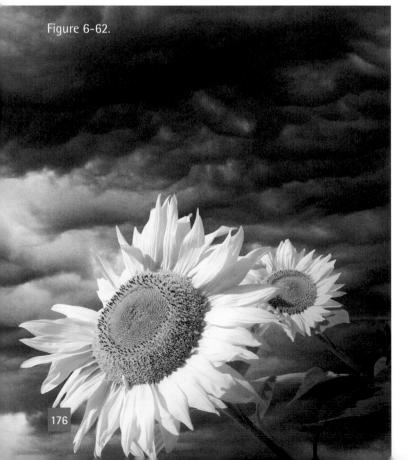

The stalks are now shaded to match their stormy backdrop. But the bright yellow flowers still look out of place. Rather miraculously, you'll fix this problem with one click.

14. *Turn on the Colorize layer*. See that top layer in the Layers panel? Click in the box to the left of the layer name to display the [⊕] icon and reveal the contents of the **Colorize** layer in the image window. This special adjustment layer colorizes the contents of all layers below it, thereby binding sunflowers and clouds with a common color scheme.

Displayed in Figure 6-62, the effect is fairly spectacular. But lest you get the wrong impression about the quick selection tool, we hasten to note that the *Sunflower.tif* image is just about as perfect a subject for the tool as one could hope for: a well-defined foreground set against a smoothly transitioning, differently colored background. And yet, it's still not exactly a "quick" or simple process.

WHAT DID YOU LEARN?

Match the key concept in the numbered list below with the letter of the phrase that best describes it. Answers appear upside-down at the bottom of the page.

Key Concepts

Descriptions

- 1. Magic wand
- 2. Tolerance
- 3. Grow
- 4. Similar
- 5. Haloing
- 6. Antialiasing
- 7. Inverse
- 8. Feather
- 9. Polygonal lasso
- 10. Mask
- 11. Lock transparency
- 12. Refine Edge

- A. This command allows you to apply fine-tuned smoothing, feathering, and contracting/expanding of a selection made by another selection tool.
- B. This command selects currently deselected pixels and deselects currently selected pixels.
- C. This term describes a fringe of background color around a selected object; the Magic Extractor command's Defringe option helps climinate the problem.
- D. This command expands the range of a selection to include additional adjacent pixels.
- E. The 🖾 icon near the top of the Layers panel that protects the transparent pixels in a layer—ensuring that you paint and modify only those pixels that fall inside the edges of the layered element.
- F. This tool enables you to select free-form, straight-sided areas in an image.
- G. This command blurs the edges of a selection outline to create fuzzy transitions.
- H. A setting in the options bar that determines how many colors the magic wand selects at a time, as measured in luminosity values.
- I. A tool that selects regions of color inside an image.
- J. This command expands the range of a selection to include additional nonadjacent pixels.
- K. A very slight softening effect applied to selection outlines to simulate smooth transitions.
- L. This selection brush mode uses a translucent overlay to show you varying degrees of selection by equating them to levels of transparency.

Answers

11' 5H' 3D' 4l' 2C' 9K' 2B' 8C' 6E' 10F' 11E' 15V

FILTERS AND DISTORTIONS

PHOTOSHOP ELEMENTS offers more than a hundred *filters*. Named for the interchangeable camera lenses once commonly used to adjust and tint a scene before it was captured on film, Elements' filters permit you to modify the focus, color, and overall appearance of an image long after it is captured.

But while this group of commands derives its moniker from traditional filters, one bears little if any resemblance to the other. In fact, comparing Elements' filters to *anything* is an exercise in futility. Some filters modify the contrast of neighboring pixels, others trace the contours of a photograph, and still others deform an image by moving pixels to new locations. (See Figure 7-1 for examples.) And that's just some of them. If we had to come up with a definition for filters, we would call them a loosely associated collection of

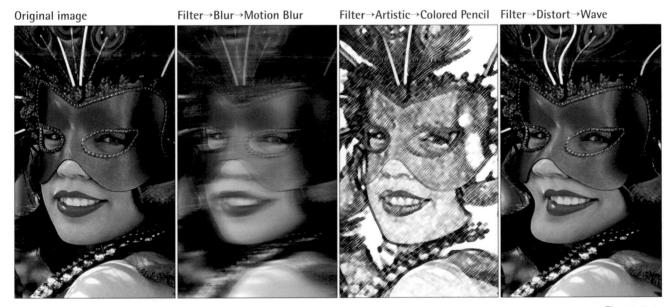

Figure 7-1.

ABOUT THIS LESSON

Project Files

Before beginning the exercises, make sure you've downloaded the lesson files from *www.oreilly.com/go/deke-PSE8*, as directed in Step 2 on page xiv of the Preface. This means you should have a folder called *Lesson Files-PSE8 10n1* on your desktop (or whatever location you chose). We'll be working with the files inside the *Lesson 07* subfolder. In this lesson, we explain how to modify the perceived focus of a photograph, apply effects filters, and apply free-form distortions. You'll learn how to:

	Amplify the edge detail in an image using the Adjust Sharpness filter
0	Use the Radius value and High Pass filter to achieve the best possible sharpening effect page 187
	Experiment with multiple effects filters in the Filter Gallery dialog box

• Change the shape of eyes, jaw lines, and other facial features using the Liquify command page 197

The Filter menu offers access to just over 100 commands. Known generically as *filters*, these commands range from extremely practical to wonderfully frivolous. In this lesson, Deke shares some of the best of the filters, including those that let you sharpen an image, add special effects, and apply complex, transformative distortions.

You can either watch the video lesson online or download to view at your leisure by going to *www. oreilly.com/go/deke-PSE8.* During the video, you'll learn about the keyboard equivalents and shortcuts listed below.

Command or operation Hide or display the Effects panel Hide or show the thumbnails in the Filter Gallery Add effect inside Filter Gallery window Adjust selected value incrementally Adjust selected value by 10× the increment Duplicate (jump) image to an independent layer Reapply last-applied filter (with different settings) Change the Opacity setting of the active layer

Keyboard equivalent or shortcut F7 click \circledast or \circledast button click \blacksquare icon in bottom-right corner \uparrow or \downarrow Shift+ \uparrow or \downarrow Ctrl+J Ctrl+F (Ctrl+Alt+F) 1, 2, 3, ..., 0 commands—some easy to use, others quite complex—that apply effects to an image and reside in both the Filter menu and the Filters section of the Styles and Effects panels. Otherwise, filters are as varied as they are abundant.

This lesson makes no attempt to introduce you to all the filters in Photoshop Elements or even a broad cross section of them. Either task would consume an entire book—and not a particularly helpful one at that. For one thing, filters are too unpredictable in approach, implementation, and quality to warrant that sort of attention. More to the point, you can learn most of what you need through experimentation. Choose a command, adjust a few slider bars, apply the filter, and see how it looks.

For example, open a picture of a person's face. Choose Filter \rightarrow Distort \rightarrow Pinch. Set the Amount value to 50 percent and click OK. Admire the goofy effect for a moment or two. Then press Ctrl+Z to undo the filter. Suddenly, the original face (which once looked fine) appears downright swollen. For extra fun, reapply Pinch with a negative value to bulge the face further (see Figure 7-2).

As parlor tricks, filters rate high marks. But as a rule, they tend to be better timewasters than tools. So for the sake of expediency, we'll spend this lesson homing in on a handful of representative filters

that serve a practical or creative purpose. Before you read on, take a few minutes to watch Video Lesson 7, "Filtering Basics" (as explained on the facing page). It'll give you a sense of how filters work and how to make the most of your experimentation.

The Subterfuge of Sharpness

The most useful filters in Photoshop Elements are devoted to the task of adjusting focus. If you think that sounds a bit far-fetched, you're right. After all, the focus of an image is defined when it is formed by the camera lens. The moment you press the shutter release, you accept that focus and store it as a permanent attribute of the photograph. If the photograph is slightly out of focus, it stays out of focus. No post-processing solution can build more clearly

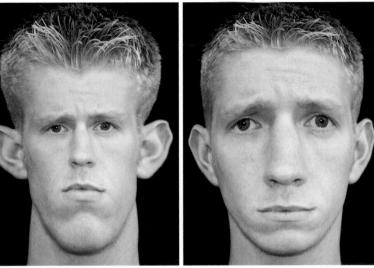

Undo, Pinch again: -30%

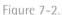

defined edges than what the camera actually captured, or fill in missing or murky detail.

So how does Elements adjust focus? It fakes it. Although the program can't reach back into your camera and modify the lens element for a better shot, it can simulate worse or better focus. It can compare neighboring pixels to enhance or impair the edges inside an image. Your eyes think they see a differently focused image, but really they see an exaggerated version of the focus that was already there.

Consider the photos in Figure 7-3. The first is a detail from a highresolution image that was shot to film and then scanned. The focus is impeccable, but even so, you can make out film grain in the magnified inset. The second and third images show variations imposed by Photoshop Elements. Softening blurs the pixels together; sharpening exaggerates the edges. Softening bears a strong resemblance to what happens when an image is out of focus. Sharpening is a contrast trick that exploits the way our brains perceive definition, particularly with respect to distant or otherwise vague objects. A highly defined edge with sharp transitions between light and dark tells us where an object begins and ends.

This is not to impugn Elements' sharpening capabilities. Photography itself is a trick that simulates reality, specifically geared to the human eye and brain. If Elements' sharpening augments that trick, more power to it. We just want you to know what you're

Figure 7-3.

doing. After all, magicians who knows their bag of tricks are better equipped to perform magic.

Sharpening an Image

There are two sharpening filters in Elements, Unsharp Mask and Adjust Sharpness, both of which were moved, sometime around Photoshop Elements 5, out of the Filters menu and into the Enhance menu where they live now. But trust us: they are filters, inasmuch as a filter can be defined as something that uses surrounding pixel information to change the appearance of your image.

The older feature, Unsharp Mask, derives its name from an old and largely abandoned traditional darkroom technique in which a photographic negative was sandwiched together with a blurred, low-contrast positive of itself and printed to photographic paper. This blurred positive (the "unsharp" mask) traced shadows around the dark edges and bright halos around the light edges. As a result, the process accentuated the edges in the original image, resulting in the perception of increased sharpness.

To see how Unsharp Mask's arcane origins translate to the way Elements' sophisticated sharpening functions work, read the upcoming sidebar "Using Blur to Sharpen" on page 188.

But Unsharp Mask is no longer the only, or even the most preferable, sharpening tool in town. These days, Unsharp Mask takes a back seat to Adjust Sharpness, which is why we'll focus exclusively on Adjust Sharpness in this exercise.

1. Open a soft image. Go to the Lesson 07 folder inside Lesson Files-PSE8 1on1 and you'll find a photo of an unconscious young tabby, Sleepy kitten.jpg (see Figure 7-4). The kitten was asleep in a pen, so Deke had to position the camera lens between links in the surrounding fence. The image is soft, and we don't mean that because of the adorable cuddly ball of fur that is its subject; it's technically soft, meaning it's a little off from its ideal focus, most likely a function of moving the camera after focusing it.

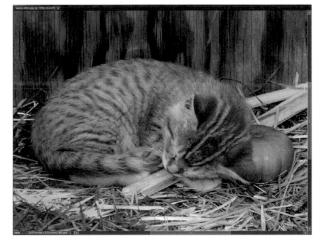

Figure 7-4.

- 2. *Choose the Adjust Sharpness command*. As we noted earlier, the sharpening tools no longer live with the rest of the filters. From the menu bar, choose Enhance→Adjust Sharpness.
- 3. *Turn on the Preview checkbox*. Pictured in Figure 7-5, the Adjust Sharpness dialog box includes a cropped preview of the effect inside the dialog box. When the **Preview** checkbox is on, Elements applies the effect in real time to the larger image window as well.

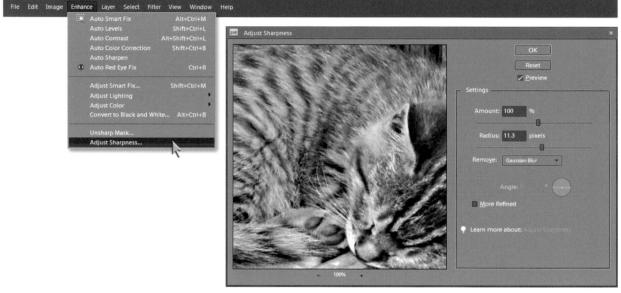

Figure 7-5.

As elsewhere in Photoshop Elements, the Preview checkbox is an essential tool for gauging the results of your numerical settings. We can think of only two reasons to turn off Preview: first, if you want to compare before-and-after versions of an image, and second, if you're working on a very large image and your computer just can't keep up with your changes.

WISDOM

PEARL OF

- 4. *Click in the image window.* In the main image window, click the cat's forward-facing paw to center the preview inside the dialog box. You want to center on some detail that you'd like to bring into sharper focus. Drag inside the preview box to further adjust the view if necessary.
- 5. *Set the views to different zoom ratios.* Set the image window to the 100 percent view size and the preview to 50 percent, or vice versa. This way, you have two views into the results of your changes.

Why 100 and 50 percent? Because the first shows you every pixel in the image, and the other more closely represents the image as it appears when printed (which packs more pixels into a smaller space). Also worth noting, 50 percent is an interpolated zoom, meaning that Elements properly smooths over pixel transitions. By comparison, odd zooms such as 67 and 33 percent are jagged and misleading.

- 6. Set Remove to Lens Blur. The default setting for the Remove option— Gaussian Blur, which highlights edges in gradual, circular patterns duplicates the behavior of the old Unsharp Mask filter. Serviceable to be sure, but the Lens Blur setting enjoys a higher degree of accuracy and is better suited to reversing the effects of soft focus, particularly in digital photography (and the lenses used therein).
- 7. *Raise the Amount value*. Raise the **Amount** value to 300 percent. This is a temporary value that merely exaggerates the effect and permits us to see what we're doing.
- 8. *Specify a Radius value*. Even though **Radius** is the second value, we recommend you start with it, because it's the hinge pin of the sharpening operation. Like Unsharp Mask before it, Adjust Sharpness simulates sharper edges by drawing halos around the edges (see the sidebar "Using Blur to Sharpen" on page 188). The Radius value defines the thickness of those halos. Thin halos result in a precise edge; thick halos result in a more generalized high-contrast effect. Figure 7-6 shows some examples.

For everyday sharpening, the best Radius value is the one you can barely see. This value varies depending on how your final image will be viewed:

- If you intend to display the image on-screen (say, for a web page or projected presentation), enter a very small value, such as 0.5 pixel.
- For medium-resolution printing, a Radius of 1.0 to 2.0 pixels tends to work best.
- For high-resolution printing, try a Radius between 2.0 and 4.0 pixels.

The examples in Figure 7-6 were printed at 280 pixels per inch, so the 2.5-pixel Radius delivers the best edges. A smaller Radius value most likely looks better on your screen, but for now pretend you're going to print the image, and enter a **Radius** value of **2.5**.

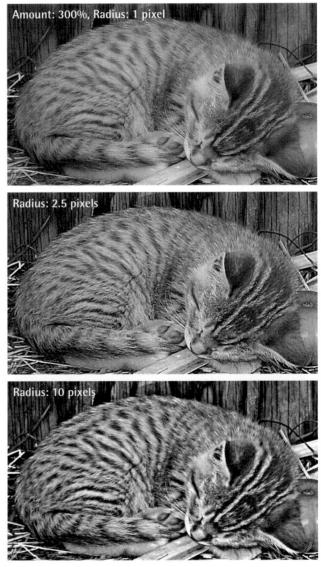

Figure 7-6.

9. Lower the Amount value. The Amount value controls the degree to which the image gets sharpened. Higher Amount values result in more crisply defined edges. The effects of the Amount value become more pronounced at higher Radius values as well. So where 300 percent may look dandy with a Radius of 1 pixel, the image may appear jagged and noisy at a Radius of 2.5. An image set to too high an Amount value is said to be oversharpened, as is presently the case for our tabby.

Press Shift+Tab to highlight the Amount value. Then press Shift+ \downarrow a few times in a row to nudge the value down in increments of 10 percent. Figure 7-7 shows where we started, and what we think is the best fit at **150** percent.

Figure 7-7.

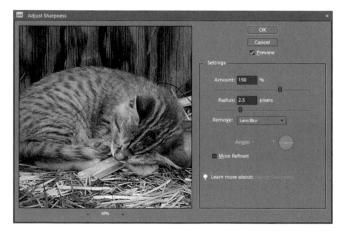

Figure 7-8.

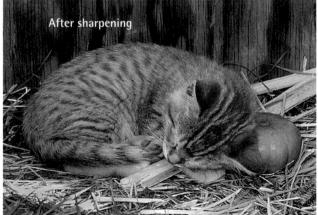

- 10. Leave the More Refined value turned off. If you were to turn it this checkbox on, you'd be riddling your kitten with an extra layer of sharpness, which isn't what we're looking for. For some high-resolution, low-noise images from high-end cameras, this might give you a desirable effect, but most of the time (especially with portraits, by the way) leave it alone.
- 11. *Click the OK button*. Confirm that your values match those in Figure 7-8. Turn on and off the **Preview** checkbox to see how far you've come (or for some filters, like this one, you can click and hold in the dialog box preview window). And then click **OK** to apply the filter.
- 12. *Save your image*. If you like, save this cuddly but sharp creature by pressing **Ctrl+Shift+S**.

Creating Sharpness with the Emboss Filter

For the next exercise, we'll use an official Photoshop Elements filter (meaning it still lives in the Filters menu) to solve a more problematic focus issue. Let's just set the scene: When Deke shot the picture of the kitten, he was on a farm with an army of enthusiastic preschoolers. Unfortunately, his companions would, without warning, grab the fence and shake it until their mothers made them stop. When he captured the first photo, the fence was in between shakes. Not so lucky on the second photo—Deke got smacked.

So, this second image, shown in Figure 7-9, looks blurred because the camera was moving when he took the shot. The kind of blur and degree of blurriness determine how we approach the images and just how much good we can do.

- 1. Open a blurry image. Open Sloppy kitten. jpg from the Lesson 07 folder inside Lesson Files-PSE8 10n1. In Figure 7-9, you once again see our sleepy kitty, this time clearly not just soft, but completely out of focus.
- 2. Display the Unsharp Mask dialog box. To see what a conventional sharpening tool can do for this image, choose Enhance→Unsharp Mask. You'll see a dialog box vaguely reminiscent of the one we saw for Adjust Sharpening in the last exercise.
- 3. *Raise the Amount value*. This image requires more sharpening than the first one. So click **Amount** in the **Unsharp Mask** dialog box and then press Shift+↑ several times to increase the value in 10-percent increments. This adds to the sharpness of the image, but it also brings out more of the diagonal lines of noise associated with the motion blur, as shown in Figure 7-10.

An Amount of 200 percent gets the image as close to focused as we can reasonably expect. Increasing the Radius value doesn't really help. This is as good as it gets.

4. *Cancel out of the dialog box.* But let's say this isn't good enough. Let's say this is your *only* picture of this cute little kitten sleeping on a pumpkin and you're bound and determined to make it the best you possibly can. In that case, press the **Esc** key and kiss Unsharp Mask goodbye. Turns out that there is another way.

Figure 7-9.

187

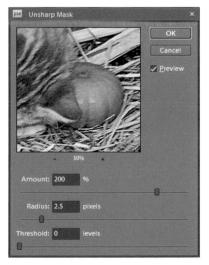

Figure 7-10.

Using Blur to Sharpen

The "unsharp" in Unsharp Mask is a function of the softly tapering halo applied by the Radius value. Understand this and you can master the art of focus in Photoshop Elements.

Consider the line art in the figure below. The top-left example features dark lines against a light background. The other three images are sharpened with increasingly higher Radius values. (Throughout, the Amount value is set to 200 percent.) In each case, the Unsharp Mask filter traces the dark areas inside the lines (the brown areas) with a blurry dark halo and the light areas outside the lines (the green areas) with a blurry light halo. The thickness of these halos conforms to the Radius value. So all Unsharp Mask does is increase the contrast by tracing halos around edges. Given that the Radius value is all about blurring, it's no surprise that this option also appears in the Gaussian Blur dialog box (Filter \rightarrow Blur \rightarrow Gaussian Blur), where it once again generates halos around edges. In fact, if we were to trace the lineage of these filters, we would find that Gaussian Blur is Unsharp Mask's grandparent. The missing family member in between is an obscure command called High Pass.

Why should you care? Because Unsharp Mask's parent, High Pass, is a more flexible sharpening agent than its progeny.

Try this: Go ahead and open *Sleepy kitten.jpg*. (If it's still open from the "Sharpening an Image" exercise, choose Edit→Revert to revert the image to its original appearance.) Now press

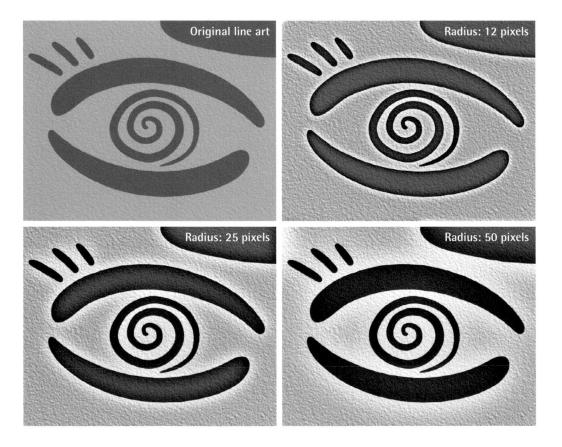

Ctrl+J to copy the image to an independent layer. Next, choose Filter \rightarrow Other \rightarrow High Pass. Pictured below, the High Pass dialog box contains a single option, Radius. Change this value to 2.5 pixels, the same Radius you applied in the exercise using Unsharp Mask. Then click OK.

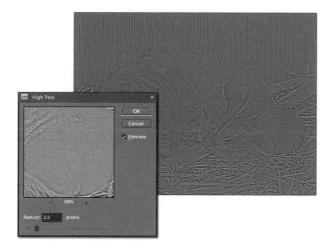

Looks like a big mess of gray, right? But there are tenuous edges in there. To bring them out, press Ctrl+L or choose Enhance→Adjust Lighting→Levels to display the Levels dialog box. Change the first and third Input Levels values to 75 and 180, respectively, as in the figure below. Then click OK.

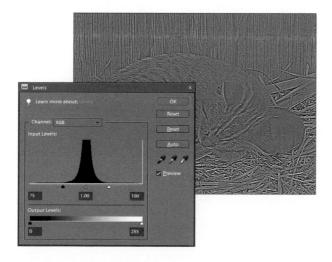

Still looks terrible. But what you're looking at are the very same light and dark halos that Unsharp Mask creates. To apply those halos to the original photograph, go to the Layers panel and choose Overlay from the top-left pop-up menu. Just like that, Photoshop Elements drops out the grays, blends in the edges, and makes it all better, as shown below. The result is almost exactly what you'd get if you applied Unsharp Mask with a Radius of 2.5 and an Amount of 200 percent. (In other words, the current High Pass layer is twice as strong as the equivalent Unsharp Mask.) This means that the photograph is oversharpened, just as it was at the outset of Step 9 on page 186. To match the more pleasing Amount value of 100 percent that we eventually settled on in the exercise, reduce the layer's Opacity setting to 50 percent.

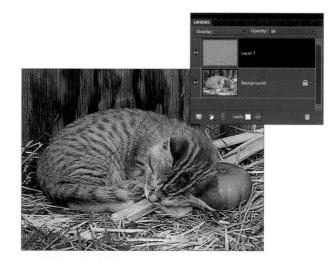

Why go through all this just to get the same effect we achieved in the exercise? Because now you have a floating layer of sharpness whose Amount you can change at any time just by modifying the layer's Opacity setting. This means you can change your mind well into the future, as opposed to being locked into the static result of Unsharp Mask. Sure, it's an unusual approach, and it takes a bit of experience to get it down pat. But the additional flexibility you gain is well worth the effort.

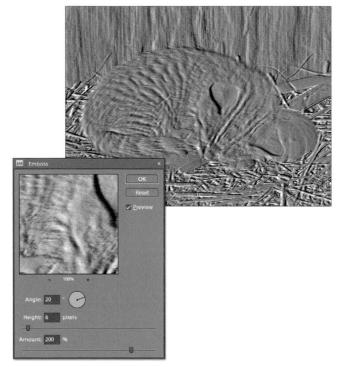

Figure 7-11.

Figure 7-12.

- 5. *Duplicate the image to a new layer.* Press Ctrl+J to jump the image to a new layer.
- 6. *Choose the Emboss command*. Unsharp Mask has many relatives. For example, it has a close cousin that's adept at removing motion blur (though you wouldn't know it to look at it). To access this virtuous cousin, choose Filter→Stylize→Emboss.
- 7. *Adjust the settings and apply the filter.* As you'll see in the preview, the Emboss command etches an image in gray relief. It looks a bit ugly and anything but sharp. But suspend disbelief and imagine the grays dropping away. Then apply these settings:
 - Your first task is to match the angle of the motion blur inherent in the image. We found that an **Angle** value of **20** degrees came closest.
 - Height is analogous to the Unsharp Mask command's Radius value. Set it to 6 pixels.
 - Amount is Amount. Make it 200 percent.

Click the **OK** button. The result appears in Figure 7-11. Looks awful. But as with the High Pass filter (see page 189), all we care about is how the edges look. And the edges look great.

8. Set the blend mode to Overlay. Go to the Layers panel and select Overlay from the first pop-up menu. Or press Shift+Alt+O. The grays drop away, leaving just the directional edges. Press the Esc key and then press 8 to reduce the Opacity value to 80 percent. The result appears in Figure 7-12.

EARL OF

WISDOM

We like using the Emboss method here, but yes, you can use Adjust Sharpness and its Motion Blur setting to get a similar effect. Choose Enhance→Adjust Sharpness. In addition to setting the Remove to Motion Blur, enter a Radius of twice the Height you used for the Emboss filter (so, 12 pixels), an Angle of 20 degrees, and an Amount of 200.

To get a feel for the difference, turn on and off the ^(*) in front of Layer 1 in the Layers panel. Not satisfied? Then grab your camera, go back to that farm, and try your best to talk the kitten into sleeping on that pumpkin just one more time.

Playing with the Filter Gallery

The Filter Gallery is a cluster of special effects filters that you can mix and match inside a single dialog box before applying them. Fewer than half of the hundred or so filters in Elements qualify for inclusion in the Filter Gallery. Many of these effects are *media filters*, meaning they try to make your digital photos look like drawings and paintings created with traditional tools such as chalk, charcoal, or watercolor. But the best thing about the Filter Gallery is that it lets you apply multiple filters in sequence, and even juggle the order in which the filters are applied, all from a central location. The order in which you apply filters can make a big difference in the final result, and with the Filter Gallery, you can experiment until you're satisfied.

In this exercise, you're going to work on another orange kitty cat—this one a ferocious Bengal tiger. You'll maneuver through the Filter Gallery and combine its media filters to construct a unique and foreboding effect.

- 1. Open an image. Go to the Lesson 07 folder inside Lesson Files-PSE8 10n1 and open the file called Big kitty.jpg, an iStockphoto image captured by Kitch Bain. Figure 7-13 shows a screenshot of the majestic feline.
- 2. *Prepare the interface.* Many of the filters in the Filter Gallery draw on the active foreground and background colors to work their magic. Press the **D** key to set the former to black and the latter to white. If your colors were previously set to something other than black and white, you'll see the change at the bottom of the toolbox.
- 3. Open the Filter Gallery. There are lots of ways to open the Filter Gallery. For example, you can choose any of the 47 filters that are members of the Gallery from either the Filter menu or the Effects panel's Filter array. But the most straightforward method is to invoke the command with clear intent: choose Filter→Filter Gallery to display a window like the one in Figure 7-14 on the next page.

Figure 7-13.

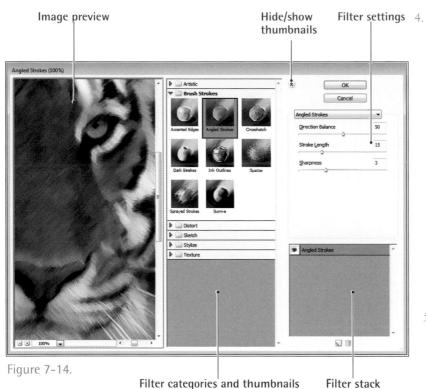

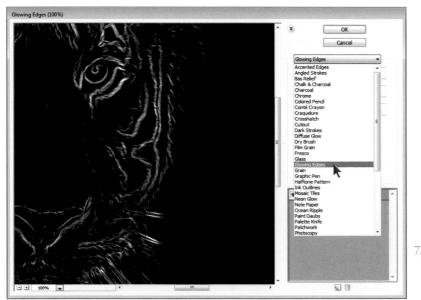

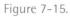

Zoom in on the image. The left side of the Filter Gallery features a generous image preview that you can navigate by clicking the \Box or \oplus buttons in the lower-left corner or by using familiar keyboard equivalents.

Ctrl-click in the preview to zoom in; Altclick to zoom out. Alternatively, you can press Ctrl+ (=) or Ctrl+ (=). To scroll the image, just drag inside it.

Make sure the zoom ratio is set to 100 percent. Then, drag the image so you can see some portion of the tiger's face, as in Figure 7-14.

- 5. *Tuck away the thumbnails*. The middle section of the Filter Gallery houses filter thumbnails, arranged in folders that correspond to the submenus found in the Filter menu and the Styles and Effects panel. To give yourself more room to preview your edits, collapse this section by clicking the \otimes button to the left of the OK button.
- 6. *Apply a filter.* We want to begin by applying an etched-line effect to the tiger. And the best way to start things off is with a filter that traces edges. Click the pop-up menu below the Cancel button—which provides access to all the Filter Gallery effects—and choose the **Glowing Edges** filter. You should see light edges against a black background, as in Figure 7-15.
- Add a second filter. Glowing Edges does a fine job of finding edges, but the result is more intricate than what we have in mind. Let's add another filter to simplify the edges. And that filter is Cutout.

Problem is, if you were to select Cutout from the popup menu, you'd replace the Glowing Edges filter. You want to combine the effects of the two filters, so you'll need to add a filter to the stack. Click the \Box icon at the bottom of the dialog box to add a new effect.

- 8. *Switch to the Cutout filter*. By default, the Filter Gallery adds another layer of Glowing Edges. Obviously, we don't need that. Click **Glowing Edges** in the popup menu up top and choose the **Cutout** filter in its place. The result is a dim series of chiselled polygons—interesting, but not what we're looking for. We want the Cutout filter to simplify the behavior of the Glowing Edges filter, so we need to reverse the order of the commands.
- 9. Reorder the filters. To hide the effects of a filter, click the ^(*) icon beside its name in the lower-right region of the dialog box. For example, if you click the ^(*) in front of Glowing Edges, you can observe the effect of the Cutout filter on its own. Cutout reduces an image to a few distinct fields of color, making it look like the image is clipped from construction paper. If this filter is to simplify the effects of Glowing Edges, it needs to

be behind it. So turn the **Glowing Edges** filter back on, and then drag the word **Cutout** below Glowing Edges. When you see a heavy horizontal line below Glowing Edges, release your mouse button. Figure 7-16 shows the result.

10. Add a third filter. Click the a icon again to add another filter to the top of the stack, this time a copy of Cutout. Click **Cutout** in the pop-up menu and swap it for **Plaster**. The Filter Gallery converts the colors to grayscale and carves the lines into deep grooves against the black background. Now we're talking.

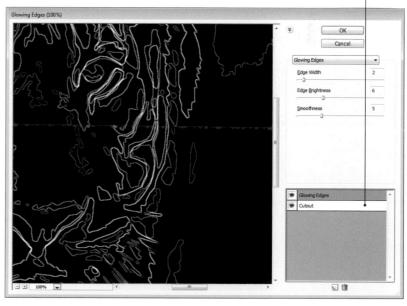

Figure 7-16.

Drag Cutout below

Glowing Edges

Figure 7-17.

- 11. *Adjust the filter settings.* Now that we have the correct filters in place—and in the desired order, no less—we just need to do a little noodling with the settings:
 - Select the **Cutout** filter at the bottom of the stack to display its settings. The line effect is currently a little busy, so raise the **Edge Simplicity** value to **5** to have the filter ignore some of the more complex details.
 - The result is still too complex, so let's take a more drastic plan of attack: Shift+Tab to select the **Number of Levels** value and press ↓ to lower the value to **3**.
 - Click the **Glowing Edges** item in the middle of the filter stack. We think the edges could be thicker in general, so raise the **Edge Brightness** value to **8**. This gives the Plaster filter a better opportunity to carve into the edges.

We could spend all day goofing around with these settings. But let's not. Click **OK** to close the Filter Gallery and accept your changes. Figure 7-17 shows the etched-line effect.

PEARL OF

WISDOM

As you play away inside the Filter Gallery, make sure you take a moment to appreciate what's happening. For example, when you updated the settings of the Cutout filter, you saw the changes refracted through the two subsequent filters, Glowing Edges and Plaster. Had you applied a similar command outside the Filter Gallery, you would have no such option to tweak one and preview its effect on the other two. The Filter Gallery gives you an extra dimension of creative flexibility; the shame is that so many of Elements' filters—particularly the really great ones, such as Adjust Sharpness—aren't included.

- 12. *Undo and layer.* Let's say that you're happy with the chiseled appearance of the image, you'd like to retrieve the rich array of colors from the original. To do that, you'll need to restore the original image and add a layer. But if you undo the current effect, you lose it, right? Not quite. Here's what to do:
 - Click the 🗇 icon in the shortcuts bar or press Ctrl+Z to undo the effects of the Filter Gallery.
 - Press **Ctrl+J** to create a duplicate of the Background layer named Layer 1.
 - Click the **Background** layer in the **Layers** panel or press Alt+1 to make the rear version of the tiger active.

Go to the **Filter** menu and notice in Figure 7-18 that it now begins with two variations of the Filter Gallery command, the second with an ellipse (...) and the first without. The first command applies the most recent filter—or in our case, filters—subject to the same settings. The second one brings up the Filter Gallery dialog box so you can apply new settings.

- 13. *Reapply the three filters.* Choose the first **Filter →Filter Gallery** or press Ctrl+F to reapply the Cutout, Glowing Edges, and Plaster filters to the Background layer. You won't see any changes in the image window, because Layer 1 is covering them. But you can see the filter combo applied to the Background thumbnail in the Layers panel. In other words, take heart—the filters were applied and everything is going according to plan.
- 14. Apply a new filter. Click Layer 1 in the Layers panel or press Alt+[] to make the top layer active. Then choose the second Filter→Filter Gallery, or press the shortcut for invoking the last-used filter with new settings, Ctrl+Alt+F. Once again, Photoshop Elements displays the Filter Gallery dialog box. Most likely, you'll see the same trio of filters—Cutout, Glowing Edges, and Plaster—in the stack at the bottom. If so, click the trash can icon in the bottom-right corner of the dialog box twice in a row to delete the Plaster and Glowing Edges filters. You should be left with a single application of Cutout.

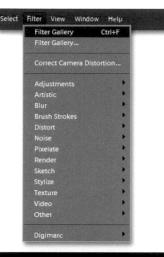

Figure 7-18.

The Filter Gallery offers another technique that lets you wipe out all filters in one fell swoop. Hold down the Ctrl key and notice that the Cancel button changes to Default. With Ctrl still down, click that button. Elements removes all the filters and lcaves you with nothing. Then click the \square icon in the bottom-right corner of the dialog box to add a brand-new filter to the stack.

15. *Apply the Palette Knife filter*. Click the pop-up menu below the Cancel button and choose the **Palette Knife** filter. Palette Knife tries to simulate the blotchy effect of oil paint applied to canvas with a knife, but a close inspection reveals that it leaves jagged edges. So raise the **Softness** slider all the way up to 10, as in Figure 7-19.

Figure 7-19.

Figure 7-20.

- 16. *Add one last filter.* Click the □ icon to add another filter to the stack. The Filter Gallery creates a copy of the Palette Knife filter. Click the pop-up menu at the top of the dialog box and choose the **Craquelure** filter instead. Named for the cracking that occurs in very old paintings (and which is often imitated by art forgers like Deke's Uncle Zeke to simulate age), Craquelure adds a cracked plaster surface to the face of the tiger. The problem is that the cracks go a little too deep. To soften things up a bit, reduce the **Crack Depth** value to **2**. Then boost the **Crack Brightness** to **10** to take off that last bit of edge, as in Figure 7-20. Click **OK**.
- 17. *Apply a blend mode.* We have an etched-line effect on one layer and a digital fresco effect on another. All that's left is to combine the two. See that option in the top-left corner of the **Layers** panel that says **Normal**? Click it to bring up a list of *blend modes* that let you mix the active layer with the ones below it using a variety of mathematical calculations. Choose the **Screen** option, which marries the painted tiger on Layer 1 with the black areas of the Background layer below. The result is a kind of deliciously retro textile art riddled with deeply etched seams, suitable for printing and display under black light. As witnessed in Figure 7-21, this particular cat looks infinitely more ominous after his trip through the Filter Gallery.

Figure 7-21.

Applying Free-Form Distortions

If Adjust Sharpness is the most practical filter and Filter Gallery is the most fun, the award for the most powerful filter in Photoshop Elements goes to Liquify. Less a filter, it's more an independent program that happens to run in the Editor workspace. Liquify lets you distort an image by painting inside it using a collection of tools. One tool stretches pixels, another twists them into a spiral, and a third pinches them. These and other tools make Liquify ideally suited to cosmetic surgery. Whether you want to tuck a tummy, slim a limb, or nip a nose, Liquify gives you everything you need to get the job done.

In this exercise, we'll do something more radical. We'll take a photo of a mild-mannered, 2-year-old Sammy McClelland of yesteryear and morph him into a teenage superhero, complete with square chin, rugged jaw, cocky sneer, and eyes bright with righteous anger. Only one filter can aid us, and that filter is Liquify.

PEARL OF

WISDOM

Be forewarned: Unlike other exercises, in which the instructions are concrete and easy to replicate, these next steps are subject to more interpretation. We'll be asking you to paint—not inside lines, as in Lesson 6, but free-form. You don't necessarily need heaps of artistic talent, but a little doesn't hurt. And regardless of how talented you are, your results and ours will be different. Don't sweat it. Even when all you're doing is making a big mess, this is one entertaining filter. In fact, Deke will tell you he has never once demonstrated the Liquify filter—whether to a few family members or an audience of 500 professionals—that it didn't inspire giddy laughter. So don't be frustrated; be amused.

L. Open an image that you want to distort After capturing the very cute picture of Sammy dressed up for Halloween that appears at the top of Figure 7-22, it struck his father that it might be fun to make him appear every bit the caped crusader that his outfit suggests. A couple of hours of dodging, burning, sponging, healing, and finally painting the snapshot eventually produced the bottom image in the figure. Although it possesses an undeniably graphic, surreal quality, this fair-haired boy continues to exude cuteness, the kind one associates less with a guardian angel and more with an excitable cherub. Few superheroes list "cute" or "cherubic" on their résumés, and so these attributes, however laudable, must be eradicated. To join us in our quest to convert child into champion, open the image titled *Gold hero.jpg*, included in the *Lesson 07* folder inside *Lesson Files-PSE8 10n1*.

Figure 7-22.

2. Choose the Liquify command. Go to the Filter menu and choose Distort→Liquify. Photoshop Elements displays the Liquify window, which appears in Figure 7-23. This full-fledged, free-form distortion utility sports 11 tools on its left edge and several options on the right. The rest of the window is devoted to a comprehensive, accurate view of the image itself.

The same navigation techniques that work outside the Liquify window work inside it as well. You can zoom in or out by pressing $Ctrl+\frac{1}{2}$ or $Ctrl+\frac{1}{2}$, respectively. Press the spacebar and drag to pan the image.

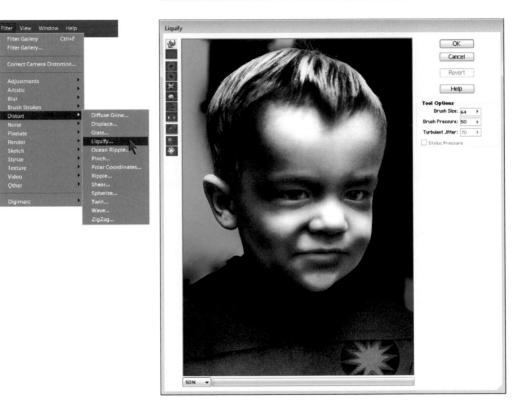

- 3. *Select the warp tool.* Click the topmost tool in the Liquify window or press the W key to select the warp tool, which lets you stretch or squish details in an image by dragging them. Of all Liquify's tools, this one is the most consistently useful.
- Increase the Brush Size value to 100 pixels. Select the Brush Size value (or press Alt+S) and enter 100 in its stead.

As elsewhere in the Standard Edit mode, you can change the brush size by pressing a bracket key. But the shortcut behaves a bit differently. Press the [] or [] key to scale the brush by 1 pixel. Press and hold the key to scale more quickly. Press Shift+[] or [] to scale the brush in 10-pixel increments. (Liquify has no such thing as brush hardness.)

- 5. *Arch the eyebrows*. Using the warp tool, drag the eyebrows to make them appear arched, as in Figure 7-24. This is an exaggerated effect, so if you try to pull it off in one or two brush strokes, you'll smear the colors and wind up with digital stretch marks. Here's how to achieve more photo-realistic results:
 - Keep your strokes very short—just a few pixels at a time.
 - Because you're keeping your brush strokes short, you'll need a lot of them. We laid down about 20 strokes in all.
 - Drag *on* the detail you want to move. For example, to move an eyebrow, center your brush cursor on the eyebrow and then drag. If you drag next to the eyebrow (which, though it may sound weird, is the more natural tendency), you'll pinch the eyebrow and slim it down to a thin line.

If you make a mistake, you'll be glad to learn that Liquify offers multiple undos. But how they work is weird. Pressing Ctrl+Z undoes or redoes only a single brush stroke. To revert further, press Ctrl+Alt+Z. To redo brush strokes, press Ctrl+Shift+Z. It's a sloppy holdover from the senior version of Photoshop, which handles all undos this way.

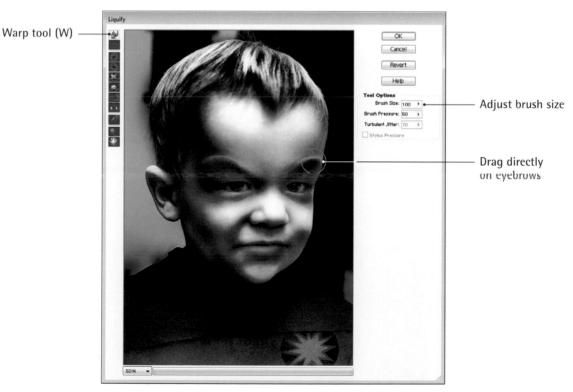

Figure 7-24.

For the present, be careful to avoid painting the eyes. We'll edit them in the next steps with a different tool.

- 6. *Switch to the pucker tool.* Click the fifth tool down or press the P key. This selects the pucker tool, which lets you pinch portions of an image, in much the same way as the Pinch filter, which we mentioned at the beginning of this lesson (see Figure 7-2 on page 181).
- 7. *Reduce the eyes.* Toddlers have lots of physical characteristics that distinguish them from adults. They're short, they have pudgy cheeks, and their skin is really smooth except for occasional patches of dried snot and spaghetti sauce. But if we had to choose their most unique feature, it'd be their eyes. Kids have adult-sized eyeballs packed inside pint-sized heads, which makes their eyes look enormous. Outside Japanese animé, superheroes don't have big old baby eyes, and so Sammy's must be reduced.

Raise the **Brush Size** value to **200** pixels. Then click each of Sammy's eyes. Click quickly and do not drag. If one click doesn't do the trick, click again. The finished eyes should look like those shown in Figure 7-25.

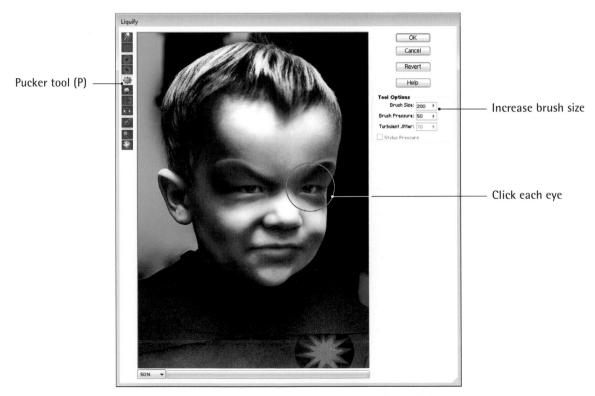

Figure 7-25.

- 8. *Switch to the twirl clockwise tool.* To give Sam a menacing appearance—so that he can more easily intimidate criminals and thwart their evil plans—we want to slant his eyes very slightly. Click the third tool on the left side of the window or press the R key to select the twirl clockwise tool.
- 9. *Slant the eyes.* Center the brush cursor on the iris of the left eye (his right). Then click. Again, click briefly; do not hold or drag. The eye spins a degree or two clockwise, raising the outside edge and lowering the inside.

To slant the right eye (his left) in the opposite direction, you could switch to the twirl counterclockwise tool. But as it turns out, both tools do double duty. To twirl a detail opposite to the direction in which the tool usually works, press the Alt key and click. The results of both twirls appears in Figure 7-26.

10. *Return to the warp tool.* We imagine Sammy to be the sort of edgy, cynical, postmodern superhero who openly sneers at his archenemies and lesser opponents. And there's no better tool for constructing sneers than the warp tool. Get it now by pressing the W key.

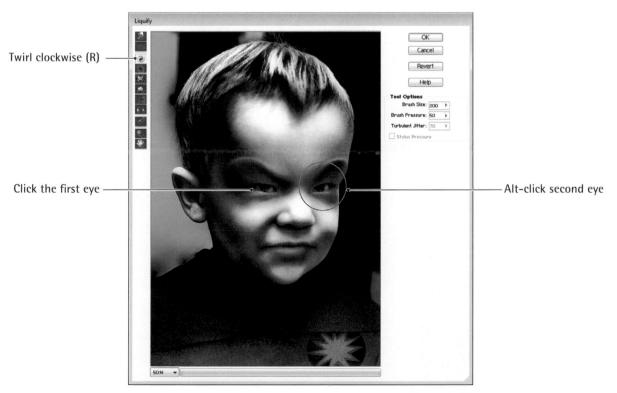

Figure 7-26.

- 11. Work the nose and mouth into a sneer. Reduce the Brush Size to 120 pixels. Then, drag downward on the nose, up on the nostrils, up on the left side of the mouth, and down on the right. You'll also want to drag that crease that connects the nose and mouth on the left side of the image. The results of Deke's 30 or so brush strokes appear in Figure 7-27.
- 12. *Switch to the bloat tool.* Okay, we've managed to outfit Sam with smaller eyes, arching eyebrows, and a tough-guy sneer. But he's still a little kid. It's time to bulk him out. Click the sixth tool on the left side of the window or press the B key to select the bloat tool.

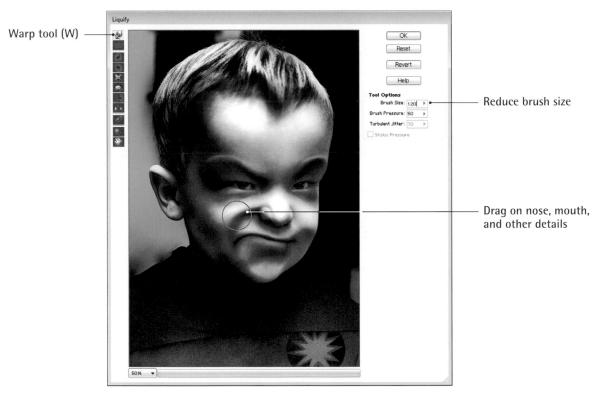

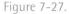

13. *Bloat the chin and jaw.* Start by increasing the **Brush Size** value to **400** pixels. Then test the waters by clicking and holding for a brief moment on Sammy's chin. Also click a few times along the left and right sides of the jaw. We want to really exaggerate the jawline (see Figure 7-28 on the facing page), so feel free to hold the mouse button down for, say, a half second or so at a time. However, as when using the pinch and twirl tools, we recommend you refrain from dragging. (In other words, hold the mouse button down but keep the mouse still.)

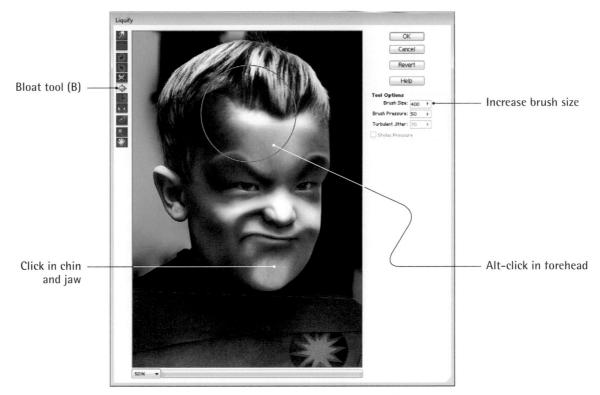

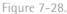

14. Pucker the forehead. In real life, Sammy doesn't have much hair, but he has an ample forehead. That gives him a sort of Poindexter look that superheroes shun. Best way to get rid of it? Pinch it down to a more reasonable size. Which tool to use? You can use the one you already have, the bloat tool.

Center your brush cursor somewhere along the hairline. Then press the Alt key and click for a half second or more. Pressing Alt reverses the behavior of the tool, letting you swell with the pucker tool or, in our case, pinch with the bloat tool.

Continue to Alt-click along the hairline until you get an effect similar to the one pictured in Figure 7-28. For the best results, move the mouse at least slightly *between* (not during) clicks. This varies the center of the distortion and keeps your pinches from resulting in sharp points of converging color.

15. *Apply your finishing touches*. Continue distorting Deke's son's face as you see fit. (Naturally, we rely on you to apply your adjustments in good taste—he is beloved progeny, after all.) We smoothed out the eyebrows, lifted the cheeks, tugged down

the hairline, lifted the shoulders, and increased the size of the chest, all using the warp tool. When you arrive at an effect you like, click the **OK** button to accept your changes and return to the Standard Edit mode. Just for the sheer joy of it, Figure 7-29 shows our final effect incorporated into an elaborate poster treatment. Note that we used Image→Resize→Image Size to stretch the image vertically. This gives the head a less squat appearance. We also dodged and burned the chin to lend it more volume.

PEARL OF

WISDOM

Unlike the other filters in Photoshop Elements, Liquify does not remember your last-applied settings the next time you choose the command. So if you apply the filter, think better of it, undo the operation, and decide to take another stab at it, steel yourself to start the Liquify process over again from scratch. Our advice: Be sure you've *completely* finished distorting an image before clicking the OK button. And don't even think about clicking Cancel unless you're content to trash everything you've done since you chose Filter→Distort→Liquify.

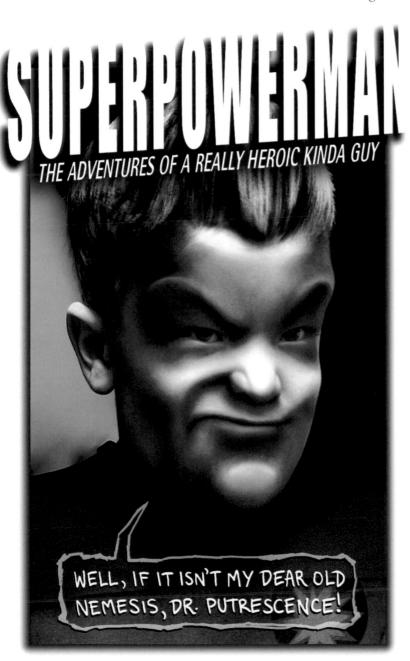

Figure 7-29.

WHAT DID YOU LEARN?

Match the key concept in the numbered list below with the letter of the phrase that best describes it. Answers appear upside-down at the bottom of the page.

Key Concepts

Descriptions

- 1. Focus
- 2. Filters
- 3. Edge
- 4. Adjust Sharpness
- 5. Radius
- 6. Unsharp Mask
- 7. High Pass
- 8. Media filters
- 9. Blend modes
- 10. Warp tool
- 11. Pucker tool
- 12. Bloat tool

- A. The most consistently useful of the Liquify functions, this lets you stretch or squish details in an image by dragging them.
- B. This Liquify function lets you pinch selective portions of an image.
- C. These are designed to make your digital photos look like drawings and paintings created with traditional tools.
- D. A filter named for a traditional technique in which a photographic negative is combined with a blurred version of itself.
- E. Unsharp Mask mimics the functionality of this filter by retaining areas of high contrast and sending low-contrast areas to gray.
- F. Bulging and enlarging are the specialities of this function, available exclusively inside the Liquify dialog box.
- G. Named for camera lenses once commonly used to adjust and tint a scene before it was captured on film, these permit you to modify the focus, color, and overall appearance of an image after it is captured.
- H. The clarity of the image formed by the lens element and captured by the camera.
- I. A ridge formed by areas of extreme contrast between adjacent pixels.
- J. These let you mix the colors in the active layer with those in the layers beneath it using a variety of mathematical calculations.
- K. The newer of Elements' sharpening filters that allows for lens and motion blur corrections.
- L. The thickness of the effect applied by a filter, often expressed as a softly tapering halo.

Answers

1H' 5C' 3I' +K' 2T' 9D' LE' 8C' 6l' 10V' 11B' 15E

Timi

BUILDING LAYERED COMPOSITIONS

EVERY IMAGE begins life as a few panes of primary color most commonly, one each for red, green, and blue—fused into a single, continuous image (see Figure 8-1). Whether it comes from the least expensive digital camera or the most expensive drum scanner, the image exists entirely on one layer. One and only one full-color value exists for every pixel, and there is no such thing as transparency. Such an image is said to be *flat*.

But as soon as you begin combining images, it's best to add layers. Each layer serves as an independent image that you can stack, transform, or blend with other layers.

A document that contains two or more layers is called a *layered composition*. There's no need to wait until a specific point in the editing cycle to build such a composition. You can add layers to a document whenever you like, as we have several times over the course of the book so far. But layers have a way of becoming even more useful after some of the basic editing work is out of the way. That's why we've waited until now to show you the many ways to create and manage layers in Photoshop Elements.

The Benefits and Penalties of Layers

Photoshop Elements' reliance on layers makes for an exceedingly flexible (if sometimes confusing) working environment. As long as an image remains on a layer, you can move or edit it independently of other layers in the composition. Moreover, you can create relationships between neighboring layers using a wide variety of blending options, Figure 8-1.

ABOUT THIS LESSON

Project Files

Before beginning the exercises, make sure you've downloaded the lesson files from *www.oreilly.com/go/deke-PSE8*, as directed in Step 2 on page xiv of the Preface. This means you should have a folder called *Lesson Files-PSE8 1on1* on your desktop (or whatever location you chose). We'll be working with the files inside the *Lesson 08* subfolder. In this lesson, we'll explore the many facets of building a layered composition in Photoshop Elements, from creation to navigation, from stroking to stacking order, from free-form transformations to four-point distortions, from applying blend modes to erasing backgrounds. You'll learn how to:

- Edit the contents of individual layers and move them forward or backward in the stack page 211
- Use the magic and background eraser to separate an image element to an independent layer page 227

Video Lesson 8: Layers at Work

Layers are nothing more than independent images that you can set to interact with each other from the Layers panel. But what a difference they make. By relegating image elements and effects to independent layers, you give yourself the flexibility to adjust your artwork well into the future. In this video lesson, Deke introduces you to Elements' layers functions.

You can either watch the video lesson online or download to view at your leisure by going to *www. oreilly.com/go/deke-PSE8.* During the video, you'll learn about the keyboard equivalents and shortcuts listed below.

Operation
Show or hide Layers panel
Select move tool
Exit transformation mode
Cut selection to independent layer
Deactivate highlighted option (such as blend mode)
Group active layer with layer below it
Create and name new layer

Keyboard equivalent or shortcut F11 V (or press Ctrl to access temporarily)) Esc Ctrl+Shift+J Esc Ctrl+G Ctrl+Shift+N all of which work without changing the contents of the layers in the slightest.

But layers come at a price. Because they are actually independent images, each layer consumes space both in memory and on your hard drive. Consider the following example:

- Let's start with the image on the right, which measures 2100 by 2100 pixels, or 7 by 7 inches at 300 pixels per inch (see Figure 8-2). Each pixel takes up 3 bytes of data. The result is a total of 4.41 million pixels, which add up to 12.6MB in memory. Because the image is flat, we can save it to the JPEG format, which compresses the file down to 3.7MB at the highest quality setting.
- We introduce another image that measures the very same 2100 by 2100 pixels. Photoshop Elements puts the image on its own layer. We apply the Multiply blend mode to get the effect shown in Figure 8-3. The image size doubles to 25.2MB in memory. We can no longer save the layered composition in the JPEG format because JPEG doesn't permit layers. Thus, we save it in Photoshop's native PSD format instead. Although PSD is versatile, it lacks JPEG's exceptional compression capabilities, so the file on disk balloons to 25.7MB.
- We then add a series of image and text layers to fill out the composition, as pictured in on the next page. Because the layers are smaller, and the text layers are defined as more efficient vectors (see Lesson 9, "Text and 5hapes"), the size of the image grows only moderately in memory (34.4MB) and barely at all on disk (26.2MB).

So as you add layers, your composition gets bigger. And as your composition gets bigger, Photoshop Elements requires more space in memory and on disk to manage the file. Generally speaking, you can let Elements worry about these sorts of nitty-gritty details. But bear in mind that no matter how sophisticated your computer, its memory and hard disk are finite. And if the memory or (worse) the hard disk fills up, your ability to edit your marvelous multilayer creations may come to a skidding halt.

Flat image, 2100 × 2100 pixels 12.GMB in memory, 3.7MB on disk (saved in JPEG format, Quality 12)

Figure 8-2.

Second layer, full 2100 × 2100 pixels 25.2MB in memory, 25.7MB on disk (saved in native PSD format)

Figure 8-3.

How to Manage Layers

Fortunately, a few precautions are all it takes to keep layered compositions on a diet and Photoshop Elements running in top form:

• First, don't let your hard disk get anywhere close to full. We recommend keeping at least 1GB available at all times, and more than that is always welcome. (Consult your computer's documentation to find out how to check this—or just hope and pray you're okay, like everyone else does.)

Figure 8-4.

- Back up your Elements projects regularly to CD, DVD, or some other storage medium (which you can do by choosing File→Backup to CD, DVD, or Hard Drive inside the Organizer workspace). This not only preserves your images but also permits you to delete files from your hard disk if you start running out of room.
- As you work in Photoshop Elements, you can keep an eye on the size of your image in memory by observing the document size values in the bottom-left corner of the image window. Click the D arrow at the bottom of the window and choose Document Sizes. The value before the slash tells you the size of the image if flat; the value after the slash tells you the size of the composition with layers.
- You can reduce the size of an image on disk by *merging* two layers into one by choosing Layer→Merge Down or pressing Ctrl+E.
- To merge all layers and return to a flat image, choose Layer→Flatten Image. But be aware that this is a radical step. We usually flatten an image only as a preamble to printing it or placing it into another program. And even then, we make sure to save the flattened image under a different name to maintain my original layered file, using Organizer's version sets to keep track of everything. (See "Saving in a Version Set" on page 83 in Lesson 3 for the skinny on version sets.)

Finally, when in doubt, err on the side of too many layers as opposed to too few. This may sound like strange advice, but it's better to push the limits and occasionally top out than unnecessarily constrain yourself and hobble your file. After all, you can always upgrade your computer to better accommodate your massive compositions. But you can never recover an unsaved layer (that is, one that you merged or flattened before saving and closing the file).

Arranging and Modifying Layers

The most basic use for layers is to keep objects separated from each other so you can modify their horizontal and vertical position as well as their front-to-back arrangement. Elements also permits you to transform layers by scaling, rotating, or even distorting them, as you'll see in the second of the upcoming exercises.

By way of demonstration, we'll take a cue from the classical artist we believe would have benefited most from layers, 16th-century imperial court painter Giuseppe Arcimboldo. Celebrated in his time as a master of the composite portrait, Arcimboldo rendered his subjects as fanciful collections of fruits, vegetables, flowers, trees, animals, meats; he even famously represented one fellow upside-down (right image, Figure 8-5). We'll embark on something infinitely simpler—Giuseppe had to thrill and delight Emperor Maximilian II, but happily, we do not. Even so, you'll get an ample sense of the pure imaging flexibility that layers afford.

In the following exercise, you'll begin the process of assembling a layered piece of artwork. You'll establish the content and order of the key layers in the composition and, in the process, learn how to select layers, modify their contents, change their order, and even rotate them.

1. Open a layered composition and some images to add to it. We'll be looking at three files altogether, Composite cowboy.psd, Cowboy hat.tif, and Eight

ball.tif, all included in the *Lesson 08* folder inside *Lesson Files-PSE8 1on1*. At first glance, the layered image (shown on the left in Figure 8-6) looks like a football with flippers standing on a pile of towels. But as we'll see, there's so much more.

- 2. *Bring up the Layers panel*. If it's on-screen and expanded, fabulous. If not, choose **Window→Layers** or press the F11 key. The **Layers** panel shows thumbnails of every layer in the document, from the front layer at the top of the panel to the rearmost layer at the bottom. This arrangement of layers from front to back is called the *stacking order*.
- 3. *Make the multilayer file active*. Click the *Composite cowboy*. *psd* image or tab to make that image active. If you take a peek at the Layers panel, you'll see that the file contains 10 layers in all. And yet we can see just four items in the image window: football, flippers, towels, and background. (In case you're curious, the flippers are found on the Collar layer. More on that topic shortly.) The other layers are turned off or hidden by the football.

- 4. Send the Football layer backward. Click the Football layer in the Layers panel to make it active. Then drag it down the stack in this same panel to between the Teeth and Collar layers. You should now see all visible layers from the Teeth upward, as illustrated in Figure 8-7.
- 5. Load a selection outline. The next step is to carve the football into the shape of a face, which we'll accomplish using a selection outline that we defined in advance and saved with this image for you. To access this selection, choose Select→Load Selection. With the Selection pop-up menu set to face outline (as in Figure 8-8), click the OK button.

Source	ОК
Selection: face outline	Cancel
n <u>v</u> ert	Cance
Operation	
New Selection	
Add to Selection	
 Add to Selection Subtract from Selection 	

- 6. *Reverse the selection*. Choose **Select→Inverse** or press Ctrl+Shift+I to reverse the selection and select the area outside the cowboy's face.
- 7. *Delete the selected pixels*. Make sure the Football layer is active. Then press the **Backspace** or Delete key to erase the selected pixels. Only the cowboy's silhouette remains, as shown in Figure 8-9.
- Restore the face selection. Now let's add a cartoon outline around the cowboy's face. To restore the face outline from Step 5, again choose Select→Inverse or press Ctrl+Shift+I.
- 9. Create a new layer. Choose Layer→New→Layer or press the keyboard shortcut Ctrl+Shift+N to display the New Layer dialog box. Name the layer "Cowboy Outline" and click the OK button. Elements adds the new layer to the Layers panel.

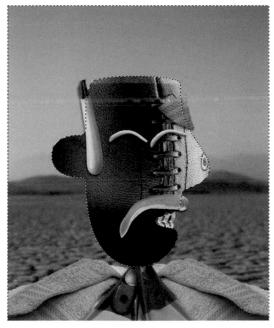

Figure 8-9.

- 10. *Stroke the selection*. Choose Edit→Stroke (Outline) Selection to bring up the Stroke dialog box, which allows you to trace a colored outline around the contours of a selection outline. There is no short-cut for this command, but you can get to it from the keyboard by holding down the Alt key and then typing E and S.
- 11. *Specify the stroke settings*. Let's say you want to create a yellow outline that's 13 pixels thick. Change the numbered settings in Figure 8-10 as follows:
 - Change the Width value to 13 pixels (**0** in Figure 8-10).
 - Click the Color swatch (labeled ② in the figure) to display the Color Picker dialog box.
 - Change the **R**, **G**, and **B** values to 255, 240, and 180, respectively (see **③** in the figure). The result is a pale yellow. Click the **OK** button to accept the new color.

Check that the other options in the Stroke dialog box are set to their defaults (as they are in Figure 8-10). Then, click the **OK** button to apply the stroke. Elements traces a 13-pixel yellow brushstroke around the perimeter of the face, as in Figure 8-11.

Image Enhance Layer Select Filter View Window Help

Figure 8-11.

- 12. *Deselect the image.* We're finished with the selection outline, so choose **Select→Deselect** or press Ctrl+D to get rid of it.
- Click the Scruff layer. Back in the Layers panel, find the layer called Scruff and select it. Then click the blank square next to the layer name to toggle the
 and reveal the layer. It looks like gray sandpaper, but it's actually our fellow's stubbly beard.
- 14. Set the blend mode to Multiply. Click the word Normal at the top of the Layers panel to display a list of blend modes. Then choose Multiply from the list or press the keyboard shortcut Shift+Alt+M. Multiply drops out the whites and preserves the dark colors, thus burning the stubble into the cowboy's football flesh, as in Figure 8-12.

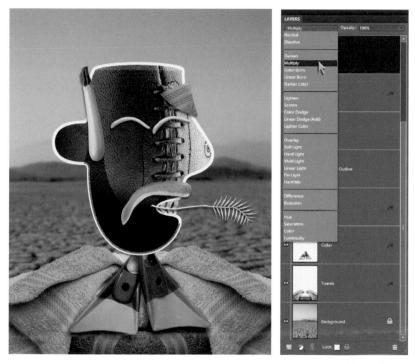

Figure 8-12.

15. Turn on the Hayseed layer. This time, click not directly on the Hayseed layer but rather in front of it, in the column of icons. This shows the layer without activating it. The layer in question turns out to be a sliver of barley clasped tightly in the cowboy's teeth (the latter of which are actually seams in a baseball, for what it's worth). Shown in Figure 8-12, the look is interesting but inconsistent. The face outline should be in front of the teeth, hayseed, and scruff. The football flesh needs to be moved forward a couple of layers as well. 16. *Select the Cowboy Outline layer*. You might find it simplest to click the layer name. But we'd be remiss in our duties if we didn't tell you how to select the layer from the keyboard.

You can cycle from one layer to the next by pressing Alt with a bracket key. First, press the Esc key to make sure no options are active. Then press Alt+[] to select down the layer stack; press Alt+[] to select up. In this case, pressing Alt+[] three times cycles from the Scruff layer down to Cowboy Outline.

17. Bring the Cowboy Outline layer in front of Scruff. You can accomplish this by choosing Layer→Arrange→Bring Forward three times in a row. But isn't life short enough without choosing inconveniently located commands multiple times in a row?

To move a selected layer up or down the stack, press Ctrl with a bracket key. Ctrl+ i moves the layer behind the layer in back of it; Ctrl+ moves it forward. To properly arrange the Cowboy Outline layer, press Ctrl+ three times in a row.

- 18. Select the Football layer. You can just click the layer name in the panel, but we have another technique for you to try. Press the V key to select the move tool. Turn on the Show Highlight on Rollover checkbox in the options bar. Then, hover over the an unobstructed portion of the hayseed in the image window until a blue bounding box appears, and then click. (Elements automatically switches to the Hayseed layer.) Next, click inside the football, wait for the bounding box, and click to select that layer. Notice in Figure 8-13 that until you commit to the new layer by clicking, the Hayseed layer remains selected, as indicated by a dashed bounding box with handles. The move tool's ability to switch layers is a function of the Auto Select Layer checkbox, which is active by default in the options bar.
- 19. *Bring the Football layer in front of Hayseed*. To make it happen, press Ctrl+[] twice. The properly arranged layer elements appear in Figure 8-13.

You can also right-click on a layer when its bounding box appears in the image window to get a shortcut list that gives you a variety of choices for where to send the layer. In this case, you would have to choose Bring Forward twice, so it doesn't seem as handy as the keyboard shortcut, which is easier to repeat. But if you wanted to send something all the way to the back or bring it all the way to the front, or just one step forward or backward, then a mouse-based shortcut might be handy.

- 20. *Switch to the Collar layer.* Click the reddish snorkeling fins with the move tool to select the Collar layer. You may reckon those flippers look more like a dandy kerchief than a rugged collar, but that's just because they're upside-down.
- 21. Rotate the flippers 180 degrees. The best way to flip a layer upside-down—assuming that you don't want to create a mirror image of it—is to rotate it 180 degrees. To do so, choose Image→Rotate→Layer 180°. This command spins the fins so they look like a collar, at least in Deke's active imagination. To perform the operation from the keyboard, press Alt+I and then type E, 1 (□).
- 22. *Nudge the flippers upward*. Press Shift+↑ seven times in a row. Assuming the move tool is still active, each press of Shift+↑ nudges the layer up 10 pixels; so in all, you will have moved it 70 pixels, placing it as in Figure 8-14.
- 23. Save your changes thus far. It's always a good idea to save versions of a file as you go along. This way, you have the option of recovering elements from your original image later if things go wrong. To save a new version, choose File→Save As or press Ctrl+Shift+S and give your file a new name, such as "Cowboy in progress." Then set the options as follows:
 - There's no need to manage this file in the Organizer workspace, so we recommend you turn off the **Include in the Organizer** checkbox.
 - Turn on both the **Layers** and **ICC Profile** checkboxes to save all layers and color settings.
 - Set the Format option to Photoshop (*.PSD; *.PDD).

Finally, click the Save button to save the composition.

Importing and Transforming Layers

Now that you've successfully arranged the layers in the composition, it's time to bring into the mix the rest of the elements, namely the eyes and the hat. In this exercise, you'll introduce portions of the *Cowboy hat.tif* and *Eight ball.tif* images into the composition that you've created so far (and saved in Step 23 of the preceding exercise). Then you'll scale and otherwise transform the layers so they fit into place. The result will be a fanciful cowboy face made of objects that you don't often see on cowboys—especially that hat.

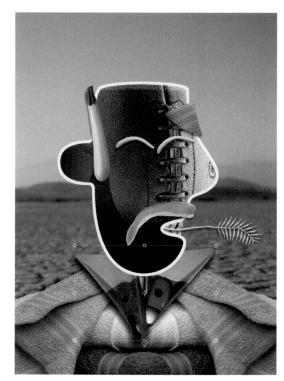

Figure 8-14.

Figure 8-15.

1. *Bring the eight ball image to the front*. If you did not complete the preceding exercise, you can open *Catch up cowboy.psd*; otherwise, start with *Cowboy in progress*.

psd. Then make sure the other two documents from that exercise remain open—namely, *Cowboy hat.tif*, and *Eight ball.tif*. Click the title bar for *Eight ball.tif* to make the pool ball active.

- 2. Select a central portion of the pool ball. Use the elliptical marquee tool to select the circular area shown in Figure 8-15. Or, to guarantee that your circle exactly matches ours, load the one included in the image. How, you ask? Choose Select→Load Selection, confirm that the Selection option is set to circle, and click the OK button.
- 3. *Drag the eight ball into the cowboy composition*. Press the V key to make sure the move tool is active. Then, drag the selection from *Eight ball.tif* into the *Cowboy in progress.psd* image window. Drop it near where one of the eyes should go. In all likelihood, you'll see the pool ball land in an undesirable position, behind the head, as in Figure 8-16. Photoshop Elements places the object in front of the previously selected layer (Collar, in this case). Looks like we'll need to rearrange.

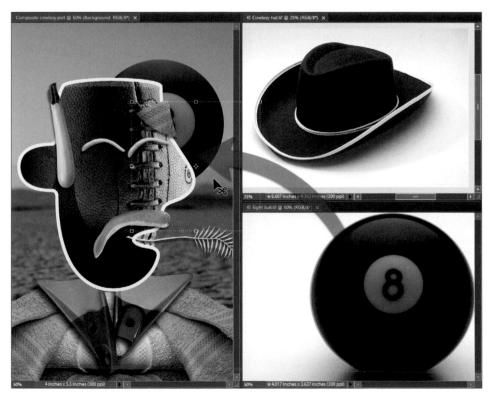

Figure 8-16.

- 4. *Rename the new layer*. In the **Layers** panel, double-click the current layer name, **Layer 1**, to highlight the letters. Then change the name to the more descriptive "Eyes."
- 5. *Bring the Eyes layer in front of Cowboy Outline*. Either drag the layer up the stack or press Ctrl+[] five times in a row.
- 6. Adjust the eight ball with the Auto Contrast command. The eight ball is dimly lit with respect to its new surroundings. So choose Enhance→Auto Contrast or press Ctrl+Shift+Alt+L to correct the brightness without upsetting the color balance.
- 7. *Scale the pool ball to 32 percent of its original size*. The pool ball is too big, so you need to scale it. To be precise, you need to reduce it to 32 percent of its current size. Armed with the move tool, you can pull this off in one of two ways:
 - Notice the dotted marquee with square handles that surrounds the pool ball. This is the *bounding box*, which allows you to scale, rotate, or otherwise transform a layer. (If you do not see the marquee, turn on the Show Bounding Box checkbox in the options bar.) To scale a layer uniformly—

so that the width and height are affected equally—press the **Shift** key and drag a corner handle to constrain the proportions of the ball. As you drag, keep an eye on the scale values that appear in the options bar. When they reach 32 percent (or thereabouts), release the mouse button, and then release Shift.

For more precision, scale by the numbers. Move your cursor over the edge of the bounding box until it looks like ‡ or +i+, and then click to make the bounding box active and enter the *free transform mode*. Turn on the Constrain Proportions checkbox in the options bar (circled in Figure 8-17). Change either the W or H value to 32 (both will update) and press Enter.

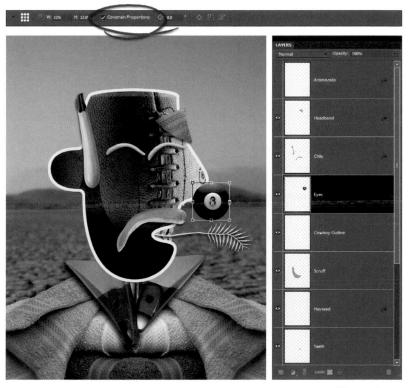

Figure 8-17.

To accept the scaled image and exit the free transform mode, press the Enter key (yes, again) or click the green \checkmark on the image window.

8. *Move the eye into position*. For the sake of convenience, let's imagine that this pool ball is the left eye (which, to be fair to this fictitious person, is the cowboy's right). Drag the eye into the position shown in Figure 8-18.

Figure 8-18.

- 9. *Add a drop shadow.* The interior of the layer exhibits the interplay of highlight and shadow that one typically associates with a real-world object. (Or as Giuseppe himself might have said, the pool ball possesses *chiaroscuro.*) But the layer fails to interact with its environment. Most obviously, the pool ball lacks a shadow. To remedy this gross oversight, do like so:
 - Go to the Effects panel. (If the panel is not open already, choose Window→Effects.)
 - Click the second icon from left under the word Effects to display the Layer Styles. Then, choose Drop Shadows from the pop-up menu to the left of the icons.

• Click the thumbnail labeled **Soft Edge**. This adds a fuzzy drop shadow positioned close to the object itself. Click **Apply** at the bottom of the Effects panel.

If you can't see the names of the various effects under the thumbnails, click the at the top right of the panel to open the panel menu and choose **Show Names**.

Elements casts a fuzzy black shadow behind the active layer.

- 10. *Add an inner shadow*. Now for some shadow along the inside edge of the layer. Choose **Inner Shadows** from the pop-up menu in the Effects panel. Then click the first thumbnail, which goes by the name **Low**. Click **Apply**.
- 11. *Set the blend mode to Screen*. Return to the **Layers** panel and change the blend mode from **Normal** to **Screen**. You can also use the keyboard shortcut Shift+Alt+S. (If the shortcut doesn't work, press the Esc key and try again.) The opposite of the Multiply mode, Screen drops out the blacks and preserves the light colors, creating the appearance of a glass eyeball against the football background.
- 12. Scale the shadows to 50 percent. The transparent portions of the eye reveal the drop and inner shadows we applied in Steps 9 and 10. Only one problem: the shadows are too big. To shrink them, choose Layer→Layer Style→Scale Effects. Change the Scale value to 50 percent and click OK. The glass eye and its more acceptable shadows appear in Figure 8-19.
- 13. Select the eye and clone it. Even a guy with a football for a head deserves depth perception. Therefore, let's add a second eye. Of all the ways you can duplicate the eye, here's the easiest:
 - Press the Ctrl key and click the **Eyes** layer thumbnail in the Layers panel. This traces a selection outline around the exact perimeter of the layer.

Figure 8-19.

• Check that the move tool is still active. Then, hold down both the **Shift** and **Alt** keys, and drag the eye to the right. Pressing the Shift key constrains the movement along a horizontal axis. Pressing Alt creates a clone of the eye. After you get the pool ball into more or less the location pictured in Figure 8-20, release the mouse button and then release the Shift and Alt keys.

Figure 8-20.

WISDOM

The result of these steps is pretty impressive. It may even appear more impressive than it really is. For example, the right eye looks as if it's distorting the laces of the football, just as a piece of rounded glass really would. But that's an illusion—Elements is doing no such thing. The fact that the effect reads like a glass distortion is pure bonus.

PEARL OF

14. *Deselect the image*. Press **Ctrl+D** to abandon the selection, which has now served us to its utmost capacity.

- 15. *Bring the cowboy hat image to the front*. The only thing missing in our strange and amazing composition is the hat. Let's go get it. Click the title bar for *Cowboy hat.tif*.
- 16. Select the hat. The hat is a little more difficult to select than the eight ball. So, wouldn't you know it, this image contains a predefined selection outline to help you on your way. Choose Select→Load Selection. Verify that the hat outline selection is active and click OK. The selected hat appears in Figure 8-21.

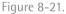

- 17. *Drag the hat into the cowboy composition*. Once again using the move tool, drag the selection from *Cowboy hut.tif* into the *Cowboy in progress.psd* image window. Drop the hat near the top of the head. Naturally, it comes in all wrong. The hat is too low on the head, too far down the stack, and *way* too big, as in Figure 8-22 on the next page. Such are the ways of the layered composition, and the reasons for the remaining steps.
- Rename the new layer. Double-click the current layer name (as always, Layer 1) and change its name to "Hat".
- Bring the hat to the front of the composition. Choose Layer→Arrange→Bring to Front or press Ctrl+Shift+[]. The layer pops all the way to the top of the stack, where it belongs.

Figure 8-22.

20. *Lower the Opacity value to 50 percent*. Change the **Opacity** value in the Layers panel. Or with the move tool active, you can bypass the option and just press the 5 key. We'll want the final hat to be fully opaque. So why lower its opacity? By making the hat translucent in the short term, you can more easily align it with elements underneath.

Note that it's essential that you perform the previous step right now; you cannot modify the opacity or the blend mode when inside the free transform mode.

- 21. *Scale and rotate the layer.* Because the bounding box handles extend off-screen, we recommend that you start things off by scaling the hat numerically. Here's the wisest approach:
 - With the ‡ or +++ cursor, click any side of the bounding box to enter the free transform mode.
 - Turn on the Constrain Proportions checkbox in the options bar. Then change either W or H to 62 percent (see the circled values in Figure 8-23 on the facing page).

- Having reduced the size of the hat so that it fits inside the image window, you can rotate the image in one of two ways. Move the cursor outside the bounding box and drag to spin the hat clockwise around its center until the rotate value in the options bar (△, to the right of H) reads 3.5 degrees. Or enter 3.5 into the △ option box and press Enter.
- Drag inside the boundary to move the hat as needed. You can also nudge the layer from the keyboard by pressing one or more arrow keys.

Don't press the Enter key yet. You want to remain in the free transform mode for the next step.

Figure 8-23.

22. *Distort the hat.* The one variety of transformation that you can't express entirely with numbers is the *four-point distortion*, which permits you to scale or slant one portion of a layer independently of another. To distort a layer in Elements, press the Ctrl key and drag a corner handle. The handle moves independently of the other handles, stretching the hat in that one direction.

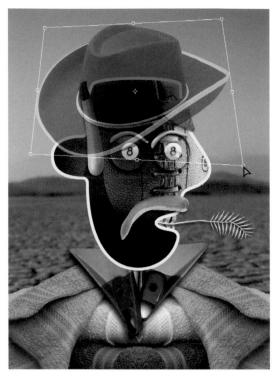

Figure 8-24.

We ended up Ctrl-dragging all four corner handles to taper the top of the hat, as shown in Figure 8-24. (Note that your scale and rotate values in the options bar will change as you perform the distortion. The values only partially track the transformation, so feel free to ignore them.)

23. Accept the transformation. Click the ✓ in the options bar or press the Enter key. Photoshop Elements applies the various transformations and exits the free transform mode.

PEARL OF

WISDOM

You may notice that you just finished applying several operations inside one free transform session. We recommend that you work this way when creating your own projects as well. Each session rewrites the pixels in the image, so each is potentially destructive. By applying all changes inside a single session, you rewrite pixels just once, minimizing the damage caused by multiple interpolations.

24. *Restore the opacity to 100 percent.* Press the 0 key (that's zero, not the letter) or change the **Opacity** value in the Layers panel. The hat becomes opaque again.

CRED

Everything looks pretty good. But in our opinion, the Hat and Cowboy Outline layers are just begging for drop shadows. If you don't share that opinion, skip ahead to the next exercise, "Erasing a Background," on the facing page. But then you'll miss yet another new technique. Rather than defining the shadows manually, as you did back in Steps 9 and 10 (see pages 220 and 221), we'll repurpose them from other layers.

- 25. Copy the Collar layer's drop shadow. Click the Collar layer in the Layers panel to make it active. Then, choose Layer→Layer Style→Copy Layer Style. This tells Elements to tag the layer and make a mental note of the shadows and other effects assigned to it.
- 26. *Paste the drop shadow on the Hat layer*. Click the **Hat** layer to make it active. Next, choose **Layer→Layer Style→Paste Layer Style**. The cowboy hat receives a drop shadow that exactly matches the one applied to the flippers.
- 27. *Add a scaled drop shadow to the Cowboy Outline layer*. Click the **Cowboy Outline** layer and choose the **Paste Layer Style** command again. The shadow is way too big for the yellow outline, so let's scale it.

Choose Layer \rightarrow Layer Style \rightarrow Scale Effects. Change the Scale value to a mere 20 percent, and click the OK button to accept your changes. The shadow slims down to a more reasonable size, as in Figure 8-25.

- 28. *Turn on the Arcimboldo layer*. Click the empty square to the left of the one remaining hidden layer to show its **③** icon and display a frivolous caption that Deke drew by hand with a Wacom tablet.
- 29. Save your composition. So ends another jam-packed exercise. Choose File→Save to update the file on disk or choose File→Save As to save an independent version.

Erasing a Background

So far we've been talking about creating and managing the contents of layers. Now let's talk about ways to delete from layers and, paradoxically, create layers as we delete from them.

How is this possible? The answer resides with the Editor's trio of eraser tools. When used on any layer other than the Background, each of the eraser tools does just what you think it would do wipcs away pixels from the layer, leaving transparency in its wake.

Figure 8-25.

However, when working on the Background layer, transparency is not an option. So the first of the three erasers, known simply as the eraser tool, paints with the background color, which is white by default. But the other two erasers—the background eraser and the magic eraser—do something extraordinary. They convert the Background layer to an independent layer and then set about erasing to transparency. When the eraser can't go to the mountain, Photoshop Elements brings the mountain to the eraser.

In this exercise, you'll use each eraser to eliminate the background from an image, thereby permitting you to combine the extracted foreground with an entirely different background and still maintain a photorealistic effect. You'll see that each eraser tool resembles one of Elements' selection tools. Indeed, you'll discover that erasing and selecting are closely related tasks.

Figure 8-26.

1. Open a couple of flat images. Open Ruins.jpg and Zephyr.jpg, both conveniently located within the Lesson 08 folder inside Lesson Files-PSE8 10n1 and shown in

Figure 8-26. Make *Zephyr.jpg* the active image. And note that like all JPEGs, this photograph is flat, possessing a single Background layer and nothing more. This piece of sculpture, happens to be Zephyr, the god of wind, which seems only appropriate to the topic of erasing. We're going to blow his background away.

- 2. *Select the magic eraser in the toolbox.* The first eraser we'll explore is the enticingly named magic eraser. Like its mentor, the magic wand, the magic eraser identifies an area of homogeneous color. Unlike the wand, it then deletes that area. Click and hold the eraser tool to display a flyout menu of erasers; then select the magic eraser, as in Figure 8-27. Alternatively, you can press the E key (or Shift+E) to switch between erasers until you get the one with the sparkle.
- Set the eraser tools back to their defaults. To make sure your eraser tools work like ours, click the pink eraser icon on the far left side of the options bar, choose Reset All Tools, and click OK. (This may seem like overkill, but it's the easiest way to restore the default settings for all three erasers.)

ARL OF

WISDO

The options bar settings are mostly identical to those that accompany the magic wand (see "Selecting Colored Areas with the Magic Wand" on page 142 in Lesson 6). The one addition is Opacity, which permits the tool to create translucent pixels. This option should be called Transparency because the default setting of 100 percent makes erased pixels 100 percent transparent.

- 4. *Magically erase part of the sky.* Click the wedge of cloudy sky to the right of Zephyr, as circled in Figure 8-28. In a heartbeat, the magic eraser blasts away the patch of sky that falls inside the Tolerance range, just as if you had clicked with the magic wand and then pressed Backspace. The difference is that the magic eraser has automatically turned the Background layer into a floating layer, giving it the name Layer 0. The gray checkerboard represents transparency, or nothingness.
 - 5. *Switch out the checkerboard pattern*. The checkerboard isn't ideal for judging the outline of this particular layer. The checkers are too busy and too light. So let's change them:
 - Choose Edit→Preferences→Transparency, or press the shortcut Ctrl+K and then Ctrl+4.
 - Click each of the color swatches under the Grid Colors option and enter the **H**, **S**, and **B** values listed in Figure 8-29. The result is a vivid red pattern with little variation between one square and the next.
 - Click the OK button.

Zoom in on the image. Examine the outline along the back of Zephyr's head now, and you'll see a thin but sharp line of lightaqua fringe. Unacceptable; let's try again.

- 6. *Raise the Tolerance value*. Apparently, the magic eraser didn't erase enough pixels. So we need to incorporate more colors into the erasing equation. Click the word **Tolerance** in the options bar, raise the value to **75**, and press **Enter**.
- 7. Undo the magic eraser. As was the case with the magic wand, the Tolerance value is static, affecting the next erased area, not the current one. So we have to run the operation again. Click the 𝔅 icon in the shortcuts bar or press Ctrl+Z. Happily, Elements undoes Step 4, not Step 5 or 6. Because the Undo command ignores the changing of preferences and other settings, the last thing it remembers is the magic eraser.
- 8. *Click again with the magic eraser tool*. Click again where you clicked in Step 4, behind the droopy-looking Zephyr's head. Thanks to the more liberal Tolerance setting, the magic eraser leaves only the slimmest hint of a gossamer fringe around the sculpted head. Indeed, as a bonus, the generous Tolerance value has permitted the tool to erase most of the blue area at the top of the sky as well. The much improved results appear in Figure 8-30.

Figure 8-28.

Figure 8-30.

Figure 8-31.

If you're feeling skeptical about the results you get with this or the other eraser tools, permit us to allay your concerns. We intentionally designed the red checkerboard pattern to be unforgiving. When we drop Zephyr into his new home, we'll have a much smoother blend, and any slight imperfections in the edges will be almost invisible.

9. *Select the background eraser*. The remainder of the background is too complex for the simple but ultimately remedial magic eraser. So let's switch to a more powerful eraser. Choose the background eraser from the flyout menu in the toolbox, as shown in Figure 8-31.

Strictly speaking, the background eraser is a brush-based tool. Even so, it works a little like the magnetic lasso tool; you trace loosely around the perimeter of an object, and the tool does its best to accurately identify the edges (see the sidebar "The Magnetic Lasso" on page 163 in Lesson 6). But in addition to evaluating edges, much as the magnetic lasso does, the background eraser reads which colors you want to erase as you drag over them. The trick is to keep the *sampling point*—identified by + in the center of the cursor—in the background, and move the outside of the brush over the object's edge and slightly into the foreground. It's tricky, but you'll soon get a sense of it.

- Adjust the options bar settings. The background eraser offers three settings in the options bar, which you can see in Figure 8-32. Here's how they should be set:
 - Click the **Brush** preview to see a pop-up panel of options that control the size and shape of the brush. For this exercise, enter a value of **60** or **70** pixels.
 - The Limits option determines which colors get erased inside the brush diameter. The default setting, Contiguous, erases only those colors that fall inside the Tolerance range *and* are adjacent to the sampling point; Discontiguous leaps over colors, sometimes into the foreground object. For most work (and the project at hand), **Contiguous** is the better choice.
 - The Tolerance (now measured as a percentage) defines how close a color has to be to the pixel under the + to be erased. We can't really evaluate this option until we try it, so leave the **Tolerance** set to 50 percent for now.

Brush: Tolerance: 50%

Figure 8-32.

11. *Give the background eraser a try.* Position the background eraser as shown in the first example in Figure 8-33, with the cursor's central + inside the thin fringe of blue sky visible between the green of the tree and the red of the checkerboard. Drag around the perimeter of Zephyr until you are about level with his nose, as in the second example in the figure.

Multiple brushstrokes are okay. For the best results, paint slowly so Elements has time to sample colors along the way. Keep the + outside Zephyr, but overlap the outer edge of the brush into the sculpture.

The results are uneven. The tool did a pretty good job distinguishing the foliage from the sculpture when the + passed through the green of the trees. But when the + hit a blue patch of sky, the background eraser erased some of the sculpture as well.

- 12. *Adjust the tolerance and undo*. Reduce the **Tolerance** value to **30** percent, a little more than half its default setting. After all, it was working okay; no sense in being *too* conservative. Then press Ctrl+Z one or more times to undo the background eraser brushstrokes. (If you back up too far and undo the magic eraser operation, click the (R) icon in the shortcuts bar or press Ctrl+Y to redo the operation.)
- 13. Try painting again. But with a few changes:
 - Position the brush just after the little patch of sky at the top of Zephyr's head, as indicated by the circled cursor in the first example in Figure 8-34. The sky is too complex for the background eraser to handle; we'll clean it up in a moment with the standard eraser tool.
 - Click to set the initial spot that you want to erase. Then Shift-click at brief intervals along the perimeter of Zephyr's head, down to the fellow's chin. Take care to Shift-click often; each click samples a color, and it's important to have lots of them.
 - You'll have the best luck dragging in the neck region. If you see red creep into Zephyr's face, undo the brushstroke and try again. Keep dragging until you come up with something resembling the right image in Figure 8-34.

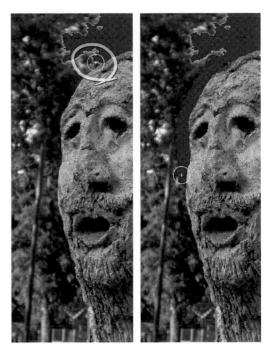

Figure 8-33.

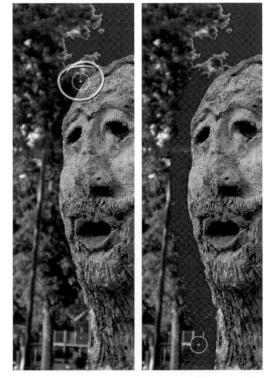

Figure 8-34.

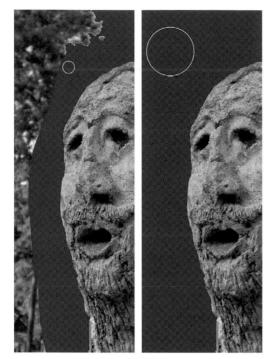

Figure 8-35.

- 14. Select the eraser tool. We'll finish things off with the ordinary eraser tool, which is nothing more than a brush that paints transparency. Press the E key (or Shift+E) a couple of times, or choose it from the flyout menu in the toolbox. Then press the
 ☐ key four times to increase the brush size to 50 pixels.
- 15. *Finish erasing around Zephyr.* Use the eraser to complete the selection. You'll have to undo every once in a while, so minimize your pain by keeping your brushstrokes short. Note that the vertical aquamarine bar along the neck is the edge of a tile and belongs to the sculpture rather than the background; you can click at the top of the outside edge and then Shift-click at the bottom to erase in a straight line. Otherwise, reduce the brush diameter as you need to, and persevere. Eventually, you should get a nice edge, as in the left example in Figure 8-35. Finally, switch to a huge 200-pixel brush and erase the last of the background, leaving Zephyr awash in a red checkered sea, as in the right example in the figure.
- 16. Relocate Zephyr to a new image. Press the V key to get the move tool. Then drag Zephyr and drop it into the Ruins.jpg image. Move Zephyr to the lower-right corner of the ruins until it snaps into place. For Figure 8-36, we also switched to the Background layer and applied Filter→Blur→Gaussian Blur with a Radius of 8 pixels to create a quick depth-of-field effect. With a little help from the eraser tools, the god of wind has blown himself all the way from his original home of Nashville, Tennessee to the crumbled ruins in Antigua, Guatemala.

WHAT DID YOU LEARN?

Match the key concept in the numbered list below with the letter of the phrase that best describes it. Answers appear upside-down at the bottom of the page.

Key Concepts

- 1. Flat
- 2. Layered composition
- 3. Stacking order
- 4. Free Transform
- 5. Photoshop (PSD) format
- 6. Merge Down
- 7. Bring Forward
- 8. Four-point distortion
- 9. Magic eraser
- 10. Background eraser
- 11. Sampling point
- 12. Eraser tool

Descriptions

- A. The arrangement of layers in a composition, from front to back, which you can adjust by pressing Ctrl with the bracket keys, [] and [].
- B. The ideal file format for saving all layers, blend modes, selections, layer styles, and anything else you can create in Photoshop Elements.
- C. The original single-layer state of a digital photograph or scanned image.
- D. Nothing more than a "dumb" brush, this tool paints in the background color (by default, white) on the Background layer or with transparency on any other layer.
- E. This command moves a layer upward in the stacking order.
- F. This type of transformation permits you to scale or slant one portion of a layer independently of another.
- G. The one command that enables you to scale, rotate, flip, skew, or distort layers.
- H. When you click with this tool, it identifies an area of homogeneous color and then deletes that area.
- I. Choose this command to combine the contents of the active layer with the layer beneath it.
- J. A Photoshop Elements document that contains two or more images on independent layers.
- K. When you trace loosely around the perimeter of an object with this tool, Elements tries to identify the edges and delete just those pixels that fall outside the edges.
- L. Identified by a +, this component of the background eraser cursor reads colors from the image and decides which pixels to delete.

Answers

IC' 51' 3V' +C' 2B' 9I' LE' 8E' 6H' I0K' IIF' I5D

TEXT AND SHAPES

AS YOU'VE NO doubt discerned by now, the overwhelming majority of features in the Editor workspace are devoted to the creation and manipulation of pixel-based images. The two exceptions are the subjects of this lesson. Known as text and shapes, they have nothing whatsoever to do with digital photography, scanned artwork, or pixels in general.

Where text and shapes are concerned, Photoshop Elements is more illustration program than image editor. You can create single lines of type or set longer passages. You can select text you created long ago and edit typos. You have access to a variety of common formatting attributes, including typeface, size, and style. You can even distort type along a curve. In addition to using type, you can augment your designs with rectangles, polygons, and custom predrawn symbols—the kinds of geometric shapes that you take for granted in a drawing program but rarely see in an image editor.

All this may seem like overkill, the sort of off-topic folderol that tends to burden every piece of consumer software these days. But while you may not need text and shapes for *all* your work, they're incredibly useful on those occasions when you do. Whether you want to prepare a bit of specialty type, mock up a commercial message (see Figure 9-1), or design a special component for a project, Elements' text and shape functions are precisely the tools you need.

Figure 9-1.

ABOUT THIS LESSON

Project Files

Before beginning the exercises, make sure you've downloaded the lesson files from *www.oreilly.com/go/deke-PSE8*, as directed in Step 2 on page xiv of the Preface. This means you should have a folder called *Lesson Files-PSE8 10n1* on your desktop (or whatever location you chose). We'll be working with the files inside the *Lesson 09* subfolder. In this lesson, we'll show you how to use Photoshop Elements' text and shape tools, as well as ways to edit text and shapes by applying formatting attributes and transformations. You'll learn how to:

•	Create a text layer and modify its appearance page 238
•	Apply transformations and filters to produce special text effects
•	Draw, combine, transform, and duplicate scalable vector-based shapes
•	Edit text on a path as well as warp text by bending and distorting it
	Apply and modify layer styles page 265

Video Lesson 9: Scalable Objects and Effects

Photoshop Elements treats text and shapes as special kinds of layers. Once created, they remain fully editable with the type and shape tools. And because they're vector-based, you can scale or otherwise transform the layers without degrading their quality. In this video lesson, Deke also introduces you to layer styles.

You can either watch the video lesson online or download to view at your leisure by going to *www. oreilly.com/go/deke-PSE8*. During the video, you'll learn about the keyboard equivalents and shortcuts listed below.

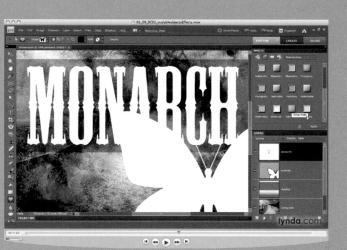

Operation

Preview font on selected type

Incrementally increase or reduce size of selected type Update text layer and return to the Standard Edit mode Move text when type tool is active Fill the text or shape layer with background color

Position a shape on-the-fly as you draw it

Cycle through custom shapes

Keyboard equivalent or shortcut ↓ or ↑ when font option is active Ctrl+Shift+? or Ctrl+Shift+? Enter on keypad (or Ctrl+Enter) Ctrl-drag text Ctrl+Backspace Space bar [] or [] (left or right bracket)

The Vector-Based Duo

Generally speaking, Photoshop Elements brokers in pixels, or *raster art*. But the subjects of this lesson are something altogether different. Elements treats both text and shapes as *vector-based objects* (or just plain *vectors*), meaning that they rely on mathematically defined outlines that can be scaled or otherwise transformed without degradation in quality.

For a demonstration of how vectors work in Elements, consider the composition shown in Figure 9-2. The Q is a text layer with a drop shadow. The black crown and the orange fire are shapes. The background is a pixel-based gradient. The reason the artwork appears so jagged is because it contains very few pixels. The image measures a scant 50 by 55 pixels (less than 2,800 pixels in all) and is printed at just 15 pixels per inch!

Clearly, you'd never create such low-resolution artwork in real life. It's here to demonstrate a point: If this were an entirely pixel-based image, we'd be stuck forevermore with jagged, indistinct artwork. But because the Q, crown, and fire are vectors, they are scalable. And unlike pixel art, vectors grow smoother as you make them bigger.

The best way to scale vectors is to apply the Image Size command. To achieve the result pictured in Figure 9-3, you'd chose Image→Resize→Image Size and turn on the Resample Image checkbox. (Scale Styles and Constrain Proportions were also turned on.) Then increase the Resolution value to a whopping 480 pixels per inch and click the OK button. The result is an amazing transformation, with vectors and drop shadow growing in picture-perfect form to fit the enhanced resolution. Only the greenish-blue pixel-based gradient in the background remains jagged.

The upshot is that vectors are a world apart from anything else inside Photoshop Elements, always rendering at the full resolution of the image. To see more on this topic, watch Video Lesson 9, "Objects and Effects."

An incredibly low-res composition (50 x 55 pixels), rendered at 15 ppi

Figure 9-2.

The same image, scaled to 480 ppi (3200%) using the Image Size command

Creating and Formatting Text

Text inside Photoshop Elements works just like it does inside your average publishing application. You can apply typefaces, scale characters, adjust line spacing, and so on. However, because Elements is first and foremost an image editor, it isn't particularly well-suited to routine typesetting. Rather than belabor the routine typesetting functions, we'll take a look at some text treatments to which Photoshop Elements is well suited, as well as a few functions that are exceptional or even unique to the program.

In this exercise, we'll add text to an image and format the text to fit its background. In the next one, we'll apply a few special effects.

1. *Open an image*. Not every image welcomes the addition of text. After all, text needs room to breathe, so your image should have ample dead space, the kind of empty

background you might normally crop away. Such is the case with *Pumpkin light.psd* (Figure 9-4). Found in the *Lesson 09* folder inside *Lesson Files-PSE8 10n1*, this digital photo includes two strong foreground elements with lots of empty space below and above. These are perfect places for some relevant text.

EARL OF

WISDOM

When you open this document, you may see the following alert message: "Some text layers might need to be updated before they can be used for vector based output." Most likely you won't, but if you do, click the **Update** button. This ensures that the one live text layer remains editable.

Figure 9-4.

- 2. *Click the type tool in the toolbox.* Or press the T key. Elements provides four type tools, but the horizontal type tool—the one that looks like an unadorned T (see Figure 9-5)—is the only one you need. So press T to cycle to the horizontal type tool.
- 3. *Establish a few formatting attributes in the options bar.* When the type tool is active, the options bar provides access to *formatting attributes*, which are ways to modify the appearance of live text. Labeled in Figure 9-6, they include the following:
 - Click the first □ arrow to see a list of typefaces available to your system. We prefer the term *font families* (or just plain *font*) because most typefaces include multiple styles, such as bold and italic.
 - To make the figures in this book look their best, we used Adobe Caslon Pro. (If it happens to be installed on your computer, you'll find it alphabetized under the Cs.) Most likely, you don't have Caslon, in which case select Times, Times New Roman, or a similar font.
 - The type style pop-up menu lists all the stylistic alternatives for the selected font. Set the style to read **Regular** or Roman. (All style icons toward the middle of the options bar should be off.)

- If you're using Caslon Pro, set the **type size** to **60** points. For Times or Times New Roman, set the value to **68** points. Then press the Enter key to accept the new size value.
- Antialiasing determines whether Elements applies edge softening to the text. Leave it turned on.
- The alignment setting lets you align rows of type to the left, center, or right of the point at which you click with the type tool. Click the ⊡ to see the pop-up menu, and choose the first item for Left Align Text.
- The distance between one line of type and another is called *leading*. By default, Elements' leading is set to Auto, which is 120 percent of the prevailing type size. This text will include just one line, so the leading here is inconsequential.

- The color swatch determines the color of the type. By default, the swatch matches the foreground color. Press the D key followed by the X key to make the swatch white.
- The final option lets you apply a layer style to the text. For now, this option should be set to none, as in ⊠.

You can change any of these formatting attributes after you create your text. Getting a few settings established up front merely saves a little time later.

4. *Click in the image window.* Click below the pumpkins in the lower-left portion of the image. Don't worry about the exact location. Better to get the text on the page and align it later.

PEARL OF

WISDOM

When you click, Elements greets you with a square alignment point intersected by a vertical blinking insertion marker. You are now set to create *point text*, which is type that is unhampered by a maximum column width and aligned to the point at which you clicked, perfect for setting headlines and individual words or lines of type.

5. Enter a line of text. Turn on Caps Lock on your keyboard. Then type "fright lights". Be sure to turn off Caps Lock when you're finished. You should see white capital letters across the bottom of your image, as in Figure 9-7. If the Layers panel is visible, you'll also notice the appearance of a new layer marked by a T icon. This T indicates that the layer contains live text.

Figure 9-7.

If you see a weird red pattern in the thumbnails in your Layers panel, it's because you changed the transparency pattern (albeit, per our instructions) in the preceding lesson. To restore the default gray, press Ctrl+K, press Ctrl+4, set the Grid Colors option to Light, and click OK.

6. Accept your changes. Press Enter on the numeric keypad (not the Enter key above Shift) to exit the type mode and accept the new text layer. You can also press Ctrl+Enter or click the green ✓ in the options bar. But don't press the standard Enter key on its own—doing so will add a carriage return.

At this point, Elements changes the name of the new text layer in the Layers panel to FRIGHT LIGHTS. The program will even update the name if you make changes to the type. You can also rename the layer, but doing so prevents Elements from updating the layer name later.

7. *Drag the text to the lower-left portion of the image.* Press the **Ctrl** key and drag the text into the position illustrated in Figure 9-8.

Figure 9-8.

8. *Select and show the Body Copy layer.* Click the Body Copy layer, and then click the empty box in front of it to make it visible. This layer contains a paragraph of type set in the world's ugliest font, Courier New. (For you, it may appear in some other Courier derivative, but rest assured, they're all dreadful.) The only reason the layer is here is to spare you the tedium of having to enter the type on your own. But that doesn't mean there's nothing for you to do. Much formatting is in order.

PEARL OF

WISDOM

The Body Copy layer contains a special variety of text called *area text*. To create such a layer, you drag with the type tool to define the boundaries of the *text block*. As you enter text from the keyboard, Elements automatically wraps words down to the next line as needed to fit within the confines of the block.

- Assign a better font. As long as a text layer is active, you can format the entire layer by adjusting settings in the options bar. For starters, click Adobe Caslon Pro (or your current font) in the options bar to highlight the font name. Then you can either:
 - Press the ↑ or ↓ key to cycle to a previous or subsequent font in alphabetical order. This technique lets you preview your text as it appears when set in the various fonts installed on your system, which is handy if you want to see what fonts such as Chalkboard or Britannic Bold will look like. (Those are just examples; your strange fonts will vary.)
 - Enter the first few letters of the name of a font you want. For example, type V-e-r to switch to Verdana, which is included with Microsoft Windows. Then press the Enter key to apply the font and see how it looks.

Figure 9-9 shows the result.

Figure 9-9.

- 10. *Make the first two words of the paragraph bold.* Zoom in on the words *Happy Jacks* at the beginning of the paragraph to better see what you're doing, either by pressing Ctrl+ (plus) or by switching to the zoom tool. Then select the type tool again, if necessary, and follow these instructions:
 - Select both words by double-clicking *Happy* and, while holding the second click, dragging over *Jacks*.
 - Choose **Bold** from the type style menu in the options bar, as shown in Figure 9-10. You can do the same from the keyboard by pressing Ctrl+Shift+B.

AA TTTTE E Auto

Figure 9-10.

11. *Make the word* clowns *italic*. Find *clowns*—the third-to-last word in the paragraph—and double-click it. Then choose **Italic** from the type style menu in the options bar or press the keyboard equivalent Ctrl+Shift+I.

PEARL OF

WISDOM

Even if a font doesn't offer a bold or italic style, the keyboard shortcuts still function. In place of the missing designer style, press Ctrl+Shift+B to thicken the letters for a *faux bold*; press Ctrl+Shift+I to slant them for a *faux italic*. Beware: faux styles don't always look right.

- 12. *Select the entire paragraph, except the first two words.* Next let's change all but the first two words, *Happy Jacks*, to a yellowish orange to match the pumpkin. Start by double-clicking the third word, *What*. Then press the Shift key and click just after the period at the end of the paragraph.
- 13. Change the color to a yellowish orange. Click the white color swatch toward the right side of the options bar to display the Color Picker dialog box. Then move the cursor into the image window and click in one of the fleshy areas inside the big pumpkin's nose, as shown in Figure 9-11 on the next page. You should end up with a color in the vicinity of H: 40, S: 50, B: 90. (If you can't get a good match, go ahead and enter the values manually.) Then click the OK button to recolor the text. (Note that the text will appear blue on white because it's highlighted.)

- 14. Accept your changes. Press Enter on the keypad, click the green

 ✓ in the options bar, or press Ctrl+Enter to exit the type mode
 and accept the changes to the Body Copy layer. Then press
 Ctrl+Ξ to zoom back out a bit.
- 15. Save your composition. You're going to need this file to complete the next exercise, so choose File→Save As. Name your updated file "My pumpkin type.psd" and save it in the same *Lesson 09* folder inside *Lesson Files-PSE8 10n1*. If you plan on moving on to the next exercise immediately, go ahead and leave the file open, and skip to Step 2 on the facing page.

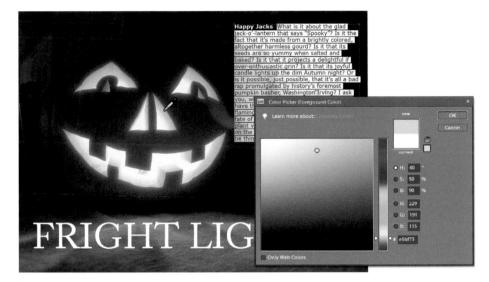

Figure 9-11.

Applying a Special Text Effect

All this editing and formatting is fine and dandy, but it's the kind of thing that you could accomplish in a layout program such as Adobe InDesign, which is better designed for composing and printing highresolution text. In this exercise, however, you'll do something that's a perfect task for an image editor such as Photoshop Elements: apply some photographic depth and shadow treatments.

1. *Open the file you saved in the last exercise.* If the jack-o'-lanterns remain open, skip to the next step. Otherwise, find the file called *My pumpkin type.psd* in

the Lesson 09 folder inside Lesson Files-PSE8 1011. (Note that this is the file you created and saved in the last exercise. If you can't locate the file, we've also supplied a catch-up file called Prepared pumpkin.psd.)

- 2. Show the Color Holder layer in the Layers panel. Click in front of the Color Holder layer to display the ^(*) icon. A tiny brown pumpkin appears above the big pumpkin's head. This layer holds the color we'll apply to the FRIGIIT LIGHTS text.
- 3. *Eyedrop the brown pumpkin.* Press the I key to select the eyedropper tool and then click the little pumpkin to make its brown the foreground color.
- 4. *Fill the Fright Lights layer with the sampled brown.* Click the **FRIGHT LIGHTS** layer in the **Layers** panel to make it active. Then press **Alt+Backspace** to fill the text with brown, as shown in Figure 9-12. When filling an entire text layer, this time-saving keystroke lets you recolor text without having to visit the Color Picker dialog box.

Figure 9-12.

- 5. Maximize the interface window. The next trick is to add a *cast* shadow, which is a shadow cast by the letters that falls away from the light source. In this case, the light source is the pumpkin, so the shadow needs to extend toward the viewer in the area below the letters. To pull this off, you'll need some extra room. Click the \Box icon in the top-right corner of the interface (not the image) window to surround the pumpkin artwork with gray pasteboard. To give yourself even more room, zoom out.
- 6. *Duplicate and transform the text*. Press **Ctrl+J** to duplicate the **FRIGHT LIGHTS** layer, then **Ctrl+T** to enter the free transform mode.

There's no way to convey in one or two exercises all the wonderful ways Photoshop Elements permits you to edit and format text. So here are a few truly terrific tips and techniques to bear in mind when working on your own projects:

- Double-click a T thumbnail in the Layers panel to switch to the type tool and select all the text in the corresponding layer.
- Armed with the type tool, you can double-click a word to select it. Drag while holding the second click to select multiple words. Triple-click to select an entire line. To select all the text in a layer, press Ctrl+A when the text is active.
- To underline some type, press Ctrl+Shift+U. To draw a line through the type, press Ctrl+Shift+D. To restore the Regular or Roman style of a font, as well as turn off any underline or strikethrough style, press Ctrl+Shift+Y.
- To increase the size of selected characters in 2-point increments, press Ctrl+Shift+?. To reduce the type size, press Ctrl+Shift+?. To change the type size by 10 points, press Ctrl+Shift+Alt+? or Ctrl+Shift+Alt+?.
- To override the default leading, click the tA icon in the options bar to highlight the word (Auto) and then type a number. In the figure below, we changed the leading to 16 points. Note that the new leading value affects the distance between a selected letter and the line above it.

- To right-justify a layer of type, so the right edges are aligned and all text appears to the left of the alignment point, press Ctrl+Shift+R. To center the text, press Ctrl+Shift+C. To return the text to flush left (preferable for long passages), press Ctrl+Shift+L.
- To move text when it's active, press the Ctrl key and drag inside the text.
- The foreground color icon at the bottom of the toolbox does not always reflect the color of highlighted text. But if you change the foreground color, any highlighted text changes as well.
- Elements lets you change the formatting of multiple text layers at a time. Click one layer and Shift-click another to select a range of layers. Or press Ctrl and click to select multiple nonadjacent layers. Then select a font, style, size, or other formatting attribute from the options bar.
- When editing text, Edit→Undo is dimmed and Ctrl+Z is ineffective. Your only option for undoing a text edit or formatting adjustment is to press the Esc key or click the red circle with a line through it. Problem is, this abandons *all* changes made since you entered the text edit mode. Furthermore, if you press the Esc key in the midst of creating a new text layer, you forfeit the entire layer. And because Esc can't be undone, there's no way to retrieve the layer. So be sure before you press Esc.

- 7. Flip and scale the duplicate layer. Here's how:
 - Click in the center of the icon on the far left in the options bar to make it look like **\$\$** (as circled in red in Figure 9-13). This sets the transformation origin to the center of the boundary box for the text layer, meaning that's where the transformation will start.
 - Make sure the Constrain Proportions checkbox is turned off. Then click the H in the options bar and change the value to -116 percent (circled in blue in the figure). The negative value reverses the height of the layer, thus flipping it vertically. Press the Enter key to accept the value.
 - Press Shift+↓ four times to scoot the text 40 pixels down from the bottom of the original upright text.

The final position is illustrated in Figure 9-13. Press **Enter** to apply the transformation and exit the free transform mode.

PEARL OF

WISDOM

A couple of special benefits when transforming a text layer: The type remains live and editable, so you can add text or fix typos. And because Photoshop Elements is working from vectors, the transformation does not stretch pixels or otherwise reduce the quality of the graphic. This means you can transform the text in multiple sessions without fear of degrading the quality.

Figure 9-13.

Figure 9-14.

- 8. *Rename the layer.* Double-click the name of the new layer in the Layers panel and change it to "Cast Shadow". Press Enter to accept the new name. Then press Ctrl+[] to move the renamed layer behind the original Fright Lights letters, as you can see in the Layers panel.
- 9. Set the blend mode to Multiply and reduce the opacity. This layer is a shadow, so it must darken its background. Choose Multiply from the blend mode menu at the top of the Layers panel, or press Shift+Alt+M. Press Esc and then press the 9 key to reduce the Opacity to 90 percent.
- 10. Choose the Gaussian Blur filter. To create a soft shadow, you need to apply one of the filters from the Filter→Blur submenu. But Elements' filters are applicable only to pixels; none of them can change live type. So when you choose Filter→Blur→Gaussian Blur, the program alerts you that continuing requires you to "simplify" the type (see Figure 9-14), which is Elements' euphemism for converting the type to pixels. (After nearly 300 pages of steps, it's fair to ask: What's so *simple* about pixels?) Click OK to confirm. From here on, you can no longer edit this particular layer with the type tool.
- 11. *Change the Radius value*. Enter a **Radius** value of **6** pixels and click **OK**. The blurred shadow type appears in Figure 9-15.

Figure 9-15.

- 12. *Again enter the free transform mode.* Now let's give the shadow some directional perspective so it looks like it extends out toward the viewer. Press **Ctrl+T** to enter the free transform mode, this time without creating a duplicate.
- 13. *Distort the shadow type.* The image in Figure 9-16 illustrates the two distortions we want you to apply:
 - Click the skew icon (∠) in the options bar, labeled in the figure.
 - Drag the handle in the lower-right corner of the transform boundary directly to the right, as indicated by the red cursor in the figure. Keep dragging until the W value in the options bar reads **115** percent.
 - Drag the lower-left handle of the transform boundary to the left, this time until the W value reads **121.5** percent, as indicated by the blue cursor in Figure 9-16.

When you're satisfied that your shadow looks like ours—or, if you prefer, more to your liking than ours—press the **Enter** key to apply the perspective distortion.

Figure 9-16.

WISDOM

You may wonder why two fundamentally opposite distortions were tracked by a single scale value. First, the W value reflected the amount of stretch applied to the bottom edge of the text only. So you stretched the bottom of the text independently of the top. Second, the value was cumulative, meaning that you added 15 percent (115) in one direction and 6.5 percent (121.5–115) in the other, thus resulting in a distortion.

EARL OF

You may also wonder why we had you wait until now to apply this distortion. Why didn't we do it when we were flipping and stretching the text back in Step 7? Although Elements lets you scale, rotate, and slant live type, you can't distort it. Therefore, this step had to wait until after the pixel conversion that took place in Step 10.

- 14. Show the Style Holder layer. Notice a hidden layer called Style holder at the top of the Layers panel? Click to the left of the layer name to reveal its icon. The layer is empty of pixels, so you won't see any change in the image window. But the empty layer includes a bevel style that will light up the type effect.
- 15. *Move Style Holder behind Fright Lights.* Either drag the layer behind **FRIGHT LIGHTS** or click on **Style Holder** and press Ctrl+[] three times to move it to the desired position.
- 16. Merge the Fright Lights and Style Holder layers. Click the FRIGHT LIGHTS layer to make it active. Then choose Layer→Merge Down or press the keyboard shortcut Ctrl+E. Either way, Elements merges the two layers, converts the text to pixels, and applies the beveled edges associated with the Style Holder layer to the FRIGHT LIGHTS letters.
- 17. *Delete the Color Holder layer.* Drag the Color Holder layer (the one that contains the brown pumpkin face) to the trash icon at the top of the Layers panel. The finished artwork appears in Figure 9-17.
- 18. *Save the file.* Choose File→Save As, give the file a different filename, such as "Happy Jacks.psd", and click Save. If you decide to revisit this file in the future, the Body Copy layer will remain editable with the type tool. As for the other layers, you can modify them as pixels.

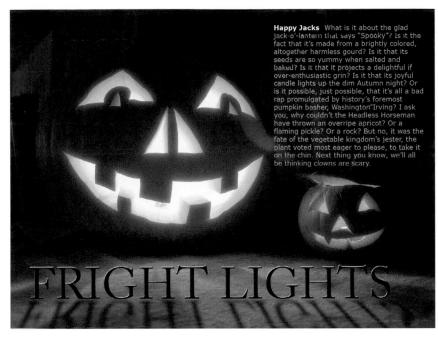

Figure 9-17.

Drawing and Editing Shapes

Elements' shape tools allow you to draw rectangles, ellipses, polygons, and an assortment of prefab dingbats and symbols. On the surface, they're a pretty straightforward bunch, but you'll quickly discover that the uses for shapes are every bit as wide-ranging and diverse as those for text.

You found out how to draw rectangles and ellipses back in Lesson 6 ("Using the Marquee Tools" on page 149). The techniques you learned there apply to the rectangle, ellipse, and custom shape tools as well. So in the following exercise, we'll focus on shapes you haven't yet seen, namely polygons, stars, and lines.

1. **Open an image.** Open the file *Election.psd* located in the *Lesson 09* folder inside *Lesson Files-PSE8 10n1*.

You'll see what appears to be a couple of text layers set against a fabric background, as shown in Figure 9-18 on the next page. But in fact, the word *Election* is a shape layer. Originally, the text was set in Copperplate, a well-regarded typeface that you may not have on your system. To avoid having the letters change to a different font on your machine, we converted them to shapes using the more expensive full-fledged Photoshop. This prevents you from editing the type, but you can scale or otherwise transform the vector-based shapes without any degradation in quality.

Figure 9-18.

- 2. Convert the 2032 layer to pixels. Let's say we want to similarly prevent the text 2032 from changing on another system. Unlike full-blown Photoshop, Elements doesn't let you convert text to shapes, but you can convert text to pixels. Right-click the word 2032 in the Layers panel and choose Simplify Layer (see Figure 9-19). Elements converts the characters to pixels, which will easily survive the journey from one system to another.
- 3. *Select the polygon tool in the toolbox.* Click and hold the shape tool icon near the bottom of the toolbox to display the flyout menu pictured in Figure 9-20. Then choose the polygon tool, which lets you draw regular polygons—things like pentagons and hexagons—as well as stars.
- Change the foreground color to white. Press the D key followed by X. Elements now knows to draw the shape in white.
- 5. Copy the Election layer's drop shadow. Right-click the Election layer and choose Copy Layer Style to copy the layer's drop shadow for later use. This action also selects the layer, ensuring that the next layer you draw appears at the top of the stack.

Figure 9-20.

- 6. Set the Polygon Options to Star. Our image is a States-side election graphic, so naturally one feels compelled to wrap the composition in stars and stripes. Click the arrow to the left of the Sides value in the options bar. This displays the Polygon Options pop-up menu pictured in Figure 9-21:
 - Turn on the **Star** checkbox to have the tool draw stars.
 - Make sure both **Smooth** checkboxes are off so the corners are nice and sharp.
 - Check that the **Indent Sides By** value is **50** percent (the default). This ensures that opposite points align with each other, as is the rule for a 5-pointed star.

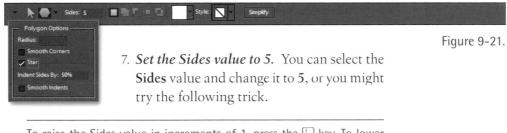

To raise the Sides value in increments of 1, press the [] key. To lower the value, press the [] key. Add the Shift key to raise or lower the value by 10. This tip holds true for any other value that might occupy this space in the options bar.

8. *Draw the first star.* The polygon tool draws shapes from the center out. To draw the star shown in Figure 9-22, drag from the location highlighted by the yellow ⊕ to the one highlighted by the dark green **●**. The new star receives a white fill and a new layer.

Figure 9-22.

- 9. Paste the drop shadow. Right-click the new Shape 1 layer and choose Paste Layer Style. The star receives the drop shadow that you copied in Step 5.
- 10. Carve a second star out of the first. Hold down the Alt key and draw another star from the same starting point (the yellow \oplus in Figure 9-23) to just inside the first star point (the dark green €). Because the Alt key is down, Elements subtracts this shape from the last one. The result is a star-shaped white stroke.

Figure 9-23.

As you draw the inner star, you may find that your alignment is a wee bit off. If so, bear in mind that you can adjust the placement of a shape on the fly by pressing and holding the space bar. When you get the star in the right position, release the space bar and keep drawing.

- 11. Choose the shape selection tool. Click the arrow tool in the toolbox, or press the U key three times to advance to the arrow. Elements calls this the shape selection tool (see Figure 9-24) because it lets you select and modify individual path outlines in a shape layer.
- 12. Select both inner and outer star paths. Turn off the Show Bounding Box checkbox in the options bar. (The arrow tool behaves more predictably with this option off.) Click the inner star, and then press the Shift key and click the outer star. Or drag around any portion of the star outlines to surround them with a marquee. Either way, Elements selects both paths.

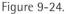

ded Rectangle Too

on Tool

- 13. Transform and duplicate the star. Press Ctrl+Alt+T to duplicate the selected star paths and enter the free transform mode. As in the last exercise, you have to have faith that you've cloned the paths since they exactly overlap the original paths.
- 14. *Scale, rotate, and move the duplicate star.* At this point, you'll need to make some precise adjustments:
 - Turn on the **Constrain Proportions** checkbox in the options bar so the W and H values scale the star paths proportionally. Then change either the W or II value to **80** percent.
 - Move to the Rotate value (see Figure 9-25), change it to -16 degrees, and press the Enter key. This tilts the star counterclockwise.
 - Drag the shape until it appears above and to the left of the larger star, as in Figure 9-25. Assuming the rotate value is no longer active, you can nudge the star with the arrow keys.

When the new star appears in the proper position, press the **Enter** key to confirm the transformation.

15. *Repeat the last transformation three more times.* This means pressing Ctrl+Alt+T to duplicate the latest star and enter the transform mode. Again scale the star proportionally to 80 percent, rotate it –16 degrees, press Enter, move it to the left, and press Enter again. Repeat the process twice more. It's a bit tedious, but the result—the arcing sequence of five stars shown in Figure 9-26—is worth the effort. Really now, how often are you rewarded with five stars?

Figure 9-25.

Figure 9-26.

- 16. *Name the new layer.* Double-click the Shape 1 layer name in the Layers panel and enter the new name "Stars".
- 17. *Turn on the Field layer.* Click the empty box in front of the **Field** layer in the Layers panel to display a slanted blue shape layer. We created this layer by drawing a plain old rectangle with the rectangle tool and distorting it in the free transform mode.
- 18. Set the Field layer to Hard Light. Click the Field layer in the Layers panel and either choose the Hard Light mode or press Shift+Alt+H. Press the Esc key, and then press 8 to lower the Opacity value to 80 percent. Even though Field is a vector shape layer, it's subject to the same blend modes and transparency options that are available to all layers in Photoshop Elements.
- 19. *Turn on the Stripes layer.* Click in front of the **Stripes** layer to display a sequence of red stripes. We created the top stripe by distorting a rectangle, then duplicated and transformed the other four.
- 20. *Set the Stripes layer to Multiply.* Click the Stripes layer to make it active, and press **Shift+Alt+M** to burn the stripes into the background image; the results are displayed in Figure 9-27.

Figure 9-27.

- 21. *Select the line tool.* The next step is to draw a rule under the word *Election*. The best tool for this job is the line tool, which you can select in any of the following ways:
 - Choose the line tool from the shape tool flyout menu, just as you chose the polygon tool back in Step 3.
 - Alt-click the shape tool icon in the toolbox or press the U key as many times as it takes to advance to the line tool.
- 22. *Increase the Weight value to 12 pixels.* The Weight value determines the thickness of lines drawn with the line tool. You can modify the value directly in the options bar, as shown in Figure 9-28, or press Shift+ to raise the value by 10 and to raise it another 1.

🔹 📐 👻 Weight: 12 px 🔳 🖬 🗖 🛄 🔽 💉 Style: 🔹 👻 Simplify

Figure 9-28.

- 23. *Select the Stars layer*. Click the **Stars** layer in the **Layers** panel. This tells Elements to create the next shape layer in front of the Stars layer and pick up the Stars layer's attributes.
- 24. *Draw a line under the word* Election. We want the rule to extend beyond the left edge of the canvas, so it's easiest to draw from right to left. Begin your drag below and just to the right of the last letter in *Election*, as illustrated in Figure 9-29. *After* you begin dragging, press and hold the **Shift** key to constrain the rule to precisely horizontal. (If you press Shift before you start to drag, you run the risk of adding the line to the existing Stars layer.) Drag beyond the edge of the canvas before releasing the mouse, and then release Shift.

Figure 9-29.

If you don't like the position of your line, change it. To move the line as you draw it, press and hold the space bar. To nudge the line after you draw it, Ctrl-click the shape outline to select it and then press Ctrl along with the appropriate arrow key $(\uparrow, \downarrow, \leftarrow, \text{ or } \rightarrow)$.

25. *Name the new layer.* Again, Elements automatically names the new layer Shape 1. Double-click the layer name and enter the new name "Underscore". Then click the **2032** layer to accept the name and hide the vector outlines around the shape layers. The final artwork appears in Figure 9-30.

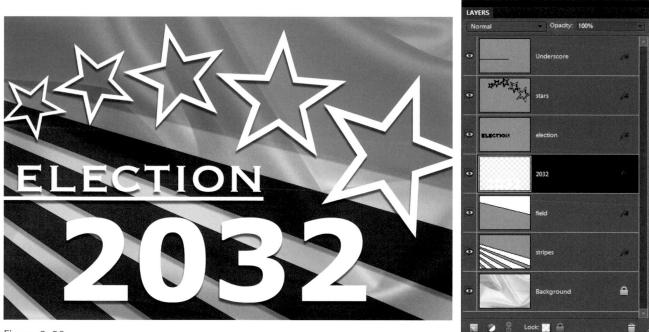

Figure 9-30.

The beauty of this design is that most of it is scalable. For example, to turn this into a piece of tabloid-sized poster art, choose Image→Resize→Image Size, turn on the Resample Image checkbox, and change the Width value in the Document Size area to 17 inches. Make sure all three checkboxes at the bottom of the dialog box are selected. To heighten the effect, change the Bicubic setting to Nearest Neighbor and then click OK. The background image and the pixel-based 2032 become jagged. But as witnessed in Figure 9-31 on the facing page, everything else remains supersmooth, a testament to the power of vector-based shapes in Photoshop Elements.

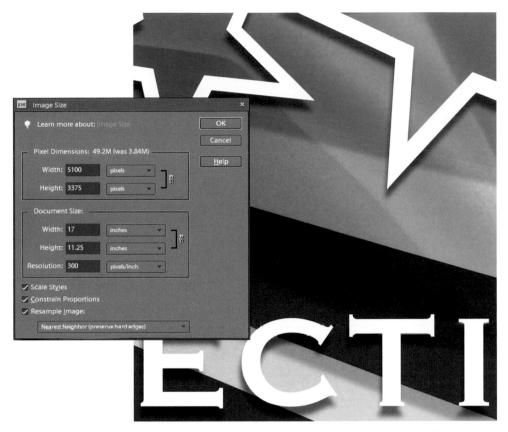

Figure 9-31.

Bending and Warping Type

The distortions we performed back in Step 13 of the "Applying a Special Text Effect" exercise (see page 249) aren't possible with live, editable text layers. But that doesn't mean live text distortions are entirely out of the question. Elements offers a text-specific distortion function called Warp Text. And it's so fantastic and easy to use, we lament the fact that it can't be applied to shapes and images.

This exercise shows you how to work with distorted type in Photoshop Elements. We'll start things off by editing text wrapped around the perimeter of a circle. Then we'll stretch and distort letters inside the contours of a predefined free-form shape. All the while, our text layers will remain live and fully editable.

1. *Open a layered image*. This time around, the file in question is *Radio-free space.psd*, which you'll find in the *Lesson 09* folder inside *Lesson Files-PSE8 10n1*. If

the program complains that some layers need to be updated, click the **Update** button. Pictured in Figure 9-32, the composition contains several layers of shapes and live type. We'll modify a couple of the text layers in the upcoming steps.

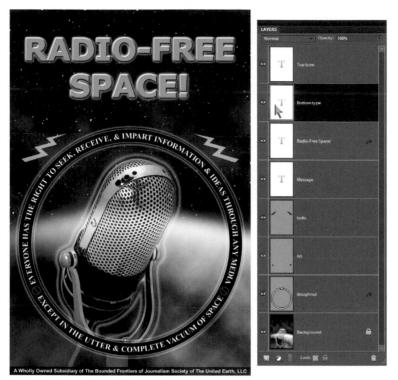

Figure 9-32.

Figure 9-33.

2. Select the text in the Bottom Type layer.

Among the text layers are two—Top Type and Bottom Type—that were pre-aligned to a circle inside full-service Photoshop. As fate would have it, Photoshop Elements lacks any means for creating text on a circle, but it does let you edit it. For example, let's say we want to reverse the order of the words *utter & complete* along the bottom of the circle. To select this type, double-click the T thumbnail to the left of **Bottom Type** in the **Layers** panel. Elements switches to the type tool and highlights the text.

- 3. *Edit the text.* The type tool is versatile, but it is not adept at selecting type along a curve. Better to select the text from the keyboard as follows:
 - Press the ← key to move the insertion marker to the beginning of the text.
 - Press Ctrl+→ three times in a row to advance to the word *utter*.
 - Press Ctrl+Shift+→ three times to highlight *utter & complete*, as shown in Figure 9-33.

Now replace the type with "complete & utter", which is the more natural and conventional word order. You can enter the words as lowercase characters; Elements will automatically change them to uppercase thanks to a formatting attribute assigned in Photoshop. When you finish, press the Enter key on the numeric keypad or the green ✓ in the options bar to accept your changes.

- 4. Select the Radio-Free Space! layer. Press Alt+[] to drop down to the layer. Right now, the text treatment at the top of the page is almost comically bad. Cyan letters, wide leading, thick red strokes, Verdana—how much worse could it get? We'll start by spicing up the text with a blend mode, and then we'll warp the text for a classic pulp fiction look.
- 5. Change the blend mode to Overlay. Select Overlay from the pop-up menu at the top of the Layers panel, or press Shift+Alt+O. The already much improved result appears in Figure 9-34.
- Click the warp icon in the options bar. Press T to reselect the type tool. Then look to the far right side of the options bar for an icon that looks like I (labeled in Figure 9-35). Click this icon to bring up the Warp Text dialog box.

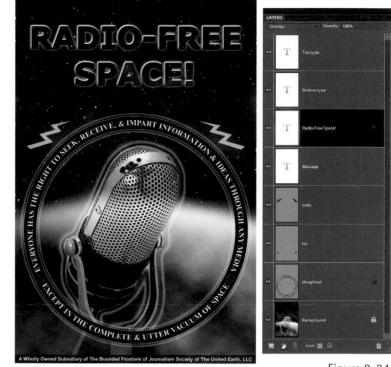

Figure 9-34.

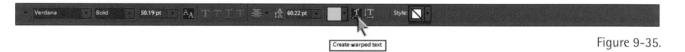

- 7. *Apply the Arc Lower style.* The Warp Text dialog box features these options:
 - The Style pop-up menu defines the shape inside which the text bends. The icons provide hints as to what the effect will look like. But if in doubt, choose an option and watch the preview in the image window.
 - Change the angle of the warp by selecting the Horizontal or Vertical radio button. With Western-world text like the stuff we're working with in this exercise, Horizontal bends lines of type and Vertical warps the individual letters.
 - Use the Bend value to change the amount of warp and the direction in which the active text layer bends. You can enter any value from -100 to 100 percent.
 - The two Distortion sliders add a hint of perspective to the warp effect.

Bending and Warping Type **261**

For example, Figure 9-36 shows four variations on the Arc Lower style. The icon next to the style name represents the effect as flat on top and bent at the bottom. Assuming Horizontal is active, this means the warp is applied exclusively to the bottom of the text. A positive Bend value tugs the bottom of the text downward (first image); a negative value pushes it upward (second image).

To achieve a strict perspective-style distortion, choose any Style option and set the Bend value to 0 percent. Examples of purely horizontal and vertical distortions appear in the last two images in Figure 9–36.

For this exercise, choose **Arc Lower** from the **Style** pop-up menu, and then set the **Bend** value to -40 percent. The resulting effect

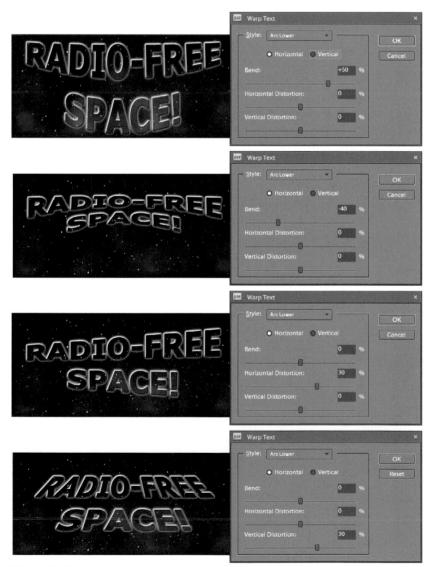

looks awful—easily the worst of those shown in Figure 9-36—but that's temporary. Have faith that we'll fix things in future steps, and click **OK**.

- 8. *Increase the size of the word* Space! Triple-click the word *Space!* with the type tool to select both it and its exclamation point. Press Ctrl+Shift+? to increase the type size incrementally until the width of the selected text matches that of the text above it. (To resize faster, press Ctrl+Shift+Alt+?).) Or just change the type size value in the options bar to **88** points, as in Figure 9-37.
- 9. *Increase the leading.* Although the selected word better fits the horizontal dimensions of its layer, it overlaps the line above it. Click the $\frac{A}{IA}$ icon in the options bar to highlight the leading value. Change it to 76 points and press **Enter** (see Figure 9-38).
- Accept your changes. Press the Enter key on the keypad to exit the text edit mode and accept the formatting adjustments.
- 11. Scale the text vertically. One of the byproducts of warping is that it stretches or squishes characters, thus requiring you to scale them back to more visually appealing proportions. In our case, the text is really squished, so some vertical scaling is in order. Choose Image→Transform→Free Transform, or press Ctrl+T. Turn off the Constrain Proportions checkbox, change the H value to 167 percent, and then press the Enter key twice in a row to make the letters taller without making them wider, as in Figure 9-39.

Figure 9-37.

Figure 9-38.

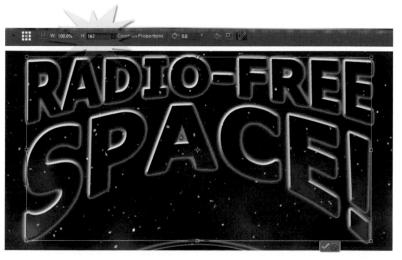

12. *Nudge the text down*. The text now rides too high on the canvas. Press Ctrl+Shift+↓ three times in a row to nudge the text down 30 pixels. The final composition appears in Figure 9-40.

It's important to note that throughout all these adjustments, every single text layer remains fully editable. For example, to change the text from *Radio-Free Space!* (indicating a space completely free of radio) to *Radio Free Space!* (which suggests a broadcast organization devoted to the advancement of freedom and liberty in outer space), simply replace the hyphen with a space character. The layer effects are likewise live. To change the style of warp, select the text layer in the Layers panel and click the text warp icon in the options bar. We ask you: what in the world could be more flexible?

Figure 9-40.

Applying and Modifying Layer Styles

One of the easiest and most effective devices for adding texture to your shape- and text-based compositions is the use of layer styles. Layer styles serve two opposing purposes: to set layers apart and to bring them together. For example, a layer style that casts a shadow suggests that the object in a layer is raised above the surface of its surroundings. This calls attention to the perimeter of the layer and adds depth to the image, both of which help to distinguish the layered element from a busy composition. Meanwhile, a layer style can also blend the interior or perimeter of a layer with its background. The independent layers appear not as disparate elements of a composition, but instead as seamless portions of a cohesive whole.

We've used layer styles casually in a couple of previous exercises, but this exercise takes a directed look at these two roles. We'll take a plain composition and embellish it using a trio of predefined styles that we've created in Photoshop. (Photoshop Elements can only modify styles, not create them.) Before beginning this exercise, make sure that you've installed the style libraries and metadata files onto your computer (see Step 6 on page xvi). In all, these libraries contain more than 80 styles that you can apply, mix, and modify as you please.

1. **Open a layered composition.** Go to the Lesson 09 folder inside Lesson Files-PSE8 10n1 and open the file called Paper letters.psd. Pictured in Figure 9-41, this

image features a total of four layers. The background was scanned from a brown paper bag. The other layers are filled with various shades of gray. Drab, yes, but it just so happens this is precisely the kind of drab art that benefits most from layer styles.

- 2. *Select the E layer.* Click the top layer in the Layers panel or press Shift+Alt+[].
- 3. Open the layer styles. First make sure the Effects panel is available on screen. (If necessary, choose Window→Reset Panels to put it back at the top of the panel bin.) Then click the second icon from the left under the word "Effects". Most likely, you'll see a series of none-too-exciting thumbnails that represent various drop shadows. Blah. But trust us, plenty of exciting stuff is here—you just have to know where to look.

Figure 9-41.

Figure 9-43.

- 4. Apply the Green Glass style. The pop-up menu at the top-right of the Effects panel lets you select a library of styles that Elements loaded automatically when you started the program. Click the pop-up menu and choose a library midway down titled Deke Glass. (If you don't see this option, refer to the Preface for installation instructions.) You should see a total of 12 candy-colored thumbnails. Click the one called Green Glass and click Apply at the bottom of the Effects panel to apply the shimmering, translucent effect shown in Figure 9-42.
- 5. Apply the Indigo Matte style to the 3 layer. Sometimes a style works as is, right out of the box. Such is the case with the almost liquid Green Glass effect. Other times, a style needs some help, as we'll see in this next example. Let's start by applying a base style to another layer:
 - Click the 3 layer in the Layers panel to make it active. Or press Alt+1 to move backward. (If the shortcut doesn't work, press the Esc key to deactivate the style name and then press Alt+[].)
 - Choose Deke Surfaces from the upperright pop-up menu in the Effects panel.
 - Click the style marked Indigo Matte, and then click Apply at the bottom of the Effects panel. The result appears in Figure 9-43.
- 6. Edit the style settings. We like the color and drop shadow associated with this style, but the beveled edges are just too much for this image. To modify the style, double-click the fx icon that now appears to the right of the 3 layer in the Layers panel. This brings up the Style Settings dialog box, which lets you modify the attributes associated with the active style. Here's a quick rundown of the options that currently confront you, along with the settings you should enter:

- If it isn't already on, go ahead and select the **Preview** box so you can see the results of your edits.
- Set the **Lighting Angle** value to **100** degrees, which shifts the light source more directly above the layer. This casts a shadow in the opposite direction, almost straight down.
- Press Tab a couple of times to advance to the Drop Shadow's **Distance** option. Enter a value of **20** pixels to move the shadow 20 pixels away from the layered objects.
- Next tab to the **Bevel Size** option, which controls the thickness of the beveled edges. Reduce the value to **5** pixels, to make the edges thin.
- The **Bevel Direction** should be set to **Up**, which makes the layer appear raised as opposed to recessed.

Click the **OK** button to accept your changes. Both the settings and the modified result appear in the resplendent Figure 9-44.

- 7. *Group the 3 layer with the square below it.* We want the vertical lines of the 3 layer to fit inside the gray square. And we can do that using a special function called a *clipping mask*, in which one layer fits inside the layer below it. So choose **Layer→Create Clipping Mask** or press Ctrl+G to combine the two layers into a clipping mask, as in Figure 9-45.
- 8. *Apply Orange Glass to the Box layer.* Now we turn our attention to the final layer, the light gray square:
 - Click the word **Box** in the **Layers** panel or press the handy shortcut Alt+ to make the layer active.
 - Again choose **Deke Glass** from the upper-right pop-up menu in the **Styles and Effects** panel.
 - · Click the Orange Glass layer style, and then click Apply.
- Edit the style settings. The result is nice, but again it needs work. Double-click fx and change the settings like so:
 - Set the Lighting Angle value to 165 degrees. The Use Global Light checkbox is off, so adjusting the Angle value won't affect the other layers.
 - Lower the Drop Shadow Distance to 10 pixels.
 - Likewise lower the **Bevel Size** value to **10** pixels. Then change the **Bevel Direction** option to **Down** to create the effect of a slight depression in the background.

Figure 9-44.

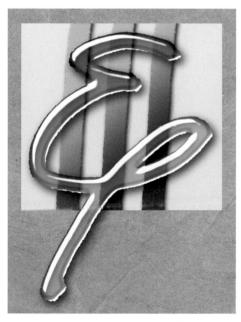

Figure 9-45.

Figure 9-47.

When your settings—and the altered effect—look like those in Figure 9-46, click the **OK** button.

10. *Change the fill opacity to 30 percent.* Photoshop Elements offers a remarkable hidden feature that lets you adjust the transparency of the pixels in a layer independently of the layer style. Termed *fill opacity*, this function is represented neither by command nor option; you can get to it only from the keyboard.

Try this: Press the V key to confirm that the move tool is active. Then press Shift+1. Notice how the layer becomes more transparent but the drop shadow and bevel remain unchanged. You just changed the fill opacity to 10 percent. Now press Shift+0. The light gray of the square returns because you restored the fill opacity to 100 percent. Do you feel the rare satisfaction of discovering a top-secret, ultrahidden feature? You should, because that's precisely what you have just done.

Now that you've had a chance to experiment, press **Shift+3** to change the fill opacity to 30 percent.

- 11. *Nix the Indigo Matte style on the 3 layer.* Having had time to reflect, we're not terribly impressed by the layer style we applied to the 3 layer. So let's get rid of it. Right-click to the right of the **3** in the **Layers** panel. Then choose **Clear Layer Style** from the shortcut menu. The style and its associated fill opacity setting go away, leaving behind fully opaque black stripes.
- 12. *Change the standard opacity to 30 percent*. Press the **3** key without Shift to reduce the standard opacity of the 3 layer to 30 percent. Or you can adjust the **Opacity** value in the Layers panel directly. The final composition appears in Figure 9-47.

Now that you've made it through this lesson, you have a sense of the objects you can create and manipulate beyond those pixel-based images you've captured with a scanner or digital camera.

WHAT DID YOU LEARN?

Match the key concept in the numbered list below with the letter of the phrase that best describes it. Answers appear upside-down at the bottom of the page.

Key Concepts

Descriptions

- 1. Raster art
- 2. Vector-based objects
- 3. Formatting attributes
- 4. Font family
- 5. Flush left
- 6. Leading
- 7. Faux styles
- 8. Point text
- 9. Area text
- 10. Simplify
- 11. Live type
- 12. Warp Text

- A. Font family, type style, size, leading, alignment, and a wealth of other options for modifying the appearance of live text.
- B. To convert live type into noneditable, rasterized type.
- C. Lines of text that are aligned along the left side.
- D. This dialog box bends and distorts live text to create wavy, bulging, and perspective effects.
- E. Use these Elements-imposed formatting attributes when a font doesn't come with bold or italic variations.
- F. To create this kind of type layer, first drag with the type tool in the image window to draw a rectangular bounding box, and then enter your text from the keyboard.
- G. A digital image composed exclusively of colored pixels.
- H. Text that has no maximum column width and aligns to the place at which you clicked with the type tool.
- I. Mathematically defined text and shapes that can be scaled or otherwise transformed without any degradation in quality.
- J. A typeface and its multiple related styles.
- K. The distance between lines of type.
- L. Text that remains editable.

Answers

IC' 5I' 3V' tl' 2C' eK' LE' 8H' 6E' I0B' IIF' I5D

CORRECTING COLOR AND TONE

WAY BACK in Lesson 3, you saw how the automatic correction features of Photoshop Element's Edit Quick tab really do try like crazy to address some of the most common color- and tone-related problems that afflict digital images. But it is not what we would call *predictable*. Even if you know exactly what a specific Auto command is supposed to do, clicking it is as likely to mess up an image as make it better. Photoshop Elements' brand of artificial intelligence is no substitution for the real thing—the power of the Edit Full tab to correct color casts and exposure issues.

At heart, Elements' color correction features are more or less an image cobbler. You can take a worn, maybe even poorly constructed photograph, with the pixelbased equivalent of sagging arches and worn heels, and make it better. As with shoes, not all images can be repaired; some are hopelessly defective from the moment they leave the factory. But most images have more life left in them than you might suspect (see Figure 10-1).

In this lesson, you'll learn how to correct the colors in an image, making up for some of the strange things that can happen to color as it moves from reality to pixels. We'll also hammer on some image weaknesses involving exposure: images that are too light (overexposed) or dark (underexposed) in the wrong places. Finally, we'll take a look at the Adobe Camera Raw plug-in, which allows for one-stop correction of many of these problems and can be used for more than just the raw file format for which it was originally designed.

Uncorrected shoe

Corrected automatically (with Smart Fix) in the Quick Fix mode

Corrected in the Standard Edit mode (could still use a real cobbler)

Figure 10-1.

ABOUT THIS LESSON

Project Files

Before beginning the exercises, make sure you've downloaded the lesson files from *www.oreilly.com/go/deke-PSE8*, as directed in Step 2 on page xiv of the Preface. This means you should have a folder called *Lesson Files-PSE8 1on1* on your desktop (or whatever location you chose). We'll be working with the files inside the *Lesson 10* subfolder. This lesson introduces you to the program's most capable color adjustment commands. We'll also explore such concepts as white balance, color temperature, and Camera Raw. You'll learn how to:

- Correct widespread color imbalance page 273
- Increase the saturation of a drab photo page 278
- Correct highlights, shadows, and midtones using the Levels commandpage 282
- Reduce backlighting and boost shadow detail . . . page 289
- Correct a photograph in Adobe Camera Raw page 292

Video Lesson 10: Color Adjustments and Adjustment Layers

In this video, Deke shows you some of the easy-to-use tools for color adjustment, including how to quickly adjust skin tone, remove a color cast, and even add a color to a previously black and white image. He'll also show you how to make edits using adjustment layers, which work nondestructively, retaining all the information of your original image.

You can either watch the video lesson online or download to view at your leisure by going to *www. oreilly.com/go/deke-PSE8.* During the video, you'll learn about the keyboard equivalents and shortcuts listed below.

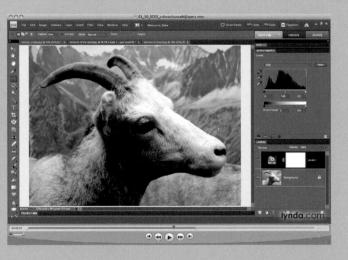

Tool or operation

Open an image from the Organizer in the Standard Edit mode Advance to the next or previous open image Hide or show panels Fit the image on screen or view actual pixels Zoom in or out with the magnifying glass Scroll with the hand tool Keyboard equivalent or shortcut Ctrl+I Ctrl+Tab or Ctrl+Shift+Tab Tab Double-click hand or zoom tool icon Ctrl+space bar-click or Alt+space bar-click space bar-drag in image window

Hue, Saturation, and Brightness

Before we set about correcting the colors in an image, it may help to know what the term *color* means. As it just so happens, it means a lot. Color is too complex to define with a single set of names or numerical values. For example, if Deke describes a color as purple, Colleen doesn't know whether it's bluish or reddish; vivid or drab; dark, light, or somewhere in between. To give you a better sense of what a color looks like, Photoshop Elements divides it into three properties called *hue*, *saturation*, and *brightness*:

- Sometimes called the *tint*, the hue is the core color—red, yellow, green, and so on. When you see a rainbow, you're looking at pure, unmitigated hue.
- Known variously as *chroma* and *purity*, saturation measures the intensity of a color. By way of example, compare Figure 10-2, which shows a sampling of hues at their highest possible saturation values, to Figure 10-3, which shows the same hues with much of the saturation removed.
- Also known as *luminosity*, the brightness of a color describes how light or dark it is.

The contrast between Figures 10-2 and 10-3 may lead you to conclude that bright, vivid hues make for better colors. Although this may be true for fruit and candy, most of the real world is painted in more muted hues, including many of the colors we know by name. Pink is a light, low-saturation variation of red; brown encompasses a range of dark, low-saturation reds and oranges. Figure 10-4 shows a collection of browns at normal and elevated saturation levels. Which would you prefer to eat: the yummy low-saturation

morsel on the left or the vivid science experiment on the right?

Photoshop Elements provides a wealth of commands for correcting the colors in an image. The best of these—that is to say, the ones we'll be looking at—provide you with *selective control*, meaning that the commands let you adjust one color property independently of another. For example, you might change the brightness without affecting the hue or saturation. Armed with these amazingly capable commands, you have all the tools you need to get the color just right. Be it red or blue, night or day, the sky's the limit.

Figure 10-2.

Figure 10-3.

Figure 10-4.

Balancing the Colors

In the video for this lesson, you saw two relatively straightforward, bordering-on-automatic tools that are great if your image falls into a specific type of limited problem. The Remove Color Cast command is swell as long as your image contains a color that should be gray. And Adjust Color for Skin Tone is just peachy, provided that your image contains only Caucasian skin tones. What do you do if there are no obvious grays or well-lit "flesh tones"? In those circumstances, you should take advantage of Photoshop Elements' all-purpose color-balance command, Enhance \rightarrow Adjust Color \rightarrow Color Variations.

Like the two previous functions, Color Variations takes a straightforward approach to color restoration. But rather than previewing your corrections in the main image window, Color Variations presents you with a collection of tiny thumbnail previews. Your job is to click the one thumbnail that looks better than the others. You can click as many thumbnails as you like and in any order. The following exercise walks you through a typical use of the Color Variations command.

> 1. Open an image. Open the file Color science.jpg, included in the Lesson 10 folder inside Les-

Figure 10-5.

son Files-PSE8 10n1. Captured without a flash under colored lights on the set of one of Deke's training videos, in which he played one of those kooky chemists whose specialty is dry ice, this image suffers from what we like to call "A Nutty Preponderance of Red." You can see why in Figure 10-5.

To look at it, you might assume that this image would be well suited to one of the previous commands. After all, the bottled smoke contains gobs of what ought to be neutral colors, and Deke's showing plenty of skin. Two problems: Both commands apply wholesale changes, thus affecting all colors in an image by roughly equal amounts. And the red lighting is too extreme for either command to correct. This photo requires a more nuanced approach. 2. Choose the Variations command. Choose Enhance→Adjust Color→Color Variations to display the Color Variations dialog box, as shown in Figure 10-6.

Once again, Elements fails to provide a shortcut for Color Variations. But you can choose the command using Windows-imposed hot keys. To do so, press the Alt key and type N-C-N (Nuanced Color Neutralizer).

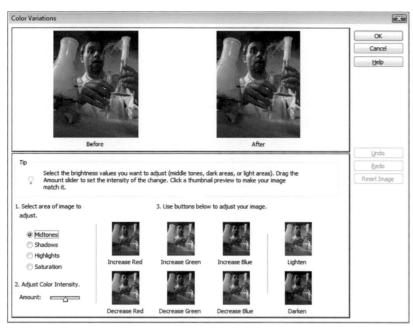

Figure 10-6.

- 3. Select the Midtones option. The Color Variations command lets you modify certain color ranges independently of others. It does so by subdividing the brightness of an image into three tiers—shadows, highlights, and midtones, or what the uninitiated might call dark colors, light colors, and everything in between. To specify the desired range, select one of the first three items in the lower-left portion of the Color Variations dialog box. Of the three, Shadows is sometimes useful, and Highlights is almost never useful. That leaves Midtones as the option of choice. (As for Saturation, we'll come to it in a moment.) If it isn't already selected, give **Midtones** a click.
- 4. *Set the intensity slider to the middle.* The slider bar labeled **Adjust Color** lets you modify the intensity of your edits. Set the triangle to the exact middle of the slider, as it is by default.

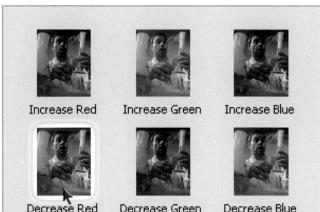

Decrease Rec

Figure 10-7.

5. *Click the Decrease Red thumbnail twice.* When Shadows, Midtones, or Highlights is active, the bottom portion of the dialog box contains a total of eight thumbnails: six hue and two brightness variations. Click any hue variation thumbnail to nudge the colors in the image toward or away from a range of hues. For example, Increase Blue represents not only blue but a whole range of hues—violet, cobalt, and so on—that have blue at their center. (For more information about these and other hues, refer to the sidebar "The Visible-Color Spectrum Wheel" on the facing page.)

Our problem color is red, so click the **Decrease Red** thumbnail twice in a row. (Be sure you get both clicks in; if you click too fast, Elements has a tendency to ignore one.) All six hue thumbnails update to reflect the change, as illustrated in Figure 10-7.

- 6. *Decrease the intensity setting.* The remaining problems with the image are more subtle. To prepare for the subtle solutions, move the **Adjust Color** slider triangle two notches to the left. The triangle should now appear as circled in the diminutive Figure 10-8. This setting will reduce the intensity of the next steps.
- 7. *Click the Lighten thumbnail*. At this point, the photo strikes us as a wee bit dark. So click the **Lighten** thumbnail to make the image lighter. Because the Midtones button is active (Step 3), clicking the Lighten thumbnail affects only the medium colors in the image. The darkest and lightest colors remain untouched.
- 8. *Click the Increase Green thumbnail*. After all these wonderful changes, the image remains a bit too purple. There is no Decrease Purple thumbnail. But by referring to "The Visible-Color Spectrum Wheel" chart on the next page, we find that purple's closest complement is green. So click the **Increase Green** thumbnail to infuse the image with green and reduce the amount of purple.
- 9. *Select the Saturation option*. So much for the brightness and hue; now on to saturation. To display the saturation controls,

The Visible-Color Spectrum Wheel

To feel comfortable working in the Color Variations dialog box, it helps to understand the composition of a little thing called the *visible-color spectrum wheel*. Pictured below, the wheel contains a continuous sequence of hues in the visible spectrum, the saturation of which ranges from vivid along the perimeter to drab gray at the center.

The colors along the outside of the circle match those that appear in a rainbow. But as the labels in the circle imply, the colors don't really fit the childhood mnemonic Roy G. Biv, short for red, orange, yellow, green, blue, indigo, and violet. An absolutely equal division of colors in the rainbow tosses out orange, indigo, and violet and recruits cyan and magenta, producing Ry G. Cbm (with the last name, we suppose, pronounced *seebim*). Printed in large, colorful type, these six even divisions correspond to the three primary colors of light—red, green, and blue—alternating with the three primary pigments of print—cyan, magenta, and yellow.

In theory, cyan ink absorbs red light and reflects the remaining primaries, which is why cyan appears a bluish green. Cyan and red represent *complementary colors*, meaning that they form neutral gray when mixed together. The Color Variations dialog box treats complementary colors as opposites. For example, clicking the Decrease Red thumbnail not only reduces the amount of red in the image but also adds cyan. Similarly, Decrease Green adds magenta and Decrease Blue adds yellow.

Of course Ry G. Cbm is just a small part of the story. The color spectrum is continuous, with countless nameable (and unnameable) colors in between. Deke took the liberty of naming secondary and tertiary colors in the wheel. Because there are no industry standards for these colors, he took his names from other sources, including art supply houses and consumer paint vendors. We offer them merely for reference, so you have a name to go with the color.

The practical benefit is that you can use this wheel to better predict a required adjustment in the Color Variations dialog box. For example, the color orange is located midway between red and yellow. Therefore, if you recognize that an image has an orange cast, you can remove it by clicking red's opposite, Decrease Red, and then clicking yellow's opposite, Increase Blue.

The other color-wheel-savvy command, Adjust Hue/Saturation (see the "Tint and Color" exercise on page 278), tracks colors numerically. A circle measures 360 degrees, so the Hue value places each of the six primary colors 60 degrees from its neighbor. Secondary colors appear at every other multiple of 30 degrees, with tertiary colors at odd multiples of 15 degrees. To track the difference a Hue adjustment will make, just follow along the wheel. Positive adjustments run counterclockwise; negative adjustments run clockwise. So if you enter a Hue value of 60 degrees, yellow becomes green, ultramarine becomes purple, indigo becomes lavender, and so on. It may take a little time to make complete sense of the wheel, but once it sinks in, you'll want to rip it out of the book and paste it to your wall. Trust us, it's that useful.

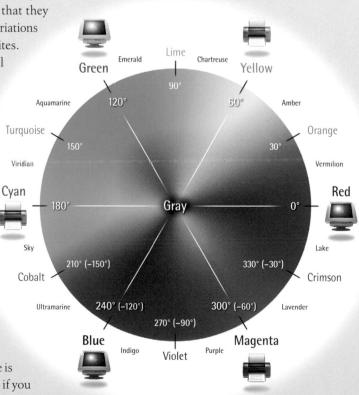

Figure 10-9.

select **Saturation** in the lower-left portion of the dialog box. Color Variations swaps in two new thumbnails, which let you add or delete saturation.

- Click the Less Saturation thumbnail. The colors in the photograph are a bit too vivid. Click Less Saturation to leech away colors and make them more neutral.
- 11. *Click the OK button*. It's hard to judge for sure from a bunch of dinky thumbnails, but the After image in the upper-right portion of the dialog box appears more or less on target. Click **OK** or press the Enter key to exit the Color Variations dialog box and apply your changes.

Figure 10-9 shows the finished image, unencumbered by color cast, with Deke's natural pale skin tone restored to all its pasty glory. Dry-ice chemists are notorious for not getting out much.

Tint and Color

Like the Color Variations command, Enhance \rightarrow Adjust Colors \rightarrow Adjust Hue/Saturation lets you edit a range of colors independently from or in combination with luminosity values. But where Color Variations permits you to limit your adjustments to brightness ranges (highlights, shadows, and midtones), Adjust Hue/Saturation lets you modify specific hues. This means you can adjust the hue, saturation, and luminosity of an entire photograph or constrain your changes to, say, just the blue areas. The following exercise provides an example.

1. Open an image. Open the file Helicopter & hotel.jpg in the Lesson 10 folder inside Lesson Files-PSE8 10n1. Hav-

ing awoken one downtown Los Angeles morning to the unrelenting thrashing of a circling helicopter, Deke snapped this photo from the window of his hotel room. As shown in Figure 10-10, Deke pointed his camera into the sun, so reflected light obscures the view and washes out the image.

- Apply the Auto Smart Fix command. The photo obviously suffers from low contrast and pale shadows. To right these wrongs, choose our old pal Enhance→Auto Smart Fix (yet another function available in both the quick and full editing modes) or press Ctrl+Alt+M. The result appears in Figure 10-11.
- 3. Choose the Hue/Saturation command. Choose Enhance→Adjust Colors→Adjust Hue/Saturation or press the keyboard shortcut Ctrl+U to display the Hue/Saturation dialog box, as shown in Figure 10-12.
- Raise the Saturation value. Click the word Saturation to select the numerical value and change it to +60 percent. This radically increases the intensity of colors throughout the image. (Unlike the Color Variations dialog box, Hue/Saturation updates the appearance of the image dynamically.)

Figure 10-10.

Figure 10-11.

Figure 10-12.

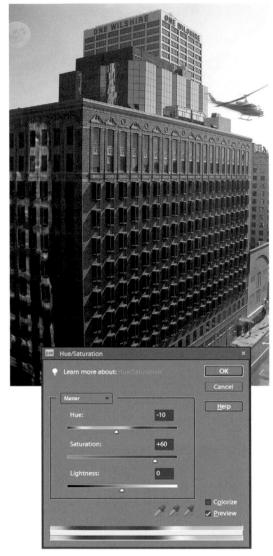

You can change the Saturation value by entering 60 into the option box (the + sign is not necessary) or by dragging the corresponding slider control. Alternatively, you can press Shift+↑ to raise the value in increments of 10. Or, weirdest of all, you can *scrub* the value by dragging directly on the word **Saturation**. Press Shift while scrubbing to adjust the value in increments of 10.

5. Lower the Hue value. The sky and mirrored windows of the building are trending distinctly toward purple. Deke's sense is that they would look better if they trended toward blue. According to the color wheel (see the sidebar "The Visible-Color Spectrum Wheel" on page 277), shifting the hues from purple to blue is a clockwise rotation, which means a negative value. Press Shift+Tab to select the Hue value. Then press Shift+↓ to reduce the value to -10 degrees, which removes the slight purple tint, as in Figure 10-13.

Generally speaking, the dramatic boost to the Saturation value holds up nicely. The red brick of the building looks terrific, as do the yellow reflections and some of the other touches. But the blue sky is just too much. In a lesser piece of software, we'd have to split the difference—that is, come up with a Saturation value high enough to boost the brick but low enough to avoid overemphasizing the sky. Fortunately, Elements lets us work on the sky and brick independently.

6. Isolate the blues. The Edit pop-up menu at the top of the Hue/ Saturation dialog box is set to Master, which tells Elements to transform all colors in an image by an equal amount. To limit your changes to just the sky colors, select Blues from the Edit menu instead. This appears to wipe out your previous values, but don't worry: they remain in force. They're just hidden so you can work on new values.

Now just because you select Blues doesn't mean you've isolated the *right* blues. The blues in this particular photograph could exactly match Elements' definition of blue, but just as likely they could lean toward ultramarine, indigo, cobalt, or sky (again, see page 277). Although the Edit pop-up menu doesn't provide access to these colors, it does permit you to nail a range of hues by moving your cursor into the image window and clicking on the precise color you want to identify. The following step explains how.

7. Confirm the colors in the image window. The numerical values at the bottom of the dialog box read 195°/225° and 255°\285°. According to the color wheel chart, this tells you

that Photoshop Elements is prepared to modify the colors between ultramarine (225°) and indigo (255°), centered at blue. The change will taper off as the colors decline to sky (195°) and purple (285°).

Change your cursor to an eyedropper by moving it outside the Hue/Saturation dialog box. Then click near the moon in the upper-left region of the image. The numbers at the bottom of the dialog box should shift to something in the neighborhood of $180^{\circ}/210^{\circ}$ and $240^{\circ}\backslash270^{\circ}$, as in Figure 10-14. (If your numbers differ by more than 5 degrees, move your cursor slightly and click again.) These values describe a range of cobalt (210°) to blue (240°), with a softening as far away as cyan (180°) and violet (270°). In other words, Elements has shifted the focus of the adjustment by -15 degrees, so instead of changing the blues in the image, you're all set to change the slightly greener ultramarines.

Admittedly, the theory is dense, but one click is all it takes to translate the theory into action. Having isolated the colors in the sky, you're ready to make your changes.

- 8. *Lower the Saturation value*. Reduce the **Saturation** value to -40 percent to take some of the intensity out of the sky. This large Saturation shift may seem to make only a modest difference. But the sky no longer overwhelms other elements of the image, so all is well.
- 9. *Click OK*. Or press the Enter key to accept your changes and exit the Hue/Saturation dialog box.

The final image (Figure 10-15) is both more accurate and more dramatic than the original. One might argue that, of the two attributes, drama is given the edge. Well, for crying out loud—the photograph has a helicopter in it! If that doesn't call for drama, we don't know what does.

PEARL OF

WISDOM

You may have noticed that throughout the entire exercise, we never once touched the Lightness value. And for good reason—it's rarely useful. The Lightness value changes the brightness of highlights, shadows, and midtones by compressing the luminosity range. Raising the value makes black lighter while fixing white in place; lowering it affects white without harming black. It's not the worst luminosity modifier ever seen, but other commands—most notably Levels and Shadows/Highlights—provide much better control. Happily, these very commands are the topics of the next exercises.

Figure 10-14.

Figure 10-15.

Adjusting Brightness Levels

Thus far, we've looked at several commands that permit you to adjust colors inside Photoshop Elements. But what happens if your image problems have less to do with color and more to do with luminosity? You most often hear such problems characterized as issues of brightness and contrast, where *brightness* indicates the prevailing lightness or darkness of an image and *contrast* denotes the degree of difference between light and dark colors.

Photoshop Elements pays lip service to this colloquialism with a little ditty known as Enhance→Adjust Lighting→Brightness/Contrast. Although exceedingly easy to use, this command does lack some predictability and control. Simply put, Brightness/Contrast leaves you shooting in the dark; it is every bit as likely to damage an image as it is to make it better.

Which is why we turn our collective attention to a better command, Enhance→Adjust Lighting→Levels. Although a bit harder to use this command isn't shy about asking you to roll up your shirtsleeves

> and smear on the elbow grease—Levels provides a perfect marriage of form and function. It lets you tweak highlights, midtones, and shadows predictably and with authority while maintaining smooth transitions between the three. In other words, it makes an image look its absolute best.

> > PEARL OF

WISDOM

The Levels command is better at increasing contrast than decreasing it. To decrease the contrast of an image—particularly one with overly harsh shadows and highlights—see the exercise "Compensating for Flash and Backlighting" on page 289.

The following exercise explains how to correct the brightness and contrast of an image with the Levels command.

 Open an image. Open End of rail.jpg, found in the Lesson 10 folder inside Lesson Files-PSE8 10n1. Captured at the top of Pikes Peak—right

S

at the point where the cog railway drops into the abyss this image features some atrocious light metering, as you can see in Figure 10-16. But don't blame the camera; Deke dropped it and broke off an important dial hours before he shot the photo. Fortunately, even though the camera was damaged, it captured enough color information so we could repair the photo in Photoshop Elements.

Figure 10-16.

- 2. Choose the Levels command. Choose Enhance→Adjust Lighting→Levels or press Ctrl+L. Pictured in Figure 10-17, the stark and technical dialog box that follows may seem like something of a cold slap in the face, especially when compared with its user-friendly counterparts from previous exercises. And so we feel it incumbent to provide an optionby-option introduction. If you don't care to be introduced, skip to the next step—it won't affect your ability to follow along with the steps one iota. Then again, you may find that you understand what you're doing a little better if you take a few moments to read the following:
 - In the word of digital photography, an image is expressed as a combination of three primary colors: red, green, and blue. Each of the three primary colors resides in an independent reservoir called a *channel*. Located at the top of the Levels dialog box, the Channel pop-up menu lets you edit the contents of each primary channel independently. To edit the entire image at once, choose RGB, which just so happens to be the default setting.
 - The three Input Levels values list the amount of adjustment applied to the shadows, midtones, and highlights, respectively. The default values—0, 1.00, and 255—indicate no change. More about these in a moment.
 - The black blob in the middle is the *histogram*, which is a graph of the brightness values in your image. (For more information on this item, read the sidebar "How to Read and Respond to a Histogram" on page 286.)
 - The two Output Levels values let you lighten the darkest color in the image and darken the lightest color. In other words, they let you reduce the contrast. Although useful for dimming and fading, they rarely come into play when correcting an image.
 - The Auto button applies the equivalent of the Auto Levels command, which you can then modify as needed.
 - See the three eyedropper tools above the Preview checkbox? Select an eyedropper and then click in the image window to modify the clicked color. The black eyedropper makes the clicked color black; the white one makes it white; and the gray one robs it of color, leaving it a shade of gray.

Figure 10-17.

Figure 10-18.

• Turn on the Preview checkbox to see your changes applied dynamically to the active image.

The Preview checkbox is great for before-and-after comparisons. So useful, in fact, that you have a shortcut: Alt+P.

- 3. *Click the Auto button*. Click the **Auto** button to apply the Auto Levels function. The histogram stretches to fill the center portion of the dialog box, but the numerical Input Levels values stay the same, as in Figure 10-18. (You'll see why in the next step.) As in the previous lesson, Photoshop Elements' automated adjustment isn't perfect, but it's a good place to start. Now, however, we can use Levels to tweak the adjustment.
- 4. *Switch to the Red channel.* Choose **Red** from the **Channel** pop-up menu or press Alt+3. You now see the histogram for the Red channel, complete with adjusted Input Levels values, as shown in Figure 10-19.

WISDOM

Clicking Auto in step 3 changed the Input Levels settings on a channel-bychannel basis. So even though you see an altered histogram in the composite view, you have to visit the individual channels to see the numerical changes.

PEARL OF

5. *Nudge the shadows and highlights.* Notice the black and white slider triangles directly below the histogram (highlighted red in Figure 10-19). They correspond to the first and last Input Levels values, respectively. In our case, the black slider says that any pixel with a brightness of 20 or less will be made black in the Red channel; the white slider says any pixel 198 or brighter will be made white. (Remember, 0 is absolute black and 255 is absolute white.) Those values are okay, but we recommend you tighten them up a little—that is, send a few more colors to black or white. Nudge the black value from 20 to 30; nudge the white value from 198 to **168**.

By *nudge*, we mean use the arrow keys on the keyboard. Highlight the 20 and press Shift+ \uparrow to raise it to 30. Highlight 198 and press Shift+ \downarrow three times to lower the value to 168. Together, these adjustments make the image slightly redder.

6. *Raise the midtones value*. Increase the middle **Input Levels** value to 1.23, thus increasing the brightness of the midtones in the Red channel. The result appears in Figure 10-20 on the facing page.

Figure 10-19.

PEARL OF

WISDOM

The middle Input Levels number (as well as the corresponding gray triangle below the histogram) is calculated differently than the black and white points. Expressed as an exponent, this *gamma value* multiplies all colors in a way that modifies midtones more than shadows or highlights. The default value of 1.00 raises the colors to the first power, hence no change. Higher gamma values make the midtones brighter; lower values make them darker.

- 7. *Switch to the Green channel*. Choose **Green** from the **Channel** pop-up menu or press Alt+4.
- Adjust the shadows, midtones, and highlights. Change the three Input Levels values to 36, 1.25, and 205. This brightens the green values, as in Figure 10-21.
- 9. *Switch to the Blue channel.* Choose **Blue** from the **Channel** pop-up menu or press Alt+5.
- 10. Adjust the shadows, midtones, and highlights. This time, change the three Input Levels values to 50, 1.26, and 187. The changes to the black and white values darken the Blue channel, while the change to the gamma value lightens the midtones. The result is a slight shift in colors in the evergreens in the background and the dirt beneath the track.
- 11. *Switch to the RGB composite image.* Choose **RGB** from the **Channel** pop-up menu or press Alt+2.
- 12. Raise the gamma value. Advance to the second Input Levels value. (If this value was last active in the Blue channel, it remains active in the composite image.) Then press Shift+↑ twice to raise the value to 1.2. This lightens the midtones across all color channels.
- 13. *Click OK.* Or press the Enter key to accept your changes and exit the Levels dialog box.

The resulting image is significantly brighter than the original photograph, especially where the midtones are concerned. One of the downsides of lightening midtones is that it tends to bleed some of the color out of an image. Fortunately, you can restore color using Adjust Hue/Saturation, as explained in the next step.

Figure 10-20.

How to Read and Respond to a Histogram

In the world of statistics, a *histogram* is a kind of bar graph in which the bars vary in both height and width to show the distribution of data. In the Levels dialog box, it's a bit simpler. The central histogram contains exactly 256 vertical bars, each only one pixel wide. Each bar represents one brightness value, from black (on the far left) to white (on the far right). The height of each bar indicates how many pixels correspond to that particular brightness value. The result is an alternative view of your image, one that focuses exclusively on the distribution of colors.

Consider the annotated histogram below. We've taken the liberty of dividing it into four quadrants. If you think of the histogram as a series of steep sand dunes, a scant 5 percent of that sand spills over into the far left quadrant; thus, only 5 percent of the pixels in the image are dark. Meanwhile, fully 25 percent of the sand resides in the big peak in the right quadrant, so 25 percent of the pixels are light. The image represented by this histogram contains more highlights than shadows.

One glance at the image itself (opposite page, top) confirms that the histogram is accurate. The photo so obviously contains more highlights than shadows that the histogram may seem downright redundant. But the truth is, it provides another and very helpful glimpse into the image. Namely, we see where the darkest colors start, where the lightest colors drop off, and how the rest of the image is weighted.

With that in mind, here are a few ways to work with the histogram in the Levels dialog box:

- Black and white points: Bearing in mind the sand dune analogy, move the black slider triangle below the histogram to the point at which the dunes begin on the left. Then move the white triangle to the point at which the dunes end on the right. (See the graph below.) These adjustments make the darkest colors in the image black and the lightest colors white, which maximizes contrast without harming shadow and highlight detail.
- **Clipping:** Take care not to make too many colors black or white. If you do, you'll get *clipping*, an effect in which Photoshop Elements renders entire regions of your image flat black or white. Clipping is fine for graphic art but bad for photography, where you need continuous color transitions to convey depth and realism.

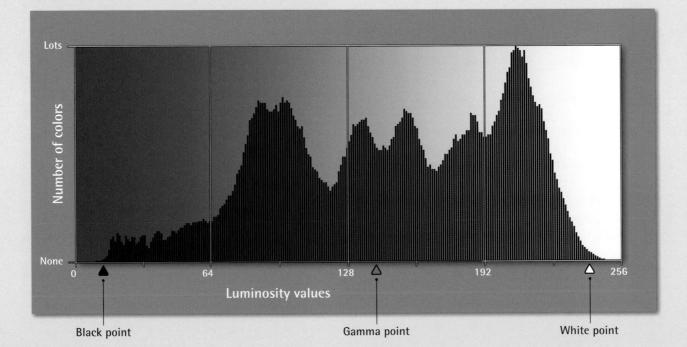

286 Lesson 10: Correcting Color and Tone

To preview exactly which pixels will go to black or white, press the Alt key as you drag a slider triangle. When dragging the black triangle, any pixels that appear black or any color *except* white (as in the example at the bottom of this page) are clipped. When dragging the white triangle, Photoshop Elements clips the nonblack pixels.

• Balance the histogram on the gamma: When positioning the gray gamma triangle, think "center of gravity." Imagine that you have to balance all that sand in the histogram on a teetering board poised on this single gray triangle. If you position the gamma properly, you can distribute the luminosity values evenly across the brightness spectrum, which generally produces the most natural results.

Bear in mind that these are suggestions, not rules. For example, clipped colors can result in interesting effects. Meanwhile, an overly dark image may look great set behind white type. These suggestions are meant to guide your experimentation so you can work more quickly and effectively inside the Levels dialog box.

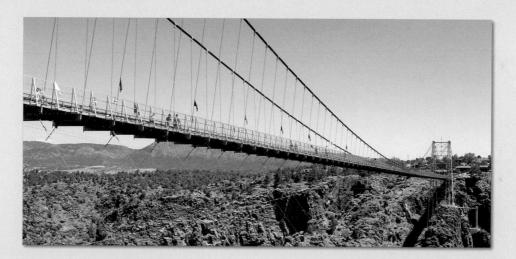

Figure 10-22.

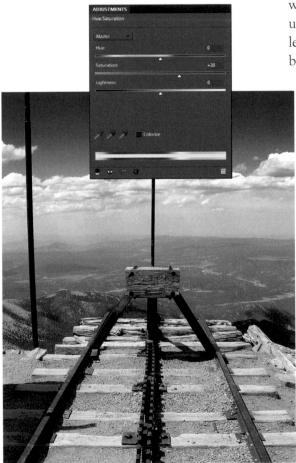

Figure 10-23.

- 14. *Add a Hue/Saturation adjustment layer*. As we saw in the "Tint and Color" exercise that began on page 278, the Hue/Saturation control is especially adept at modifying the intensity of colors in an image. But now we're going to use a version of the command that lives on its own layer, allowing for future modifications should we change our minds. Start by clicking the *O* icon at the bottom of the **Layers** panel and choosing **Hue/Saturation** from the pop-up menu, as shown in Figure 10-22. You'll notice that Elements will create the new layer in the Layers panel and open up the Adjustment panel with a familiar-looking set of Hue/Saturation sliders.
- 15. Raise the Saturation value. Move the Saturation value in the Adjustment panel to the right until you've raised the value to +30 percent. The once drab image is now brimming with color, as you can see in Figure 10-23. If you find the effect garish, you can readjust the sliders at any time by first clicking on the icon with the two gears in the Hue/Saturation layer, which will bring up the sliders again in the Adjustment panel. You can even delete this layer altogether by dragging it to the trash can at the bottom of the Layers panel.

PEARL OF

WISDOM

Adjustment layers are a handy way to make modifications that you may want to rethink later or abandon altogether. You'll note in the pop-up menu in Figure 10-23 that you also could have applied the Levels corrections the same way, rather than through the Enhance menu as we did in this exercise. Once you created the new layer, the Adjustment panel would show you the familiar histogram with the same ability to set Shadows, Midtones, and Highlights that you saw in the Levels dialog box.

The final image is a resounding success. But you may wonder how in the world we arrived at the specific values that you entered into the various Input Levels option boxes. The answer, of course, is trial and error. We spent a bit more time flitting back and forth between the channels and nudging values than the exercise implies, just as you will when correcting your own images. But as long as you keep the Preview checkbox turned on, you can see the effect of each and every modification as you apply it.

Compensating for Flash and Backlighting

Photography is all about lighting—specifically, how light reflects off a surface and into the camera lens. So things tend to turn ugly when the lighting is wrong. One classic example is *backlighting*, in which the background is bright and the foreground subject is in shadow. You can adjust for backlighting by adding a fill flash, but even the best of us forget. An opposite problem occurs when shooting photos at night or in a dimly lit room using a consumer-grade flash. In that case, you end up with unnaturally bright foreground subjects set against dark backgrounds.

Whether your image is underexposed or overexposed, the solution is the Shadows/Highlights command. This marvelous function lets you radically transform shadows and highlights while maintaining reasonably smooth transitions between the two. Here's how it works:

- 1. Open an image. Open Sammy in snow.jpg from the Lesson 10 folder inside Lesson Files-PSF8 1on1. Having set his youngest against such a bright background (see Figure 10-24), Deke should have known better than to shoot a picture without a flash. The result is a photograph that casts Sammy in deep gloom, quite out of keeping with his sunny personality. Fortunately, Photoshop Elements can fix that.
- 2. Open the Histogram panel. Shadows/Highlights lets you modify the contrast of an image in ways that the Levels command simply can't match. But it lacks the Levels command's most prominent feature, the histogram. Fortunately, Elements lets you display the histogram as a separate panel any time you need it. Choose Window→Histogram to display the Histogram panel, with the same histogram display you see in the Levels dialog box. As you might expect, the histogram includes peaks on the left and right with a valley in the center, indicating lots of shadows and highlights separated by scarce midtones.
- 3. Refresh the histogram. Most likely, you'll see a tiny caution icon (\triangle) in the upper-right corner of the histogram, which means you're viewing a cached (that is, old and inaccurate) version of the histogram. Caching saves Elements some computational effort, but it proves a hindrance when you're trying to gauge the colors in an image. To update the histogram based on the latest and greatest information, click the circular C arrows or the yellow \triangle icon, as in Figure 10-25. And incidentally, go ahead and leave the Histogram panel open. You may find it helpful to keep an eye on it in future steps.

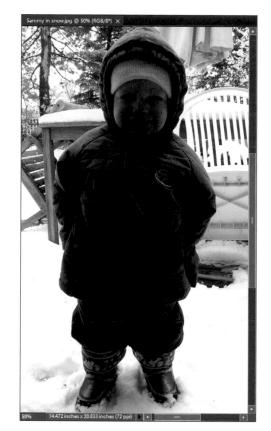

Figure 10-24.

Figure 10-25.

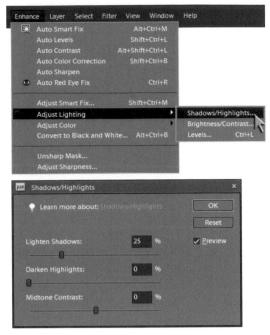

Figure 10-26.

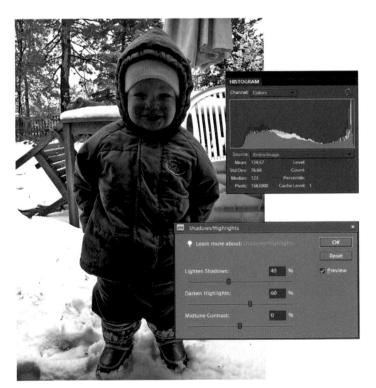

Figure 10-27.

- 4. Choose the Shadows/Highlights command. Again visit the Enhance menu and this time choose Adjust Lighting→Shadows/ Highlights. The resulting Shadows/Highlights dialog box (see Figure 10-26) contains just three slider bars:
 - The *Lighten Shadows* option lets you lighten the darkest colors in the photo—i.e., Sammy.
 - The *Darken Highlights* option darkens the lightest colors, which would be the snowy background.
 - The *Midtone Contrast* expands or contracts the midtones in the image to increase or reduce, respectively, the amount of contrast between light and dark pixels.

No Ctrl-key shortcut exists for Shadows/Highlights. To choose the command using Windows-imposed hot keys, press the Alt key and type N-L-W. Again, it isn't memorable, but it's an option.

- Adjust the shadows and highlights. By default, Elements is too conservative about both lightening the shadows and darkening the highlights. To temper the dark colors, raise the Lighten Shadows value to 40 percent. Then raise the Darken Highlights value to 60 percent. Assuming the Preview checkbox is on (as by default), Elements updates both the image and the histogram, as you can see in Figure 10-27.
- 6. *Reduce the contrast*. In the process of lightening the shadows and darkening the highlights, the Shadows/Highlights command effectively reduces the contrast of the image. Elements provides the Midtone Contrast option so you can restore the contrast. But we have the opposite problem. This photograph exhibited such radical contrast in the first place that, if anything, we need to remove more. So press the Tab key to advance to the **Midtone Contrast** value, and reduce the value to **-40** percent.
- 7. *Apply your changes.* Click **OK** or press the Enter key to accept your changes and exit the Shadows/Highlights dialog box.

The result, which appears in Figure 10-28, is an improvement over the original, but it still needs some help. The shadows are now a bit too light; the midtones are a bit too dark. There's not much we can do about this with the Shadows/Highlights command—not without compromising the integrity of the image, anyway. But we can easily fix both problems with a Levels adjustment.

- 8. Add a Levels layer adjustment. We could use the Levels command under the Enhance menu as we did in the last exercise, but instead, click the ● icon at the bottom of the Layers panel and choose Levels from the pop-up menu. This creates a new layer and brings up the familiar Levels controls within the Adjustment panel.
- 9. Change the shadows and midtones values. In the Adjustment panel, darken the shadows by changing the first **Input Levels** option to **20**. Unlike the dialog box, this is not labeled, so we'll point out it's the first field on the right under the Levels histogram, highlighted in red in Figure 10-29. Then lighten the midtones by tabbing to the gamma value (the center one, just to the left) and changing it to **1.3**. When you arrive at the effect pictured in the figure, click the **OK** button.

Shadows/Highlights is an amazing command, capable of reconstructing image detail captured under some of the worst lighting conditions imaginable. But it may produce some undesirable effects. Witness the almost greenish glow of Sammy's face. Using Adjust Color for Skin Tone to increase the blush in Sammy's face helps, but just a bit. In the course of exacting its radical brightness adjustments, the Shadows/Highlights command tends to flatten or exaggerate color transitions in ways that may compromise the credibility of surfaces and textures. The upshot is that even an inexperienced viewer might look at the photo and wonder, "Did you do something to this?"

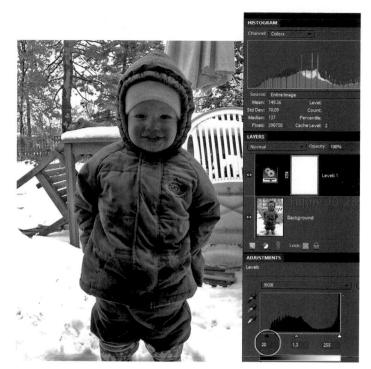

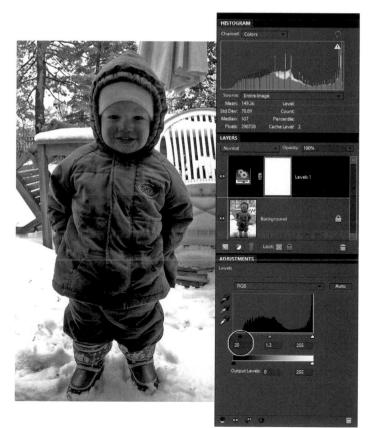

Figure 10-29.

Still, we regard these issues as acceptable casualties of correction. The lighting is now significantly more balanced than it was in the original photograph, and Sammy no longer appears shrouded in silhouette. Despite its occasional compromises, Shadows/Highlights is Photoshop Elements' best tool for correcting high-contrast images.

Correcting with Camera Raw

The final method we'll cover for correcting colors with Photoshop Elements uses a tool originally created for those photographs that are captured by a midrange or professional-level digital camera and saved in the camera's *raw* format, Adobe Camera Raw (ACR). A raw file represents the unprocessed data captured by the camera's image sensor. Such a file is typically several times larger than a digital camera's equivalent JPEG file, because it also contains more information. This means you can shoot fewer pictures at a time, but you capture a wider range of colors and more accurate image detail. Plus, in Photoshop Elements, you can open a raw image and correct its colors and luminosity values in a single operation.

WISDOM

One very real advantage of using Adobe Camera Raw (ACR) is that the adjustments are nondestructive, meaning that until you save the image in the Editor proper, everything can be changed. In addition to a plethora of proprietary file formats from the likes of Olympus, Canon, Nikon, and more, ACR can also process files in the TIFF and JPEG formats, making it a convenient and effective tool for processing your JPEGs and TIFFs as well as your raw images.

1. *Open a raw image.* Open the file *Deke-easy.dng* in the *Lesson 10* folder inside *Lesson Files-PSE8 1on1*. Colleen captured this photo of her charming coauthor in front of a secret, undisclosed location with an Olympus E-620 as an ORF (Olympus Raw Format) file. We then saved the image to the more universal DNG (Digital Negative) format, Adobe's own raw specification.

Rather than opening the photograph in a new image window, Elements displays the Camera Raw window pictured in Figure 10-30 on the facing page. The window includes a highresolution preview of the image and a full-color histogram, both of which update as you adjust the color settings. Use the zoom and hand tools in the upper-left corner of the window to magnify and scroll the preview, respectively. The title bar lists the version of ACR that's currently installed and the model of camera that was used to shoot the photo. You can see that there is information about the aperture, shutter speed, ISO (sensitivity), and focal length underneath the histogram. Elements uses this information to automatically process the image in case you decide to skip the manual adjustment and go straight for the Open button.

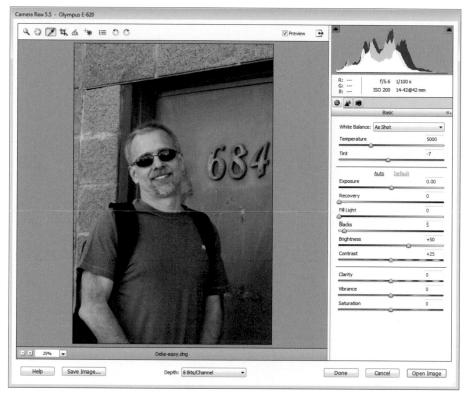

Figure 10-30.

- 2. Set the White Balance controls. The color cast of highlights in a photograph is commonly known as the *white balance*. Because of the trickle down nature of white balance, you can neutralize a color cast throughout an image using the White Balance controls in the Adjust panel. Here's how:
 - By default, the White Balance option is set to As Shot, which refers to the default calibration settings for this specific model of camera. To override this setting, select a lighting condition from the White Balance popup menu or dial in your own Temperature and Tint values, as follows.

- This marks our third encounter with a Temperature option in this book, but this time we have a numerical value, which compensates for the color of the lighting source, measured in degrees Kelvin. Low-temperature lighting produces a yellowish cast, and higher temperature lighting produces bluish casts. Direct sunlight hovers around 5500 degrees.
- Tint compensates for Temperature by letting you further adjust the colors in your image along a different color axis. Positive values introduce a magenta cast (or remove a green one); negative values do just the opposite.

ACR offers an alternative to using the sliders to set the white balance; use the eyedropper tool in the upper-left corner of the Camera Raw window. Select the eyedropper and click a color in the image that should be white or neutral gray. In this case, the spot in the mortar just to the left of Deke's head works well, as shown in Figure 10-31. Elements removes the slightly magenta cast from the image and cools down the temperature just a tad. If you don't like the results, try again or adjust with the sliders. Double-click the eyedropper icon to restore the As Shot values.

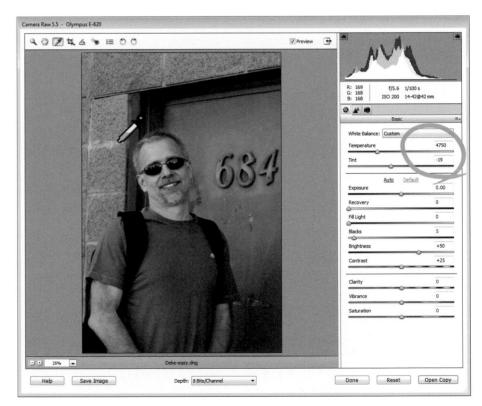

Figure 10-31.

3. *Adjust the Exposure*. The Exposure values are analogous to the white and black slider triangles inside the Levels dialog box (see "Adjusting Brightness Levels," page 282). The main difference is that Exposure is computed in f-stops. For example, raising the Exposure to +0.50 simulates opening the lens aperture of the camera a half-stop wider.

Because Deke is in the shade, raising the **Exposure** just a tad to about +.75 helps move the values in the histogram more toward the center, leaving the range of tones more open.

If your image has clipped highlights or shadows, you can click the left or right triangles at the top of the histogram to have those exposed in the preview of the image. You can then increase the Recovery (for highlights) or Fill Light (for shadows) sliders to restore those clipped areas if you wish. For instance, if you click on the right triangle above the histogram, you'll see a few dots of blue along the edge of Deke's backpack strap. This small amount of clipped shadows is not really worth tweaking the values of the whole image to get back.

- ⁴ *Lower the Brightness setting* The closest thing to a gamma control in the Camera Raw window is the Brightness setting. It's not an exact match, but it does let you adjust midtones using a rough percentage system. Values below 50 compress shadows and expand highlights, thereby lightening an image; values above 50 do the opposite. In this example, raising the Exposure in the previous step made the image a little flat, so decrease the **Brightness** value to 20 to bring back some texture.
- 5. *Adjust the Contrast values.* The rest of the slider bars have no equivalents in the Levels dialog box. The Contrast slider expands or compresses the histogram to increase or decrease the contrast between pixels, respectively. Because this image is fairly neutral-toned throughout, raising the Contrast to 40 helps distinguish the similarly toned elements more clearly.
- 6. *Increase the non-flesh-toned colors with Vibrance.* Speaking of color, it would be nice to play up the matching colors in Deke's shirt and the numbers of the secret location by increasing the greens. Unfortunately, ACR as it exists in Elements doesn't allow you to choose one small range of colors for adjustment. If you try increasing the Saturation slider to play up the two colored objects, you're going to unpleasantly increase the oranges in Deke's skin at the same time. Instead, increase the **Vibrance**, which avoids colors found in skin tones, to 55; this helps the greens (and the blue sky reflected in Deke's sunglasses) pop without turning Deke into an alien.

7. Zoom in on the image. The next set of options we'll look at let you sharpen the focus of a photo and smooth away noise artifacts. To best judge the details in your image, double-click the zoom tool icon in the upper-left corner to zoom in to 100 percent. Then press the space bar to access the hand tool and drag the image so you can fill the preview window with Deke's friendly face, as in Figure 10-32.

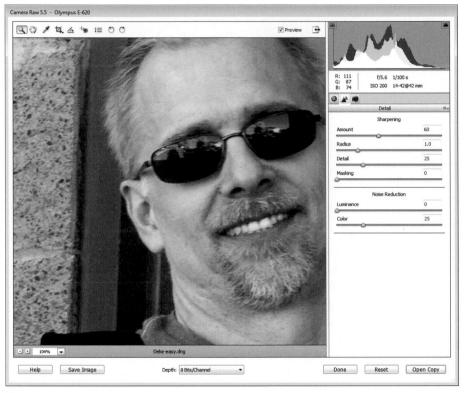

Figure 10-32.

- 8. *Set the Sharpness* Click the **Detail** tab to access the remaining slider bars. Here's how they work:
 - Raise the Amount slider to increase the amount of contrast between neighboring pixels. Unlike Contrast, Sharpness doesn't affect the overall histogram; rather, it compares adjacent pixels and increases their difference from one another. (Lesson 7, "Filters and Distortions," contains lots more information.) The result is increased edge definition, which gives the appearance of sharper focus.

- If you increase the Sharpness too much, you'll increase the contrast between pixels that should be smooth. The result is randomly colored pixels, or *noise*. To soften areas of noise that are the result of variations in lightness and darkness, increase the Luminance value in the Noise Reduction section.
- To soften noise that results from variations in hue or saturation, increase the Color Noise Reduction value.
 - PEARL OF

WISDOM

If you plan to make significant changes to an image-particularly changes involving filters or layers (see Lessons 7 and 8, respectively)-you should leave all three values set to 0 to avoid overly harsh edges and increased noise down the road.

For this image, we recommend increasing the **Sharpness** to 60 and the **Radius** value to 1.0. This particular image doesn't need any help from the Noise Reduction sliders as a result of the increased sharpness.

9. Leave the Depth setting unchanged. Now turn your attention to the bottom-left corner of the window, where you'll find an option called Depth. At the risk of overloading your brain—trust me, we wouldn't do it if we didn't have to—Photoshop Elements supports two varieties of full-color images. One contains 8 bits of data per channel, which works out to a maximum of 16.8 million potential colors. The other contains 16 bits of data per channel, which works out to as many as 281.5 *trillion* colors.

The latter option might sound better, but 16-bit images are demanding on computer resources, and most of Elements' editing functions don't work in the 16-bit color mode. Our advice: make sure **Depth** is set to **8 Bits/Channel**, which is the default. Otherwise, you'll slow down the performance of the software, sacrifice much of the program's functionality, and gain almost nothing in return.

10. *Click Open*. Click the **Open** button. After you do, Photoshop Elements imports the image from the raw DNG format and applies the color and focus corrections that you specified in the previous steps. Note that the program does not save the zoom information; the image will appear zoomed out, so that it fits on the screen.

The corrected photograph appears on the left side of Figure 10-33. For the sake of comparison, the righthand image shows the same photo subject to the default settings defined by the camera. (To see the image on your screen in this same condition, open the file again and choose Camera Raw Defaults from the Settings pop-up menu in the Camera Raw window.) Obviously, the camera's default suggestions were off, as were the automatic guesses made by Elements' Camera Raw function. It just goes to show you that taking the time to assign your own deliberate and carefully considered color corrections makes all the difference in the world.

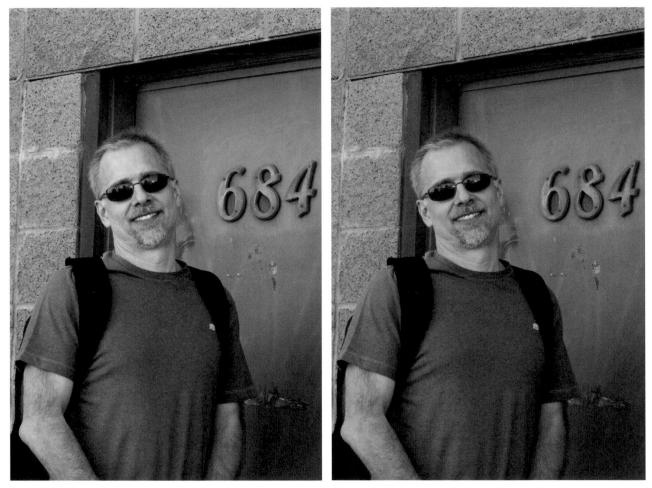

Figure 10-33.

WHAT DID YOU LEARN?

Match the key concept in the numbered list below with the letter of the phrase that best describes it. Answers appear upside-down at the bottom of the page.

Key Concepts

Descriptions

- 1. Hue
- 2. Saturation
- 3. Brightness
- 4. Shadows
- 5. Highlights
- 6. Midtones
- 7. Complementary colors
- 8. Contrast
- 9. Temperature
- 10. Histogram
- 11. Gamma value
- 12. Adobe Camera Raw

- A. The darkest range of colors in an image.
- B. Known variously as *chroma* and *purity*, this property measures the intensity of a color.
- C. A bar graph in which each bar represents one brightness value in an image, from black (on the far left) to white (on the far right).
- D. Located on opposite sides of the visible-color spectrum wheel, these form neutral gray when mixed together.
- E. This type of file format preserves the unprocessed data captured by a camera's image sensor.
- F. Sometimes referred to as tint, this property defines a color's core value—red, yellow, green, and so on.
- G. This is generally the most useful range of colors to adjust with the Color Variations command.
- H. The lightest range of colors in an image.
- I. This refers to the warmth or coolness of the color of the lighting source.
- J. Also known as *luminosity*, this color property describes how light or dark the color is.
- K. The degree of difference between an image's light and dark colors.
- L. Known as the Levels command's "center of gravity," adjusting this setting modifies the midtones in an image independently of the shadows or highlights.

Answers

1E' 5B' 3Ì' 4V' 2H' 9C' 1D' 8K' 8I' 10C' 11F' 15E

LESSON

minnin

SLIDESHOWS AND OTHER CREATIONS

AFTER YEARS of working with the latest and greatest Adobe has to offer by way of imaging software, we remain captivated by Photoshop Elements, especially the features of the program that are absent from the senior full-fledged Photoshop. Given that the latter costs so much more, it almost defies belief that Elements offers so much as a single function that's missing from Photoshop, let alone an entire group of functions, particularly a group of functions as useful and just plain tun as those found in the Create tab. Across the wide range of Adobe graphics applications, these creations are unique to Photoshop Elements.

Creation is Adobe's catchall term for any media project that includes one or more images. It might be an on-screen slideshow, a photo album, or even something as essential as a wall calendar (see Figure 11-1). Elements provides the basic layout and embellishments, you provide the photos, and together you and Elements assemble the finished projects.

Photoshop Flements is built to serve dedicated, creative spirits those who care enough about their digital photos to organize, optimize, and enhance their treasured photos. And how better to acknowledge that than to provide you with a way to use those carefully crafted images in projects that allow you to show them off? We all need at least one wall calendar every year, and who wouldn't rather see images that have personal meaning instead of swimwear models, Dilbert cartoons, or Thomas Kinkade paintings? Thankfully, we have Photoshop Elements.

Figure 11-1.

May 2006

ABOUT THIS LESSON

Project Files

Before beginning the exercises, make sure you've downloaded the lesson files from *www.oreilly.com/go/deke-PSE8*, as directed in Step 2 on page xiv of the Preface. This means you should have a folder called *Lesson Files-PSE8 1on1* on your desktop (or whatever location you chose). We'll be working with the files inside the *Lesson 11* subfolder. Elements lets you assemble your images into slideshows, albums, and other creations. In this lesson, you'll use both the Organizer and Editor workspaces to assemble four kinds of creations. Along the way, you'll learn how to:

- Create print-ready photo album pages page 303
- Design and save a postcard-style greeting page 315
- Assemble images into a wall calendar page 323

Video Lesson 11: Making a Slideshow

Of Photoshop Elements's many and various creations, the most essential is the common slideshow. This simple function permits you to peruse a day's photo shoot, present a group of images to friends or clients, and even export the finished piece as a Windows Media movie, complete with music and fades.

Slideshows in Photoshop Elements are such a powerful way to impress your audience that Deke dedicates a whole video lesson to them. You can either watch the video lesson online or download to view at your leisure by going to *www.oreilly.com/go/deke-PSE8*. During the video, you'll learn about the keyboard equivalents and shortcuts listed below.

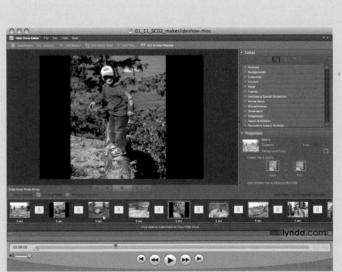

Operation

Deselect all images in the Organizer Play or pause the slideshow Move from one slide to the next (or previous) Preview a full-screen slideshow Save your slideshow project Keyboard equivalent or shortcut Ctrl+Shift+A spacebar \rightarrow (or \leftarrow -) F11 Ctrl+S

How Creations Work

Most of the creations we'll cover in this lesson are initiated in the Create tab, which is available via either the Organizer or the Editor workspace. Once you've started a project, Elements walks you through the process of creating any of several kinds of creations using a hand-holding wizard-style process. So you may wonder why we've elected to further hold your hand with a lesson full of step-by-step exercises. Four reasons:

- Things are never as easy as they seem.
- Some of the wizards deposit you into interfaces that are as complex as other parts of Elements. As long as we're here, we reckon we might as well be of service.
- The Creation Setup wizard suffers some odd limitations, sometimes preventing you from modifying an option and sometimes only appearing to do so. Oftentimes, there are workarounds.
- We've added a "creation" to this lesson, namely creating a panorama, that Elements hides outside of the Create environment.

To get started, click the purple **Create tab** on the right side of either the Organizer or Editor workspaces, as shown in Figure 11-2. Either way, you'll end up in the Editor, with a panel full of buttons for specific types of projects, and a More Options button that hides a few more possibilities. You've already seen Deke demonstrate slideshow creation in the video for this lesson and we'll cover the other options we find the most useful in the course of this lesson's text-based exercises.

When you complete a creation, Photoshop Elements usually adds it to the active Organizer catalog. You can then email, print, or export the project, depending on its type.

Laying Out Photo Book Pages

In the pre-digital age, photo albums were generally considered lowtech affairs. But Elements gives them a modern twist. Rather than requiring you to painstakingly affix individual photos to album pages, the program lets you lay out your photos on screen and print them as fully rendered book pages.

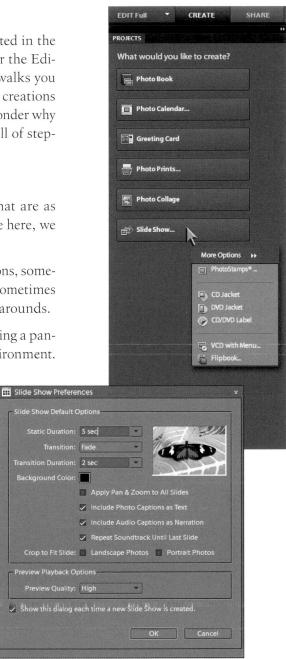

In these steps, you'll start with a dozen photographs and assemble them onto picture-perfect pages.

1. Import the images. As we mentioned, you can initiate a creation from either workspace, but you'll eventually end up in the Editor. For the sake of demonstration, we'll start our first project in the Organizer workspace. Choose

Get Photos and Videos→From Files and Folders. Then do like so:

- In the dialog box, turn off the Automatically Fix Red Eyes checkbox from the list of three on the righthand side. These photos lack human eyes, so we needn't waste time inaccurately identifying and correcting them.
- Navigate into your Lesson Files-PSE8 10n1 folder, then click the Lesson 11 subfolder once to select it—but don't open it.
- Click the Get Media button.

After a moment, several thumbnails fill your browser window. If you see a warning or a question about keywords, click the OK button to dismiss it. Make sure you can see the first 12 images after they are loaded into the Organizer (as in Figure 11-3), and if not, resize the thumbnails so you can.

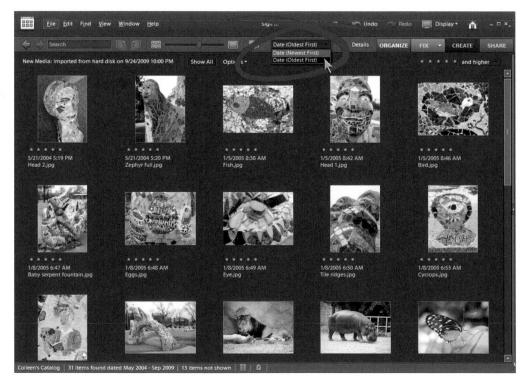

Figure 11-3.

If your images aren't sorted from oldest to newest as they are in Figure 11-3, choose Date (Oldest First) from the pop-up menu (circled in the figure) to the left of the Details checkbox in the shortcuts bar.

- 2. *Choose the sea serpent photos.* For this project, we're going to use 12 images that feature the details of the climbable Sea Serpents sculpture in Nashville's Fannie Mae Dees park, the product of a remarkable community project led by Chilean mosaic artist Pedro Silva. Click the first image in the Preview window, *Head 2.jpg*, then Shift-click the twelfth one, *Big serpent.jpg*, in order to select all the sea serpent photos.
- 3. *Start a new creation*. Click the **Create** tab and from the button options that appear, choose the first one in the list, **Photo Book**. You'll be presented with another list of buttons from which you can choose your printing method. Choose **Print with Local Printer**. This will open the Editor workspace with your selected files in the Project Bin and the first steps of the Photo Book creation displayed in the Projects panel.

PEARL OF

WISDOM

The other options for print methods each set you up with third-party photo book producers, which at the moment include Shutterfly and Kodak EasyShare Gallery. The nature of the Web being what it is, we'll stick with the method that's self-contained within Photoshop Elements. But you should be able to extrapolate what you learn here to help you navigate the proprietary interfaces.

- 4. Decide on your page layout. The first panel of the Photo Book project wizard, displayed in Figure 11-4, will walk you through some basic choices, the first of which concerns the layout of your pages. The first option is Random Photo Layout, which could end up giving you several (sometimes tiny) images on each page, not to mention overlapc and ackew placement that only a computer could love. Skip that and select Choose Photo Layout instead so that you retain some control. When you click the radio button, the panel changes, giving you the opportunity to choose specific left and right page layout schemes.
 - For this project, set the Left Page Layout to the first option, with one big centered image.
 - Set the **Right Page Layout** to the second option in the second row, which has two portrait-oriented images side by side.

Once you've chosen right and left placement, leave the **Page Size** set to **Letter**, and click **Next** at the bottom of the panel.

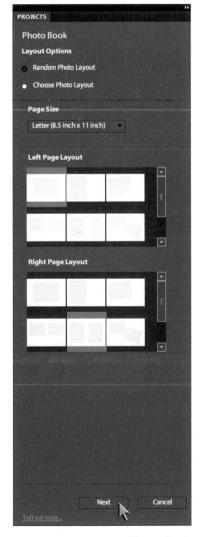

Figure 11-4.

5. *Rearrange the photos in the Project Bin*. Because we know that each left page will have one (preferably horizontally oriented) photo and each right page will have two (preferably vertically oriented) images, we can tweak the order of the photos to suit that layout. In the **Project Bin**, drag the *Fish.jpg* image from the third position to the first. You will see a vertical black bar that shows you where it will land when you let go. Rearrange the next three landscape images (the bird, the eggs, and the eye) forward or backward enough spaces so that the pattern of one horizontal followed by two verticals continues, as shown in Figure 11-5.

Figure 11-5.

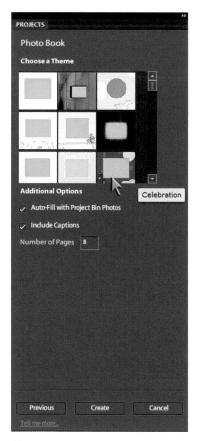

Figure 11-6.

We use the word "preferably" with regard to orientation because Elements will force your image into the corresponding frame regardless of appropriate orientation.

- 6. *Anticipate the title image*. You don't get a warning about this, but the first page of your album is going to end up as a cover, or title, page. This throws off our whole 1 horizontal/2 vertical pattern scheme, but armed with foreknowledge, we can respond appropriately. Drag the final image in the **Project Bin**, *Big serpent.jpg*, to the second position so that *Fish.jpg* becomes the cover and *Big serpent.jpg* becomes the single image slated to land on the first left-hand page.
- 7. *Select a theme.* The next task is to choose a background theme for the pages. In the aptly titled **Choose a Theme** window, which you can see in Figure 11-6, click the third one in the third row, called **Celebration**. It's a little garish, but given that the Sea Serpent exists for the express purpose of letting kids climb on it and go wild, we reckon it's appropriate.
- 8. *Establish a few additional options*. The final bit of the wizardly choices lets you customize the appearance of your album. Set the remaining options as follows:
 - Turn on the Auto-Fill with Project Bin Photos checkbox.
 - Turn on the Include Captions checkbox.
 - Set the **Number of Pages** to **8**, which will properly accommodate our four sets of three in 2-page spreads.

After you've made these choices, click the **Create** button at the bottom of the Projects panel. The Projects panel will collapse and Elements will start cooking up your pages according to the directions you've set, eventually revealing your title page plus the eight pages you actually told it to create in the Project panel.

- 9. Adjust the navigation toolbar. When the project appears in the preview window, you'll see the title page (we warned you, even if Elements didn't) and a toolbar to facilitate navigating your project that appears at the top of the page (Figure 11-7). It should indicate that you are on page "T of 8," thus admitting that it has added a ninth (title) page at the beginning without your asking it to. (The navigation bar may still read 7/8 of 8, in which case click on the big blue left-pointing arrow to go all the way to the beginning.) Grab the toolbar and move it up into the gray pasteboard area so that it's out of your way.
- 10. *Resize the title image*. The fish image is a little too big for the frame, so resize it by right-clicking on it and choosing **Position Photo in Frame** from the context menu, as in Figure 11-8. Another semi-transparent control bar appears. Move the slider to the left until the entire fish fits inside the frame, then click the ✓ to accept your adjustment.
- 11. *Change the caption to an album title*. Previous versions of Elements had a "click-n-fill" Title text box on the cover page, but Elements 8 lacks this bit of template help, so we'll have to create it ourselves.
 - Start by making sure the **Show Bounding Box** checkbox is turned on in the options bar.
 - Click anywhere outside the fish image to deselect it. Hover over the caption "Detail of a fish" until the blue bounding box appears, and then click.
 - Place your cursor over the circle in the center of the selected text box and drag downward. For some annoying reason, Elements has made a duplicate text box. Rather than fight it, we'll just delete it in the next bullet.

Figure 11-7.

Figure 11-9.

PEARL OF

WISDOM

Rather than struggle with why Elements creates a duplicate text box, we finally just got in the habit of grabbing the move tool, dragging the mysterious new one out away from the first, then deleting the original. Elements will ask you if you want to delete that layer, and you should click OK. As in, "OK, I never wanted it in the first place so please make it go away." If you're feeling really peevish—and trust us, you might be—you can turn on the checkbox in that warning dialog to make it go away for good.

- Click the original caption to select it and press the **Back-space** key. When Elements asks you if you want to delete this layer, click **Yes**.
- Choose the T in the toolbox in order to get the text tool, then click three times on the "Detail of a fish" text to select the entire line. Type "Sea Serpents" to replace the current text and make a title that's appropriate for the whole book.
- In the options bar, increase the type size to 36 pt, and set the type color to white as well, as shown in Figure 11-9.
- Don't be alarmed! It appears as though your text has completely disappeared, but actually the box is now just too small to contain the larger text. Drag the center-bottom handle down until you can see your all your new text.

When you've finished these changes, press the green \checkmark in the options bar to accept them. Review the first spread, and then click the blue \bigcirc in the navigation bar to move to the next spread. The image on the right could use a little repositioning in its frame. Right-click over the image again and choose **Position Photo in Frame**. Rather than changing the size, this time simply drag the image to the left so that all of the larger foreground spine of the serpent is visible, as in Figure 11-10.

- 12. *Add a caption*. On the opposite spread, we have two caption issues:
 - For some reason, Elements decides to scale the caption text to match the photo size, which is just plain silly and leaves us with a smaller typeface on the right page's photos. Select the text on the "End of baby serpent's tail" image by triple-clicking with the text tool. Then type the odd **18.07** into the text size box so that it matches the facing page and press Enter.
 - The Zephyr image lacks any caption at all (our bad; we left it off the original image file from whence Elements obtains such information). With the lefthand caption still selected, hold down **Shift+Alt** while dragging a copy over to the Zephyr image. (The Alt key tells Elements you want a copy, and the Shift key keeps it on the same horizontal plane as its neighbor.)
 - Select the text in the new caption and replace it with the word "Zephyr".

When you've finished these changes, press the green \checkmark in the options bar to accept them. The results are shown on the right side of Figure 11-10.

13. *Review the next spreads.* You may have noticed that when you created your project, Elements switched the items in the Project Bin from your source files to the pages of your creation. Kinda silly, wethinks. But it does give you another way to navigate your pages. Simply click on the next spread in the Project Bin, as in Figure 11-11. Review each spread, resizing and repositioning text and images as you see fit. Work your way through until you get to the last spread.

Figure 11-11.

- 14. *Resize the frame on the last image.* Thus far, we've been scaling images to make them fit the frame, and now it's time to turn the tables. Right-click on the image of the woman reading, and choose **Fit Frame to Photo**. The frame expands to reveal the entire image.
- 15. *Reposition the image.* Resizing the frame in place caused the right edge to go into the gutter (that's book-talk for the place where the right and left pages come together). Drag the final image to the right, slightly under the empty frame, as in Figure 11-12. Reposition the caption by dragging it to a suitable location of your choice. (And watch our for doubles like we saw back in Step 11!)

Figure 11-12.

16. Fill the empty frame. As the fish image inadvertently became the cover shot for this book, we want to give it another appearance here at the end. But at the moment, Elements has seen fit to only show us our Photo Book pages in the Project Bin. Remedy this by clicking the ▼ to the right of where it says Show Open Files under the Project Bin tab (see Figure 11-13). Choose Show Files from Elements Organizer from the pop-up menu, and the Project Bin will be repopulated with our original images.

With this setting, everything that's selected in the Organizer will appear in the Project Bin. You can even switch over to the Organizer (press Alt+Tab) and add to the collection that appears. Just don't forget to hold down the Ctrl key when you add a new image, or you'll deselect the ones you already have.

- 17. *Drag the fish to the empty image holder*. Adding an image to the empty frame is as simple as dragging it from the Project Bin and letting go over the empty frame. The frame is too big for the layout and the fish is too big for the frame, but we can fix that in the next step.
- 18. Resize the fish image. Click the frame containing the fish to select it. Then hover over the lower-right corner until you see the two-headed diagonal arrow (not the curvy one; we'll use that next). You could immediately start dragging to resize, but to get results consistent with ours, click once and note that the options bar now has width and height settings. Type a value of 60 percent into the box marked W. Then make sure the Constrain Proportions checkbox is turned on, and press the green ✓ at the lower right of the image.
- 19. *Tilt the fish frame*. Let's make our little fishy look like he's going to swim right off this last page. Start by hovering over any of corner or midpoint handles until you see that curved two-headed arrow cursor. Then twirl the fish's frame around until it's tilted, as in Figure 11-14 on the next page. Press **Enter** to accept your change, and then drag the frame down to the lower corner of the page as you see in the example.

Figure 11-14.

Figure 11-15.

- 20. *Reorient the fish.* You may have noticed as you were spinning the box that the fish was spinning too. Let's get him headed the right way.
 - First, **right-click** in the image and choose **Position Photo in Frame**.
 - In the toolbar that appears, use the slider once again to shrink the image so that the entire body of the fish is visible.
 - Press the icon to the right of the slider, indicated in Figure 11-15, to turn the image 90 degrees counter-clockwise. Depending on which way you twirled the frame, you may have to press it a couple of extra times to spin the fish around so that his nose is pointing toward the bottomright corner of the page.

When you get our fishy friend in the right direction, press **Enter** to accept your changes.

- 21. *Tilt the caption.* The caption can be tilted in the same way as the image. Click it once to select, hover over a corner and wait for the curved two-headed arrow, and then align it to the fish image for that extra touch of whimsy.
- 22. *Change the background*. You're probably as sick as we are of the festive but tiresome balloon-filled background of our theme. Turns out the mosaic images of this particular project need a less distracting environment, and Elements has us covered.

If you were paying attention when you started the creation, you noticed Elements collapsed the Project panel and automatically opened the Content panel full of various graphically useful resources from which we might find a more suitable background. Here's what to do:

- In the **Content** panel, set the pop-up menu on the left to **By Type**, and from the menu on the right choose **Backgrounds**.
- Hmm, there are obviously a lot to choose from. To more easily find the one we're looking for,

change the lefthand pop-up menu to **By Color** and the righthand one to **Green**.

- Press the first icon in the row of icons under the pop-up menu in order to filter for backgrounds.
- Click the first one in the fourth row. Then click **Apply** at the bottom of the **Content** panel.

As you can see in Figure 11-16, the balloons are replaced by a subtler but definitely still sea monster–appropriate context.

Note that you have to change the background of each spread individually. We think you should be able to switch back to the open files in the Project Bin, select them all, and apply the background. We've submitted that to the Adobe suggestion box.

A mysterious person reading

Figure 11-16.

23. *Print your project*. Once you get each spread adjusted to your heart's content, click the **Print** button in the navigation toolbar, as indicated in Figure 11-17.

In the **Print** dialog box that appears, make the following choices:

- Choose the printer you wish to use.
- In Step 2, click the **Change Settings** button to see a list of choices. You'll need to set these based on the capabilities of your particular printer and your particular desires.
- Leave the Paper Size set to Letter.
- Leave Select Type of Print set to Individual Prints.
- Change the Select Print Size to 8 × 10. (Although you could choose Actual Size from the bottom of the pop-up menu, leaving it slightly smaller keeps the whimsical edges of our background from being cut off.)

You can review the other controls afforded to you by the Print dialog box in Figure 11-18. When everything is set to your satisfaction, click the **Print** button.

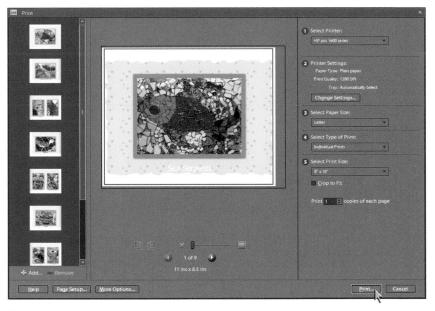

24. Save your project. Choose File→Save As, and name your new file Sea Serpent Album.pse. (The .pse format is a proprietary format exclusive to Elements, but it is useful in case you want to return to this project and make edits later.) Turn on the Include in Elements Organizer checkbox so that you can easily find your project from within the Elements environment, and then click Save.

Creating a Greeting Card

The next project we'll explore in the Create tab is the Greeting Card. At least, that's what Photoshop Elements calls it. But the project that Elements creates for your desktop printer is a one-page, unfolded card, much closer to something we would call a postcard. In fact, if you look carefully, the icon Elements uses for this creation even has a stamp in the upper-righthand corner.

PEARL OF

WISDOM

The Shutterfly and Kodak Gallery options will take you to those respective web sites where fairly simple wizards allow you to create projects that more closely resemble actual greeting cards, i.e., something that folds in the middle with a suitable sentiment inside. You'll want to select your photos in the Organizer before you start either of these options. Both sites either require you to have an account already or help you create one during the process. Then, friendly interfaces will walk you through the rest of the fairly straightforward process, including purchasing some number of copies of your final creation. They'll even supply the envelopes. (Envelopes being another requirement to meet the threshold of "greeting card" in our minds.)

We'll forge ahead in this exercise with making a postcard-like greeting for Valentine's Day that you can print on your local (i.e., desktop) printer and send off to your sweetie next February. By the time we're done, we'll have loaded it with so much obnoxious heartshaped sincerity that the object of your affection will never doubt the enormity of your undying love. Because we're bound to end up there anyway, we'll start this project in the Editor workspace.

- Choose the Greeting Card project. If you've been using the Organizer, start by making sure all your photos are deselected there, and then press Alt+Tab to switch to the Editor workspace. If you're starting without either workspace open, simply click Edit on the Welcome screen. Then choose the Create tab, and click the button for the Greeting Card. In the next panel, choose Print with Local Printer, as you did in the previous exercise.
- 2. *Choose a page size and basic layout.* This panel, shown in Figure 11-19, will look quite familiar to those of you who did the last exercise. Start by setting the **Page Size** to **4** inch × 6 inch, which to our mind seems more appropriate for a postcard. We'll skip the theme this time and choose the first option, a simple one-photo layout, in the **Choose a Layout** pane. Leave the checkboxes turned off this time. Then click **Done**. Yeah, not much to this one, is there?

Figure 11-19.

3. *Choose a background.* Because our objective is a sweet, comic valentine, let's see whether Elements' sorting function can help us find some suitable fodder to spice up our creation. In the **Content** panel, set the lefthand pop-up menu to **By Mood** and the righthand menu to **Romantic**. (Yes, you could also set them to By Event and Valentine, respectively, but that's so literal. Your sweetheart will see right through that.) The Content panel is immediately constrained to the kind of pink and red and heart-shaped goodness we need. Double-click on the third background in the top row, entitled simply and sincerely "Hearts," in order to add it to your creation (Figure 11-20).

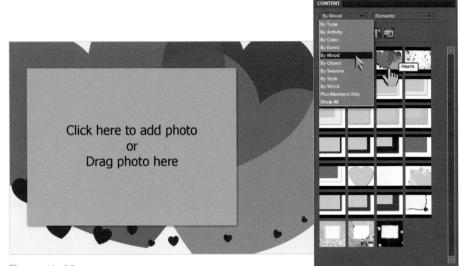

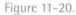

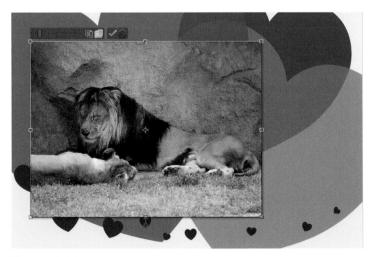

Figure 11-21.

4. *Add a photo*. The creation is inviting you to "Click here to add photo," so do just that. When you

click on the text, the **Replace Photo** dialog box opens (although admittedly, you're really just replacing a gray box). Navigate to the *Lesson 11* folder and click the *Lyin lions*. *jpg* image, then click **Place**.

5. *Resize the image to fit the frame*. Elements seems to know you are going to want to fit your image right away, and the familiar resizing toolbar appears above the photo. Drag the slider to the left until the entire image is visible, as in Figure 11-21, then click the green ✓ to accept.

6. *Change the frame.* The ordinary rectangular photo is not contributing to our romantic ambiance, and what better way to fix that than by putting the photo in a heart-shaped frame, surrounded by more hearts? Start by dragging the image up and to the right slightly so that the photo is not covering the dark red hearts of the background. Then, from the **Content** panel, choose the frame that's currently the fourth one in the fifth row in Figure 11-22, aptly titled "Pink Hearts." Click **Apply** at the bottom of the Content panel, and voilà. As you can see in the figure these lovin' lions are encased in a flurry of pink hearts around a heart-shaped window.

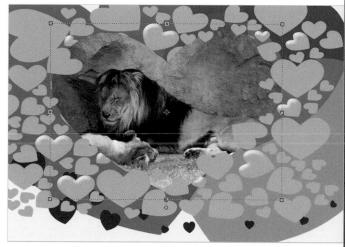

- 7. *Add a pink layer style to the frame.* The natural rock and grass of the zoo habitat where Deke shot these lions is great for everyday feline lying around, but it's not quite fitting with our sentimental theme. Of course, what these guys need is some soft (pink, naturally) romantic lighting to set the mood. You can create such ambiance easily with a layer style, as follows:
 - Right-click the photo, and choose Edit Layer Style from the context menu.
 - In the **Style Settings** dialog box, shown in Figure 11-23 on the next page, turn on the **Glow** checkbox. We want the pink glow to envelop the lions, so turn on the **Inner** checkbox that appears.
 - Click the swatch to the right of the Size slider in order to choose an appropriate color. In the **Select Inner Glow Color** dialog box that appears, create a nice rosy glow by entering these values: **H**: **350**, **S**: **70**, and **B**: **80** ("circled" with love in the figure).

Figure 11-22.

- Click **OK** to close the Select Inner Glow Color dialog box.
- Back in the **Style Settings** dialog box, make sure the **Preview** checkbox is turned on so you can observe the effect take place.
- Set the **Opacity** of the Inner Glow to **75** percent.
- Move the Size slider up to 200 px and watch as the lions are encased in a warm, romantic glow.

Click **OK** to confirm your adjustments. Aw, just makes you want to curl up and snuggle your beloved.

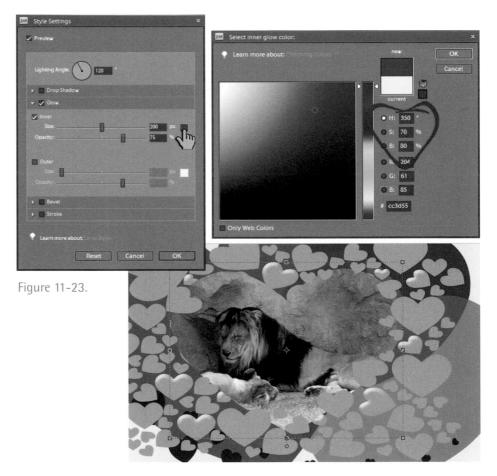

8. *Create a text-friendly area for a message.* Of course, you'll want to add a sincere declaration of love to this creation, but before you do, you'll need to create a slightly less distracting space for text.

- Set your Foreground color to white. (The easiest way to do this is to press the D key to get the default colors, then the X key to switch them.)
- In the **Content** panel, set the lefthand pop-up to **Object** and the righthand one to **Symbols**. Three-quarters of the way down the generated list, you'll find the Heart symbol shown in Figure 11-24.
- Drag the Heart symbol out onto your card and place the upper-left corner over the male lion's hindquarters.
- Hover over the lower-righthand corner of the heart's bounding box until you have the double-diagonal arrow, and click once to change the options bar.
- Uncheck the **Constrain Proportions** checkbox in the options bar so that you can reshape the heart a bit as you resize.
- Go back to the lower-right corner of the bounding box around the heart. Drag the shape out to the lower-righthand corner of the card. As you move, widen the heart a bit to fit in with the shapes that already exist in your creation.

When you've got the white heart set the way you want it, press the green \checkmark to confirm your changes.

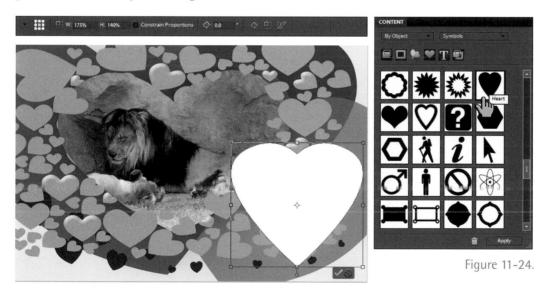

- 9. *Add the text of your heartfelt message*. You'll notice there is no handy text tool available for this project like there was when you were creating your photo album in the previous exercise. In the greeting card project, you add text via the Content panel.
 - Set the lefthand pop-up menu to **By Type** and the righthand one to **Text**. As you can see in Figure 11-25, a variety of text options are presented, but seriously, did you think we could resist the second one in the top row, called Animal Fur Pink? If you haven't already anticipated the lengths we'll go to go over the top, double-click that one now.
 - Elements will create a text box with the placeholder text "Your Text Here" somewhere on your image. Or it will just give you a blinking cursor. No matter, it's selected and ready to be typed over. Type something straight from the heart. Or type something silly, like we've done.
 - Triple-click somewhere in the text to select the entire line. Then choose a fancy font by pressing the to the right of to the current font in the options bar. Pick something curvy and romantic.
 - Set the type size in the options bar by typing 16 pt into that field.

Click the green \checkmark to accept your changes. You can see our example in Figure 11-25.

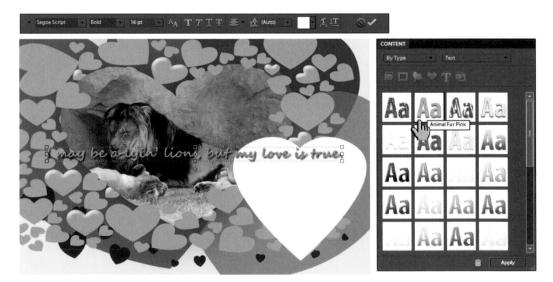

Figure 11-25.

- 10. *Adjust the text display.* Reposition your text by dragging it over to the white heart background you created for it. In our case, we had to add a few hard returns before we moved it so the text would wrap properly, as you can see in Figure 11-26. (Resizing the box will stretch rather than wrap the text.) Of course, perhaps you are more succinct with your sentiments than we and your simple message fits easily without too much fuss.
- 11. *Change the background to suit the text*. As appropriate as the pink fur text is, it's a little hard to read against a white background. Here's a handy trick to fix that:
 - Click the black swatch that represents the background color in the toolbox.
 - In the **Color Picker** dialog box that opens (shown in Figure 11-27), choose a nice deep red and click OK.
 - Click a white area of the heart shape to make it active.
 - Press **Ctrl+Backspace** to fill the selected object with the background color.

This trick, Ctrl+Backspace to fill any selection with the background color, works in a variety of useful places. You'll thank us later.

- 12. Rotate the heart. Just for fun, hover over one of the corners until you see the double-curved arrow cursor and twist the heart shape a bit so that it doesn't look so staid. This is a passionate declaration, after all. You may have to reposition the heart or the text inside to keep the text within the heart container. Press the green ✓ when you're done. The final results are shown in Figure 11-28 on the next page.
- 13. *Save your file.* Choose File→Save and name your homage to true love as *Lyin love.psd*. Saving as a Photoshop file format will allow you to revisit your document and make changes as necessary. (And you know, even true love can grow cold, or even grow up, as the case may be.)

Figure 11-26.

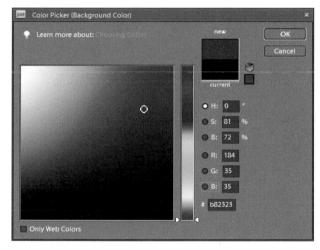

Figure 11-27.

Figure 11-28.

Stitching a Panoramic Picture

And what about those five photos that we imported in the first exercise and have neglected ever since? Fret not, the time for those photos has come at last. Armed with a tripod, an Olympus E-620, and a 300 mm-equivalent lens, Colleen shot these photos of her hometown with the express intention of stitching them together into a panoramic "big picture" view of the Sacramento skyline. Knowing Photoshop Elements had just the tool for the job, she could zoom in on all the interesting details of the Old Sacramento waterfront in five different (if overlapping) frames.

Unlike the other creations we've explored in this lesson, panoramic pictures can't be created from the Create tab. In this last exercise in this lesson, you'll learn how to create a panoramic picture using one of the Editor's Photomerge commands, plus pick up a few tips on shooting suitable source pictures for just such a project.

PEARL OF WISDOM

The Photomerge technology can also be used for a variety of other mergedependent creations. Some are silly and some are complicated. We're going with Panorama because it's the best executed and gives wonderful results. A Photo Calendar is a great way to use your carefully crafted photographs to make a personalized gift for that special someone, or just a normal person who likes photographs and wants to know what day it is. The bad news is that the output options for Photoshop Elements Photo Calendars are limited to using one of two web services, so you can't quite use it for last-minute gift-giving. The good news—and this far outweighs the Plan Ahead requirement—is that either of the online services, Shutterfly or Kodak EasyShare, walks you through the project with simple steps that are even simpler than the ones we saw in Elements proper. And, more importantly, they do all the hard layout calculation that comes with making a calendar. Then they print your copies and ship them to you. Not a bad deal at all.

A few words of advice if you're going to try one of these services:

- Choose your images in the Organizer ahead of time to expedite the upload process. This saves you from having to upload from the web interface.
- You will need an account to use either of these sites, but both interfaces will allow you to create said account on the fly as part of the project creation process.
- Both services have embellishment options that let you personalize your calendar and create a complimentary setting for your images.
- Both services let you add captions, and Kodak even lets you auto-fill them based on image captions, but typeface options are limited, as in nonexistent.
- Shutterfly has a few cool extra features, including the ability to add your own special "holidays," like say, Deke's birthday (March 26th).
- We're talking about the Internet here, so things could get worse (break) or better (added features) each time you use them.
- Both sites have a way to preview your calendar. On the left is a sample from Kodak's Red Linen theme.

So grab yourself 12 awesome images, like Deke's collection below of a year in butterflies (all shot in a day), and check it out. It's free to try, and you pay only for what you like enough to order.

Figure 11-29.

1. *Start a new Photomerge Panorama file.* Creating a panorama is one of the Editor's neatest tricks, but for some rea-

son the good people at Adobe have chosen to bury the command in what seems to us to be a remote location. Then again, who cares? You have us to pass along that info to you, so let Adobe hide one of their easiest yet most spectacular features if they want to. Choose **File→New→Photomerge Panorama** to display the Photomerge dialog box, shown in Figure 11-29, which gives you a place to gather the photos that you want to merge.

As we mentioned at the outset, Colleen shot these images for the express purpose of creating this exercise. With the almost miraculous power of Photomerge technology in post-production, most of the user contribution to a good outcome happens at the moment of capture. Here are some key things to keep in mind when you're shooting for a panorama creation:

- Shoot each frame with some overlap to its neighbors. Adobe recommends an overlap of 15 to 40 percent, a big range. In this case, Colleen shot them with a little extra for good measure, closer to 50 percent overlap.
- Turn off your camera's automatic exposure setting and meter the scene manually. This eliminates the chance that some images will come out lighter or darker than others. The Photomerge process can account for slight differences in brightness, but the more similar your photos, the better.
- Use a tripod to keep the camera level and stationary.
- 2. Add the five Sactorama photos. Click the Browse button in order to add source photos. Navigate to the Lesson 11 folder inside Lesson Files-PSE8 1on1. Click Sactorama_1.jpg, then Shift-click on Sactorama_5.jpg to select it and all the images in between. Click OK, and you'll be returned to the original Panorama dialog box with the five images now listed in the Source window.
- 3. *Start the merge process.* Leave the **Layout** set to Auto, and then click **OK**. Suddenly the Editor swings into action as if there were a ghost in the machine. A glance at the Layers panel reveals that the Editor is busy at work copying the five images and pasting them into a single document.

4. *Enjoy the miracle of the Photomerge calculations*. It may take a while (a long while on older machines), but as you can see in Figure 11-30, Elements has done a spectacular job of merging the pieces together. Each piece is represented on its own layer with its own layer mask. You can see that Elements did in fact overlap parts by 40–50 percent. You can see how using a tripod made for nice, even spacing of the contributing photos, but the fact that Colleen was directly across the river from the stern of the river boat means that she caught more river on the left and more sky on the right.

- 5. *Flatten the image.* The layers may be interesting and all, but having these five layers is going to make the next steps problematic. We really don't need them, so click the *→*≡ at the top right of the Layers panel menu (Figure 11-31) and choose Flatten Image.
- 6. Crop the image. Press the C key to select the crop tool. Our goal is a rectangular image, but there isn't really a rectangle that catches the gold tower of the bridge on the right and yet still avoids the white (i.e., missing) area on the left. We'll fix that in the next step. For now, drag out a rectangle that captures the tower and don't worry about losing the (relatively uninteresting) water on the lower left, as we've done in Figure 11-32 on the next page. Press the green ✓ when you get it set correctly. (Warning: It's still a big image, so it may take a while.)
- 7. *Clone the sky.* We've solved the problem of the missing river (by cropping it out), but we still need to fill in the missing sky. Start by choosing the Clone Stamp tool from the toolbox. Then proceed as follows:
 - Set your brush **Size** to 250 pixels in the options bar. Leave the **Mode** set to Normal and the **Opacity** at 100 percent.

Figure 11-31.

Figure 11-32.

• Because the sky at sunset has an almost gradient effect, getting bluer as you move away from the horizon, you want keep the clone source on the same horizontal plane as the area you're trying to fill in. Alt-click the area in the sky just to the right of the bridge tower (indicated by the cursor in Figure 11-33) in order to set the source point for cloning across the top of the image.

Figure 11-33.

- Use horizontal right-to-left brush strokes to take advantage of all that open blue sky just ripe for cloning. As you fill in closer to the horizon line, watch the source point, indicated by the plus sign moving across the righthand side of the image (see Figure 11-34), to make sure you aren't grabbing bits of building in your clone.
- Reset the mouse in between strokes so you can use the Undo command if necessary without wiping out all your work.

Figure 11-34.

- If you need to, reset the source point a little lower by Altclicking at a lower point than your initial source as you get closer to the trees and buildings, so that you pick up a little bit of that lighter peachy glow.
- Don't worry if the transitions seem a little rough; we'll fix those in the next step.
- 8. *Switch to the Healing brush to smooth out the filled-in sky.* To smooth out the cloning effect on the lefthand side of the image, switch to the healing brush in the toolbox. Reduce the brush **Size** to about 125 pixels. Make sure your **Type** is set to Proximity Match. Then make a single stroke over the transitional area in the sky (as in Figure 11-35).

Figure 11-35.

The sky is a fairly forgiving subject, but you can make extra passes until the transitions suit your taste. Making your brush bigger (but still keeping it small enough to control so you don't brush over the trees and buildings) can be helpful as well. You may see a status pop-up message flash across the screen as Elements makes its healing calculations, depending on how hard your computer is working. (Unfortunately, we can't show it to you, because ours flashed only when we weren't ready to take a screenshot. It's an elusive pop-up, to be sure.) Nevertheless, your final outcome is a smooth sunset sky over the Sacramento River.

 Save the panorama. After all this work, you'll want to save the results. Choose File→Save or press Ctrl+S. Name the file "Right Here in River City" or something equally clever and trademarkable. Then set the Format option to JPEG (*.JPG; *.JPEG; *.JPE). Click the **Save** button, and then click **OK** in the JPEG Options dialog box.

You can see (most of) the final creation in its almost full glory in Figure 11-36.

Congratulations! You've reassembled an entire city skyline. Time to give yourself a well-deserved break. We recommend a relaxing drink in the lounge that resides in the stern of that large paddlewheel boat. It's the perfect place to unwind, especially at sunset.

Figure 11-36.

WHAT DID YOU LEARN?

Match the key concept in the numbered list below with the letter of the phrase that best describes it. Answers appear upside-down at the bottom of the page.

Key Concepts

- 1. Creation
- 2. Random Photo Layout
- 3. Project Bin
- 4. Theme
- 5. Page T
- 6. Constrain Proportions
- 7. Content panel
- 8. By Color
- 9. Inner Glow
- 10. Ctrl+Backspace
- 11. Photomerge
- 12. Flatten Image

Descriptions

- A. The title page designation in a photo book creation.
- B. A sorting setting in the Content panel that limits the choices to those of a particular hue only.
- C. A layer style effect that adds a soft, diffuse interior edge to an object.
- D. Adobe's catch-all term for any media project that includes one or more images.
- E. A layout setting that abdicates photo arrangement in a creation to the software's whim.
- F. A panel that appears during the creation process that allows you to choose your own backgrounds, frames, and other embellishments.
- G. A background and typeface collection that Photoshop Elements allows you to assign as part of a creation.
- H. A keyboard shortcut that allows you to fill a selection with the background color.
- I. Elements technology that facilitates stitching photos together into a continuous panorama.
- J. A Layers panel command that collapses a multi-layer file.
- K. A panel-like feature that holds items selected in the Organizer for use in a creation.
- L. A setting in the options bar that keeps the image dimensions proportional during resizing.

Answers

1D' 5E' 3K' +C' 2V' PT' 2E' 8B' 6C' 10H' 111' 151

LESSON

Tri

SHARING YOUR PHOTOS

The old ways of sharing photos were quaint

UNTIL FAIRLY RECENTLY, "sharing" photos meant bundling them into a 45-minute slideshow and inflicting them on an innocent and undeserving audience of future ex-friends. The more merciful photo enthusiast might collect his or her prints into a photo album so that guests could tour them at their leisure. But the ancient conventions illustrated in Figure 12-1 are becoming increasingly uncommon and even unrealistic. Thanks to the prolif-

eration of digital cameras, desktop scanners, and other varieties of capture devices, we create ten images for every one amassed by our parents. Many of us have too many photos to fit them into albums, and if we did, what casual visitor in his or her right mind would want to sift through them all?

Thankfully, today's notion of photo-sharing has expanded to keep up with our increasingly frenzied and eclectic habits. Certainly, we *can* print our photos; and under many circumstances, the printed snapshot remains our best and most practical imagesharing medium. (Which is why we devote the first exercise to the printing of single photographs.) But you can likewise group photos onto a page, email images to friends and colleagues, and collect the photos in an online gallery. Happily, photo-sharing is one of Photoshop Elements' strongest and best-developed features. Ecstatically, photo-sharing also happens to be the topic of this lesson.

Figure 12-1.

ABOUT THIS LESSON

Project Files

Before beginning the exercises, make sure you've downloaded the lesson files from *www.oreilly.com/go/deke-PSE8*, as directed in Step 2 on page xiv of the Preface. This means you should have a folder called *Lesson Files-PSE8 10n1* on your desktop (or whatever location you chose). We'll be working with the files inside the *Lesson 12* subfolder. This lesson explains ways to share your images with other people, whether by printing or distributing the electronic files online. You'll learn how to:

•	Print an image from your computer to an inkjet printer
	Use photo-grade paper to produce film-quality output from an inexpensive inkjet printer page 334
	Combine multiple images onto a single page using the Organizer's Prints command page 343
	Share pictures online for free using Photoshop.com

Video Lesson 12: Emailing Your Images

Of all the ways Elements lets you share images with others, emailing is the most convenient. All you need is an email account and an Internet connection. No mysterious printer settings, no new subscription fees. Your only concern is to fire off the photos to your various friends and associates.

Elements prepares an email-friendly document with such aplomb that Deke devotes an entire video lesson to the topic. You can either watch the video lesson online or download to view at your leisure by going to *www.oreilly.com/go/deke-PSE8*. During the video, you'll learn about the keyboard equivalents and shortcuts listed below.

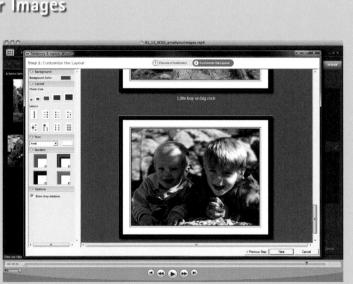

Operation

Return to the Organizer workspace Display the Properties panel (for entering captions) Zoom an image in the Organizer workspace Select multiple nonadjacent images Print a selected image Flatten a layered image Keyboard equivalent or shortcut Click the Organizer (企謡) button Alt+Enter Double-click the image thumbnail Ctrl-click image thumbnails in the Organizer Ctrl+P Alt+L, then F

21st-Century Sharing

Don't get us wrong, nothing says you *have* to share your images. (In fact, you may prefer to keep your initial attempts at image editing to yourself.) But after you gain a sufficient degree of confidence, you'll want to let loved ones and acquaintances see what you're up to. And no program—not even the professional-grade Photoshop CS4—lets you share with the ease and proficiency of Photoshop Elements. Figure 12-2 is an illustration of a supernova, but it gives you a rough sense of the infinite ways in which Elements lets you share images. And besides, after spending two hours painting a supernova—in Elements, no less—there's no way Deke's not using it in his book, however flimsy its relevance.

The ways of sharing photos with Elements are boundless

Although Elements has the aptly named Share tab where many sharing options live, we'll begin this lesson by printing an image difectly from the well-worn and beloved Editor workspace. But to truly exploit sharing, we must eventually return to the workspace that launched us on this journey, the Organizer. As Deke shows you in Video Lesson 12, "Emailing Your Images," the Organizer can assemble pages of photos and transfer them directly to your favorite email program. The Organizer is also capable of packaging photos onto pages like those you get from a professional photo studio, as well as posting images online using your Photoshop.com account. As you saw in Lesson 11, where you learned to make slideshows, postcards, and a host of other creations, Elements gives you a universe of image-sharing options. Corny hyperbole, sure, but on a page that features a supernova, how could we resist?

Figure 12-2.

Obviously, we have no idea what printer you're using, so your experience may diverge from ours starting at Step 6 on page 336, as we explain in the exercise. We'll leave it up to you to make sure your printer is set up properly and in working order. This means that the power is turned on, the printer is connected to your computer, print drivers and other software are installed, the printer is loaded with plenty of paper and ink, and the print head nozzles are clean. For more information on any of these issues, see the documentation that came with your printer.

Printing to an Inkjet Printer

When it comes to printing full-color photographic images, your best, most affordable solution is an inkjet printer. Available from Epson, Hewlett-Packard, Canon, and a cadre of others, a typical inkjet printer costs under a hundred dollars. In return, you get printed images with outstanding color and definition (see the sidebar "Quality Comes at a Price" on page 340), better than you can achieve from your local commercial print house. However, you can't use a color inkjet printer to reproduce artwork for mass distribution. Inkjet printers are strictly for personal use.

In this exercise, you'll learn how to get the best results from a color inkjet printer attached to your computer. If you don't have such a device, don't fret. You won't be able to follow along with every step of the exercise, but you'll get an idea of how the process works.

Assuming you have an inkjet device at your disposal, please load it with the best paper you have on hand. Ideally, use a few sheets of glossy or matte-finish photo paper, readily available at any office supply store (again, see "Quality Comes at a Price" for more information). If you don't have such paper, or if you simply don't feel like parting with the good stuff for this exercise, go ahead and load what you have. Just remember the kind of paper you loaded so you can make the correct selections in Step 6 on page 336.

1. *Open the test image*. Look in the *Lesson 12* folder inside *Lesson Files-PSE8 10n1* and you'll find a file called *Y2K+10 invite.psd*. Pictured in Figure 12-3 on the fac-

S

ing page, this file hails from a wildly successful Y2K party Deke helped throw a few years back. In addition to making some adjustments for time—who knows what Y2010 has in store? we expanded the range of hues and luminosity values to make it easier to judge the accuracy of our color prints. The image is sized at 4 by 5 inches with a resolution of 300 pixels per inch. But as you'll see, that can be changed to fit the medium.

2. Choose the Flatten Image command. This file contains a photographic background composition as well as some text layers that we converted to pixels using Layer→Simplify Layer. Although great for editability, layers require more computation and thus slow down the print process. Best solution: get rid of them by choosing Layer→Flatten Image. Or press Alt+L, then F.

- 3. Save the file under a different name. You don't want to run the risk of harming the original layered image, so choose File→Save As or press the shortcut Ctrl+Shift+S. As long as you save the image under a different name (or in this case, a different file format), you're safe. But here are the settings that we'd recommend:
 - In the Save As dialog box, select the option TIFF (*.TIF; *.TIFF) from the Format pop-up menu.
 - Make sure the ICC Profile: Adobe RGB (1998) checkbox is on.
 - Click the Save button.
 - In the **TIFF Options** dialog box, click **LZW** to minimize the file size without harming the image.
 - For Pixel Order, choose Interleaved (RGBRGB).
 - From **Byte Order**, select the platform you're using, presumably **IBM PC**.
 - Click **OK** to save the file.

The original layered file is safe as houses, and the flat file is ready to print.

4. Choose the Print command. Choose File→Print or press Ctrl+P. Elements displays the Print dialog box, which shows you how the image sits on the page, as in Figure 12-4.

If you're coming to this lesson directly from printing your photo book pages in Lesson 11, you may need to set the Select Print Size to Actual Size in order to see the same results in the preview window as we have in ours. It's not necessary, and we'll get to where we want to be later in this exercise, but we don't want you to get disoriented.

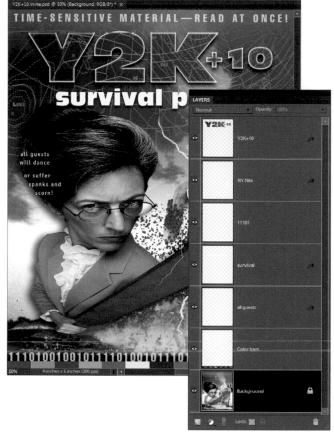

Figure 12-3.

Change Settir	The second second second second	
Printer:	HP psc 1600 series	•
Paper Type:	Plain paper	•
Print Quality:	1200	-
Paper Tray:	Automatically Select	-
Paper Size:	Letter	•
	Advanced Settings	

Figure 12-5.

Figure 12-6.

- 5. *Choose your printer*. In Section **①**, the **Select Printer** field, choose the printer model you want to use from the pop-up menu.
- 6. *Change the settings for your printer*. Section **2** is where you can change settings that are particular to your printer. Start by clicking the **Change Settings** button in this section. Here are the choices we made in the **Change Settings** dialog box, shown in Figure 12-5 (again, your mileage may vary with your printer).
 - We've already chosen the Printer in Section **①**, but apparently Elements wants to give us a chance to change our minds. We'll leave that one alone.
 - For **Paper Type**, we're using a glossy photo paper, so we chose that from the pop-up menu.
 - Print Quality at the moment is set to 1200 dpi (dots per inch), which is probably a little excessive. Things will change later based on our other choices, so we'll leave it. (Besides, we have no options at this point in the pop-up menu, because this particular printer controls its own print settings.)
 - Our simple desktop printer only has one tray, so we don't need to make any choices in the Paper Tray option.
 - Our particular paper is a standard 8.5 × 11-inch letter size, so that's what we'll set here.
 - 7. *Investigate the Advanced Settings*. Click the Advanced Settings button in the Change Settings dialog box in order to access the proprietary properties dialog box for your printer. The HP version that opens in our case looks like Figure 12-6.
 - 8. *Turn on the printer's color management controls.* This is where things are really going to vary depending on your printer, but the first thing you want to do here is to turn on your printer's color management controls. For the HP desktop printer we're using, we found what needed in the Advanced tab of the Document Properties dialog box, in the Image Color Management field. In our case, we're changing that setting to ICM Handled by Printer. (ICM stands for Image Color Management.) If you have more than one option, you may have to run some tests to see which yields the best results.

9. Set the Print Quality. Back in Section ^(G) of the Print dialog box, we weren't able to change the print quality from 1200 dpi, but there is a control for it here. For our HP, we clicked the Paper/Quality tab and set Print Quality to Best (Figure 12-7). The resulting 600 dpi print resolution will be fine for this combination of photo and paper. Color management and print quality were the only things we needed in this proprietary dialog box, so we'll click OK twice to escape the Document Properties and then the Change Settings dialog box. Your experience will depend on how complex the Document Properties dialog box is for your printer.

PEARL OF

WISDOM

If you have problems finding the print quality option (or its equivalent), consult the documentation that came with your printer. Remember: choose the highest setting *only* if you're using photo-grade paper. Standard photocopier grade bond cannot handle that much ink, and the highquality setting will produce a damp, smeared page, thereby resulting in a ruined print and wasted ink.

- 10. Confirm the making of a single print. Back in the main Print dialog box, we can skip Section
 (a) because we set it in the previous step. For Section (a), confirm that you are making Individual Prints, since that's the stated goal of this entire exercise. (The other two items require the assistance of the Organizer workspace anyway, as you'll see in the next exercise.)
- Increase the print size to fill the page. In Section ⁽¹⁾, choose Custom from the pop-up menu. In the More Options dialog box that appears (Figure 12-8), turn on the Scale to Fit Media checkbox so the image fills the maximum printable area of the page. This way, you don't waste any of your expensive paper by, say, printing a tiny image smack dab in the middle of the page. Click Apply. (Do not click OK; we have a few things yet to do in this handy dialog box.)

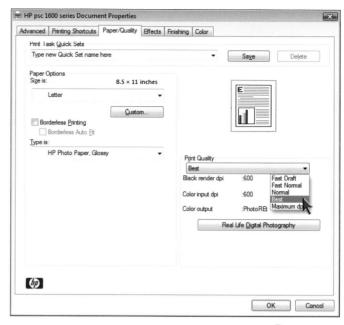

Figure 12-7.

Figure 12-8.

URTHER INVESTIGATION

Understanding how to make good prints takes a certain understanding of print resolution. It's a convoluted enough subject that Deke and Colleen once spent two episodes of their audio podcast, *Martini Hour*, talking about it. To hear the first of two, with links to the second, check out Martini Hour 025, "In Which Colleen Experiences Deke in High Resolution" at *http://www.deke.com/content/martini-hour-025-in-which-colleen-experiences-deke-high-resolution.*

12. Make your Color Management choices. When we chose a Custom print size, we inadvertently landed in the More Options dialog box (which you also could have accessed by clicking the More Options button at the bottom left of the main Print dialog box). We might as well take advantage of being here. One of the aforementioned "more" options is choosing how Photoshop Elements converts the colors in the image from your screen to your printer. To print the colors as accurately as possible, you must identify the *image space*—the color space used by the image itself—and the *destination space*—in this case, the printer profile—employed by the printer software.

Start by clicking **Color Management** in the lefthand pane of the **More Options** dialog box, shown in Figure 12-9.

- Confirm that the **Color Handling** option is set to **Printer Manages Colors**. This setting conveys the source space and leaves the printer software in charge of the color conversion process. This is why we put the printer in charge back in Step 6. (You'll see that Elements actually has a little reminder to make sure we did. And for the record, if we hadn't, the Printer Preferences button would take us back to the Properties dialog box so we could do so.)
- Note that the Image Space is already set to Adobe RGB (1998). This source space is the variety of RGB employed by the *Y2K+10 Invite* image file.
- The Printer Profile in our case is set to Working RGB sRGB and a long string of numbers after that. You can see in Figure 12-9 that the pop-up is dimmed, presumably because that's the only profile the printer has access to.

Printing Choices	Color Management			
Custom Print Size	Color Management			
Color Management	Color Handling:	Printer Manages Colors		
	Image Space:	Adobe RGB (1998)		
	Printer Profile:	Working AGB - sRGB IEC61966-2.1		
	Rendering Intent:	Perceptual		
		iber to enable color management references dialog?		
		Printer Preferences		

Figure 12-9.

- Set the **Rendering Intent** option to **Perceptual**, which maintains the smoothest transitions when converting colors the best solution for photographic images.
- Click OK to exit the More Options dialog box and return to the main Print dialog box.

For the record, the Print Preferences button in the More Options dialog box would take you back to the proprietary Document Preferences dialog box we used in Steps 7 through 9.

Figure 12-10 shows the righthand pane of the Print dialog box as it should appear at this point.

- 13. *Confirm portrait orientation*. One thing you can't set from the otherwise utilitarian Print dialog box is orientation. Click the **Page Setup** button at the lower left of that main Print dialog box. Then, in the lower-left corner of the **Page Setup** dialog box shown in Figure 12-11, choose **Portrait** for the orientation (meaning it prints vertically on the page). Click **OK**.
- 14. *Click Print and dismiss the warning.* Click the Print button and you'll be met with a warning that tells you that the image will now print at less than 220 pixels per inch. This might lead you to believe that 220 ppi is a resolution threshold, above which the image looks good and below which it looks bad. Not so. It's a ballpark figure, and a rough one at that. Assuming you follow our advice in the remaining steps, your image will look fine, so click Continue.
- 15. *Wait and compare.* It takes a long time (usually several minutes) to print a high-quality image from an inkjet printer. But thanks to the miracle of background printing, you can continue to use Photoshop Elements and even get a head start on the next exercise. When the print job finishes, compare it to the image on screen. Assuming that your printer is functioning properly (no jams, no paper flaws, all inks intact, no missing lines in the output), the colors in the printout should bear a healthy resemblance to those in the image that you see on your computer monitor.

But there are always variations. On page 342, Figure 12-12 shows two versions of the same image printed to photo-grade paper from Deke's Epson Stylus Photo 1280. The only difference between them is the Color Management setting that he assigned.

Figure 12-10.

Figure 12-11.

Quality Comes at a Price

Inkjet printers are cheap, often sold at or below cost. But the *consumables*—the paper and the ink—are expensive, easily outpacing the cost of the hardware after a few hundred prints. Unfortunately, this is one area where it doesn't pay to pinch pennies. Simply put, the consumables dictate the quality of your inkjet output. Throwing money at consumables doesn't necessarily ensure great output, but scrimping guarantees bad output.

Consider the following scenario:

- Of the handful of inkjet devices Deke owns, the one he uses most often is his Epson Stylus Photo 1280. It's getting to be a little long in the tooth, but it works great, the software makes more sense than most, and it can print as many as 2880 dots per inch.
- The Stylus Photo 1280 requires two ink cartridges, pictured below. The first cartridge holds black ink; the second contains five colors, including two shades of cyan, two

shades of magenta, and yellow. (As the reasoning goes, the lighter cyan and magenta better accommodate deep blues, greens, and flesh tones.) Together, the cartridges cost about \$60 and last for 45 to 120 letter-sized prints, depending on the quality setting you choose. The higher the setting, the more ink the printer consumes. So the ink alone costs 50% to \$1.33 per page.

- You can print to regular photocopier-grade paper. But while such paper is inexpensive, it's also porous, sopping up ink like a paper towel. To avoid over-inking, you have to print at low resolutions, so the output tends to look substandard—about as good as a color photo printed in a newspaper.
- To achieve true photo-quality prints that rival those from a commercial photo lab, you need to use *photo-grade paper* (or simply *photo paper*), which increases your costs even further. For example, 20 sheets of the stuff in the packet shown below costs \$13.50, or about 67¢ per sheet.

The upshot: a low-quality plain-paper print costs about 50 cents; a highquality photo-paper print costs about 2 bucks. Although the latter is roughly four times as expensive, the difference in quality is staggering. The figure below compares details from the two kinds of output, magnified to six times their printed size. The plain-paper image is coarse, riddled with thick printer dots and occasional horizontal scrapes where the paper couldn't hold the ink. Meanwhile, the photo-paper image is so smooth, you can clearly make out the image pixels. Where inkjet printing is concerned, paper quality and ink expenditure are the great determining factors.

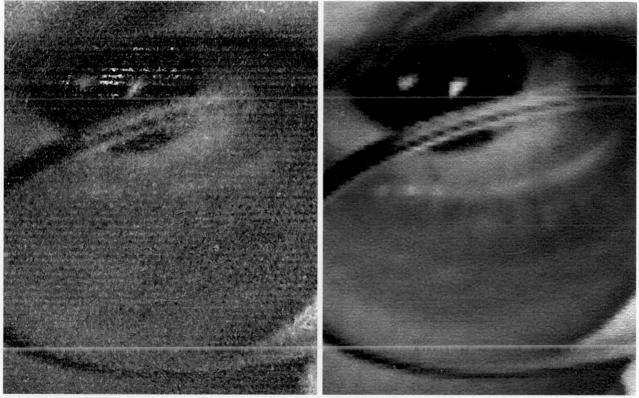

360 dots per inch, plain paper, 50¢

2880 dots per inch, glossy photo paper, \$200

Figure 12-12.

- The lefthand image printed using the sRGB setting is darker and bluer than the other one. But it also happens to be a close match to what he saw on screen. Therefore, the result is a rousing success.
- The second image was printed using Microsoft's ICM color matching. Although this version more closely matches the previous figures in this book, it strays from the image's appearance on Deke's monitor. So we would call it the less successful print.

WISDON

If the output doesn't match the screen image to your satisfaction, try experimenting with your printer-specific options (in the dialog box you reached by clicking the Advanced Settings button in Step 6) until you arrive at a better result. When you do, write the settings down for future reference. Feel free to scribble them down in the margins—it's your book.

PEARL OF

Creating a Picture Package

Now that you've successfully printed a single image to your inkjet printer, it's time to learn how to print multiple photos at a time. Turns out, this is nothing short of a minor miracle. In the old days, Adobe limited the senior and more expensive Photoshop to printing a single image to a single page, and even with Photoshop proper's companion application, the Bridge, you could still only print a grid-like proof sheet. But Adobe blessed the supposedly lesser Photoshop Elements with the ability to print a customizable page with multiple images at a time, all without preparing a special file in advance (which was Photoshop's way). Oh sure, Photoshop proper eventually came on board the multi-photo printing bandwagon, but remember, folks—Elements had it first.

Multiple photo printing in Photoshop Elements is the exclusive domain of the Organizer. Even if you begin your work in the Editor, Elements transfers you to the Organizer. Whether you want to assemble quick-and-dirty proof sheets or fit different-sized images onto a page, Elements does a superb job of making the most of your expensive inkjet paper. And that is precisely what we'll do in this next exercise, where you'll learn to use the Print function's Picture Package option to create a page of different photos at different sizes.

- Open the Organizer. Most likely, the One-on-One catalog that you created at the outset of Lesson 1 (see "Getting Your Photos into Elements"—specifically Step 2 on page 8) remains the active catalog in the Organizer workspace. If not, open it now by going to the Organizer, choosing File→Catalog, and loading the One-on-One catalog file from the Catalog Manager. Then click the Open button.
- 2. *Import a set of images*. For this exercise, we'll use a delightful set of images that Delte shot with his cons at a butterfly preserve. Start by choosing **File→Get**

Files and Videos→From Files and Folders. Then navigate to your *Lesson 12* folder inside *Lesson Files-PSE8 10n1* and select the 12 files that begin with the word "Butterflying". The easiest way to do so is to click *Butterflying_01.jpg*, then Shift-click on *Butterflying_12.jpg*. Then click the **Get Media** button, to import those files into the Organizer.

Of course, you're welcome to import photos into any catalog you like, but we're trying to give you an easy way to keep track of images you may not want to keep forever.

3. Choose the images for your picture package. Back when we were in school, the school photographer would allow you to order a page of different-sized versions of your yearly portrait. Usually, Grandma got the 5 × 7, Mom and Dad got the wallet-sized photos, and the tiny ones were for trading with school chums. Elements allows you to create a similar page, only with different images in each slot if you like, thus optimizing the space on your precious photo paper. To create such a wonder, start by selecting the first five images in the Organizer window; click Butterflying_01.jpg and then Shift-click on Butterflying_05.jpg, as shown in Figure 12-13.

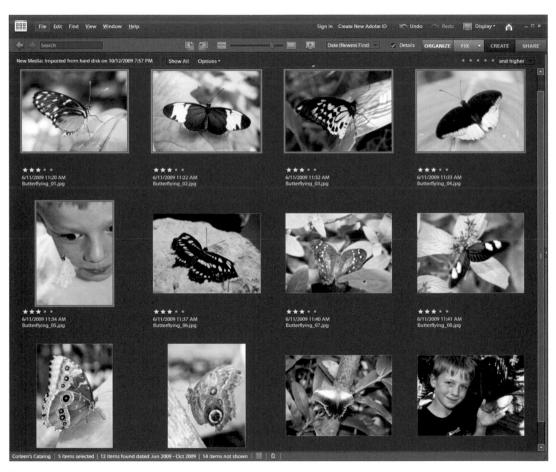

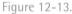

4. Bring up the Print dialog box. Choose File→Print or press Ctrl+P. Photoshop Elements displays the Prints (oddly plural in the Organizer version) dialog box. It looks very similar to the Print dialog box that appeared in the Editor workspace during the last exercise. As you can see in Figure 12-14, the five images you selected in the Organizer appear in a column on the left. You'll also see one or many of the images positioned inside the large preview window in the middle of the dialog box. To the right, you'll find Elements' now-familiar five-step printing method. For this exercise, to show some variety, we're going to switch to a very basic Canon desktop printer (Colleen's old—by technology standards—Canon iP4300), which we selected in Section **①** of the Print dialog list.

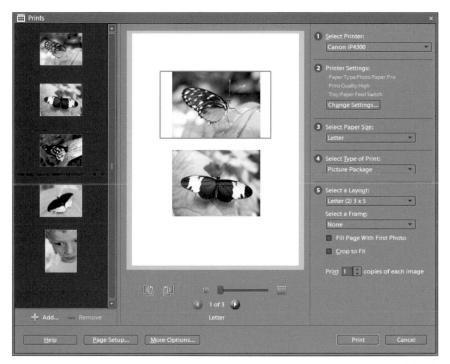

Figure 12-14.

5. *Set the Printer settings.* Since we're using a different printer from the last exercise, we need to review the Printer Settings III Section **2**.

If you're coming straight from the last exercise and using the same printer you did then, you can skip this step. Unless, of course you're interested in seeing the variety of proprietary dialog boxes created by printer manufacturers.

Start by clicking the **Change Settings** button. Here's how we're configuring our printer this time (with the repeated warning that, unless you have the same exact model printer, your mile-age will vary).

	Page Size:		Letter		
B [*] ₀	Orientation:		Portrajt Rotate <u>1</u> 80 degr	ees	Lan <u>d</u> scape
	Print <u>e</u> r Paper !	Size:	Same as Page Size		
	Page Layout:		Borderless Printin	-	
Glossy Photo Paper Letter 8.5x11in 215.9x279.4mm) [Normal-size Printing Fit-to-Page Printing Scaled Printing Page Layout Printin		
	Duplex Printing				Print Area Setyp
	Staple Side:	Long-si	ide stapling (Left)	-	Specify Margin
	<u>C</u> opies:	1 Print	(1-999) from Last Page	Collate	
	F	Print Option	ns Stamp/Ba	ckground.	Defaults
Options	2	×	ОК	Cano	xel Hel
Reduce spool data size					
Disable ICM required from the application	on software				

Figure 12-15.

- The **Printer** setting is, again, already set from the choice we made in the preceding dialog box.
- The **Paper Type** options have changed. Where the HP printer offered only HP-manufactured papers, this time we're offered a suitable generic paper, **Glossy Photo Paper**.
- The **Print Quality** choices are all available this time, so we'll choose **High** from the pop-up menu right away, instead of using the Advanced Settings like we had to with the HP printer in the previous exercise.
- Once again, the Advanced Settings button takes us to the specific properties of this printer. After a thorough search for the kind of color management setting we found in the HP dialog box, Colleen discovered only the **Print Options** dialog box shown in Figure 12-15, which only offers to *disable* ICM. No need for us to turn it on this time, apparently.

In our case, we need to click three **OK** buttons to get back to the Prints dialog box.

6. Direct Elements to make a picture package. We'll stick with our letter-sized paper in Section ⁽³⁾, Select Paper Size. Then, the multi-print options are accessed via Section ⁽³⁾, Select Type of Print. From that pop-up menu, choose Picture Package. As we mentioned, this feature is designed to accommodate portrait photographers who routinely need to print common picture sizes onto cut sheets that they can sell to their clients. We think it's pretty great for printing multiple images at a time, especially because unlike those cut sheets of all the same photo, we can choose different photos for each space in the "package."

PEARL OF

WISDOM

If your paper measures 8¹/₂ by 11 inches or smaller, Elements may warn you that the layout is too big for the paper and "some clipping will occur." Although results will vary from printer to printer, don't simply take Elements' word for it. Print a test page. With any luck, you may find that your printer is fully capable of printing the artwork without cutting off or otherwise modifying the edges of a single photo. Or not. But it's a good idea to check. Choose your layout. In Section ^(G), Select a Layout, the picture package option has a variety of different combinations of image sizes and arrangements to choose from. For this project, scroll all the way down to the bottom of the pop-up menu and choose Letter (2) 4×6 (4) 2×3. Immediately, the Preview window reveals that Elements has automatically placed the first two images in our list in the top two 4×6 spaces, and the other three images down in the bottom 2×3 area, as shown in Figure 12-16.

PEARL OF

WISDON

The other option for Type of Print is the Contact Sheet option, which prints identically sized thumbnail images of the selected files. The Contact Sheet is helpful if you want to check colors before committing to larger prints, add pages to a printed catalog, or make a hard copy of a photo session. The Picture Package has much more flexibility in terms of size and image used.

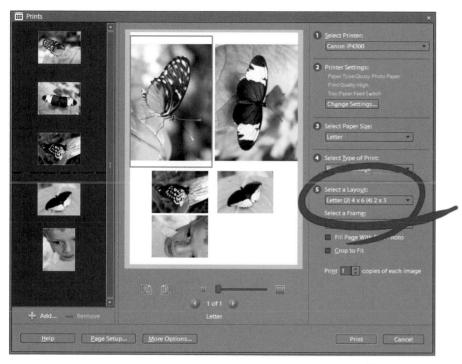

Figure 12-16.

PEARL OF

ISDOM

The second half of Section **③**, Select a Frame, would be handy if there were actually a tasteful, nondistracting border in the set, but there isn't, so we prefer to skip it and create a white border by leaving extra paper during the cutting process if we can. But don't count on being able to maintain a white border around each photo, whether you add frames or not. Some layouts force the Prints dialog to print photographs with the edges flush against each other.

8. Add an image from the catalog. Our layout has six slots, but we chose only five images to start with. We can add another one on the fly now. Click the ⇔ Add button in the lower-left corner of the dialog box to display the Add Media dialog box, as shown in Figure 12-17 on the next page.

It allows you to choose material from the following categories:

- Media Currently in Browser lets you add a photo from those displayed in the Organizer's browser window. If you're viewing the results of a tag search, not all the photos in the catalog will be available.
- The Entire Catalog option gives you access to all the photos in the catalog, regardless of whether they appear in the photo browser.
- If you created any Albums, the Album radio button gives you access to them.
- If you want to add an image and you remember assigning a tag to it, select the Keyword Tag option to specify a tag and find the associated images.

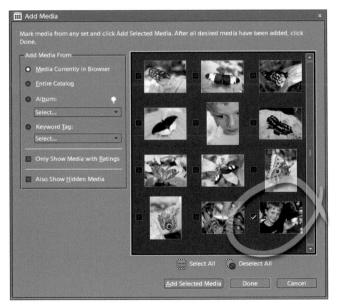

Figure 12-17.

For our purposes, select **Media Currently in Browser**, and you'll see the 12 butterflying images appear. Click the checkbox next to the last thumbnail, Deke's older son Max holding a butterfly, as circled in Figure 12-17. Then click **Add Selected Media** at the bottom of the dialog box. The checkmark for the Max photo goes away and the dialog box remains open, so naturally you think Elements is ignoring you. But not so; the photo has been added to the queue. To make the box actually go away, click the **Done** button. Notice when you return to the Prints dialog box that the layout has been completed automatically with the picture of Max in the lowerrighthand corner.

If you add a photo to the print queue by mistake, select the photo in the Print Photos dialog box and click the little minus sign icon in the bottom-left corner of the dialog box. You can also add more photos while you still have the Add Media dialog open; click Apply after each selection. You can even change the parameters of what you're looking for, and then keep clicking the Add Selected Media button until you've gathered up everything you need from wherever you need it. The window doesn't close until you click Done.

9. *Rearrange the photos in the layout.* As charming as the butterfly shots are, they aren't as cute as the photo of Deke's younger son Sammy with the yellow butterfly on his face.

Let's make him one of the bigger pictures by dragging his image in the preview window up to the lefthand 4×6 slot. Notice in Figure 12-18 that Elements is smart enough to put the previous occupant of that spot, the orange butterfly, down in the lowerleft slot that Sammy had occupied. The image of Sammy has also changed orientation automatically based on its new location and is now upright. Nice.

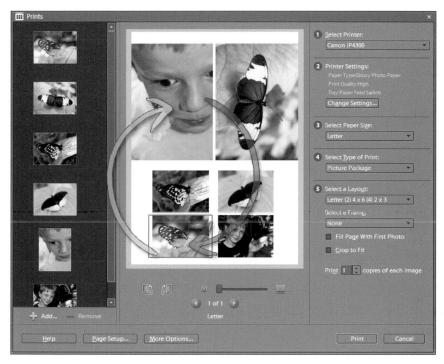

Figure 12-18.

While we're at it, let's move the equally charming Max up to the righthand 4×6 next to his brother, exchanging his place with the blue and white butterfly. Max, too, gets properly reoriented to fit into the space.

- 10. *Consider the final two checkboxes*. There are two checkboxes at the bottom of the list that are worth understanding:
 - When turned on, the Fill Page With First Photo checkbox generates a separate page for each selected photo and fills each page with multiple copies of that single photo, which is great for creating various sizes of one image. Remarkably, even with this option turned on, it's still possible to swap out different photos within each page's layout. But for this exercise, leave the checkbox off.

• When turned on, the Crop to Fit checkbox shaves away the height or width of a photo so that it conforms to the aspect ratio of the slot it occupies. The best way to understand this is to turn the **Crop to Fit** checkbox on and off and watch the effect this has on the preview. When Crop to Fit is on, the image appears larger on the page and the nearly square aspect of the original photo is cropped on the sides (see Figure 12-19). This option makes quick work of fitting photos to the dimensions of a real-life store-bought frame, so turn it on.

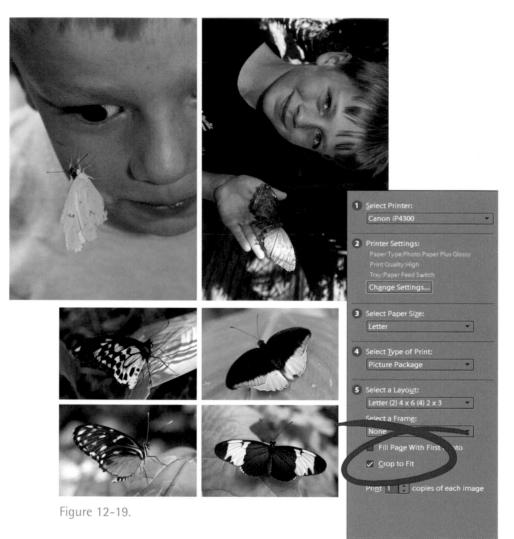

- 11. *Determine how many copies you want to make*. The final item in the list allows you to set the number of copies you want to print. In our case, we only want one, but we bring this up because you can't save this layout in any way, so for your own projects, be sure to make as many copies as you need at this stage.
- 12. *Make your color management choice.* This time, we'll set color management by actually clicking on the **More Options** button on the lower-left side of the **Prints** dialog box. This time Color Management is the only choice in the lefthand pane, and the only option is to set the Print Space, as shown in Figure 12-20.

More Options	
Color Management	Color Management
	Color Management
	Image Space: sRGB IEC61966-2.1
	Print Space: sRGB IEC61966-2.1
L	OK Cancel <u>H</u> elp

13. *Set your color management preferences.* As you learned in the preceding exercise, sRGB is the standard color space for the vast majority of inkjet printers. So choose **sRGB IEC61966-2.1** from the **Print Space** pop-up menu and click **OK**.

PEARL OF

WISDOI

You may be able to download printer profiles from your manufacturer. You'll have to follow the documentation that came with the printer or the instructions on the manufacturer's web site in order to download and install these profiles, but once you do this, they'll show up in the Print Space pop-up menu.

14. *Print the images.* All that's left is to click the **Print** button in the bottom-right corner of the Prints dialog box. A few moments later, you'll have a hard copy. Or if you don't want to use your paper, click Cancel instead. Who knows—maybe you don't want to waste ink and paper printing pictures of cute but unfamiliar children and butterflies you don't even know. Some people are weird that way.

URTHER

Elements also provides easy access to some thirdparty web sites from which you can order prints rather than using your inkjet at home. Online services can be fluid, so we're going to cover those over at dekeOnline (http://www.deke.com) where we have the flexibility of actually keeping up with Web developments.

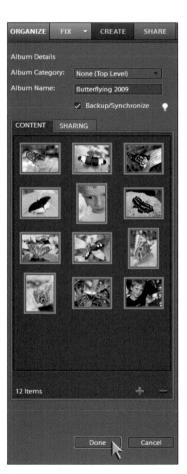

Sharing Pictures Online

Printing is a local sharing solution. Someone visits your home or office, you have some extra photos of the young and dear ones, and you offer them with the gladdest of tidings. So what about the remote relations? In the old days, you could toss a few snapshots in an envelope and mail them. But that was when a postage stamp cost a fifth of what it costs today and the Postal Service accounted for the transmission of most of the country's personal missives. These days, snail mail just can't compete with the alternatives.

Online is the cheaper, speedier alternative. Of course, Deke showed you how to share photos via email in the video that began this lesson, which is great for sending a shot or two to one or two distant recipients. But wouldn't you know it, Photoshop Elements can also help you share entire collections of photos at once with as many recipients as you feel like notifying, directly from an Organizer album to an online gallery via your free account at Photoshop.com. And your loved ones don't even have to join anything. All they need to view your latest snapshots are a computer, an Internet connection, your "vanity" Photoshop.com URL, and a bit of curiosity. In this exercise, we'll use Deke's Butterflying photos to create an album that we'll then post to share with all lovers of colorful insects and charming children.

- Create an album from the "Butterflying" collection. Start back in the Organizer workspace where we've stashed all those lovely butterfly images. Select all 12 by clicking on Butterflying_01.jpg and then Shift-clicking on Butterflying_12.jpg. In the Albums panel, click the pop-up menu next to the green ⇔ under the word Albums, then choose New Album from the pop-up menu.
- Name your album. The panel shifts to a new view, shown in Figure 12-21, which is currently displaying a Content subpanel that contains all the pretty butterfly thumbnails. Type "Butterflying 2009" into the Album Name field. Turn off the Backup/Synchronize checkbox (presuming you don't want to use up your precious online storage for Deke's photos). Then click the Done button at the bottom of the panel.

You can see a tab for the Sharing subpanel in Figure 12-21 as well, where you could immediately start sharing the Butterflying album as you're creating it. We'll return to a nearly identical panel in the next step. But here we want to show you the Share tab version, which allows the sharing of any album in your library, not just this new one.

- 3. *Switch to the Share panel.* Click the green tab at the top to switch to the Share panel. In Figure 12-22, you'll see familiar-looking buttons that are very similar to those in the Create tab we used in the last lesson. Click the button for sharing an **Online Album**.
- 4. *Share the existing Butterflying 2009 album.* The one variation between the share-on-the-fly option in the Sharing subpanel you see when you're creating an album and the one you see in the Share panel (Figure 12-23) is that you can choose to either share an existing album or create a new one.
 - Since we already have the Butterflying 2009 album ready to go, choose **Share Existing Album**.
 - Then click the **Butterflying 2009** album in the list.
 - Choose the radio button for Photoshop.com.
 - Click Next.
- 5. *Choose a template*. Elements will think for a minute and then place your album photos into the default template, which is a bit busy and inspires a change to something more elegant. Make sure **Select a Template** is set to Classic, then move the scroll bar above the preview window all the way to the right. When you do so, the "Sliding" template will be just left of center. This template is perfect for our butterflies, since it possesses this lovely slideshow effect where images initially appear in black and white, then immediately reveal their color. If you double-click the Sliding template (indicated in Figure 12-24), Elements will build a preview that lets you enjoy this Oz-like effect.

Figure 12-24.

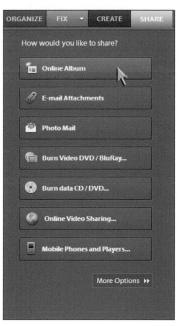

Figure 12-22.

Figure 12-23.

Figure 12-25.

Figure 12-26.

The "Sliding" template leverages the power of Adobe Flash to create its slideshow effect. Cool, but it requires your viewers to have the Flash plug-in installed in their browser, and when you're viewing it online it takes a certain amount of bandwidth to get the full effect. If your intended audience is technologically hampered by either techno-fear or spotty Internet connections, then it might be better to choose a less "flashy" template.

- 6. *Add a subtitle*. While your album is rotating through its preview, you'll notice a ghost-like dialog box called **Slideshow Settings** hovering over the top. Shown in Figure 12-25, this gives you the few tweakable items that are available for this template. Click the box to wake it up to full opacity so you can actually see what it has to offer. In the **Subtitle** field, type "Deke and the boys at the Butterfly Pavilion".
- 7. *Turn off the captions*. The Slideshow Settings dialog box also lets you control whether there are captions. The captions on our butterflies would be fun if Deke had looked up the scientific names of the bugs or written something equally pithy, but at the moment they are just announcing the camera with which he shot the photos. We love our Olympus cameras and all, but it gets a bit repetitive, so turn off the **Show Photo Captions** checkbox. Click the **Refresh** button and the captions are gone and the subtitle you entered in the previous step is added.

PEARL OF

WISDOM

Captions can be added or edited in several ways, and this final exercise seems like a good place to go over those options, all of which live in the Organizer workspace. As you recall from Lessons 1 and 2, you can add them in Single Photo view, in the Properties panel, or in the Caption field of the Date view. Perhaps the most straightforward way is to select an image in the Organizer and choose Edit \rightarrow Add Caption, type in your caption, and click OK. Regardless of where or how you add them, any caption that you want to appear in a project like this has to be added before you initiate the project.

8. *Sign into Photoshop.com*. Oddly enough, you have to tell Elements again that you want to use Photoshop.com to share this album, so turn on the **Share to Photoshop.com** checkbox, as shown in Figure 12-26. If you aren't already signed in, you'll immediately be met with a dialog box that invites you to sign into the account you created back in Lesson 1. Please do so now. Also notice that the Backup/Synchronize checkbox gets turned on automatically.

Kinda makes sense, we suppose, but we were really trying to spare you from backing up Deke's personal photos. We'll just proceed knowing you'll eventually delete this album and replace it with images of your own.

PEARL OF

WISDOM

Your Photoshop.com account can be attached to only one catalog at a time, and while we don't blame you for wanting that to be your own personal catalog, for the purposes of this exercise you'll need to change it to *Oneon-One* catalog to make it work as advertised. You can switch which catalog is connected to Photoshop.com by first opening the *One-on-One* catalog, then choosing Edit→Preferences. In the Backup/Synchronization tab, click the Backup/Synchronize This Catalog button. Make sure you switch back to your own later, or if you're feeling confident, just use a collection of photos from your own catalog to create the album for this exercise.

- 9. Choose to display your album. Turn on the Display in My Gallery checkbox in order to have your images passively presented on your Photoshop.com page. You can also choose to allow your visitors to download photos or order prints (via the third-party provider Shutterfly) by turning on the appropriate checkboxes near the bottom of the panel.
- 10. *View your album online.* Frankly, we want to see what the album looks like online before we invite friends to see it. Ideally you could click the View Online button near the bottom of the window and immediately be transported to your personal URL, but alas, it is dimmed at the moment. It seems that this button works only after you click Done, an act that problematically reverts you back to the Organize tab and removes the View Online button from your grasp. But we have a workaround:
 - First click **Done** to actually send your album on its way. As we predicted, you're sent back to the Organize tab.
 - Click the Welcome. Colleen link at the top of the window's menu bar. (OK, yours says Welcome, [insert name of discerning purchaser of tutorial books here], but you get the idea.)
 - Elements will ask you to confirm your password. Type it in the appropriate field and click **My Account**.
 - In the My Account info page, the Personal URL listed is actually a live link, as indicated in Figure 12-27 on the next page.

My Account			
wiy Account		Welcome, Col	leen Sign Out
 Summary Personal info 	Adobe ID: colleen@deke.com Name: Colleen Wheeler		
	Account Type: Basic Upgrade to Plus Learn More Member Since: Fri Oct 9 2009 Personal URL: http://colleenosaurus.photoshop.com		
	Total storage: 2.0GB	Buy More	Learn More
	Used space: 17.8MB Free space: 1.9GB		Done

• Click the link and your designated default browser will launch automatically to reveal your online gallery. You can see Colleen's version in Figure 12-28. Viewers can simply double-click the album in their browser and see the same slideshow presentation you saw in the preview.

Figure 12-28.

- 11. *Invite viewers to your online album.* Now that you know it's safe to do so, you can invite people to view your album directly from the Organizer workspace. Start in the **Organize** tab if you're not already there. Next to the *Butterflying 2009* album, you'll see two icons that allow you to stop sharing or edit your sharing parameters. Click the **Share** icon as shown in Figure 12-29 to return to the Sharing subpanel and make adjustments for this album.
- 12. *Open your Contact book.* About halfway down the Sharing subpanel, you'll see a field labeled "Send E-mail To:". Don't fret that you're emailing your entire album to anyone; this merely sends a notification email with a link to viewing your album online. Click the icon to the right, as shown in Figure 12-30, and choose Open Contact Book.
- 13. *Create a new contact*. In the Contact Book window, click on the **New Contact** button at the top left. A **New Contact** window opens, allowing you to add information about your recipient. Frankly, we're at a loss (and somewhat suspicious) as to why so much info would be necessary, so as far as we're concerned just fill in the **Name** (only one is required) and **E-mail Address** fields, as we've done in Figure 12-31. Click **OK** to close the New Contact window, then click OK again.

Contact Real

ORGANIZE	FIX 🔫	CREATE	SHARE
- Albums			
+ • 📧	•		
Last 6	Months		
Butte	iying 2009	C	Share
			-

Figure 12-29.

Figure 12-30.

e Name	E-mail	Address		Last Used
Colleen	colleen@deke.com			
	New Contact			
	Name First Name:		E-m	ail ail Address:
	Deke		Contractory of the local division of the loc	ke@deke.com
	<u>M</u> iddle Name:			
	moule Name.		MOL	aile Phone E-mail Address:
	Last Name:			
	Address		Dho	ne Numbers
	Street 1:		<u>H</u> on	
	Street 2:		Mo <u>t</u>	<u>a</u> íle:
	<u>C</u> ity:			
	<u>S</u> tate: <u>Z</u> ip: Cou			

Figure 12-31.

- 14. Send the notification. Once you have your contacts established, turn on the checkboxes next to any contacts you want to include on this notification. You can type a greeting in the Message area above the contacts list, as we've done in Figure 12-30. Then click Done to send.
- 15. *Enjoy the enjoyment and accolades.* Your friends will receive an email message, like the one shown in Figure 12-32, that will link them to your online masterpiece. Since Elements has automatically set these images up to sync, any other photos you add to the album will automatically be updated in your online gallery.

Check out Colleen's album on Photoshop.com Inbox | X

Figure 12-32.

There you have it, friends, a whirlwind tour of a very powerful image-wrangling application. If you've followed the lessons in this book, you now know how to organize, edit, beautify, and share your photo creations. Now get in there and share your own creative concoctions with the world (or at least a friend or two).

FURTHER INVESTIGATION

There are many more features of Photoshop Elements 8 to explore, but alas this book has room for only the most useful and amazing. However, we'll undoubtedly be discussing our other favorites, as well as those things about Photoshop Elements that we don't quite love but have figured out how to live with, at *http://www.deke.com.* Come by, become part of our community, and let us know what you think and what you'd like us to take a closer look at in our blog, articles, and podcasts. See you in dekeVille!

WHAT DID YOU LEARN?

Match the key concept in the numbered list below with the letter of the phrase that best describes it. Answers appear upside-down at the bottom of the page.

Key Concepts

- 1. Image preview
- 2. Page Setup
- 3. Flatten Image
- 4. Image space
- 5. Destination space
- 6. sRGB
- 7. Perceptual
- 8. Contact Sheet
- 9. Picture Package
- 10. Crop to Fit
- 11. Photoshop.com
- 12. Online album

Descriptions

- A. When printing, this signifies the color space used by the image.
- B. When printing multiple images, select this option from the Select Type of Print list to combine multiple copies of one or more images onto your printed pages.
- C. This dialog box allows you to specify the desired printer, as well as the paper size and orientation.
- D. This Rendering Intent option in the Print Preview dialog box maintains the smoothest transitions when converting colors and is the best choice for photographic images.
- E. Using Photoshop.com, you can create this to share your photos with distant friends and relatives.
- F. This Picture Package option crops the height or width of a photo to make it conform to the aspect ratio of the slot that it occupies.
- G. The color space employed by the printer software.
- H. When printing from the Editor workspace, this part of the dialog box shows you how the image will sit on the page.
- I. This command allows you to collapse a multi-layered file into one flat image, facilitating printing.
- J. This option prints small thumbnail images of the selected files.
- K. A standardized color space embraced by most consumer-level hardware, including nearly all brands of inkjet printers
- L. Adobe's online space where a free account allows you to share your images with the world.

Answers

1H' 5C' 3I' 4V' 2C' 9K' \D' 8J' 6B' 10E' 11F' 15E

INDEX

Symbols

8 bits of data per channel, 297 16 bits of data per channel, 297

А

Actual Pixels button, 81 Add Media dialog box, 347 Album radio button, 348 Crop to Fit checkbox, 350 Entire Catalog option, 348 Fill Page With First Photo checkbox, 349 Keyword Tag option, 348 Media Currently in Browser, 348 Add Missing Person button, 40 Adjust Color for Skin Tone command, 274, 291 Adjust Date and Time of Selected Items, 50 Adjust Hue/Saturation command, 278-281, 279 adjustment layers Colorize layer, 176 Hue/Saturation, 288 Adjust Sharpness filter, 183, 184, 205 Amount value, 185, 186 More Refined value, 186 Radius value, 185 Remove option Lens Blur, 185 Remove option Motion Blur, 190 Adobe Camera Raw (ACR), 292, 299 correcting, 292-298 Adobe Caslon Pro typeface, 239 Adobe RGB (1998), 338 assigning profile, 65 Advance to next option, 272 Album Category pop-up menu, 46 Album details panel, 46 albums, 59 adding images to, 47 making, 45-48 New Album, 46

reordering images, 48 sharing online (see Online Album) viewing photos, 47 Albums panel, 46, 47 aligned, 137 Allow Floating Documents in Full Edit Mode checkbox, 146 Anti-alias checkbox, 143 antialiasing, 147, 177 Arc Lower option, 262 area text, 269 aspect ratio, 95, 98, 109 audio, turning off, 9 Auto-analyzer, 59 Auto buttons, how they work, 72 Auto Color, 70, 72, 87 option (Fix tab), 63 Auto commands, 64 Auto Contrast, 68, 72, 87, 219 Auto Crop, 92–95 Auto Levels, 69, 72, 87, 284 Automatically Fix Red Eyes checkbox, 304 automatic image correction, 64-73 Auto options, 63 Auto Red Eye Fix command, 124 Auto Sharpen, 82 Auto Smart Fix, 63, 71, 72, 78, 87, 270 how it works, 72

В

background eraser, 227–232, 233 settings, 230 backlighting, compensating for, 289– 298 Back to All Photos button, 13, 43 Bain, Kitch, 191 balancing colors, 274–278 banding, 87 Before & After - Horizontal, 81 bending type, 259–264 Bicubic Sharper setting, 105 Bicubic Smoother setting, 105 Bigbee-Fott, Laura, 95 black and white image, converting to color, 116 black and white points, 286 Blanchette, Leo, 61 blend modes, 115, 205 applying, 196 Multiply, 248 Overlay, 261 bloat tool, 202, 203, 205 blur, 147 Lens Blur removal, 185 Body Copy layer, 241, 242 bounding box, 219 Show Bounding Box checkbox, 254 bracket keys, 54, 137 changing brush attributes with, 117 brightness, 273, 299 adjusting, 278-281 levels, adjusting, 282-288 Brightness/Contrast command, 282 Bring Forward command, 216, 233 Bring to Front command, 223 broken images, repairing, 128–136 brush engine, 113 Brushes palette, 117 brush, selection (see selection brush) brush size, changing, 199 brush tool, 113, 116 diameter, 112 Fade value, 118 Flow setting, 112 hard edge/soft edge, 112 incrementally changing, 117 lifting color with eyedropper, 112 Opacity setting, 112 predefined brush settings, 117 Scatter option, 118 shrinking/enlarging, 112 burn tool, 120-123, 137 Exposure value, 122 By Color, 329

С

Calendar Create New Event dialog box, 56 custom events, 56 Day button, 56 in Date View, 55 Month button, 57 preferences, 55 Set as Top of Day, 57 Year view, 58 Calendar preferences, 59 camera raw format files, 292-298 Camera Raw window, 292-298 Brightness setting, 295 Color Noise Reduction value, 297 Contrast slider, 295 Exposure and Shadows values, 295 Luminance Smoothing value, 297 opening file in, 292 Saturation value, 295 Tint, 294 White Balance controls, 293 Canvas Options setting, 96 Canvas Size, 151 card reader, getting images from, 4 cast shadow, 245 Catalog command, 8, 29 Catalog dialog box, 8 Catalog Manager, 4,8 catalogs custom events, 56 defined, 7 low-resolution proxies of imported images, 19 opening, 14 catalog title (Organizer), 10 centering text, 246 Channel pop-up menu, 283 chroma, 273, 299 circles, wrapping text around, 259-264 clipping, 286 clipping mask, 267 clockwise tool, 201–203 clone stamp tool, 128, 134 cloning, 137 cloning tools, 114 color adjustment commands, 272 Color blend mode, 154 color channels, 283 color correction Adjust Hue/Saturation command, 278-281 backlighting, compensating for, 289-298 balancing colors, 274-278 Brightness/Contrast command, 282

Color Variations command, 274– 278correcting camera raw format files, 292 - 298flash photography, compensating for, 289-298 hue, saturation, and brightness, 273 Levels command, 282-288 Shadows/Highlights command, 289 - 292Smart Fix, 271 Standard Edit mode, 271 tint and color, 278-281 transforming all colors by equal amount, 280 Colored Pencil filter, 179 Color Handling option, 338 coloring scanned art, 114-119 color intensity, 273, 299 Colorize layer, 176 color management, xvii, 336, 338 Color panel, 76 Color Picker, 153 display, 243 color profile, 87 color replacement tool, 113 Color Settings dialog box, xvii color spectrum wheel, visible, 277 Color Swatches palette, 115 Color Variations command, 274-278 modifying color ranges independently of others, 275 comparing similar photos, 20-28 complementary colors, 277, 299 constraining proportions, 329 Constrain Proportions option, 105 Contact book, 357 contact sheet, 359 Content-aware scaling, 109 Content panel, 329 Contract/Expand slider, 174 contrast, 299 decreasing, 282 Midtone Contrast slider, 80 Contrast option (Fix tab), 63 Copy Layer Style command, 226, 252 Craquelure filter, 196 Create New Event dialog box, 56 Create tab, 303 Create Tag dialog box, 35, 37 creating and formatting text, 238-244 Creations, 301-329 Greeting Card, 315–321 Kodak Gallery option, 315 Shutterfly option, 315 Photo Book, 303-314 Photo Calendar, 323

Photomerge, 322-328 Picture Package, 343–351 Creation Setup wizard, 303 crop boundary, 98–99 cropping, 95-99, 109 after rotating, 91 automatically, 92-95 Straighten and Crop Image command, 92-95 Crop to Fit, 359 crop tool, 97 Crop to Original Size, 97 Crop to Remove Background option, 97 custom events, 56 Cutout filter, 193, 194

D

Darken Highlights slider, 80 dates adjusting date and time of a selected photo, 32 finding images by, 48-58 viewing recorded, 49 Date View, 29, 48-58 calendar, 55 switching to, 32 deactivating options, 208 Defringe Layer, 148 deleting photos warning, 19 Desaturate mode option, 123 Deselect command, 32, 140, 158, 302 Destination space, 359 Difference Clouds filter, 162 digital camera, getting images from, 4 Display in My Gallery checkbox, 355 distortions, 249 four-point, 225, 233 free-form, 197-204 strict perspective-style, 262 Divide Scanned Photos, 93, 93–95, 94, 109 DNG (Digital Negative) format, 292 Document Size options, 105 dodge tool, 120, 137 Exposure value, 121 Don't Flatten button, 116 downsampling, 105, 109 saving as separate file, 108 dragging and spacebar, 160 drawing and editing shapes, 251-258 drop shadows, 168, 220, 237 soft edge, 221 duplicating shapes, 254

Е

Edge, 205

Edit Full, 66, 87 Edit Guided, 66 editing text tips, 246 editing tools, 113, 137 caveats, 121 Edit Keyword Tag dialog box, 38 Editor modes, 66 Editor workspace, 5, 29, 66-67 launching, 64 Edit Quick mode, 63, 66, 87 Edit Quick panel, 63, 69, 76 Edit Quick workspace, 78 Edit Tag Icon dialog box, 38 Effects panel hiding/displaying, 180 Elements getting photos into, 7–14 what is, 5-7Elisseeva, Elena, 100 elliptical marquee tool, 150 selecting cylindrical shapes, 159 tricks to define selection, 153 emailing images, 104 Emboss filter, 190 Entire Catalog option, 348 erasers background eraser, 230–232, 233 magic eraser, 228-232, 233 erasing backgrounds, 227-232 error messages missing profile, 68 events, custom, 56 EXIF metadata, 48, 51, 59 Expand All Tags command, 35 Expand Items in Version Set, 86 exposure, 137 Exposure value, 121 eyedropper tool, 245 Levels command, 283

F

Fade value (brush tool), 118 faux bold, 243 taux italic, 243 faux styles, 269 Feather command, 152, 155, 177 Feather Radius value, 152, 153 Feather Selection dialog box, 152 Feather setting, 174 Fibers filter, 162 Field layer, 256 File name option box, 75 Fill Layer dialog box, 170 fill opacity, 268 Fill Selection command, 170 Filmstrip, 22, 29 Filter Gallery, 191–196 adding effect, 180 hiding/showing thumbnails, 180

hiding thumbnails, 192 opening, 191 filtering basics, 182–205 filters, 59, 179-204, 205 Adjust Sharpness (see Adjust Sharpness filter) Colored Pencil, 179 Craquelure, 196 Cutout, 193, 194 Difference Clouds, 162 distortions, free-form, 197-204 Emboss, 190 Fibers, 162 Gaussian Blur, 147, 188, 232, 248 Glowing Edges, 192, 193 High Pass, 188, 189 Liquify, 197-204 media, 191, 205 Motion Blur, 179 Palette Knife, 195, 196 Pinch, 181, 200, 203 Plaster, 193, 195 reapplying, 180 reordering, 193 repeating, 162 Unsharp Mask (see Unsharp Mask filter) Wave, 179 Find People for Tagging, 39 Fix panel, 63 flash photography, compensating for, 289-298 flat, 233 flat file image settings, 335 Flatten Image command, 210, 329, 334, 359 flattening layers, 332 Flow setting of the active brush, 112, 122 flush left, 269 flush left text, 246 focus, 181, 205 adjusting, 182-205 font family, 269 tonts, 239 previewing, 236 setting bold and italic, 243 foreground color, filling selection with, 140 formatting attributes (text), 239 Fotolia.com, 61, 100 four-point distortion, 225, 233 free-floating palettes

free-floating palettes anchoring in Organize Bin, 18 free-form selection, painting, 164–170 freehand tools, 157–162 Free Transform command, 263 free transform mode, 219 distort shadow, 249 multiple operations within, 226 F-stop increments, 295 Full-screen slideshow, 24 Full Screen View, 29 Full Screen View Options dialog box Background Music option, 22 Include Captions checkbox, 22 Show Filmstrip checkbox, 22 Start Playing Automatically checkbox, 22

G

gamma value, 285, 299 Gang scanning, 109 Gaussian Blur filter, 232 blur background, 147 create soft shadow, 248 Radius value, 188 Get Photos from Subfolders checkbox, 12 Glowing Edges filter, 192, 193 gradient tool, 176 grayscale image, converting to color, 116 Green glass effect, 266 Greeting Card, 315–321 Kodak Gallery option, 315 Shutterfly option, 315 Group with Previous, 267 Grow Canvas to Fit, 96, 97 Grow command, 144, 177

Η

haloing, 177 hand tool, 62 scrolling with, 272 hard brush, 132 Hard Light mode, 256 healing brush, 128 default options, 131 hard brush, 132 source points, 131, 132 spot healing brush, 130 standard, 130 healing damaged images, 128-137 healing tools, 114, 137 high-contrast images, 292 Highlight Resolution value, 90 highlights, 275, 299 darkening, 80 High Pass filter, 188, 189, 205 Histogram palette, 289 histograms, 283, 299 black & white points, 286 cached, 289 clipping, 286 reading and responding to, 286-287

hue, 273, 299 adjusting, 278–281 Hue/Saturation adjustment layer, 288 Hue/Saturation command, 278–281 Edit pop-up menu, 280 visible color spectrum wheel and, 277

ICC Profile, 217 Adobe RGB (1998) option, 75, 335 ICM color matching, 342 image preview, 359 images adjusting time, 50 advancing through, 272 card reader, getting images from, 4 dates. 48 digital camera, getting images from, finding untagged, 32 fitting image on screen, 62 importing, 77 opening from Organizer in Standard Edit Mode, 272 organizing, 14-19 previews, 66 renaming, 75 resizing, 103-108, 237 rotating, 4 straightening, 96 two varieties of full-color, 297 viewing actual pixels, 62 whole-image transformations, 89 - 95Image Size command, 90, 105, 258 resizing image, 103-108 stretching image, 204 Image space, 359 image window, 66 Import Attached Keyword Tags dialog box, 12 importing all photos inside folders, 12 layers, 217-227 importing images, 77 Indigo Matte style, 266 Info panel, 90 inkjet printers photo-quality prints, 340 printing to, 334–342 Inner Glow, 329 Size value, 149 Inner Shadow, 221 interpolation, 109 settings, 105 Inverse command, 140, 145, 177 Invert command, 153

isolating color, 280 image element, 141 iStockphoto, 164, 167, 171, 191

J

JPEG file format, 76, 87 JPEG Options dialog box, 84, 328

К

keyboard shortcuts adding photos to catalog, 9 adding to selection, 140 Adjust Date and Time of Selected Items, 50 Adjust Hue/Saturation, 279 adjusting date and time of photo, 32 advancing through photos, 17 advancing through slides, 23 advancing to next or previous open image, 272 advancing to next or previous option, 90 Auto Smart Fix, 279 bold type, 242 bracket keys, 54 brush attributes, 117 brush diameter, 112, 131 brush harder or softer, 112 brush panel, 112 brush tool, 112 Catalog command, 8 Catalog Manager, 4 centering text, 246 changing Opacity setting of the active layer, 180 constrain the ellipse to a circle, 153 Create Clipping Mask, 267 creating new tags, 32 cutting selection to independent layer, 208 cycling through custom shapes, 236 Date View, 32, 54 deactivating highlighted option, 208 deactivating options, 156 Deselect, 140 deselecting all images, 32, 302 deselecting all thumbnails, 39 draw from center of image out, 153 duplicating layers, 180 Effects panel, 180 elliptical marquee tool, 153 eraser tools, 228 exiting photo comparison mode, 26

filling entire layer with foreground color, 116 filling selection with foreground color. 140 filling text or shape layer with background color, 236 Filter Gallery, 180, 195 fitting image on screen or view actual pixels, 62, 272 flatten layered image, 332 flush left text, 246 Free Transform, 263 full-screen slideshow, 302 getting images from a digital camera or card reader, 4 gradient tool, 176 grouping active layer, 208 hand tool, 272 hiding/showing details below thumbnails, 4 hiding/showing panels, 272 hiding/showing selection outline, 140, 156 Highlight Resolution value in Image Size dialog box, 90 Image Size, 90 incrementally increase or reduce size of selected type, 236 Info panel, 90 Inverse, 140, 145, 213 Invert, 153 italics, 243 Layers panel, 208 lift color with eyedropper, 112 magnetic lasso tool, 163 magnifying glass, 272 magnifying image to 200 percent, 166 Merge Down, 210 move tool, 146, 208 moving from one slide to the next, 302 moving marquee as you draw it, 140 moving text when type tool is active, 236 New Layer, 115, 208 Opacity setting of the active brush, 112 Open, 65 Organizer workspace, 332 play or pause slideshow, 302 polygonal lasso tool, 160 previewing collection of images as a slideshow, 48 previewing font on selected type, 236 Print command, 335 printing selected image, 332 Properties panel, 18, 332

reapplying last filter, 180 rectangular marquee tool, 150 restoring default foreground and background colors, 176 RGB Color command, 116 right-justify a layer of type, 246 rotating images, 4 rotating thumbnails, 18 Save, 74, 123 saving slideshow project, 302 Screen blend mode, 221 scrolling right or left, 62 scrolling up or down, 62 scrolling with hand tool, 62 selecting multiple nonadjacent images, 332 selection brush, 165 selection brush in subtract mode. 166 shape on-the-fly as you draw it, 236 spot healing brush, 128 Stack Selected Photos, 26 straighten tool, 96 subtracting from a selection, 140 switching default foreground and background colors, 156 thumbnail size, 16, 17 Thumbnail View, 9 Timeline, 32 transformation mode, 208 type tool, 246 underlining text, 246 Undo Auto Contrast, 69 undo or redo operation, 62 untagged photos, 32 updating text layer and return to the Standard Edit mode, 236 viewing actual pixels, 62 zooming image in Organizer workspace, 332 zooming in/out, 62, 67 zooming in/out of thumbnails, 4 200111111g lit to 100 percent view, 165 keywords, 59 Keyword Tags panel, 34–45 keyword tags (see tags) Kodak Gallery option, 315

L

lasso tool, 158 Feather value, 160 irregular shapes and, 157–162 magnetic, 163 polygonal, 140, 157–163 layered compositions, 207, 233 layer effects, adding, 265-268 layers, 207-232 arranging and modifying, 211-217 bringing forward, 216 costs involved with using, 209 creating and naming new, 208 creating new, 213 cutting selection to independent, 208 duplicating, 180 file size and, 209 filling entire layer with foreground color, 116 flattening, 332, 334 grouping, 208 importing and transforming, 217-227 managing, 210-211 merging, 210 New Layer dialog box, 213 pros and cons, 207-209 renaming, 219 rotating, 217 scaling, 219 selecting and deselecting, 215 sending backwards, 213 text (see text layers) Layers palette, 147, 240, 265 adjusting opacity, 268 Background layer, 161 Opacity value, 156 Layers panel, 212 hide/show, 208 layer styles, applying and modifying, 265-268 Layer via Copy command, 161 leading, 269 Lens Blur removal, 185 Levels command, 282-288 Auto Levels function, 284 Channel pop-up menu, 283 contrast and, 282 eyedropper tools, 283 gamma values, 285 histogram, 280-28/ Levels option (Fix tab), 63 Lighten Shadows slider, 80 Lighting panel, 76 Lightness value, 281 line art, coloring scanned, 114-119 linear units, 106 line tool, 257 moving line, 258 Liquify filter, 197–204 live type, 269 Load Selection command, 170, 213, 223 lock transparency, 177

luminosity (see brightness)

Μ

magic eraser, 228-232, 233 Magic Extractor command, 177 magic wand tool, 177 Anti-aliased checkbox, 143 Contiguous option, 143 Grow command, 144 selecting colored areas with, 142-149 Similar command, 144 Tolerance value, 143, 144 magnetic lasso tool, 163 magnifying glass, zooming in/out, 272 mark for removal tool, 102 marguee tools, 149-157 adjusting crop boundary, 98 elliptical, 159 selecting cylindrical shapes, 147 selecting rectangular shapes, 149-157 masking functions, 164 Mask mode, 168 Overlay Opacity setting, 168 versus Selection mode, 168 masks, 177 clipping, 267 McGleish, Terry, 164 Media Browser, 29 Arrangement menu, 16 media filters, 191, 205 Media Types command, 9 menu bar (Organizer), 10 Merge Down, 210, 233 merging layers, 210 metadata, 33, 48, 51, 59 Microsoft's ICM color matching, 342 Midtone Contrast slider, 80 midtones, 275, 284, 299 missing profile error message, 68 Motion Blur filter, 179 move tool, 146, 208 Multiply blend mode, 170 duplicating and preserving color, 213 reducing opacity, 248

Ν

New Collection command, 46 New Layer dialog box, 115, 213 noise, 297

0

Olympus Raw Format file, 292 One Photo Per Page checkbox (printing multiple photos), 349 Online Album, 352-358, 359 Contact book, 357 inviting viewers, 357 Select a Template, 353 Share to Photoshop.com checkbox, 354 slideshow captions, 354 Slideshow Settings, 354 "Sliding" template, 354 subtitles, 354 opacity adjusting, 268 reducing, 248 restoring to 100%, 226 temporarily adjusting, 224 value, 157 Opacity setting of the active brush, 112 Opacity setting of the active layer, 180 Opacity value, 156-157 Open image, 65 options, advancing through, 90 options bar, 66 settings, 143 Anti-aliased checkbox, 143 Contiguous checkbox, 143, 145 Tolerance value, 143 Orange Glass layer style, 267 ORF (Olympus Raw Format) file, 292 Organize pane, anchoring palettes in. 18 Organizer workspace, 8, 29 Auto commands, 64 catalog title, 10 categories and subcategories, 42 controls, 11 creating subcategories, 42 cursor, 10 Display options, 10 EXIF metadata, 48 finding photos by date, 48–58 first time opening, 8 full-screen view mode, 21 importing photos, 7–14 interface, 10-11 menu bar, 10, 11 opening images from inside Standard Edit Mode, 272 organizing photos, 14–19 Panel Bin, 11 photo browser mode, 10 printing multiple pictures, 343-351 Rating filter, 11 returning to, 332 settings, 8 sharing photos, 333 shortcuts bar, 11 single photo view, 15 cycling through, 17

Task Pane, 11 viewing filenames, 15 zooming image, 332 Zoom slider, 11 organizing photos, 14–19 Overlay blend mode, 261 Overlay Color option, 168 Overlay mode, 119 oversharpened, 186

Ρ

Page Setup, 359 paintbrush tool (see brush tool) paint bucket tool, 116 painting free-form selection, 164-170 painting tools, 113, 137 (see also brush tool; pencil tool) Palette Knife filter, 195, 196 panels, 67 hiding/showing, 272 panoramic pictures, 322-328 ideal overlap when merging photos, 324 Photomerge Panorama command, 324 saving, 327 Paste Layer Style command, 226 PDD file, 119 pencil tool, 116 People Recognition, 40, 42, 59 perceptual, 359 Pettet, Lee, 171 Photo Book, 303-314 Photo Book project wizard, 305 Photo Browser changing date order, 16 Show All button, 13 Photo Calendar, 323 photo comparison mode, 24 Photomerge, 322-328, 329 Photomerge Panorama command, 324 photo-quality prints, 340-341 Photo Review Background Music option, 22 Include Captions checkbox, 22 photo-sharing (see sharing photos) Photoshop.com, 5, 352–355, 359 Albums, sharing online, 354 what is, 6 Photoshop Elements 8 One-on-One downloading video lessons, xv installation and setup, xiv-xvii practice files, xiv requirements, xiii Photoshop (PSD) format, 119, 233 Picture Package, 343-351, 359 adding images from catalog, 347 Select a Layout, 347

Pinch filter, 181, 200, 203 Plaster filter, 194, 195 point text, 269 polygonal lasso tool, 158, 177 Polygon Options pop-up menu, 253 polygon tool, 252, 253 Preview checkbox, 184 Preview panel, turning on and off, 174 Print command, 335 printer settings, 336, 345 Advanced Settings button, 346 Change Settings button, 336 Color Management, 338 Image Space, 338 Paper Type options, 346 Printer Profile, 338 Print Quality, 336, 337, 346 Rendering Intent option, 339 Working RGB - sRGB, 338 printing, 332 color management controls, 336 converting colors, 339 inkjet printers, 334-342 printer model, 336 matching output to screen, 342 multiple pictures, 343-351 color management preferences, 351 small paper size, 346 photo-quality prints, 340 print quality, 340 to inkjet printer, 334-342 Print Photos dialog box, 348 print resolution, 106, 107, 109 modifying, 106 print size, changing, 106 Print Space pop-up menu, 351 Print with Preview command, 335-342 profiles, missing profile error message, 68 Project Bin, 67, 82, 87, 329 rearranging photos, 306 Project Bin Photos checkbox, 306 properties, 29 Properties panel, 18, 49, 332 Proximity Match option, 327 pucker tool, 200, 203, 205 purity, 273, 299

Q

Quality setting (JPEG), 76 Quick Fix functions, 69 Quick Fix panel, 63–64 Temperature and Tint settings, 79 quick selection, 170–176

R

radius, 205 Random Photo Layout, 329 raster art, 237, 269 rating photos, 26 raw format files (see camera raw format files) recompose tool, 100–103 red eye, 13, 124-127 Auto Red Eye Fix command, 124 incorrectly identified, 17 removal tool, 113, 124–126 Darken Amount value, 126 Pupil Size, 126 Red-Eye Fix option (Fix tab), 63 redo operation, 62 Refine Edge, 171–176 Contract/Expand slider, 174 Feather setting, 174 Smooth slider, 174 Reject Change button, 101 Remove Color Cast command, 274 renaming photos, 19, 75 warning, 19 repairing broken images, 128-136 Resample Image checkbox, 237 Resample Image option, 103, 105 resampling, 103, 104, 109 Reset All Tools command, 228 resizing images, 103-108, 237 changing print size, 106 resolution, 103 print, 106, 109 retouching photos color correction (see color correction) color replacement tool (see color replacement tool) editing tool (see editing tools) healing brush (see healing brush) red eye (see red eye) Reveal All, 109 Reverse selection (Inverse), 145 Revert to Saved command, 188 RGB Color command, 116 right-justify a layer of type, 246 Rotate All Layers, 96 rotating images, 91 multiple, 17 warning, 19 rotating layers, 217 Russ, Kevin, 171 Ry G. Cbm, 277

S

sampling images, 258 sampling point, 230, 233 Saturate mode option, 123 saturation, 123, 273, 299 adjusting, 278-281 Saturation slider, 81 Saturation value, 288 Save As dialog box, 74, 84 Format option, 75 ICC Profile: Adobe RGB (1998) checkbox, 75 Include in the Elements Organizer checkbox, 75 Use Lower Case Extension checkbox, 75 Save command, 74 Save in Version Set with Original checkbox, 84 saving changes, 73-76 Scale Effects command, 221, 227 scaling designs, 258 scaling layers, 219 scaling vectors, 237 scanned art, coloring, 114–119 scarring, 132 Scatter value, 118, 137 scratched images, repairing, 128-136 scratches, 128, 134 Screen blend mode, 115, 137, 221 screen image, matching print output to, 342 scrolling left/right, 62 scrolling up/down, 62 Search button, 8 searching for photos by date, 48-58 Select a Frame, 347 Select a Layout, 347 selection brush, 164-170 Hardness value, 165, 169 Selection mode versus Mask mode, 168 selection outlines Anti-aliased check box, 143 technique, 145 selections adding to, 140 tilling with foreground color, 140 hiding outline, 140 multiple nonadjacent images, 332 printing image, 332 subtracting from, 140 selections, making, 139-176 irregular images, 157–162 isolating image element, 141 selection tools lasso (see lasso tool) magic wand (see magic wand tool) marquee (see marquee tool) shadows, 299 adding with burn tool, 122 lightening, 80

Shadows/Highlights command, 289-292 Darken Highlights option, 290 Lighten Shadows option, 290 Midtone Contrast option, 290 shapes cycling through custom, 236 drawing and editing, 251-258 duplicating, 254 positioning on-the-fly as you draw it, 236 scale, rotate, and move, 255 star (see star) shape selection tool, 254 Share panel, 353 Share to Photoshop.com checkbox, 354 sharing photos, 331-359 online (see Online Album) Organizer, 333 sharpening images, 181–183 best Radius value, 185 noise, 297 using blur, 188-189 versus softening, 182 Sharpen option (Fix tab), 63 Sharpen panel, 76 Sharpen slider, 82 shortcuts bar (Organizer), 11 Show Bounding Box checkbox, 254 Show Newest First within Each Day, 16 Shrink Canvas to Fit, 96 Shutterfly option, 315 Silva, Pedro, 305 Similar command, 144, 145, 177 Simplify, 269 Simplify Layer command, 252, 334 single photo view, 15 cycling through photos, 17 slideshows, 22-23 advancing slides, 302 full-screen, 24 play or pause, 302 preview tull-screen, 302 saving project, 302 Slideshow Settings dialog box, 354 Smart Fix, 271 Auto Smart Fix command, 279 Smart Fix adjustment, 71 Smart Fix Amount slider, 71 Smart Fix option, 78 Smart tags, 59 Smooth slider, 174 soft edges, 169 softening versus sharpening, 182 source point, healing brush, 131, 132 spacebar and dragging, 160 special effects, text, 244-250

sponge tool, 120, 122, 137 Flow value, 122 Mode option, 122 spot healing brush, 130 square units, 106 sRGB, 359 Stack, 27, 29 stacking order, 233 Stack Selected Photos, 26 Standard Edit mode, 236 opening images from Organizer, 272 star drawing a, 253 duplicating, 254 scale, rotate, and move, 255 Straighten and Crop Image command, 92-95 straightening tools, 95-99, 96, 97 stretching image vertically, 204 strict perspective-style distortion, 262 Stroke dialog box, 214 Styles and Effects palette locating, 148 Style Settings dialog box Bevel Direction, 267 Bevel Size option, 267 dialog box options, 266–267 display dialog box, 149 Distance Shadow option, 267 Lighting Angle value, 267

Τ

tags, 59 adding and editing icon, 41 applying, 37 categories, 36 creating and using, 31 creating new, 32 defined, 33 double-clicking, 35 Edit Tag dialog box, 38 Edit Tag Icon dialog box, 41 filters interacting with timelines, 53 finding untagged photos, 32 organizing, 36 searching for thumbnails, 42 subcategories, 42 viewing, 39 Tags palette, 36 teeth, whitening, 127 temperature, 87, 299 Temperature slider, 79 text cast shadows, 245 creating and formatting, 238-244 distorting, 250 editing tips, 246

formatting attributes, 239 incrementally increase or reduce size, 236 nudging, 264 scaling, 263 setting color, 243 special effects, 244-250 warping type, 259-264 ways to edit, 246 text layers, 241 changing multiple, 246 transforming, 247 theme, 329 thumbnails, 11, 29 hiding/showing details, 4 making smallest, 13 searching for, 42 viewing larger, 14 zooming in/out, 4 TIFF file format, 335 Timeline, 29 showing, 32 timelines, 51 helpfulness of, 52 interacting with tag filters, 53 range markers, 53 Times New Roman font, 239 time stamp, 59 tint, 273, 278-281 (see also hue) Tint slider, 79 tolerance, 177 Tolerance value, 143-145 toning tools, 121 toolbox, 67 Top of Day, 59 transformation mode, exiting, 208 transforming all colors by equal amount, 280 Free Transform command, 263 layers, 217-227 text layer, 247 transparency, 268 Transparency command, 229 type alignment, 239 typefaces, 239 type tool, 239 moving text when active, 236

U

underlining text, 246 undo operation, 62 Unsharp Mask dialog box, 187 Amount option, 187 Unsharp Mask filter, 183, 205 Amount value, 187 how it works, 188–189 Untagged Items command, 44 upsampling, 105

V

Variations command, 275 typical use of, 274-278 vector-based objects, 237-238, 269 vectors, scaling, 237 Version Set option, 84 version set, saving in, 83-86 Video Lesson 1: Welcome to the Organizer adding copyright to photos adding images to catalog Albums Always Launch Elements Catalog command Catalog Manager catalogs creating new catalogs Edit button Get Photos and Videos metadata My Catalog New Album command Organize button Photo Downloader Photoshop.com account rotating images seeing only new images selecting files to download selecting non-adjacent images switching between albums viewing individual images Welcome Screen Video Lesson 2: Tags, Maps, and Faces Add Missing Person Auto-Analyzer options automatically analyzing photos **Display Options** Edit Keyword Tag Icon face recognition filtering by ratings Find People for Tagging Keyword Tags maps New Category New Keyword Tag photo editing Run Auto-Analyzer Show All button Show close match results Smart Tags sorting photos star ratings tags Timeline command zooming in/out thumbnails Video Lesson 3: The Fix Tab and **Quick Edit Features** Auto Color Auto Contrast

Auto Levels Auto Sharpen Auto Smart Fix correcting colors Darken Highlights Escape key Fix panel Full Edit mode Full Screen mode Guided Photo Edit hand tool hue Lighten Shadow Midtone Contrast Organizer panel Properties panel Quick Edit mode Quick Edit panel Quick Fix panel Quick Organize panel saturation temperature tint toggling between modifications Version Set view before and after edits zoom tool Video Lesson 4: Image and Canvas Size 100% zoom Arrange icon collapsing/expanding panels Consolodate All DNG format dpi dragging panels floating window Full Edit mode Image Size Info panel Open Image button ppi Project Bin **Resample** Image Reset Patiels resizing images resolution sharpening switching between images Undo History Video Lesson 5: Brush Options background color Bevel styles blend modes brush options brush sizes brush tools burn tool color picker dodge tool

Effects panel eraser tool filling layer with foreground color filling opaque pixels foreground color lavers Linear Burn blend mode New Layer opacity rectangular marquee tool sponge tool toolbox Wacom tablets Video Lesson 6: Selection Tools brush tool delete from selection Deselect command elliptical marquee tool Grow command lasso tool magic wand tool magnetic lasso tool move tool polygonal lasso tool quick selection tool rectangular marquee tool Refine Edge selection outlines selection tools Video Lesson 7: Filtering Basics Adjust Color creating unique effects duplicating layers Effects panel Emboss filter Extrude filter Filter Gallery Filter menu Gaussian Blur filter Invert filter Lens Flare filter Linear Light blend mode multiple filter effects New Layer dialog box Upacity Overlay blend mode Poster Edges filter Remove Color Show Names option Soft Light blend mode Video Lesson 8: Layers at Work blend modes Color blend mode colorizing Color option Create Clipping mask Defringe Layer extracting objects from background filling selection with color Fill Layer command

Gaussian Blur filter gradient tool Grow command Hard Light blend mode hiding selection increasing thumbnail size Inverse command layered compositions Load Selection command Multiply blend mode New Layer dialog box nondestructive modifications opacity Overlay blend mode parametric modifications Preserve Transparency option renaming layers Sample All Layers saving selections Solid Color layer mask Video Lesson 9: Scalable Objects and Effects Bicubic changing fonts **Constrain** Proportions custom shape tool drop shadows fill layer with background color Image Size interpolation Laver Styles modifying layer effects opacity **Remove Style** Resample Image resetting type Scale Styles scaling artwork shapes Style Settings text text layers text size type tool upsampling vector-based shapes vector mask Video Lesson 10: Color Adjustments and Adjustment Layers adding color to black and white image Adjust Color for Skin Tone adjustment layers Auto Levels balancing skin tones color cast problems color enhancements Colorize duplicating color stops

Video Lesson 10 (continued) Gradient Map grayscale images Hue/Saturation Levels command Load Gradients modifying gradients opacity Remove Color Cast RGB Color mode Video Lesson 11: Making a Slideshow adding text to slides Add Media Apply Pan and Zoom to All Styles Auto from Elements Organizer changing slide duration Costumes DVD - NTSC option editing pan and zoom positions Fade transition style Fit Slides to Audio Full Screen Preview Include Photo Captions as Text Maximum (WMV Setting Details) Movie File (.wmv) music, adding to slideshow ordering images Output Your Slideshow pausing slideshow Preview Quality rearranging slides

Save As a File Save Project Slideshow Editor Slideshow Preferences slideshows Transition Duration Transition styles VCD - NTSC option Video Lesson 12: Emailing Your Images Add Caption to Selected Items captions Choose a Stationery Contact Book Customize the Layout **Email Attachments** emailing images Import Contacts Include Captions Maximum Photo Size Message Photo Mail Properties command Quality Replace Existing Captions resetting photo size for email Select Recipients Stationery and Layouts Wizard video lessons downloading, xv watching online, xiv visible color spectrum wheel, 277

W

warping type, 259–264 Warp Text, 261, 269 warp tool, 198, 201, 204, 205 Wave filter, 179 Welcome Screen, 4–6, 8, 29 white balance, 293 White Balance option (camera raw files), 293 whitening teeth, 127 whole-image transformations, 89–95, 109 Working RGB - sRGB, 338 Wright, Gisele, 167

Y

Year button, 58

Ζ

zoom control, 67 zooming in/out, 62 Organizer workspace, 332 thumbnails, 4 Zoom slider (Organizer), 11 Zoom value, 68

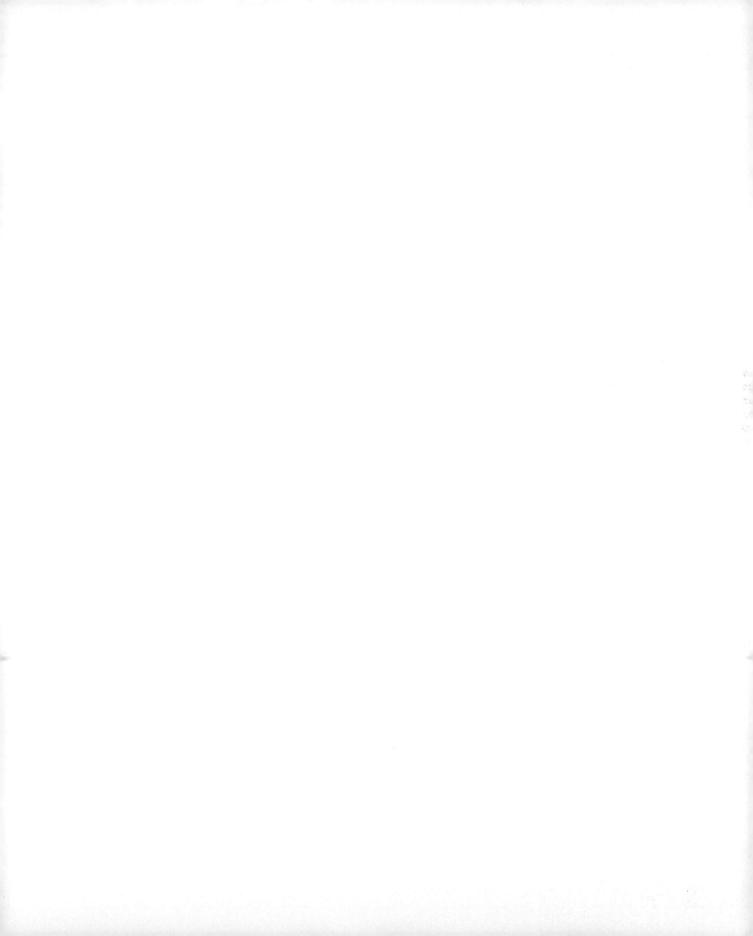

TM Uncensored, Unregulated, and Frankly Unwise deke.oreilly.com www.deke.com

Author Deke McClelland has been unleashed in dekePod, his new video podcast series on the topics of computer graphics, digital imaging, and the unending realm of creative manipulations. New podcasts are posted every two weeks. Drop by deke.oreilly.com to catch the latest show or to browse the archives for past favorites, including: "Don't Fear the LAB Mode," "Buy or Die: Photoshop CS4," and "101 Photoshop Tips in 5 Minutes."

Don't miss an episode when you subscribe to dekePod in iTunes

Learn from a Master

Boundless enthusiasm and in-depth knowledge...

That's what Deke McClelland brings to Adobe Photoshop CS4. Applying the hugely popular full-color, One-on-One teaching methodology, Deke guides you through learning everything you'll need to not only get up and running, but to achieve true mastery.

- 12 self-paced tutorials let you learn at your own speed
- Engaging real-world projects help you try out techniques
- Over four hours of video instruction show you how to do the work in real time
- Nearly 1,000 full-color photos, diagrams, and screen shots illustrate every key step
- Multiple-choice quizzes in each chapter test
 your knowledge

Also out now:

- Adobe InDesign CS4 One-on One, ISBN 9780596521912
- Photoshop CS4 Channels & Wasks Une-on-Une, ISBN 9780596516154

digitalmedia.oreilly.com

©2009 O'Reilly Media, Inc. O'Reilly logo is a registered trademark of O'Reilly Media, Inc. All other trademarks are the property of their respective owners. 80761

ENJOY a Free Week of training with Deke!

Get 24/7 access to every training video published by lynda.com. We offer training on Adobe® Photoshop Elements® and hundreds of other topics—including more great training from Deke!

The lynda.com Online Training Library[™] includes thousands of training videos on hundreds of software applications, all for one affordable price.

Monthly subscriptions are only \$25 and include training on products from Adobe, Apple, Corel, Google, Autodesk, Microsoft, and many others!

To sign up for a free 7-day trial subscription to the lynda.com Online Training Library™ visit www.lynda.com/dekeps.